The Queen and the Arts

Cincinnati Music Hall and Ex-
position Buildings (1879),
Russell, Morgan and Company
lithograph; courtesy of the
Cincinnati Historical Society.

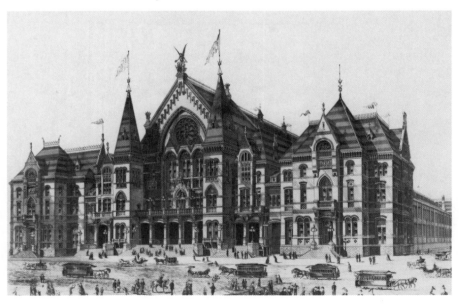

The Queen and the Arts

Cultural Life in Nineteenth-Century Cincinnati

Robert C. Vitz

THE KENT STATE UNIVERSITY PRESS

Kent, Ohio, and London, England

© 1989 by The Kent State University Press, Kent, Ohio 44242
All rights reserved
Library of Congress Catalog Card Number 88–30112
ISBN 0–87338–376–1
Manufactured in the United States of America

Library of Congress Cataloging-in-Publication Data

Vitz, Robert C., 1938–
 The Queen and the arts : cultural life in nineteenth-century Cincinnati /
Robert C. Vitz.
 p. cm.
 Bibliography: p.
 Includes index.
 ISBN 0–87338–376–1
 1. Arts, American—Ohio—Cincinnati. 2. Arts, Modern—19th century—
Ohio—Cincinnati. I. Title.
 NX511.C56V58 1989
 700′.9771′78—dc19 88–30112
 CIP

British Library Cataloging-in-Publication data are available.

For Margaret

Contents

Preface

*E*xcept from local historians, Cincinnati has never received much attention as a cultural center. New York and Boston have dominated the national perspective of the arts, while Chicago's cultural prominence after 1890 is generally regarded as the major contribution from the Midwest. During much of the nineteenth century, however, Cincinnati served as the artistic and intellectual fulcrum for the central part of the nation, and for a short time the city entertained hopes that it would become America's leading music center. It never achieved that lofty goal, but the city did contribute significantly to the general cultural development of the country. Between 1840 and 1880, Cincinnati offered the most extensive artistic support and training west of New York, and several dozen painters, sculptors, actors and musicians used that encouragement to achieve distinguished reputations in the East or in Europe. Other artists remained in the Queen City, providing much of the nourishment that established the city's major cultural institutions.

This book explores Cincinnati's general cultural and intellectual life during the last century, focusing both on the individuals involved and the civic promotion that surrounded their contributions. Of equal importance to the artistic life within the city was the national attention that Cincinnati gained, and the way that attention shaped the city's self-image. Once known principally as a commercial and manufacturing center, Cincinnati's cultural reputation helped erase the image of coal smoke and slaughterhouses. Today, as the city observes its two hundredth birthday, much of the celebration is being held in those cultural institutions that marked the city's coming of age a century ago.

Although I grew up in Cincinnati, the city's rich cultural history did not

hold my youthful attention. Indeed, despite my parents' own historical interests, I remained singularly uninterested until I was well into college. As the discipline of history gradually drew me in, somewhat serendipitously I discovered Cincinnati's cultural past. While driving from California to Ohio in 1965, my wife and I visited the Santa Fe-Taos area, and I discovered the considerable number of Cincinnati-linked artists tied to that region's past. Two years later this resulted in a master's thesis for Miami University. At that time I thought Cincinnati was a closed chapter in my life. Four years in Chapel Hill, North Carolina, research on the radical activities of New York artists in the 1930s, and a year's teaching at Purdue University left little time or inclination for the Queen City. In 1972 I accepted a position in the Department of History and Geography at Northern Kentucky University, and its physical proximity to Cincinnati rekindled my interest. But what started out as a scholarly examination of Cincinnati's role in the nation's artistic development gradually evolved into this more generalized study of the city's cultural life.

Over the years I have accumulated many debts. Dwight L. Smith and Ronald E. Shaw of Miami University provided early encouragement and planted seeds at the time of which neither they nor I were aware. The late George E. Mowry of the University of North Carolina was always a compassionate adviser and warm friend. Winton Solberg of the University of Illinois provided the opportunity to start on this topic through his 1977 summer seminar, funded by the National Endowment for the Humanities. The staffs of the Cincinnati Historical Society, the Cincinnati Art Museum, the Public Library of Cincinnati and Hamilton County, the Ohio Historical Society, the University of Illinois, and the Boston Public Library were unfailingly courteous and helpful in providing access to their collections. Carole Schwartz, former archivist and assistant librarian with the Cincinnati Art Museum, was especially helpful in guiding me through the labyrinth of that institution's records. Linda Bailey of the Cincinnati Historical Society, Bill Clark and Joy Payton of the Cincinnati Art Museum, and Ed Rider of the Procter and Gamble Company gave readily of their time in locating appropriate illustrations.

My task was considerably shortened by the many historians, both professional and dedicated amateurs, who previously explored the nooks and crannies of Cincinnati's past. I have depended on their research and insights, and my endnotes reveal the extent of my obligation to them.

Various people at Northern Kentucky University generously assisted me. Acting Provost Darryl Poole and Acting Dean Carl Slater made funds available to offset typing and illustration costs. The Faculty Benefits Committee supported my requests for a sabbatical leave in 1979 and summer fellowships in 1982 and 1985. Michael Ryan, my department chairman, con-

stantly encouraged and supported the project. Louise Brown and Ann Wick assisted with typing, and Shirley Raleigh attended to a thousand details. Jeffrey Williams, a colleague and friend, offered valuable suggestions on the early chapters, while Louis R. Thomas not only critically read the entire manuscript but gave cheerfully of his exceptional knowledge of Cincinnati's musical heritage. My debt to him is immeasurable.

To my parents, Alda Vitz and the late Carl Vitz, I owe much of my interest in things historic—even if I was a slow learner. I also wish to acknowledge my children, Kristina, Andrew, and Matthew, for their support, often silently expressed but always felt. My greatest debt is to Margaret, without whose patience, encouragement, and toleration of my many moods this book would not have been written.

Prologue
"The Paris of America"

*A*s was his custom Theodore Thomas ignored the roar of applause that greeted him as he walked across the stage. He immediately turned toward the orchestra and signaled for the opening number, but scarcely had the first notes of Gluck's overture to *Alceste* greeted the audience when Thomas abruptly halted the musicians and glared at the ranks of the chorus. A handful of tardy members quickly scurried to their places, conscious of the maestro's cold stare. Once again the orchestra began, and once again Thomas signaled for a stop. This time he fixed his gaze on the numerous late arrivals in the audience, many of whom, unaware of the director's mounting anger, continued to greet friends and chatter with companions long after reaching their seats. After several icy minutes, Thomas turned and for the third time brought his baton down for the start of the performance. Cincinnati's great May Music Festival of 1878 was underway.

Music was no stranger to the city nestled along the bank of the Ohio River, and highly successful spring festivals had already been presented in 1873 and 1875, but this was a special year. The four-day, six-concert extravaganza of choral and symphonic music inaugurated the just completed Music Hall. For weeks excitement had been building in the Queen City, and from the warehouses clustered along the public landing to the recently completed houses inching up the steep hillsides, conversations had turned to the great musical event. Talk of pork and whiskey gave way to mention of Beethoven and Theodore Thomas, and, of course, to Reuben Springer, the principal benefactor of Music Hall. On opening day, Tuesday, May 14, Cincinnati dressed for the occasion. Garlands of evergreens looped from window to window, wreathes and flowers brightened doorways, and everywhere one observed flags and bunting. Hundreds of banners and pictures displaying

the faces of Haydn, Mozart, Beethoven, and even chorus director Otto Singer, fluttered in the cool May air. Along Fourth Street throngs of visitors admired the lavish profusion of color, eagerly anticipating opening night. Many stopped to gaze at the more elaborate decorations, the chamber of commerce's huge banner which read "Commerce the Handmaid of Art," or the red, white, and blue bunting sported by several hotels. Most impressive was the Cincinnati Gas Company's "immense lyre made of gas pipe" which stretched across Fourth Street to the building opposite. On top of the lyre rose the numbers 7 and 8, in honor of the year, and below, the name Springer, and every evening the gas jets illuminated the display.

Wherever one turned, from the river to the Miami and Erie Canal and beyond, the city flaunted its pride in the great event. Main Street was a profusion of color, and Plum Street wore its decorations up to Springer's modest brownstone house at the corner of Seventh. Even the "pleasure resorts" that gave upper Vine Street its beery reputation contributed to the whirl of color and excitement. City offices closed in honor of the opening performance. Down on the levee and at the several railroad stations, visitors continued to pour into the city. Enterprising individuals hawked festival tickets for as much as fifty dollars, while scores of pickpockets and sneak thieves sized up their marks. Hotels frantically placed cots and mattresses in hallways and corridors, and even at outlying boarding houses rooms were at a premium. Cincinnati had never witnessed such grand confusion.

By late afternoon attention had shifted to the imposing structure of Music Hall. Crowds of the curious began to gather, and troops of boys raced back and forth across the spacious plaza, caught up in the excitement of the extraordinary day. A tall, mustached policeman attempted to keep the front steps clear, but with little success. When the doors opened at 6:30, Elm Street had already become a sea of hacks, streetcars, and carriages, each one discharging its passengers and slowly maneuvering back through the crowd. The waiting horde gawked at the arrivals, eagerly scrutinizing the ladies' apparel and searching for the most prominent men. The evening chill passed unnoticed. The men arrived in fashionable Prince Albert coats and white ties, the monotony of their appearance broken occasionally by an old-fashioned swallowtail coat and low cut vest. Light shades of silk, in keeping with the season, highlighted the female attire, although a *Cincinnati Enquirer* reporter noted that "many and the richest were those of black silk and velvet." White kid gloves, handsome fans, and stylish bonnets completed the evening's wardrobe, and those who declined to wear a bonnet sported elaborate coiffures decorated with flowers, pearl combs, or Grecian bands of gold. "An audience of culture, refinement and elegance," remarked another reporter, and the ladies' toilette "surpassed in richness and elegance any similar display made in this city."[1]

2

Rivaling the ladies for attention was the imposing brick edifice that had been built to house the May Festivals. The gay, surging throng gazed in awe at the magnificent structure, which still showed signs of its recent completion. Designed to seat over 4,400 people, some 6,000 worked their way into the building for the opening night. Inside the massive vestibule, graceful pillars and colored tiles welcomed the fortunate ticket holders before they passed into the great auditorium. There one immediately noticed the wood-lined walls and ceiling which cast a rich, warm glow throughout the interior. At the rear of the stage stood the great organ, built in Boston but enclosed by elaborate wood panels carved in Cincinnati by students of Benn Pitman and William Fry.[2]

Considering the ornateness of the building and the excitement of the moment, one wonders how Theodore Thomas was able to quiet the audience, even after two false starts. That the occasion overshadowed the musical performance was made evident at the dedication exercises which followed the conclusion of the *Alceste* overture. When Reuben Springer was led on stage, the immense throng rose to its feet. Cheers resounded throughout the hall, hats sailed through the air, and bouquets showered onto the stage. The cheering continued for fifteen minutes, supported by bass notes from the organ, while the kindly old man stood calmly, breathing in the enjoyment of the moment. Springer's remarks were a monument to brevity and modesty, enhancing his popularity all the more. Following the dedication ceremony, the chorus and soloists joined to present the "Festival Ode," composed by chorus director Otto Singer, and the lengthy program finally concluded with Beethoven's *Third Symphony*.[3]

That evening was very special to Cincinnati. The highly successful May Festivals, now housed in perhaps the finest auditorium in the nation, had made the city a major musical center. Indeed, Cincinnatians—and others—proudly proclaimed it "the Paris of America" and suggested that the muse of music had moved from Boston to the Queen City. Cincinnati could be excused for a certain amount of hyperbole. All music lovers acknowledged that 1878 festival as one of the nation's outstanding musical achievements, and even the eminent critic for the *New York Tribune,* J. R. G. Hassard, called it "the greatest festival of art that America has ever beheld."[4] From Chicago, Philadelphia, and even Boston came accolades. This was heady stuff to a city increasingly concerned about its economic future. In addition to this gratifying recognition, the 1878 festival led directly to the founding of the College of Music of Cincinnati, an institution which aspired to be a truly national conservatory. Theodore Thomas, the most prominent man of music in the country, left New York to head the new college, which utilized the facilities of Music Hall for its instruction. Thus, for several years Cincinnati did indeed appear to be the music center of the nation.

3

About the same time, the city's reputation for painting and sculpture received some much needed support. For a generation Cincinnati had enjoyed a well-earned reputation as the major art center of the West. It had early provided a cultural atmosphere which attracted artists from throughout the region, and by mid-century the city had spawned such nationally recognized artists as Hiram Powers, Robert Duncanson, and Worthington Whittredge. From its frontier days the city had rarely been without some type of art school, and this early push for artistic training culminated in 1867 with the establishment of the McMicken School of Design. By 1878 the McMicken School claimed credit for the success of Henry Mosler, just then gaining an international reputation for his scenes of French peasant life, and for the women's classes in woodcarving and porcelain decoration which had earned so much recognition at the 1876 Philadelphia Centennial Exhibition. Frank Duveneck, born and reared across the river in Covington, Kentucky, had just recently emerged as an important force in American painting as well. The cultural winds that blew through the city in 1878 affected the patrons of art along with those who loved music, and a movement was soon launched to establish an art museum and attach the School of Design to it. In a few years, Cincinnati would boast of its eminence in both music and art, and this new recognition would help assuage the pain attached to the city's sliding position as a commercial and manufacturing center.

Pride in Cincinnati's contribution to the fine arts was manifest on that festival evening in 1878, but support for cultural events represented only part of a new civic zeal. The years after the Civil War witnessed not only the establishment of the May Festival, the College of Music, and Music Hall, but also the Zoological Gardens, Clara Baur's Conservatory of Music, and the erection of the Tyler Davidson Fountain. Paralleling this activity was the completion of the suspension bridge across the Ohio River, the drive to construct a railroad to connect the Queen City to the South, and the initiation of a series of industrial expositions to display local manufactures. It is significant that the original purpose of Music Hall included service as an exposition and convention center as well as a music auditorium. Local residents recognized the importance of Music Hall to the city's future as both a cultural and manufacturing center, and this accounted for much of the excitement generated at the opening.

That other cities engaged in similar promotion of cultural institutions did not perturb Cincinnatians; indeed, they scarcely recognized developments in western competitors. As the *Cincinnati Commercial* explained to its readers, the Queen City—"the central great city of the nation"—would shortly become "the City of National Conventions and the social center and musical metropolis of America."[5] Music Hall served as the rock upon which Cincinnati would build its new urban reputation. As the chamber of com-

merce banner had so boldly proclaimed, commerce was indeed to be the handmaid of art.

Cincinnati never realized its loftiest ambitions. Too much ran counter to its dreams. Chicago's location and greater wealth never allowed Cincinnati to recapture the western economic leadership that it had held for half a century, and the city's cultural challenge to New York and Boston quickly faded. Still, the Gilded Age had held out the promise of a better life, and for two decades the smoky, sooty city on the Ohio dreamed its dreams, almost convinced that it had a special role to play in the arts. That it failed does not diminish the importance it once held.

1

Cultural Beginnings, 1788–1842

S ome four hundred miles downstream from Pittsburgh and a few miles past the mouth of the Little Miami River, the Ohio River takes a lazy bend to the north. At this point in late December 1788 a handful of hardy pioneers scrambled ashore from their crude flatboats. Thick strands of timber and the occasional sign of an Indian hunting party warned of difficulties ahead; however, the region showed promise. Situated opposite the Licking River which flowed from the fertile soil of the Kentucky Bluegrass to the south, and located on an alluvial plain that sloped gently northward to a semicircle of hills more than a mile distant, the site gave rise to an expectant future.

Within weeks stumps had replaced the towering trees, and a scattering of rude cabins displayed the first signs of permanency. At first the settlement called itself Losantiville, an awkward mixture of Latin, Greek, and French meaning village opposite the mouth of the Licking (L-os-ante-ville). Arthur St. Clair, the first governor of the Northwest Territory, discarded the somewhat pretentious title for the name Cincinnati, taken from the Society of Cincinnati, an organization of Revolutionary War officers to which he belonged. Bolstered by the presence of Fort Washington, constructed in 1789, the embryonic town quickly edged ahead of its rivals, and by the end of the century the youthful community boasted several hundred houses and a population approaching one thousand. The rapid opening of the interior fostered a steady commerce, and the town served as a funnel to the rich farmland of the Miami Valley. However, those who settled in Cincinnati spurned the rural life for the more cultivated atmosphere of a town, and along with economic gain they turned their energies toward carving out an urban culture amidst the wilderness.

Like other frontier communities Cincinnati had only limited time, money, and energy to devote to the fine arts, yet very early in the town's development a love of refinement and culture becomes evident. The men who lent direction and leadership to the young settlement came from cultured and sophisticated backgrounds, and they hoped to reproduce the accustomed society of their eastern origins. This proved a difficult task, and a generation of struggle, exertion, and despair would pass before the seeds of civilization sprouted in the western soil.

There were, of course, the early and surprisingly numerous references to painters, musicians, and theatrical troupes. Possessed of limited talent, these artists nevertheless reveal the first hint of the community's search for a better life. As these individuals crisscrossed the region, they made Cincinnati the focal point of their activity. George Jacob Beck, a scout in General Anthony Wayne's army, has the distinction of being the first "professional" painter in the settlement. After his arrival in the early 1790s, the English-born Beck spent the remainder of the decade painting portraits, landscapes, and a variety of ornamental work.[1] In 1812 one Edwin Smith opened an "academy," which provided instruction in "portraits, miniatures, landscapes, and Ornamental painting," all for six dollars per quarter year, plus an entrance fee of two dollars. Subscribers were scarce, and within a year Smith had abandoned art for a more profitable future in business. A few years later John J. Audubon, fresh from a Louisville debtor's prison, and Chester Harding, one of several artistic brothers, appeared in the city—the thirty-five-year-old Audubon to work in the just-opened Western Museum as a taxidermist and Harding to instruct young ladies in "the art of painting." Neither remained long. The restless naturalist soon headed downriver by flatboat for his rendezvous with destiny, while Harding set out for Philadelphia to embark on a distinguished career as a portraitist.[2]

Audubon and Harding, although more talented than most, illustrate the wandering nature of the artists who dot the early records of the area. Indifference was a hard teacher. As "Curtius" grumbled in the *Liberty Hall,* there is "entire contempt . . . for everything like the cultivation of literature and the Arts." The majority of frontier painters were itinerants, scrambling to keep brushes in their hands and food in their stomachs. Portraits offered the only real income, and that a meager one. A few "pupils," some sign painting or other decorative work, or a second trade were all that provided an income, and when a community's financial well ran dry, the artist moved to a new location. Only a few earned more than a brief newspaper comment.[3]

A change appeared in 1818 when Aaron Corwine, the most promising of the early Cincinnati artists, arrived from Maysville, Kentucky. Only fifteen, Corwine quickly attracted the attention of Benjamin Powers, the editor

of the *Inquisitor-Advertiser*. Powers promoted the "ingenious and promising youth," and soon the eminent physician, Daniel Drake, arranged for the young man to study with Thomas Sully in Philadelphia, the trip being financed by payments from prominent citizens advanced for future portraits. After returning to Cincinnati to execute those commissions, the young Kentuckian set out for further study in Europe. A few years later death cut short his career, but he remains the region's first artist of real merit, and the first to receive support and recognition from the community's emerging cultural elite.[4]

Music also left early traces in the future Queen City. Fort Washington introduced some musicians into the area, and about 1800 General James Wilkinson is said to have imported his own musicians from the East to play "the harmonies of Gluck and Haydn." Wilkinson soon departed, taking the musicians with him, but Cincinnati did not remain without song. On the very eve of the new century, a dancing school opened—"a nursery of dalliance, frippery and folly," raged the editor of the *Cincinnati Western Spy*—followed by the town's first opera production and a singing school. Little is known about the opera, but Levi McLean operated the school and charged one dollar for thirteen weeks of instruction, with the provision that the subscribers "find their own wood and candles."[5]

Brass bands and balladeers made up much of the public entertainment until the Harmonical Society presented its first concert in 1814. This amateur group rehearsed at Burt's Tavern each Saturday evening, gave occasional performances, and provided the music for the Thespian Corps, an early amateur theatrical group. Audiences for their concerts remained quite small, however, and the society's "annual Concert and Ball" in December 1819 proved to be its last. About the same time James Hoffman confidently opened his "musical academy," promising to teach "in a scientific manner, a scholar of thirteen tunes, in eighteen lessons" on any of nineteen instruments, which included the hurdy-gurdy, the sackbut, and the flageolet. Hoffman's academy did not prosper. In 1817 Philabert Ratel arrived in the community and immediately opened a music and dancing school. "In four or six months," he advertised, pupils could learn "a competent knowledge of music, and its various tunes to perform alone or in harmony correctly." Ratel met with more success, and he remained active in local musical affairs for several years.[6]

Theater also enjoyed some early success in Cincinnati, for entertainment-starved residents greedily received the first performances, usually put on by fellow residents. At the end of one "season," the editor of *Liberty Hall* complained that the populace was now left "with no other source of amusement and instruction than about twenty sermons a week—private Assemblies—state cotillion parties—Saturday Night Clubs, and chemical lec-

tures—which like the ague, return every third day with distressing regularity." Amateur thespians soon had to compete with professional troupes, the first of which reached the community in 1805, although no record exists of what was performed or how long it stayed. Perhaps encouraged by these first professionals, Peyton Symmes and Benjamin Piatt organized local theater buffs into the Thespian Corps. These exuberant citizens opened their first season in Vattier's stable where Mayor David Ziegler, replete in "knee breeches, gold laced coat, cocked hat, and sword," greeted the opening night audience.[7]

For the next ten years the Thespians, joined by an occasional touring company, provided the bulk of Cincinnati's theatrical entertainment. Among the visiting groups, the most popular was the Pittsburgh Comedians, directed by William Turner and his wife. The Comedians made frequent appearances between 1811 and 1817, and they worked well with local amateurs in several elaborate productions, including *Romeo and Juliet*. More often, however, dramatic fare consisted of comedies and farces, which invariably found favor with the citizenry, always excepting the Reverend Joshua Wilson. Wilson, pastor of the First Presbyterian Church, led the religious attack against the immoral influence of the theater, and the columns of *Liberty Hall* and the *Western Spy* provided a forum for the reverend divine's battle against the forces of evil.

In 1815 drama supporters countered with the construction of the famous Shellbark Theatre, located on Sycamore near Third Street. This brought forth Wilson's sharpest attack. But in a well-publicized response, a supporter proposed a dinner toast to "The Cincinnati Theatre—May it not, like the walls of Jericho, fall at the sound of Joshua's Horn." The building survived Joshua, but uncertain profits and limited repertoires did not encourage professional troupes to remain long in one place, and the departure of the Turners for St. Louis in 1817 brought the curtain down on the first stage of Cincinnati's theatrical development.[8]

The next spring opened a decade of decidedly more polished drama. Samuel Drake, manager of the Kentucky Theatre and an English actor of some renown, arrived in Cincinnati. Drake, no relation to either Daniel or to the actor Alexander Drake, had achieved his American reputation in Boston and Albany, but the fortunes of the stage had finally led him first to Kentucky and then to Cincinnati. Somewhat rashly he first called on the townspeople to subscribe funds for a new theater building to house his company. The *Cincinnati Inquisitor* reflected the community's skepticism:

Not a Duck, but a Drake, from Kentucky has come,
Our Bucks will now do their best,
To provide a snug place as is said by some,

For this rare bird to *feather* his *nest*.
But should the good people of this thriving place,
On this wonderful Drake chance to frown,
Why then he'll fly back with Theatrical grace,
and light where his merits are known.

The city did not support Drake's scheme, nor did the impending bank crisis help, and Samuel Drake did indeed soon fly back to Kentucky. A seed had been planted, though, for later that year a new theater, the Columbia Street Theatre, was erected on the site of the burned-out Shellbark Theatre. Local thespians inaugurated this new facility in 1820 with a performance of *Wives As They Were and Maids As They Are.* Gallery seats sold for fifty cents and box seats for one dollar, and the new building was acclaimed "the best structure of its kind in the western country this side of New Orleans." The theater measured ninety-two feet by forty-four feet, and its front displayed four pillars and a pediment in deference to the classical taste of the time. Inside a chandelier and lamps hanging from the balustrade provided light, while sperm oil footlights illuminated the performers. For the most popular plays, over seven hundred people could squeeze into the building. William Jones and Joshua Collins, the owners, promised to remain permanently in the city and return "thousands in invigorating currents to the various classes from which they had been drained." In addition, the owners announced that eastern actors would be imported to make the theater "both popular and respectable."[9]

Collins and Jones provided the young city with the finest dramatic entertainment it had yet witnessed, including a highly popular presentation of *The Merchant of Venice.* However, the pièce de résistance for the first season was *The Battle of New Orleans,* a stirring production which ended with a large transparent eagle, emblazoned with the motto "The Hero of New Orleans," descending onto the head of General Jackson. Although the economic depression which ravaged the city in the early 1820s discouraged all forms of entertainment, Collins and Jones continued to provide noteworthy theater. Alexander Drake, Edwin Forrest, Junius Brutus Booth, and Frances Denny (later to be Mrs. Alexander Drake) all made their first Cincinnati appearances under the auspices of Collins and Jones. Still, theater rarely earned a profit, and most companies played but a short time before moving on to another community. Supporting casts were often weak, company repertoires small, and audience behavior often abominable. Men's hats and ladies' bonnets obscured vision, and the general rudeness of the patrons were problems common to all forms of public entertainment. The "practice of cracking nuts" and throwing "nutshells, apples, etc. into the pit" frequently irritated the more refined members of the audience, to say nothing

of those sitting in the pit. Indeed, that may have been the purpose of those doing the throwing. An especially sore point was that theater patrons often had to push their way through gawking crowds of "boys, negroes, wenches, lewd women and devils of all sorts, sizes and kinds" to gain entrance. Uncalled for clapping, whistling, and jeering from the rowdier element disrupted performers, and one actor, a Mr. Jackson from New York, was completely unnerved by the raucous greeting which met his entry on to the stage.[10]

As has already been noted for the other arts, the number of people able to enjoy and appreciate serious theater was quite small, and even the increasing professionalism of the performances did not guarantee either crowds or profits. While patrons might turn out in droves for a well-advertised single performance of *King Lear* with Booth in the title role, all too often half-empty houses greeted the actors. Even the popular Drakes failed to stay out of debt.

Neither the time nor the place proved conducive to success. Cincinnati recovered slowly from the financial difficulties of the 1820s, and the hard times scarred several of its leading citizens. William Lytle, Daniel Drake, Judge Jacob Burnet, Oliver M. Spencer, and Martin Baum all felt the depression's sting. Furthermore, theater remained less fashionable than other forms of cultural entertainment, and the opposition of Reverend Wilson points out that for an appreciable number of people the theater remained the devil's playground. Then, too, for every Booth or Drake there were a dozen or more mediocre actors who damaged the reputation of theater, and the uneven quality of Cincinnati theater so offended that proper English woman, Frances Trollope, that it provoked some of her sharpest comments in her famous *Domestic Manners of Americans,* published in 1832. Given this struggle against adversity, one can only be amazed at the numbers of theater groups which performed in the city and at the quality of acting occasionally reached.[11]

For all of its economic turbulence, the decade of the 1820s brought a growing cultural maturity to the young city. The recent census had shown that Cincinnati's population now exceeded ten thousand, and its boosters already envisioned their city as the major commercial center of the western region. Residents took great pride in the bustling public landing and the solid- three and four-story buildings that lined Front Street, and marvelled at the belching steamboats that hugged the long sweeping curve of the river. Already the city stretched towards the surrounding slopes, and the changing skyline was punctuated by a great nine-story steam mill located at the river's edge. Further back the Lancastrian Seminary, a profusion of church steeples, and several market houses lent an atmosphere of domestic community. The entire country had begun to take notice of Cincinnati, and European visitors

frequently included the western city on their itineraries. As the city grew, it attracted more artists and developed greater resources for supporting the arts. During its first thirty years Cincinnati's cultural life remained indistinguishable from that of other emerging towns, but during the decade of the twenties the true foundation developed for the city's later eminence as a cultural center.

Indicative of this new cultural growth was the formation of the Haydn Society in 1819, Cincinnati's answer to Boston's Handel and Haydn Society founded four years earlier. Composed of singers from various church choirs, the society introduced itself with a benefit concert in Christ Church, which included pieces by Haydn, Mozart, Meinecke, and Puccitta, all under the able direction of Philabert Ratel. "With solemn stillness and riveted attention," the audience listened to the skilled performance which ended with "a little trifle from Gregor." The concert netted one hundred dollars. Two years later the society joined with singing groups from the New Jerusalem Church, the Second Presbyterian Church, and the Vine Street Methodist Church to present Handel's "Allellujah Chorus" before a "numerous and crowding audience." Established "to promote and diffuse a more correct taste for sacred music," the Haydn Society ultimately attracted about thirty-five members, but the organization's gradual departure from sacred music led to its demise in 1824. Yet, there is no question that during its five-year tenure, it raised the quality of choral music in the city.[12]

Complementing this growing choral tradition, the community also supported three pianoforte makers, two organ builders, and a scattering of other music-related businesses. Printed music was plentiful, and one could purchase almost any type of musical instrument. Teachers advertised regularly in local newspapers, and church choirs provided a wonderful medley of religious songs. In 1827 Joseph Tosso arrived in Cincinnati. Musician, teacher, and dancing master, the handsome young Italian brought a new level of expertise to the Ohio Valley. Tosso had trained at the Paris Conservatory, and his enthusiasm permeated the city's musical life for the next thirty years. He taught at John Locke's Female Academy, headed several attempts to establish a permanent orchestra, sold musical instruments, gave weekly organ recitals at St. Xavier Church, and performed at almost every important musical occasion in the city before the Civil War.[13]

In response to Cincinnati's rising importance, an increasing number of touring musical groups visited the city towards the end of the decade. In 1829 Mr. and Mrs. Knight introduced Cincinnatians to six new composers in one evening, including Von Weber and Rossini. Of even greater significance, their entire performance consisted of secular music, a sharp break with previous practice. Hard on the heels of this remarkable occasion came the Lewis family, a sort of nineteenth-century Von Trapp family, who pre-

sented twenty-six concerts over the next seventeen weeks. The city enjoyed its finest musical season. The Lewises mixed popular airs and folk songs with more serious pieces, again all secular, and the twice-weekly concerts received much popular acclaim. For weeks residents walked around humming or whistling such melodies as "Robin Adair" and "Oh Fair Lady," and for those who cared little for music there was the novelty of seeing the Lewis children sing "Yankee Doodle."

A few weeks after the Lewises moved on, William Nash opened the first regular music academy in the city, located at Fourth and Main Streets. Nash taught music theory and provided instruction in vocal and instrumental music. Tuition was five dollars per quarter and each pupil received a free copy of Nash's *Elements of Music.* Aspiring musicians who desired instruction in piano only could walk over to Thom's Row where Mr. and Mrs. William Nixon had opened a Logierian Seminary above Raff's bookstore. The Logierian system involved the use of a chiroplast, a mechanical device which held the fingers and hands in the proper position for practicing the piano. Of course, this specialized training cost more—the Nixons charged twelve dollars per quarter.[14]

Nash and the Nixons both gave numerous public concerts, and Nash even formed a Beethoven Society. In 1831, after Thomas Hawkes opened a third music school, a spirited rivalry developed. Nixon and Hawkes gained the endorsements of various members of the city's cultural elite, while Nash, apparently losing the contest for students and public support, lashed out in a newspaper advertisement at the Logierian method. Referring to "all the storming which has come against me for the last three and a half years," Nash promised a musical festival that would showcase his own students. On October 18, 1833, the first "Annual Musical Festival" took place at Trollope's Bazaar, the unusual Moorish styled building which Frances Trollope had hoped would provide economic security for her family. The great event began at four o'clock, broke for supper, resumed at seven, and ended sometime after ten that evening. Although no records exist as to the festival's success, this first occasion turned out to be the last. Nor are the results of the quarrel altogether clear. Hawkes apparently left the city within a few months; Nash remained for another three years before moving to Tennessee; while the Nixons and their children remained active in Cincinnati until the end of the century.[15]

During the next several years, the Queen City of the West, as the city now modestly began to call itself, applauded an assortment of musical endeavors. Recitals, concerts, and the increasing secularization of programs marked a sophistication commensurate with the city's emerging economic importance. New musicians and new teachers arrived, concert halls and theaters went up, and an influx of German immigrants injected a vitality

that shaped the community's cultural life for the next half century. In addition, two new music institutions appeared in 1835. The Musical Fund Society, patterned after a similar organization in Philadelphia, hoped to cultivate "musical taste," as well as to establish an academy for the teaching of music and provide relief for distressed musicians and their families. Public concerts, under Tosso's direction, were to raise the relief funds. Meanwhile, the Logierian system and Nash's *Elements of Music* disappeared. In their place appeared Timothy B. Mason, younger brother of Boston hymn writer Lowell Mason, who introduced a Pestalozzian system into the newly established Eclectic Academy of Music. The school provided instruction, a music library, and an amateur orchestra of twenty-four musicians. While the Eclectic Academy lasted only eight years, it served to heal the musical divisions which had appeared in the early years of the decade; it also introduced Victor Williams to the city.[16]

A recent emigrant from Sweden, Victor Williams led the academy's orchestra, and eventually became the driving force within the school. He also founded the Sacred Music Society and worked actively with the city's choral groups until the 1880s. As director of both the orchestra and the Sacred Music Society, Williams found himself in a unique position to provide the city with the highest quality music, and in the years preceding the Civil War his combined groups presented Haydn's *Creation,* Mozart's *Twelfth Night,* and portions of Handel's *Judas Maccabeus* and *The Messiah.* The concerts culminated in 1854 with a stirring program of several Beethoven and Haydn symphonies, presented in conjunction with the visiting Germania Society of New York. A few years later the Sacred Music Society disbanded, perhaps a casualty of the era's political distractions. While the Sacred Music Society reached new levels of artistry, a second choral organization appeared to help round out the musical life of the city. This was the Handel and Haydn Society, founded by the enterprising Timothy Mason in 1844, four years after he had left the Eclectic Academy. Its seventy-five members entertained appreciative audiences until mid-century, following which the Morris Chapel Singing Society, led by Elisha Locke, continued the concerts devoted to the popular composers.[17]

Thus, by the early 1840s Cincinnati had experienced its first orchestra, supported a serious music academy, and benefited from several well-trained choral groups, both English and German. All the ingredients that would go into the city's later musical reputation were already present. Nineteenth-century exaggeration notwithstanding, Cincinnati had firmly established itself as a community which took its music seriously.[18]

Theater in Cincinnati, more dependent on touring companies and appropriate physical facilities, all too often found the decade of the 1830s inhospitable. Although the prominent New Orleans theater manager, James

H. Caldwell, opened the New Cincinnati Theatre in 1832, the cholera epidemic of that year and the next effectively stifled public entertainment, and scarcely had the city recovered from this ravage than the financial panic of 1837 plunged the community into economic gloom. A return to more normal theater activity had to await the mid-1840s. The exception to this—and an important exception it was—was the construction of the National Theatre in 1837, one year after fire destroyed the Columbia Street Theatre. Called "Old Drury" by its friends, the elegant looking National Theatre served as the city's dramatic center until the Civil War. John Bates, a former grocer and banker, built the theater and remained its owner for over thirty years, in itself an unusual occurrence for this time.[19]

The great names of the American stage appeared at the National, as did a variety of dancers, mime artists, and singers. The chief competition to Bates's establishment came from the People's Theatre, operated by William Shires. Shires had leased the former Jacob Burnet residence, a stately home and grounds on the northwest corner of Third and Vine Streets. In keeping with its name, the People's Theatre aimed at a more plebian audience, but not even Jackoset, an Indian brave, and "two trained buffaloes," or an unending variety of farces and melodramas brought much of a profit. Theatrical fare in the city continued at an uneven level throughout the middle years of the century, and only occasional visits by such distinguished actors as Booth and Edwin Forrest helped offset the generally poor quality both of local efforts and visiting troupes. And Cincinnati audiences apparently had not improved much since Mrs. Trollope's day. When William Macready, the distinguished English actor, made a two-day stopover in 1844, he left "very much *disgusted* with the house which was very bad. I am sick of American audiences; they are not fit to have the language in which Shakespeare wrote."[20]

The truth is that drama lacked the popularity of either music or art in the Queen City, and it required greater community resources and organization. Not only were performances generally inferior, but Americans considered drama less uplifting as an art form. Where music and painting were viewed as man's attempt to reach the ideal in life, theater was often viewed as revealing man's baser nature. In Cincinnati the Reverend Wilson had been only the most vocal critic. Many others shared his view that theater, if not wicked, was decidedly unwholesome. Professional troupes came and departed, local amateurs continued to learn their lines, but actors and promoters alike found the theater a precarious existence—a condition that did not markedly change in the nineteenth century.

Weaving in and out of Cincinnati's cultural life was its literary and intellectual ambition. In the city's early years this ambition centered around a small group of men who hoped to emulate Philadelphia, at that time the

largest and most cultivated city in the nation. For the most part these men were the same individuals who encouraged the community's general cultural and civic development: Dr. Daniel Drake and his brother Benjamin; Peyton Short Symmes, who moved easily between art and poetry; Timothy Flint, the first prominent literary journalist of the region; the writer Morgan Neville, best known for his depiction of the legendary flatboatman Mike Fink; and even the Reverend Joshua Wilson. Their record of cultural and educational achievements paralleled those of other western settlements, but none of their endeavors survived more than a few years. What distinguished the emerging city was an inexhaustible energy for things western. "We should foster western genius, encourage western writers, patronize western publishers, augment the number of western readers, and create a western heart," trumpeted Daniel Drake. But the response often proved disappointing. Writing in 1827, Timothy Flint had observed that "a community without literature is like a rude family without politeness, amenity and gentleness." Cincinnati was still more rude than refined.[21]

If his literary and artistic promotions failed to bear early fruit, Drake's civic efforts never abated. As the community's most outspoken supporter, he helped organize and support a host of medical and educational institutions. His many contributions to American medicine have been frequently detailed, but his support of Cincinnati's intellectual life has been less well publicized. Drake viewed the rise of a "western culture" as the keystone which would hold the expanding nation together. For Drake there was no conflict between the intellectual man and the practical man, and he promoted canals and railroads with as much vigor as he did literary and scientific causes. The Western Museum, founded in 1820, proved the most promising of his early intellectual activities. The promotion of science, always the core of Drake's intellectual world, and the education of the general populace served as twin goals of the fledgling institution. Its collection of prehistoric remains, Indian relics, fossils, mineral specimens, bones, and stuffed animals was designed to further a sense of regional identity by associating the promise of the future with the landscape of the past. But the museum never achieved its ambitions. Most residents remained indifferent to Drake's vision. The region's past seemed ill-connected to their own time; bizarre curiosities, not scientific specimens, entertained them. In 1823 the museum passed into the hands of one Joseph Dorfeuille, and for the next twenty years it provided visitors with amusement and titillation, only thinly disguised as education. Wax figures, "mermaids," grotesquely deformed animals, and an animated depiction of the "Infernal Regions" attracted the curious and gullible, while Drake's carefully labeled collections gathered dust in the basement below.[22]

Early Cultural and Civic Leaders of Cincinnati. Top, John P. Foote; bottom, Daniel Drake. Courtesy of the Cincinnati Historical Society.

More Cultural and Civic Leaders. At top, Mrs. Sarah Worthington King Peter; bottom left, Peyton Short Symmes; bottom right, Nicholas Longworth. All courtesy of the Cincinnati Historical Society.

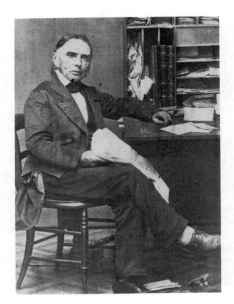

The Western Museum proved premature. The city did not yet contain a sizeable population of cultivated people willing to support such enterprises, but, as with art and music, after 1825 this began to change. Cincinnati's rapid growth brought an influx of talented and refined men and women to the banks of the Ohio, and these individuals stirred the community's intellectual atmosphere. In 1828 Frances Wright, the much-travelled English radical, presented a series of provocative, well-attended lectures, while her fellow countrywoman, Frances Trollope, spent the late 1820s trying to elevate the tastes of her adopted city. Three local literati and one budding politician—Morgan Neville, John Locke, Edward P. Cranch, and Salmon P. Chase—established a Cincinnati Lyceum in 1830, the year Mrs. Trollope left. Shortly after, Daniel Drake initiated the sporadic meetings at his home which became the Buckeye Club. Patterned after the Philadelphia literary soirees of Caspar Wistar, Jr., the Buckeye Club brought together such luminaries as the lawyer Edward King and his vivacious wife, Sarah, Judge James Hall, Reverend Lyman Beecher and his daughters Catharine and Harriet, and Lane Seminary's Calvin Stowe. In part designed to broaden the education of Drake's own two daughters, the Buckeye Club proved especially helpful in creating an intellectual environment for women. Literature, science, civic concerns, and current social topics provided the evenings' stimulation; refreshments, gossip, and occasional dancing added a social flavor.[23]

A few years later Cincinnati benefited from a happy marriage between local residents and an impressive group of young, recently arrived New Englanders, which resulted in the Semi-Colon Club. "A purely intellectual society," club members met on a regular basis at the elegant Third Street residence of Samuel Foote, a Boston-born merchant who had lived in the city for some years. The younger New England contingent included William Henry Channing, a nephew of the better known William Ellery Channing; William Fuller, the brother of the celebrated Margaret Fuller; lawyer and minister James Handasyd Perkins; Edward P. Cranch, a brother of the highly regarded Christopher P. Cranch; and the Beecher sisters, who had come West when their father took direction of Lane Seminary. Timothy Flint belonged, as did Daniel Drake, Judge Hall, and Joseph Longworth, son of the city's wealthiest citizen. Caroline Lee Hentz, who ran a female academy with her husband and later gained fame as the author of several popular novels about the South, attended club meetings, as later did the Blackwell sisters, soon to make medical history. The spirited sessions, where William Greene read the papers to ensure anonymity of the authors—an especially important detail for the women unaccustomed to speaking before an audience—softened the rawness of the community and provided a forum for emerging talent.[24]

Long after she became the nation's first female physician, Elizabeth

Blackwell recalled those years as "rich in spiritual growth." When Harriet Beecher arrived in the city in 1832, she described the local society as "drawn from the finest and best cultivated classes of the older states." "There was," she recalled, "in the general tone of life a breadth of ideas, a liberality and freedom" James Hall, himself a recently arrived resident, enthusiastically described the city as "the future seat of literature and learning; the Athens of Western America." Much of what so stimulated Blackwell, Beecher, and Hall was found at the Semi-Colon Club, where the spirit of New England permeated.[25]

Just as important for Harriet Beecher and her sister Catharine, however, were the literary journals published in the city. Several years before the arrival of the Beechers, Timothy Flint had selected Cincinnati as the place from which to promote western literature. "We are a scribbling and forth-putting people," he announced in the first issue of *The Western Monthly Review*. Although as the editor Flint contributed almost three-fourths of the material printed, and the general tone was heavy and learned, the journal provided a welcome outlet for local literary talent. It also lent credibility to the city's intellectual pretensions. The *Review* survived only three years, but Flint continued his own contributions to western literature, writing several novels dealing with frontier life and acquiring a regional reputation as a man of intellect. Mrs. Trollope found Flint a "most agreeable acquaintance," and her favorable description of him stands in marked contrast to her otherwise critical appraisal of Cincinnati life.[26]

Late in 1832 Judge James Hall arrived in the city. Descended from a refined and cultivated Philadelphia family, Hall published the *Western Monthly Magazine,* a continuation of his *Illinois Monthly Magazine,* which he had published in Vandalia, Illinois. For five years he brought before the public the best of western poetry, fiction, essays, and reviews, including Harriet Beecher's first published efforts. Eventually Hall's liberal social views clashed with Lyman Beecher's stout anti-Catholicism, and during this era of fervid nativism his literary journal succumbed.[27]

A variety of more specialized publications succeeded the *Western Monthly Magazine,* but for most of the next decade the *Western Messenger* towered above the others. Published by the Western Unitarian Association, it strengthened the link to New England intellectual circles. Edited first by Ephraim Peabody, and later by William H. Channing and James H. Perkins, the *Messenger* divided itself between Cincinnati and Louisville. In keeping with its liberal Unitarianism, the journal emphasized literature over religion, and leavened both with a heavy dose of transcendentalism. Alongside the literary outpourings of westerners, the *Messenger* opened its columns to the new generation of Boston literati. Ralph Waldo Emerson, Margaret Fuller, William Ellery Channing, and John Sullivan Dwight contributed

much to the journal's literary distinction, making it a true forerunner of the highly regarded Boston *Dial.* The transcendentalist emphasis on self-reliance and individualism attracted westerners, and the practical western spirit influenced easterners who came in contact with it. But this promising beginning did not last. Channing, Fuller, and several others returned to Boston, and the *Dial,* established in 1840, siphoned of eastern contributions. Unable to replace them, the *Western Messenger* expired the following year. "Our people, perhaps, have as yet no literature because they have nothing to say," sadly acknowledged the editor in a fitting epitaph. "They are busy living, doing, growing."[28] That Cincinnati launched such an important literary publication spoke well for the city and its ambitions; that the city could not sustain it, reminds us of the narrow cultural base that supported those ambitions.

The demise of the *Western Messenger* did not bring an end to literary journals in Cincinnati, but none achieved national distinction, and while boosters occasionally referred to their city as the "Literary Emporium of the West," Cincinnati struggled to hold even its regional reputation. Western society could not yet produce a crop of writers sufficient to carry a literary journal, nor an audience to support one. The result was often a combination of mediocre literature and pretentious essays. The city's best writers—Caroline Lee Hentz, poets John Piatt and William Gallagher, and Morgan Neville—remain obscure, or, as was the case with Harriet Beecher and the Cary sisters, gained their reputations only after leaving the city. Cincinnati provided meager nourishment for its writers, and those who remained contributed little beyond an aura of genteel culture. Thus, the city's claim as a rising center of the arts ultimately came to rest on the considerable number of painters and sculptors who began to concentrate in Cincinnati during the 1830s.

Artists worked as individuals, needing neither concert halls nor stages, and they were less affected by economic shifts. Not that they earned much for their efforts, for like all who labored in the vineyards of culture, painters and sculptors lived perilously close to the edge of poverty. One can only guess at the motivation which bound so many to the chisel and brush. From rural villages and small towns they came to Cincinnati seeking training, patrons, and encouragement, and for a community one generation removed from the frontier, the city provided a surprising amount of all three.

Just as Joseph Tosso and Alexander Drake had raised the levels of performance in music and drama, Frederick Eckstein provided a similar stimulus to art. The son of a prominent Prussian historical painter and trained as a sculptor, Eckstein disembarked at the public landing in 1823. He had recently helped establish the Philadelphia Academy of Fine Arts, and he now brought his formidable ambition to the rising star of the West. As was cus-

tomary he first advertised for pupils and sought out commissions for busts, but his real dream was to repeat his Philadelphia success. Soon he proposed an Academy of Fine Arts for Cincinnati. He envisioned an institution which would not only offer instruction in art, but also arrange exhibitions of local and foreign work, organize lectures to educate the citizenry, and establish a mechanics institute to provide aesthetic direction for local artisans. A grand scheme, it was doomed to failure. In vain Eckstein appealed to the public, emphasizing the many benefits the community might gain, but his arguments went unheeded and his exhibit of mechanical models and local paintings did not draw the necessary crowds. Worse yet, John Foote and clockmaker Luman Watson, two men active in educational activities who had originally supported Eckstein, now led a rival movement to found a school solely for mechanics. Confronted by the incipient industrial revolution, the public supported Foote and Watson rather than the more artistic leanings of Eckstein. In 1829 the state chartered the Ohio Mechanics Institute, which continues today as the Ohio College of Applied Science, a division of the University of Cincinnati. The Academy of Fine Arts faded, a vision not to be realized for another forty years.[29]

Frederick Eckstein's importance to the city extended beyond his short-lived academy. As a teacher he influenced several promising sculptors, including the talented Hiram Powers, whose subsequent career brought more acclaim to the city than any previous artist. The young Powers had migrated from Connecticut to Cincinnati in 1819. Hard times forced him to give up his schooling for a job with Luman Watson. In Watson's shop his mechanical aptitude quickly surfaced, and he became the owner's chief mechanic and close friend. Through Watson, Powers met Eckstein and learned to model in clay and wax. While still building clocks, he began to work evenings restoring wax figures at the Western Museum, and in 1829 he left Watson's employ to become chief designer and figure maker for the museum.[30]

During his six-year tenure at the museum, Hiram Powers acquired regional fame as the creator of the "Infernal Regions," a special exhibit of animated, grotesque monsters, complete with electric shocks, shrieks, and groans. The idea had originated with Mrs. Trollope, who had suggested a model based upon Dante's *Divine Comedy,* and Joseph Dorfeuille, the museum proprietor, recognized a goldmine. Creating wax figures and building a chamber of horrors did not satisfy Powers's growing artistic ambitions, however. By now word of his gifts had reached the ears of Nicholas Longworth, the city's most important early art patron, and he offered to finance a trip to Italy, then the center for training in sculpture. But Powers's own financial uncertainty, and perhaps a lack of confidence as well, precluded a trip at this time. For several years Powers continued his museum work, doing busts of prominent Cincinnatians in the evenings. Eventually with

Longworth's support he moved to Washington where he continued to execute busts and make important political contacts. Longworth followed his protégé's career closely, assisting him financially, offering advice and encouragement, and keeping him abreast of local affairs. In 1837 Powers, with numerous commissions in hand and the continued support of Longworth, departed for Florence. He never returned to the United States, although his *Greek Slave* and other neoclassical works made him the artistic sensation of the age.[31]

Hiram Powers's reputation proved a powerful stimulant for a generation of young artists in the Cincinnati region. "You and you alone are answerable for the malady," Longworth wrote the sculptor while he was still in Washington. "I scarcely meet a vagrant boy in the streets, who has not a piece of clay in his hands, moulding it into the human face divine."[32] The most promising of these younger sculptors, Shubal Clevenger, started as a stonecutter, chiseling memorials to the dead. First noticed by E. S. Thomas of the *Cincinnati Evening Post,* Clevenger soon turned his full attention to making busts. Before long this "plain, illiterate, unassuming man" came under the aegis of Longworth, who underwrote his further study, first in the East and then in Italy. Although Clevenger lacked Powers's gift for design, he did possess a powerful talent for rendering faces accurately. Unfortunately, he contracted tuberculosis shortly after arriving in Florence and died attempting to return to the United States. Other notable sculptors who started their careers in Cincinnati about the same time were Henry Kirk Brown, Joel T. Hart, and Nathan Baker, all of whom left the city for more promising opportunities in the East or in Europe.[33]

Despite this cluster of promising sculptors, Cincinnati has always been better known for its painters, and during the second quarter of the nineteenth century the city served as a funnel for regional talent. Increasing wealth, several interested patrons, a scattering of schools, and an advancing reputation for the arts pushed Cincinnati ahead of such rivals as Lexington, Louisville, and St. Louis. James Beard, William Powell, Robert Duncanson, and Worthington Whittredge were only the most prominent of the several score artists identified with the city during these years.

James Beard had arrived in the now booming city in 1830, following an apprenticeship as an itinerant portrait painter and sometime chair decorator. While Longworth never admired Beard, considering him lazy and "deficient in the foundation of his art," Harriet Martineau, the respected English writer, called his work more pleasing "than any other American artist."[34] Martineau's tribute sparked considerable interest in Beard's career, and he soon shared his time between New York and Cincinnati. Portraits and genre scenes became his stock in trade, and his facility with color impressed even Hiram Powers. Later in his career Beard established a considerable reputa-

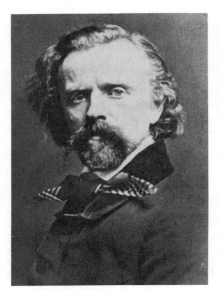

Top, Thomas Buchanan Read; bottom, James H. Beard, both courtesy of the Cincinnati Historical Society.

At top, Robert S. Duncanson, Monroe County (Michigan) Historical Museum, courtesy Allen Van Deusen; below left, William Louis Sonntag, courtesy of the Cincinnati Historical Society; below right, Godfrey Frankenstein (self portrait), courtesy of the Clark County (Ohio) Historical Society.

tion for humorous animal paintings. In 1848 the National Academy of Design made him an associate member, later a full member, and when he finally moved permanently to New York in 1870, he was one of the nation's best established artists.[35]

Among Beard's most promising pupils in Cincinnati was William Powell, who had come west with his parents in 1831. Boyish looking and small of stature—Longworth called him "Little Powell"—he found immediate success as a scene painter. Struck by his "ambition and industry," Longworth supported Powell's training in Philadelphia and New York, and the artist's reputation swelled. So did his vanity. As a boy "genius" he had been fashionable in Cincinnati, but by 1841, after marriage and early success, his egotism irritated many.[36] The city soon lost him to New York, however, where he became a well-known historical painter. Although he is remembered today only for his panel *Discovery of the Mississippi by DeSoto* in the National Capitol Rotunda and for the *Battle of Lake Erie* in the Ohio State House, during his life he brought considerable fame to the city where he began his career.

Nicholas Longworth's correspondence with Hiram Powers has left a lively record of many Cincinnati artists. About the time that William Powell slipped in the millionaire's estimation, he wrote of a "new genius" who had appeared in Marietta, Ohio. "Entirely self-taught," she is "likely to eclipse all our painters," he exclaimed in 1841. The woman in question was Lily Martin. Natives of France, the Martins had arrived in Marietta in 1832 with their ten-year-old daughter Lily. She early displayed a talent for drawing, covering the walls of the family home with charcoal sketches. At the age of nineteen she exhibited her work in a local church rectory. Edward D. Mansfield, editor of the *Cincinnati Chronicle,* described her work as an "astonishing instance of precocity," and urged Longworth to support such talent. Shortly thereafter Lily Martin arrived in Cincinnati. She studied first with the lanky, long-haired James Beard, and then with J. Insco Williams, but when Longworth offered to underwrite study in Europe on the condition she would remain there for seven years, she refused. Ambitious, outspoken, and inheriting something of her mother's feminist views, Lily Martin was determined to control her own career. After six years in Cincinnati she took her paints and brushes and her new husband, Benjamin Spencer, to New York, where her robust colors, sharp detail, and sentimental scenes earned her a national reputation.[37]

Miner K. Kellogg provides an example of another painter whose life touched the Queen City. Brought to Cincinnati by his father in 1818 at the age of four, he remained but a short time before travelling with his father to join Robert Owen's socialist experiment at New Harmony, Indiana. When that undertaking failed, they returned to Cincinnati. The younger Kellogg

briefly studied drawing at Eckstein's Academy of Art, but the inattention of his instructor led to his withdrawal. For a while he nursed musical ambitions, studying under Joseph Tosso and playing with various local musical groups. He continued to paint, however, mostly miniatures at three dollars apiece, and even gave a few lessons, but the life of an artist dilettante soon ended. His father secured for him a job as a dry goods clerk. Life behind a counter did not agree with Kellogg's restless nature, and the next year found him in New Jersey. After returning to Cincinnati he succeeded in making a reputation for himself as a portrait painter, but in 1839 he left again, this time for Washington. Taking his lead from Powers and Clevenger, Kellogg capitalized on the desire of the nation's political leaders to have their likenesses captured on canvas, and during the 1840s he painted Andrew Jackson, Martin Van Buren, James K. Polk, and other Democratic notables. From 1847 to 1851 he managed the highly successful tour of Hiram Powers's *Greek Slave,* the controversial nude statue that did so much for that sculptor's reputation. Although Miner Kellogg spent the remainder of his life shuttling between Europe and the United States, including a stint in the diplomatic corps, Cincinnati remained the one city to which his name was attached.[38]

While portraiture remained the bread and butter of the painter's world, the romantic cult of nature and the success of the Hudson River artists sparked a landscape movement after 1830. For many Americans nature had come to symbolize the very spirit of the nation, the repository of American virtue, and the rolling hills of the Ohio Valley helped pay tribute to this spirit. Lacking ancient ruins and an ancient past, American artists sought inspiration in the nation's abundant natural beauty.

Among Cincinnati landscape painters, Worthington Whittredge achieved the highest reputation. Born near Springfield, Ohio, he came to the Queen City in 1839 determined to be an artist. Painting baseboards in new homes for ten hours a day served as his introduction to the world of paint. From baseboards he graduated to signs and political banners, benefiting from the enthusiasms of the 1840 presidential campaign. About that time he discovered the scenic charms of the southern Ohio landscape, and he abandoned decorative painting forever. After achieving a considerable local reputation, in 1849—with a commission from Joseph Longworth and a letter of credit for $1,000 from bank president William W. Scarborough—Whittredge set out for the most popular art center in Europe, Dusseldorf. There he studied with Andreas Achenbach and Carl Lessing, shared studio space with fellow Americans Albert Bierstadt and Frederick Church, and established a lifelong friendship with landscapist Sanford Gifford. Whittredge's arrival coincided with the painting of Emmanuel Leutze's well-known *Washington Crossing the Delaware,* and the young Cincinnatian gained immortality as the model for George Washington. By the time he returned to

America in 1859, Whittredge had concluded that New York, not Cincinnati, was the place for him, and there he quickly emerged in the front rank of American landscape painters.[39]

Among Whittredge's many companions in Europe was Thomas Buchanan Read. Like so many of his contemporaries, Read had started as a sign painter and then as a tombstone inscriber, working under Shubal Clevenger. Longworth recognized his potential and provided enough support for him to open a painting studio, but the art patron soon grumbled about Read's lack of ambition and industry. By that time Read was already dividing his time between painting and poetry. When he finally announced his intention to go East, Longworth tartly informed him that he was on "a visionary Experiment" encouraged by "ignorant friends." The patron urged him to remain in Cincinnati until he was capable of competing with eastern artists. Finding Longworth's reasoning "absurd," Read left the city in 1841 for Boston, where he became friends with Henry Wadsworth Longfellow. His portrait of Longfellow's daughter earned him considerable attention, and he continued to write as well, producing his first book of poems in 1845. Read never abandoned his painting, but he is best remembered today for the heroic Civil War poem, "Sheridan's Ride." Perhaps Longworth was right to grumble, however, for in spite of his many talents Read failed to achieve lasting artistic distinction.[40]

Of the prominent artists who spent their formative years in Cincinnati during this time, Robert Duncanson was the only one to remain associated with the city throughout his life. Born in Canada to a black mother and a Scottish father, Duncanson found the standard difficulties of any nineteenth-century artist complicated by the color of his skin. He first appeared in Cincinnati about 1841, living with his mother in Mt. Healthy, a small village fifteen miles north of the city. An 1842 exhibition catalog which mentioned his work suggested that he had received training prior to his arrival in the Cincinnati area. Examples of his work continued to turn up in various exhibitions of the early 1840s, mostly "portrait paintings and fancy pieces." He soon sought loftier subjects. Between 1848 and 1850, he painted twelve panels for the hallway of Longworth's magnificent home, now the Taft Museum, all revealing the romantic-idealistic depiction of nature popular at the time. Recognition of Duncanson's maturing ability accelerated after the Longworth commission, and in 1850 the Western Art Union distributed his work, a sign that he had gained the respect of his peers. His *Blue Hole, Little Miami River,* completed in 1851, reveals a deeper inspiration, perhaps influenced by Thomas Cole, whose *Voyage of Life* had become part of iron manufacturer George Schoenberger's collection.

In 1853 Duncanson travelled to Europe with fellow Cincinnatian William Sonntag, a trip apparently sponsored by the Anti-Slavery League. Dun-

canson never actively supported the abolitionist cause, however. "I am not interested in colour, only paint," he once stated. Throughout the turbulent 1850s he resided in England and Europe. The Civil War years he spent on the upper Mississippi and in Canada "where his color did not prevent his association with other artists and his entrance into good society." The psychological pressures on Duncanson, both as an artist and as a black, eventually led to severe emotional stress. Henry Mosler, fellow Cincinnati artist and friend, once remarked on his "moodiness and sudden upheavals"; in 1872 Duncanson, only fifty-one years old, died following a bout of severe mental illness.[41]

As in any provincial art center only a few Cincinnati artists received national attention, to say nothing of lasting reputations. Yet, those less talented painters and sculptors who remained in the city provided the artistic atmosphere that was so important in attracting others. These artists manned the various art organizations, taught the younger generation, organized the exhibits, and shaped much of the city's taste in art. While those who earned their distinction elsewhere gave the city its reputation, those who remained provided its dynamism. Of these almost forgotten artists, the Frankenstein brothers proved the most important to Cincinnati's art life. Born in Germany, the Frankenstein family had moved to the United States in 1831, eventually settling in the Queen City. John Frankenstein revealed a certain ability both as a sculptor and painter, but his abrasive personality often irritated colleagues and patrons alike. He is best remembered today for his satirical poem *American Art: Its Awful Attitude,* in which he attacked a lifetime of enemies, both real and imagined. Godfrey Frankenstein, three years younger and considerably more affable, played an active role in the several art organizations of the time, including a stint in 1838 as president of the short-lived second Academy of Fine Arts. He, also, made a reputation as a landscape painter, particularly of romantic views of Niagara Falls and the White Mountains.[42]

In the early 1840s William Sonntag studied with the younger Frankenstein, while painting local theater sets and turning out panoramas for the Western Museum. Sonntag enjoyed almost immediate success as a landscape painter, and his local reputation surpassed even that of Whittredge. Eventually he left for New York where his popularity continued, but his finest work remains that done during his Cincinnati years. The strongest influence on Frankenstein and Sonntag may have been another local painter, Benjamin McConkey, a former pupil of Thomas Cole. Certainly McConkey knew Sonntag well, and he even travelled to Europe with Whittredge in 1849. Unfortunately little is known of McConkey's own work, and he remains a shadowy figure in the Cincinnati art world. More is known about Joseph Oriel Eaton who painted in the city from 1846 to 1864. His sensitive por-

William L. Sonntag, *Landscape, 1854,* Cincinnati Art Museum, gift of Alfred T. Goshorn.

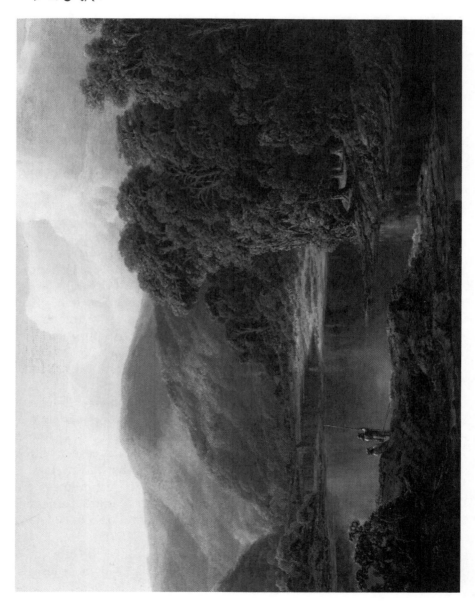

Thomas W. Whittredge,
*Scene Near Hawk's Nest,
West Virginia,* 1845, Cincin-
nati Art Museum.

Robert S. Duncanson, *Land-scape with Waterfall*, ca. 1855, The Procter & Gamble Collection, Cincinnati.

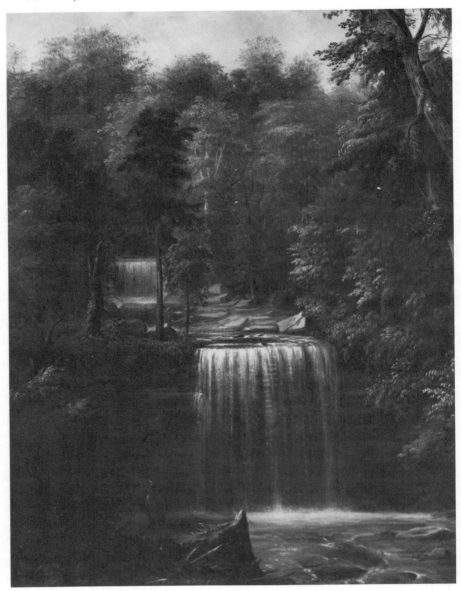

traits of Captain Jacob Strader, Robert Bowler, and other prominent residents made him the leading local portrait painter of his day, and an artist who deserves greater recognition in our own. Among other area artists both Charles Brackett and John King achieved some prominence as sculptors and participated in most local art activities. Almon Baldwin, brother-in-law of Whittredge, also maintained a studio for many years in the city, sharing it with J. Insco Williams. Baldwin served as the curator of the Western Art Union, an organization which will be discussed later.[43]

The thread that bound together so many Cincinnati artists was Nicholas Longworth, the "Maecenas" of the West, and one of the young nation's great art patrons. Born in New Jersey, Longworth came west in 1803, the year Ohio became a state, to pursue a law career. Instead he amassed a fortune in real estate, including the lovely mansion built for Martin Baum, now the Taft Museum, and most of Mt. Adams, which stretched upwards behind his home. Possessed of a "stout, rugged body" and "shaggy, unkempt eyebrows," Longworth cut an unusual figure in Cincinnati streets. "A little bit of an ugly man," one artist described him, but few took him for granted. He was a careless dresser, always wore black, and possessed a shrewd business mind. Close acquaintances remarked on his wit and readiness for repartee; others remembered his fondness for poetry and horticulture. He possessed a discerning eye for art, and quietly dispensed considerable sums to those who showed talent. "It may be said with entire truth," wrote one of his admirers, "that there was never a young artist of talent who appeared in Cincinnati, and was poor and needed help, that Mr. Longworth, if asked, did not willingly assist him."[44]

Because of his fame, Hiram Powers has often been singled out as Longworth's principal protégé, but a score of other artists, some now completely forgotten, benefited from his encouragement and assistance. Furthermore, Longworth took a keen interest in the art affairs of the city, and his letters are filled with penetrating observations concerning many of the local artists. Frankenstein "had much yet to learn," while Powell has "no rival of his age in the union." He noted Read's new industriousness at one time, and observed that "women and whiskey" were taking Tucker to the devil. He kept an eye open for housepainters and stonecutters with "genius"—a word he overused—and encouraged them towards loftier goals. When in eastern cities he often visited those artists who had left Cincinnati, noting their improvement or decline.[45] In 1843, a severe and almost year-long illness affected his emotional state. He remained subject to milder recurrences for several years, and while he lived for another twenty years, his interest in local art matters waned.[46]

Although Longworth stands out as the great benefactor of art, he was not alone in his encouragement. Many of the early residents of the city had

arrived with well-developed standards of culture and taste, and these men and women shared a sense of regional pride. They were convinced that Cincinnati was destined to be a great cultural and intellectual center, eventually supplanting the eastern cities as the artistic heart of the nation. Using first Philadelphia and later Boston as their models, the city's cultural leadership hoped to raise the arts to an important and dignified place in the community's life. They also shared an opinion that the fine arts would introduce proper manners and morals to the rough frontier society. As John Foote emphasized, it was important to shape public taste "while the character of the society is forming."[47]

Foote helped found several institutions which aimed at achieving those goals, including the Ohio Mechanics Institute established in 1828 and the Society for the Diffusion of Useful Knowledge founded ten years later. The Mechanics Institute, which embraced "all associations for the cultivation of the arts and sciences," initiated a series of exhibitions to promote "western manufactures and the encouragement of western artists." These annual fairs increasingly stressed the practical arts, however, and after several years fine art disappeared. A second outlet for Cincinnati artists also opened in 1828. Frederick Franks, a young German, established a Gallery of Fine Arts which served as a center for the small art community during the early 1830s.[48]

Additional support also came from several other interesting men. Peyton Short Symmes adorned his modest home with paintings by Corwine, Samuel Lee, and other local artists, and busied himself with sketching and writing poetry. Although never wealthy, he moved comfortably in the artistic and literary circles of the city. He actively supported the Columbia Theatre, and to the young Miner Kellogg at least appeared as one of the "art oracles" of the community. Charles Stetson, best known for his leadership in the Western Art Union, owned more than twenty-five paintings, a collection unique for its emphasis on western art. If other prominent residents did not match the Stetson collection, many of the fine homes on Fourth Street displayed portraits by Corwine or landscapes by Whittredge or Sonntag, and a Powers bust frequently graced their entranceways.[49]

In 1838 two new organizations appeared in the city. Godfrey Frankenstein led a group of artists in the organization of a new Academy of Fine Arts. Their objectives were to improve their work and their sales. First, the artists set out to procure a collection of plaster casts of the human figure, and to raise money for this end they held an exhibition of both European and American art. They borrowed paintings and sculptures from local collections, as well as from their own studios, but in the depression year of 1838 the exhibition failed to raise the necessary funds. Although several supporters eventually donated the money for the casts—"the first collection of its kind ever brought to the West"—the academy never achieved stability.[50]

Artists also made up the rival Section of Fine Arts, one of the fourteen divisions of the Society for the Diffusion of Useful Knowledge. The society attempted to bring together "All individuals desirious of higher culture to teach each other through reading, lectures, and discussion." It also hoped to establish a public library, a science museum and an art gallery to support its activities. Peyton Symmes and John Cranch led the Section of Fine Arts, which included "the great body of the Cincinnati artists."[51]

Both organizations held annual exhibitions, supported by the city's elite, but in the troubled years which followed the bank panic of 1837, there was insufficient support for two groups to survive. Consolidation seemed the only answer. In 1841 both the *Cincinnati Gazette* and Charles Cist, the city's early chronicler, predicted a merger. It never took place. The two organizations held separate exhibits that year, and by 1843 both had disappeared from the scene.[52]

The appearance and disappearance of so many art organizations during this period does not represent a lack of interest in the arts. Rather, it indicates the early immaturity of American cities in general and frontier cities in particular. Rapid growth, a shifting population, and a "democratic" spirit absorbed all the energy which might have supported the arts. Most western communities lacked the organizational and financial resources to develop permanent art institutions. Nor did cultural roots extend very deeply, despite the best efforts of Drake, Longworth, Symmes, and others. Within the American character lurked a suspicion of the arts, and the practical necessities of the frontier reinforced this attitude. People often viewed painting and sculpture as unnecessary and out of place in a democratic society, and associated them with aristocratic European courts. Even private patronage implied anti-Republican leanings to some. John Foote frowned on direct aid for individual artists. According to Foote, art should "stand upon its own two feet and be governed by the laws of trade and taste—and flourish or fade according to those laws."[53]

Given this ingrained antipathy, what is striking is the frequency rather than the permanence of artistic activity, and it is the frequency that entitles Cincinnati to its reputation. By 1840 the city's cultural reputation extended far beyond its commercial importance. "Cincinnati! What is there in the atmosphere of Cincinnati, that has so thoroughly awakened the arts of sculpture and painting?" pondered the *New York Star* that year. "It cannot surely be mere accident which gives birth to so many artists, all of distinguished merit, too" Five years later, the *New York Tribune* praised the "wealth, genius and beauty" which adorned "the Western Metropolis." "Paris of America," "Athens of the West," "London of America" became more than local promotional labels. The entire nation watched the meteoric rise of the city on the Ohio. No other western community could rival Cincin-

nati's cultural life, and the youthful city was already prepared to challenge the reputations of Boston and Philadelphia. William Adams, a Zanesville, Ohio resident, expressed the prevailing opinion when he visited the Queen City in 1842. "Wealth has engendered a taste for the arts," he wrote his friend, the painter Thomas Cole, "and its inhabitants seem to be peeping out of the transition state, and entering upon one of taste and refinement. . . . Cincinnati can boast of her artists."[54] And she did.

The Athens of the West, 1843–1855

*A*s Cincinnati approached the middle years of the century, it displayed a sturdy, if still provincial, cultural life. Its artistic sons and daughters had already begun to establish reputations in eastern cities and in Europe, while a vigorous citizenry continued to surprise its many visitors. Mrs. Trollope's literary barbs had been dulled by a score of European travellers who sang the praises of Cincinnati, and every Cincinnatian knew that the esteemed Charles Dickens had described the city as "cheerful, thriving, and animated." And who was Frances Trollope anyway! The decade of the 1840s saw the city's population more than double, soaring to over 115,000 by mid-century. Everywhere one looked, signs of success, of growth, of importance captured the eye. "Prosperity and progress are everywhere evident," marvelled one visitor, "and the long lines of steamboats and piles of merchandise on the levee, the bustle of passing crowds, the whizz and whirr of factories, and the elegant stores and bank buildings give token of a brilliant future to the Queen City of the West."[1]

"The Queen of the West, in her garlands dressed," was how Henry Longfellow had described the city, and Cincinnatians proudly claimed the title. And why not? Until the explosion that became Chicago, no western city could rival her. Of course, euphoric boosters often supplied their own, more exaggerated titles, but behind these pretentious claims lay substantial justification for rosy predictions. The great river provided commercial links to the West and South; the expanding canal system brought upstate produce to the river's edge; and already railroad tracks stretched northward to Dayton and Columbus. New York City was only seventy-two hours away. Surrounded by bountiful farmland, situated on the continent's most important

inland river system, and the terminus of the Miami and Erie Canal, Cincinnati indeed appeared to be blessed.

Much of the city's prosperity remained tied to the much-maligned hog. In other parts of the nation people derisively called the city "Porkopolis," but local residents understood well the importance of pork to the city's economy. Although the once numerous pigs which scavenged the streets—and which so offended Mrs. Trollope's sensibilities—had all but disappeared, the pig remained king. As many as five hundred thousand porkers grunted their way into the many slaughterhouses each year, reappearing later as chops, bacon, lard, and hides. Candle and soap manufacturers, tanners and coopers, and even wagon makers depended on the yearly arrival of the ubiquitous hog.[2]

If pork provided the prosperity, the public landing displayed it. Lined

Plan of Cincinnati and Vicinity, 1849; courtesy of the Cincinnati Historical Society.

with steamboats and swarming with stevedores, the levee recorded the city's vital signs. Besides the barrels and crates of pork, one found bales of cloth, barrels of whiskey, mounds of rags waiting to be turned into newsprint, shoes and boots, iron and brass products from the city's founderies, and furniture of all types. Even on Sunday the river remained "booming full," and fashionably dressed citizens gathered to watch the display of smoke, steam, and gleaming paddles. As one walked from the landing to the city center, one could not fail to be impressed by the new buildings which graced the skyline. The classical facade of the Franklin and Lafayette Bank announced that Third Street was already the financial heart of the city, while the lofty spire of the recently completed St. Peter's Cathedral signaled the growing importance of the area's Catholics. Bricks had replaced the packed dirt on most of the downtown streets, and Main Street served as the "great business highway."[3]

The massive House of Refuge signified new humanitarian concerns, and the new buildings of the Ohio Mechanics Institute and the Cincinnati College gave evidence of educational concerns. Magnificent residences already dotted surrounding hilltops, a harbinger of the later flight to the suburbs. In 1850 a customs house, a city building, several new churches, and a new structure for the Medical College were all under construction, and soon work was to begin on a Court House to replace the one that had burned the previous year. Most representative of the city at midyear, however, was the Burnet House hotel, which opened in May 1850 with "a grand soiree—a ten dollar affair," according to the young Rutherford B. Hayes. The six-story building, located on the northwest corner of Third and Vine Streets, symbolized the emergence of the city from its adolescence. Its 340 rooms, elegant dining hall, forty-two-foot dome, and columned entranceway made it one of the great hostelries of its day. A *"magnificent* hotel," gushed Frank Meyer, a Baltimore artist passing through the city. The buildings here "evince private taste and a pervading public spirit."[4]

Another mid-century visitor to Cincinnati, Horace Greeley, publisher of the *New York Tribune,* predicted that the city would become "the focus and mart for the grandest circle of manufacturing thrift on this continent," while J. W. Scott, an inveterate booster of western cities, proclaimed that it would become the greatest city in the world by the year 2000. Climate, geography, location, and the character of its people all ensured that Cincinnati was destined for greatness. It was difficult for Cincinnatians to be humble, but rapidly increasing trade, rising personal wealth, and munificent buildings did not entirely obscure the city's less impressive features. If pigs meant money, they also fouled the air and polluted the streams. The city water, carried by lead pipes from a hilltop reservoir, arrived "turbid" from the concentration of silt in suspension. Along the western edge of town, the

Whitewater Canal basin trapped stagnant water for the encouragement of diseases, and the waterfront had a well-deserved reputation for violence and low life. Summers brought humid air, and the abundant coal smoke pressed heavily on the community. August brought the dreaded cholera. Streets remained poorly paved, poorly lighted, and "filthy, filthy, FILTHY—how filthy!" according to one New Yorker. Outbreaks of disease and the flood of 1847, second highest inundation in the city's history at that time, reminded residents of the fragility of urban life.[5]

Civic promoters disregarded the escalating social conditions, but a race riot in the autumn of 1842 and a bank riot the following year exposed the troublesome problems which underlay progress. The older, more established Protestants uneasily watched the arrival of German and Irish Catholics, and in the decade of the 1850s occurred at least two confrontations sparked by religious differences. The even more divisive issue of slavery defied efforts at compromise. Of course, these issues were national as well as local, and in the optimistic atmosphere of mid-century no doubt appeared less troublesome than they do now. For most Cincinnatians the 1840s and 1850s appeared rosy. Certainly few residents envisioned anything except a promising future. The pig looked to be inexhaustable, the river flowed endlessly to the sea, and everywhere the design of progress revealed itself. What more could one wish?

Along with commercial prosperity Cincinnati's cultural life flourished. The theater recovered from the economic turbulence that followed the panic of 1837, and painting continued to thrive. Most importantly, the outline of the city's musical heritage took shape. "This is a musical city—that is, so far as a desire to cultivate the science of music, and the power to appreciate its charms can establish its claims to that title," commented the *Cincinnati Daily Citizen* in 1852. This somewhat defensive remark had been triggered by a critical column in *Dwight's Journal of Music,* the new music authority for Boston and the nation, and the Cincinnati rebuttal went on to point out that "from want of that great essential, association," the city's musical achievements remained obscure "to the stranger."[6] This assessment proved accurate, for among the city's musical people at this time only the Germans had moved towards "association."

Cincinnati's German connection extended back to David Ziegler, Martin Baum, and Frederick Eckstein, but after 1830 the Teutonic trickle broadened into a stream. Attracted by cheap land and economic opportunity, Germans emigrated to the United States by the tens of thousands. Most western cities, Cincinnati among them, benefited from this German contribution. Attracted by the Queen City's energy and prosperity, by its physical contours and the river location, they settled the area just north and east of the Miami and Erie Canal. Soon Germans and Americans alike referred to

this district as "Over-the-Rhine." "The visitor leaves behind him at almost a single step the rigidity of the American, the everlasting hurry and worry of the insatiable race for wealth," exclaimed one promotional booklet, and entered "into the borders of a people more readily happy, more readily contented, more easily placed, far more closely wedded to music and dance, to the song, and life in the bright, open air." German was the language, and Over-the-Rhine remained a foreign enclave until the end of the century.[7]

The congregation of Germans across the canal was only partly by choice. As early as the 1830s, anti-German feelings had grown in response to fears of the increasing number of German Catholics. Native-born Protestants embraced the idea of a "Papal Conspiracy" to capture the Mississippi Valley for central Europeans. Lyman Beecher, the volatile head of Lane Seminary, spearheaded this attack. By mid-century Cincinnati was an active center of nativist activity, and the Germans remained objects of deep-seated suspicion for many. Thus, isolation beyond the canal was in part a form of segregation, encouraged by the more established residents.[8]

The nativist hostility encouraged Germans to associate among themselves. German newspapers, business ventures, churches, theaters, and a variety of cultural activities flourished within the German quarter, and on a Sunday evening the residents often gathered to "drink lager beer, smoke long pipes, and sing the songs of the 'Fatherland.'" This love of song produced a quick cultural leavening into Cincinnati. The combination of beer and baritones led to a series of singing societies, which in turn resulted in a small outdoor festival held under soft summer skies in June 1846 on Bald Hill (now Mt. Lookout). Three years later, the three largest singing societies, the Liedertafel, the Schweizerverein, and the Gesang und Bildungsverein, invited German choruses from Louisville and Madison, Indiana to participate in a Saengerfest, a three-day gathering of song and pleasure. Out of this festival came the Nordamerikanischer Saengerbund. A year later the Cincinnati Germans travelled to Louisville for a second festival. The Queen City hosted the festival again in 1851, drawing choruses from as far away as Detroit and St. Louis, and for the next thirty years the festival rotated among the principal western cities.[9]

Germans in several eastern cities formed their own Saengerbund, meeting for the first time in Philadelphia in 1850, and a brief rivalry ensued. But the westerners—now calling themselves the Erster Saengerbund of Nordamerika—represented German song in the minds of most Americans. Initially the public drinking and the Sunday concerts antagonized Cincinnati's more Calvinistic citizens, and one angry editor even blamed a recent cholera outbreak on the Germans' intemperate drinking. Their exuberance and enjoyment, along with the quality of their singing, however, helped to dilute the suspicions. The *Cincinnati Gazette* went so far as to suggest that

Americans did not "allow themselves enjoyment enough of this kind," and John Sullivan Dwight, the eminent publisher of *Dwight's Journal of Music,* hinted that "we hard-scrabbling, money-making, desperately political Americans might imitate to some advantage" the Teutonic approach to song festivals.[10]

The German influence on Cincinnati's musical development cannot be overemphasized. During the second half of the century, the best teachers, the finest performers, and the most successful organizations in the city reflected the talent of the swelling German population. And Cincinnati was not unique. Philadelphia Germans provided the musical leadership for that city. The New York Philharmonic Orchestra presented its first concert in 1842 with twenty-two Germans among its fifty-two members; twenty-five years later over 80 percent claimed a German connection. The *Indianapolis Journal* noted in 1850 that that city's German citizens far excelled others "in musical attainments," while *Dwight's Journal of Music* pointed out that Germans were the "musical pioneers of the West" because they "go into musical pursuits not for the sake of novelty or mere amusement, but for the real, genuine love of Music."[11] Throughout the century American music exhibited a decidedly Germanic flavor. Carl Bergmann, Theodore Thomas, Anton Seidl, Walter and Leopold Damrosch, Carl Zerrahn, Otto Singer: the list is almost unlimited, and every community could point to its own local German musicians and singing societies.

Heinrich Rattermann, Cincinnati's leading German chronicler, has left us an insight into the world of German singing societies. The future poet, essayist, and historian of German-American life arrived in Cincinnati in 1846 at the age of fourteen. His love of singing, encouraged by German schools, found nourishment in the Over-the-Rhine district, and even arduous labor in a slaughterhouse failed to diminish his enthusiasm. He joined the St. John's Church choir and participated in the first Saengerfest. His intelligence and ambition led him to a business college, and shortly before the outbreak of the Civil War he established the German Mutual Fire Insurance Company. Along the way he sang and played the guitar, absorbed an education in art, literature, and philosophy from the numerous German newspapers of the city, joined the Maennerchor and Orpheus singing societies, and eventually directed the St. John's choir. In 1869 he became editor of and principal contributor to *Der Deutsche Pionier,* a journal devoted to German-American culture and history.[12]

In a paper read before a local literary club, Rattermann explored the relationship between music and the German people. Infused with German romanticism, he associated an innate love of song with the German child's love of nature and beauty. Exposure to the sober and materialistic values of America did not inhibit this joyous expression; rather it made it more neces-

sary. Germans sought release in the conviviality of the evenings when "a melodious song and a frugal glass of wine or beer would wipe the cares of life from his eyebrows." As "the harmonious strains poured forth from the breast of the jubilant chorus," he gushed, "it would reinvigorate the singers with new strength for the tasks of the coming day." Perhaps. At any rate, the various singing societies provided area Germans with excellent choral music on a regular basis, and made up the backbone of Cincinnati's contribution to the popular Saengerfests. When Theodore Thomas made his first visit to the city in 1869, he discovered to his surprise "excellent choral societies and an orchestra superior to that of any city west of New York"—a tribute to Cincinnati's German community.[13]

If the Germans provided an important dimension to Cincinnati's musical life, they were not alone. In 1846 the twenty-year-old Stephen Collins Foster arrived to clerk for his brother, a partner in the firm of Irwin and Foster, steamboat agents. Perched on his high stool in the Cassily's Row office near Front Street, Foster observed at close hand the mingling cultural strains of the bustling community. Life on the levee stimulated him far more than the ledgers and account books that provided his income: the steamboats discharging their passengers and cargoes; the rumble of wagons mixed with the shouts of stevedores and roustabouts; German phrases intermingled with plantation melodies. In 1848 he watched soldiers return victorious from the war with Mexico, and soon Forty-niners streamed west to California, some already whistling his "Oh! Susannah." In his spare time Foster frequented most of the city's musical events—Anna Bishop's concert and Madame Biscaccianti's, performances by the Amateur Musical Society, and Lowell Mason's popular lecture on sacred music. Surely he heard Tosso play. Browsing in the several music stores along Fourth Street, especially that of William Peter, often drew him away from his duties as clerk, and evenings frequently found him at the theater. The poet William Gallagher became his close friend, as did numerous steamboat captains and minstrel players, and it was through the latter that he gained his fame. Minstrelsy had become coarse, but Foster's ear for black dialect and rhythms lent a sentimental beauty to the songs that poured from his pen. In 1850 Foster, by then well known, departed for New York and then Pittsburgh, but his Cincinnati years left a permanent mark on his music.[14]

Paralleling Foster's unique contributions was the beginning of music instruction in Cincinnati's public schools. The influence of Boston hymnwriter and music educator, Lowell Mason, did not take long to reach the banks of the Ohio. The interest of Cincinnatians in music instruction is evident from the many music schools and private teachers in the city during the second quarter of the century. The efforts of Timothy Mason, a younger brother of Lowell, who taught music at the Eclectic Academy and later vol-

unteered his services to the public schools, and Calvin Stowe, whose 1836 report on German education stressed music in the schools, typify this concern. Of the early music teachers in the public schools, the most forceful was the "unselfish and devoted" Charles Aiken. Appointed supervisor of music in 1848, Aiken instilled a devotion to great music into a generation of children—an endeavor which bore important fruit in providing voices for the great music festivals after the Civil War. Another important addition to the community's music life at this time was D. H. Baldwin, a teacher of music who found the competition from U. C. Hill, Madame Scheidler, Joseph Tosso, and other "professors" too stiff. As a result he turned to the manufacture of musical instruments and founded the Baldwin Company, the most important and most successful of the many musical instrument companies in the city.[15]

Cincinnati's concert life also continued to improve. The Amateur Orchestra, predominantly Anglo-Saxon and directed by Victor Williams, provided competent orchestral music, on several occasions joining with the Sacred Music Society to present oratorios. "A large and fashionable audience" in Melodeon Hall enthusiastically greeted a performance of Haydn's *Creation,* and the orchestra, in its final concert, performed Neukomn's *David* as a benefit for Victor Williams. As one resident observed in 1852, "classical and scientific performances become more esteemed and appreciated."[16]

Nor did the city lack for outside talent. Cincinnati's rapid growth ensured it a prominent place on the American tour that had become both lucrative and mandatory for European celebrities. During the Christmas season of 1852 the Norwegian virtuoso Ole Bull enthralled a supportive audience—"a triumph over all triumphs in violin execution," noted one critic. Adelina Patti, an eight year old "whose upper notes strongly resemble the rich notes of a bird," toured with him. Several years later, the Swedish Nightingale, Jenny Lind, captivated audiences with her sentimental songs. Scarcely had Lind departed when Maurice Strakosch, the era's great impressario and the promoter of Ole Bull and Patti, introduced Sigismond Thalberg. Two thousand music lovers paid up to $1.50 each for the pleasure of listening to the famed pianist. Thalberg was a great success, but not everyone agreed with the increasing commercialism of art. "What a shame for music in the United States that men like Barnum and Strakosch can get hold of such celebrities as Jenny Lind and Thalberg!" lamented one concerned citizen. "How astonishing that such artists as these allow those gentlemen the entire control of their concerts! It is sad to see how much the almighty dollar can accomplish, even in the realm of art."[17]

To be fair, the Jenny Lind, Thalberg, and even Ole Bull performances were viewed as "entertainments" as much as concerts, and crowds turned

out as much for the event as for the music. Infant prodigies and bizarre performances appealed more than serious artists, a situation as true for Boston as for Cincinnati. General audiences everywhere preferred the dozens of red-shirted firemen striking anvils for the "Anvil Chorus," or a pianist who played with fists and elbows. Beethoven often shared the concert stage with "Yankee Doodle"—and the latter usually drew greater applause. Personalities succeeded, artists often failed; and the elaborate promotion by a Strakosch or Barnum frequently provided the difference. A later generation would recognize these early concerts as media events. Still, these men and women helped popularize good music, and in mid-nineteenth-century America that was enough.[18]

Other professional groups visited Cincinnati in the 1850s as well, and while lacking the crowd appeal of their more glamorous competitors, they extended the serious appreciation of music. In the spring of 1853, and again in 1854, the Germania Musical Society brought its band of professionals to the city. Organized in Berlin in 1848 by young German musicians about to emigrate to the United States, the Germania orchestra "schooled an entire era in great music." In a two-week visit to the Queen City the society performed six concerts, including joint performances with the Sacred Music Society of Reis's cantata "The Morning" and Romberg's "The Power of Song." The Germanians made an extraordinary impression on their audiences. "Their modesty, self-respect, correct deportment and gentlemanly manners" captivated concertgoers. Without sensationalism they controlled their audiences. "No loud talking during the performances, or even in the intermissions," marvelled one reporter. Another observer noted "their gentlemanly behavior." "They do not sit down during their performances, and do not differ in their mode of dressing, nor manners in entering and taking their positions," he continued, "no tuning of instruments—no talking or laughing, when they stand on the platform—everything goes off with dignity and grandeur."[19] One only wonders what had taken place previously!

Bracketed by the Germania visits, Louis A. Jullien introduced his orchestra to Cincinnati music patrons. Less polished and less serious in his approach to music, Jullien mixed in polkas, waltzes, and gallops with symphonic movements and operatic overtures—an enticing mixture of the popular and the sublime. He knew his audiences. Where the Germanians awed the city, Jullien captured it. He is "the lion of the town," roared the *Cincinnati Commercial.* How could the city resist a man who conducted Beethoven with a diamond-studded baton brought on stage to him on a silver salver? Cincinnatians succumbed to the "master magician." Jullien combined first-rate ability with the American craving for showmanship, and his flamboyant gestures aroused an interest and enthusiasm for orchestral music.[20] The visits by the Germania Society and Jullien's orchestra came

at a particularly fortuitous time, for they nourished the movement to establish a truly professional symphony orchestra, a subject covered in the next chapter.

Thus, by 1855 Cincinnati had experienced its first orchestra, the amateur orchestra connected with the Eclectic Academy of Music, supported a serious music academy, and witnessed the emergence of the Saengerfests. As one visitor phrased it, "I have found it to be the prevailing opinion, that in Cincinnati very nearly all . . . must be acquainted with the science of music."[21] Nineteenth-century exaggeration notwithstanding, Cincinnati had firmly established herself as a community which took its music seriously.

Support for painting and sculpture paralleled the city's musical achievements. The artistic energy evident in the formation of the Academy of Fine Arts and the Section of Fine Arts of the Society for the Diffusion of Useful Knowledge resurfaced in the 1847 launching of the Western Art Union. Patterned after the more famous American Art-Union in New York, the Western Art Union proved to be the most stimulating and important of the pre–Civil War art organizations in the city. Its promoters viewed the organization as "neither a Cincinnati, nor an Ohio Art Union," but as a truly western institution. They also predicted that the city would reap cultural distinction and an "extraordinary source of wealth"—a nice balance of profit and honor. As the undisputed artistic center of the West, Cincinnati would then be in a position to challenge the older, more refined eastern cities.

Operated by a board of the city's most distinguished citizens, the Western Art Union sold five-dollar memberships which entitled the subscriber to a "highly finished Original Engraving, the Annual Report, and the published Proceedings and Addresses at the yearly distribution." Members and their families could also enter the gallery free of charge. The directors used the membership revenues to purchase appropriate works of art which were first displayed in the gallery and then distributed to members by means of a lottery. Due to its open membership and to the element of chance, the Art Union succeeded in spectacular fashion. From 724 subscribers its first year, membership soared to almost 5,000 by 1850, and honorary secretaries solicited memberships in cities as distant as New Orleans.[22]

The Western Art Union gallery occupied the upper floor of a building at the corner of Fourth and Sycamore Streets, and, as its supporters boasted, it was "of equal extant" to the American Art-Union gallery in New York. Initially plans had called for a permanent art collection, but this apparently never materialized. Instead, attention focused on the end of the year lottery, which aimed at the wide dispersal of art work. The Art Union also encouraged and promoted local artists. Both James H. Beard and Lily Martin Spencer had paintings selected as the subject of the annual engraving, while

several other area artists had works chosen for the drawing. William Sonntag, Benjamin McConkey, Robert Duncanson, Joseph Eaton, and Beard seem to have been special favorites of the selection committee. The Art Union also served as a meeting place for artists, and several opened studios in the same building.[23]

However, not all artists agreed with the management of the Art Union. Concerned lest petty quarrels and jealousies destroy the organization, the organizers kept control firmly in the hands of business and professional men in the community, men who shared a similar taste in art. Although one of the Union's goals was to support artists by creating a "sure market of demand and supply," the Art Union clearly could not purchase works by all area artists, and the annual distribution reflected the taste of the board. Romantic landscapes and sentimental genre scenes predominated, much to the dismay of several artists. Furthermore, the directors made it quite clear that the purchase of art was not meant to provide "higher pay for the artists," but to provide them with "a more frequent and steadier market for their productions." "For, if this Association should materially enhance the prices of such works," explained the directors, "the effect would be to diminish the number of private purchasers." This in turn would result "in serious injury to art and artists, by destroying . . . private patronage."[24] In other words the Art Union purchased art as cheaply as possible in order not to inflate the value of the artists' work, while at the same time solemnly intoning the law of supply and demand. A curious contradiction. And so thought some of the artists.

Lily Martin Spencer complained of her treatment at the hands of the board of directors, and neither Beard nor Hiram Powers, whose *Greek Slave* was the principal prize in 1850, received anything for their works, as in both cases the board insensitively purchased them from current owners rather than from the artists. John Frankenstein, the caustic sculptor, singled out the Western Art Union for some particularly bitter invective in his *American Art: Its Awful Attitude,* and both he and T. W. Whitley, another Cincinnati artist who had previously operated a short-lived gallery, charged the board with inefficiency and favoritism. The fact that neither artist had work selected by the Art Union may account for their particular complaints. Still, many local artists resented the numerous works by eastern artists purchased by the Union, as well as the emphasis on engraved copies which brought no return for the painter.[25]

The much publicized November drawing in 1850 for the even more publicized *Greek Slave* proved to be the apex of the Art Union's success. Its sudden collapse the following year stunned the community. Only a week after the drawing, letters appeared in the *Cincinnati Daily Times* alleging financial irregularities. By early 1851 a deeper rift had emerged. In an open

letter Judge James Hall, the treasurer during the previous year, alluded to philosophical differences over the "interests of Artists and Art." Local newspapers aired the charges and countercharges for several weeks, and in February Judge Hall and fellow director William Greene resigned. Suddenly the Art Union was gone. In March the *Enquirer* mourned the dismantling of the gallery. "The Art Union will soon be ridded of all its gems—the *Greek Slave* goes East this week. . . . Rothermel's great painting of Cortez burning his ships, will no more be seen in the Art Union. All the principal gems are gone, and only a few remain to show that once there was a gallery, for the fine arts." It is not altogether clear what destroyed the Art Union. Ambitions and personalities, coupled with philosophical differences, seem to have been at the heart of the matter, however, rather than the legal issues which snuffed out the American Art-Union the following year.[26]

The Western Art Union never achieved its fullest ambitions, "to render the city a school for art, a mart for the elegant productions of the pencil, the burin, and the chisel—a center for the concentration of the patronage of the arts of our country."[27] It is unlikely that any organization could have achieved all that. Nevertheless, it did provide a showplace for local talent; promoted, however modestly, scores of local collections through its lottery; and encouraged an interest in and an appreciation of art among its subscribers. If the styles and themes of the work distributed remained tightly controlled by the board—quite possibly a cause of the rift—still the Art Union did foster and stir up interest in art, no mean achievement in 1850.

Several of the Art Union's paintings did not travel far. William Wiswell, a dealer in frames and mirrors, opened a free art gallery only days after the Art Union closed, and most of the local work reappeared on its walls. Wiswell, who had been on the Art Union board in 1850, apparently felt an obligation to maintain the collection in the city, and his gallery remained central to local art affairs throughout the decade. Other galleries appeared as well, hoping to benefit from the interest in art. In 1853 J. Insco Williams and Almon Baldwin, "those popular and experienced artists," opened their gallery in the old Art Union quarters, where they remained for several years. Not long after, a "Modern Gallery of Art" opened on Fourth Street, advertising "the finest paintings of all times." In the same year *The Pen and Pencil,* a weekly journal devoted to art and literature, was published for a brief time, displaying a fancy cover engraving and contributions from Alice Cary, Thomas Read, John Tait, and Charles Leland.[28]

This surge of cultural activity did not escape notice. In his mid-century analysis of the city, Charles Cist, in calling for an academy of design, described Cincinnati "as the center for the most cultivated and art-loving . . . the most refined people on our continent." Of course, Cist was an

outspoken booster of the city, but in the same year Frank Mayer, a Baltimore artist on his way to Minnesota, recognized that the city had been "peculiarly prolific" in turning out artists. He especially admired the Western Art Union and its studios, along with the number and quality of local landscape painters. During his brief visit, Mayer gained entrance into the stately homes of Nicholas Longworth and George K. Schoenberger, where he took the opportunity to study Powers's *Genevra* and Thomas Cole's four canvas allegory, *The Voyage of Life,* which Schoenberger had recently acquired.[29]

Osgood Mussey, writing in *The Western Lady's Book* in 1855, labeled Cincinnati the "Mother of Artists." Mussey was convinced that only in the West could the virtues of republican society properly develop. The East was already inhibited by a "crowding population and a comparatively sterile soil," thus the West would provide future artistic growth. In the public galleries, private collections, and the rich buildings of the city, Mussey found the evidence for which he searched. Cincinnati, he proclaimed, was to be the new center for the nation's fine arts. W. P. Strickland apparently agreed, for he chose the same year to launch his *Western Art Journal,* "unconnected with any prestige of wealthy or distinguished patronage, committing its fate to an appreciative public." The ambitious Strickland hoped his journal would stimulate the arts and serve as an index of art appreciation in the western country. The first issue arrived complete with impressive solographs, several philosophical articles, a flattering description of Nicholas Longworth, and a one-dollar price tag. The discerning public did not materialize, and no second number appeared. Still, the mere attempt to publish such an impressive and expensive art journal again underscores the reputation that Cincinnati achieved before the Civil War.[30]

John Tait, artist and friend of Hiram Powers, alluded to this reputation when he wrote the sculptor that "there is a very general interest taken in art here, at least so far as a certain esteem and appreciation goes " *The Western Art Journal,* the several galleries, and pride in local private collections no doubt made up a considerable portion of this esteem and appreciation, but no doubt the Ladies Academy of Fine Arts, established by Mrs. Sarah Worthington King Peter and a truly eminent group of Cincinnati women, also encouraged Tait's enthusiasm.[31]

Sarah Worthington King Peter, daughter of an Ohio governor, came to Cincinnati in 1831 with her first husband, lawyer Edward King. She quickly immersed herself in a variety of social and cultural activities, including participation in the Semi-Colon Club. The sudden death of her husband in 1835 drew a cloak over her public activities. Later she lived in Philadelphia, where she married William Peter, a gentle, refined Englishman. In the Quaker City she directed her energy towards the promotion of cultural and educational opportunities for women, which included art classes in her home. She be-

lieved that "the arts can be practiced at home, without materially interfering with the routine of domestic duties, which is the particular province of women." Widowed a second time in 1853, Sarah Peter returned to Cincinnati to be with her only surviving son, Rufus King II, professor at the Cincinnati College of Law and a strong supporter of public education. Her home at Third and Lytle Streets became a cultural salon for the city's social elite, and "many meritorious artists in music and painting and sculpture owed their success to her inspiration of hope"[32]

The indomitable Mrs. Peter launched the Ladies' Academy of Fine Arts "to aid in the cultivation of the public taste—to afford encouragement to artists, and to furnish a source of intellectual recreation and enjoyment to the people" Noble aims indeed, and all the more interesting because the organization remained entirely in the hands of women. Sarah Peter served as president during the academy's tenure, and seventeen other women joined her on the board of managers. The Ladies' Academy offered art instruction to women in order to promote "an honorable livelihood." To support that goal the managers planned a gallery of copies "to be executed in the best manner from masterpieces of painting and sculpture" Drawing on the examples of previous art organizations in the city, the Ladies' Academy opened a public gallery, provided classes and a reading room for pupils, gave public lectures, and established an annual loan exhibition—all in a matter of months.[33] From various activities and donations, they raised sufficient funds to permit Mrs. Peter to travel to Europe in 1851 to purchase the necessary copies for the gallery. Murrillo's *Virgin of Seville,* Poussin's *Diogenes Casting Away His Drinking Cup,* Van Dyke's *Charles I,* Raphael's *Virgin With the Veil,* and other notable works were soon under contract, but her payment of $1,900 for a half-size copy of Raphael's *The School of Athens,* a particular favorite of hers, caused great consternation among board members. But Mrs. Peter had her way.[34]

Rufus King served as his mother's financial advisor and general go-between with the board of managers, and it fell on his shoulders to sort out the financial confusion in 1854. Hard times at the end of the year had reduced financial support, and the "severe state of money matters" in November led to the failure of the George Milne and Company bank, in which the organization's funds had been deposited. While in Europe, Mrs. Peter had urged that the funds be transferred to Brown and Bowen of Philadelphia in order to make them more accessible to her. The board of managers at first declined, pointing to the higher interest rate at the local bank, but at a special meeting in early November they acceded to Mrs. Peter's request. A delay in the arrangements, however, allowed the $2,500 to be caught in the financial collapse two weeks later. Rufus King, who had once referred to the board as a "shabby set," exchanged heated letters with the board over the responsibil-

ity for the lost funds. Mrs. Peter sided with her son. "I have the right to feel indignant," she exclaimed in a letter to Rufus, "not at any intentional oversight, but because I am thus made the victim of the Board's negligence. . . . I trust that the ladies will not flinch from misfortune, but get along as best they can," she continued. "If we stop now, Heaven only knows who will have the courage to start again." The ladies flinched. The board instructed Mrs. Peter to cease her purchasing and cancel all outstanding contracts. She refused. Instead she concluded her quest, pledging her own funds and counting on male generosity when she returned. She had not underestimated her powers. The Ladies' Academy weathered the crisis, eventually regaining the "lost" $2,500, and in the following year opened its first exhibition.[35]

To Sarah Peter the Ladies' Academy represented more than an institution to instruct women in the arts of good design, for, like a growing number of Americans around the country, she viewed proper design as essential to manufacturing success. "The nation which surpasses others in the beauty of its designs, will control the markets of the world," she wrote Charles McMicken, a wealthy supporter. The Ladies' Picture Gallery—"so nobly commenced as an inducement to a school of design"—was to furnish the proper models "of design and colour to which the industrial arts of our day are so greatly indebted" Mrs. Peter believed the human form was the source of perfection in nature, which accounts for her taste in European masterpieces. And if Charles McMicken had not yet grasped the point, Mrs. Peter pointed out that numerous Cincinnati manufacturers could benefit from improved designs, particularly makers of furniture and pottery. "By cherishing in their midst a School of Design," she summed up, "the manufacturers of Cincinnati would in a short time be repaid ten fold for the expense of its maintainance [*sic*]." McMicken contributed one thousand dollars in support of the ladies' collection; how much other businessmen gave is not clear. Apparently not enough, for money troubles continued to plague the organization, and several board members, including Mrs. Peter, expressed bitterness over the general lack of support for art activities in the city.[36]

Public taste caused more troubles in 1856. In that year the board chose to display nude statues in a separate room in order not to offend public sensibilities. Rufus King, in an angry letter to his mother, complained of "that terrible access [*sic*] of virtue and modesty, that 'nasty-nice' taste" which the board displayed. "Just imagine," he grumbled, "the thicket of gods and goddesses, all huddled together, the Gladiator pitching into Venus, and the Belvidere [*sic*] twanging his bow strings right a posteriori to Hercules." One assumes that Mrs. Peter shared her son's irritation; nevertheless, she arranged for a Mr. Fazzi to provide suitable fig leaves with which to cover

51

the offending nakedness.[37] The annual exhibitions continued and prominent Cincinnatians were encouraged to contribute to the collection until it would become "a monument of the taste and liberality of our Western Metropolis." Several supporters did contribute, and the academy survived until the Civil War eroded its strength. In 1864 the board of managers met for the last time, bequeathing the collection of copies to the newly founded McMicken University, where it served the next generation of art students.[38]

Just as music had achieved greater maturity by the mid-1850s, so too had art. Despite a disconcerting weakening in the city's economy, tied to low river levels, the decline of the canal system, and increasing competition from cities to the north, the art world appeared solid.[39] Increased recognition of Cincinnati artists by eastern critics augured well. The city still retained its cultural leadership among western rivals, and as individual artistic activity encouraged greater institutional development, Cincinnatians eagerly looked forward to the anticipated achievements of the next decade.

Keeping pace with the arts, literary and intellectual activities further extended Cincinnati's illustrious reputation. Not that the city escaped the social turmoil which plagued all American cities of that era—ethnic and religious strife, spiraling problems of growth, and the political divisions that soon led to the Civil War—but public-spirited citizens never ceased to struggle against vulgarity and materialism. Like other cultivated Americans, Cincinnatians trusted the arts to help lift them above man's baser instincts.

In the years immediately following the demise of *The Western Messenger,* Cincinnati supported the founding of a historical society and a movement to establish a public library, two institutions which will be discussed in a later chapter. The city also benefited from the efforts of Ormsby McKnight Mitchel. Born on the edge of the Kentucky wilderness in 1809 and reared in Lebanon, Ohio, this modestly educated but very self-assured young man earned an appointment to the United States Military Academy at West Point, arriving there just twenty-one days shy of his sixteenth birthday. In spite of his age, his short stature, and his limited schooling, he graduated fifteenth in a class of forty-six, a class that included future Confederate generals Robert E. Lee and Joseph E. Johnston. Following three years of military service, part spent in teaching mathematics at West Point, Mitchel resigned his commission and settled in Cincinnati. He served as chief surveyor for the Little Miami Railroad, the city's first iron link to the north, and taught mathematics at the Cincinnati College. During the winter of 1842 John P. Foote invited him to present a series of lectures to the Science Section of the Society for the Diffusion of Useful Knowledge. His subject was astronomy.

Mitchel proved to be an extraordinary speaker, capturing his audience's imagination, and at the conclusion of his third lecture he brashly announced

Mid-century Minds. Heinrich A. Rattermann, top, and Ormsby M. Mitchel; both courtesy of the Cincinnati Historical Society.

his intention to erect an observatory in the city. To this end he founded the Cincinnati Astronomical Society and solicited twenty-five dollar memberships from supportive citizens in exchange for the future privilege of observing the heavens free of charge. With $7,500 in subscribed funds, he travelled to Europe to obtain a telescope. At Munich he found the instrument he wanted, and when the handsome brass and steel spyglass arrived, Cincinnatians could proudly boast that they possessed the largest telescope in the western hemisphere. Mitchel remained active in the city for another fifteen years, dividing his time between teaching at the Cincinnati College and enlightening his fellow citizens on the mysteries of the stars. And while he made no startling observations of his own, he did add to the general body of astronomical knowledge, for which he achieved membership in the Royal Astronomical Society of England.[40]

During Cincinnati's first half century, bone-jarring stagecoach travel and the often unreliable steamboats had discouraged visitors from the eastern seaboard, but in the early 1850s a railroad connected the Queen City to Lake Erie. Cincinnati now became a prominent stop on a national lecture circuit that brought many of the nation's finest minds to the Ohio Valley. Appropriate to his growing stature, Ralph Waldo Emerson was the first to arrive, reaching the city in 1850 on the first of his five visits. Bronson Alcott, Theodore Parker, Henry Ward Beecher, Horace Mann, and Wendell Phillips soon followed with their particular messages—an impressive array of intellect. Oliver Wendell Holmes, Sr., had the honor of opening Smith and Nixon's Hall with a lecture on Lord Byron, "replete with wit, humor, and brilliant reminiscences." The eminent Harvard paleontologist Louis Agassiz spoke at the annual meeting of the American Association for the Advancement of Science, held in the city in 1851. William Makepeace Thackeray visited during the decade, as did the Swedish writer Fredrika Bremer. Actress Fanny Kemble, the young Adelina Patti, and Jenny Lind entertained; and a recent German émigré named Carl Schurz lectured on Napoleon III.[41]

Stimulated by these visiting literati, local intellectuals gathered to discuss not only religious and political issues, but women's rights, the latest food theories, temperance, and the views of the eccentric Frances Wright (recently buried in the city). Central to this local intellectual activity was Ainsworth Rand Spofford. Born in New Hampshire, the nineteen-year-old Spofford obtained a position with Truman and Smith, booksellers and publishers, the forerunner of the American Book Company. Spofford's inquiring mind turned the bookstore into a gathering place for the younger generation of intellectuals. In October 1849 he and eleven friends organized the Literary Club, devoted to lively discussion and good fellowship, often aided by liberal amounts of the local Catawba wine. In keeping with their "radical"

nature, the members moved to have Emerson lecture in the city, and Spofford's encouraging letter, with ninety-nine signatures and a guarantee of $150, persuaded the patron saint of individualism to make his first western trip.

Emerson's five public lectures at the Universalist Church received favorable newspaper coverage, despite an occasional comment about his suspected pantheism. Religious newspapers, however, retained their suspicions. Emerson also presented semiprivate lectures on transcendentalism, which baffled local reporters and even several Literary Club members. Before leaving the city Emerson enjoyed an evening "confab" at the club, and then joined this "very intelligent group of young men" on an outing to the Indian mounds at Fort Ancient. Emerson returned to Cincinnati in 1852, 1857, 1860, and 1867, each time sharing the hospitality of the city and his friends in the Literary Club.

As a bookseller (he became a partner in Truman and Smith's in 1852), Spofford travelled frequently to Boston, and he used his connections to bring others of that city's formidable intellectual community to Cincinnati, particularly Bronson Alcott and Theodore Parker. He also served as a major force in the Historical and Philosophical Society of Ohio (formerly the Cincinnati Historical Society), working with William D. Gallagher, Peyton Short Symmes, and Manning Force to collect and preserve the region's past. During his fifteen-year residency in the city, Spofford sparked local intellectual life, and until his move to Washington, D.C. in 1861, where he became the Librarian of Congress, he remained the "most frequent debater and essayist" in the Literary Club.[42]

If Spofford was the prime mover of the Literary Club, he was not the only luminary in that prestigious society (which continues to meet weekly at its Fourth Street quarters). Other early members included James H. Beard, Rutherford B. Hayes, newspaper editor Murat Halstead, the recently elected senator Salmon P. Chase, Thomas Buchanan Read, Ormsby Mitchel, Alphonso Taft, and the German-American philosopher Johann Stallo. All were relatively young, and most were not yet prominent. Spirited discussions marked many of their Saturday evenings, and occasionally debates became quite heated. Respect and friendship prevailed, however, and the exuberant members often adjourned to Gleissner's in the Over-the-Rhine area for some German lager. While scheduled debates occupied many of the first meetings, eventually the formal paper became standard fare, and the members turned to Shakespeare for their slogan, "Here Comes One With A Paper."[43]

Ainsworth Spofford's connection with Truman and Smith's reminds us of Cincinnati's importance as a publishing and bookselling center, not only to the West but to the country as a whole. Early in the century, Connecticut

born John Foote had operated a bookstore which served as a meeting place for that generation's more literary citizens. Foote, of course, was involved in much of the city's early educational and intellectual activity, and his many interests drew him into other business ventures. In 1825 he turned his store over to George and Nathan Guilford. Nathan Guilford, a Yale graduate and longtime supporter of public education, published much of the community's literary efforts for the next fifteen years, including Timothy Flint's popular biography of Daniel Boone. Foote and Guilford reflect the personal nature of Cincinnati's book trade in the first half of the century. Both were men dedicated to good literature, whose personal love of books placed them at the center of the city's intellectual life.

By 1840 Cincinnati had acquired yet another nickname, "The Literary Emporium of the West," a reflection of its importance as a publishing center, and the following decade expanded this reputation. Home to the H. W. Derby Company, the Western Methodist Book Concern, Moore, Wilstach, Keys and Company, W. B. Smith and Company (successor to Truman and Smith), and at least a dozen smaller firms, Cincinnati owed its position to its general economic importance and geographical location. Satellite industries, such as ink and paper manufacturing, bookbinding, and engraving further contributed to the city's dominance. By 1856, according to Charles Cist, the total worth of the local publishing industry placed Cincinnati fourth in the nation, ranking just behind Boston.[44]

From these publishing houses flowed a wide range of reading materials. Of greatest importance were the various schoolbooks, led by the popular McGuffey Readers, closely trailed by books on religion, travel, history, and fiction. At the center of this publishing and selling was Uriah P. James, the heir to the personal tradition established by Foote and Guilford. U. P. James had come to Cincinnati in 1831 from Newark, New Jersey. Often in business with his brother Joseph, the various James enterprises had steadily established the two men in the community. Between 1837 and 1847 U. P. James handled the publishing and sales by himself, and it was during this decade that the name of James became synonymous with quality literature. His newspaper advertisements show a varied stock, including works by Sir Walter Scott, Lord Byron, and Robert Burns. James also sold a selection of books on western Americana, William Gallagher's *Selections from the Poetical Literature of the West,* and Lewis Collins's *Historical Sketches of Kentucky* being among the most popular.

The abundance of scientific works handled by James reveals his own interest in science. In an era when science had not yet become either specialized or professionalized, James's particular interest lay in fossils, an area of study which fascinated the early nineteenth century. Not only did U. P. James accumulate a large collection of fossils, which later went to the Uni-

versity of Chicago, but he actively participated in the Western Academy of Sciences. When the eminent English geologist Charles Lyell visited Cincinnati in 1845, James was among those who escorted him around local fossil beds. He also served as the Cincinnati agent for the sale of Audubon's American octavo edition of *The Birds of America,* which came in installments and carried a one hundred-dollar price tag. U. P. James continued in the book field until the 1880s, although the pre–Civil War decade saw the peak of his publishing activity. Indeed, as the new rail network diminished the need for regional publishing centers, the nature of his business shifted to sales only.[45]

As a publishing center in the 1840s and 1850s, Cincinnati continued to support a seemingly inexhaustible supply of literary journals, extending the tradition started by Flint, Hall, and others a decade before. Typical of these journals was the *Western Literary Journal and Monthly Review,* whose high-toned style doomed it to five issues in 1844. More successful was the *Great West* which catered more to popular taste, especially western history and legends. By 1850 this weekly journal reached 7,000 subscribers, and it continued for most of the next decade as the *Columbian and Great West.* Another popular publication was *The Ladies Repository and Gatherings of the West,* a profusely illustrated monthly "devoted to literature, art and religion." Published by the Western Methodist Book Concern, the *Ladies Repository* appealed to the swelling audience of middle-class women anxious for the polite literature and genteel romanticism found in its columns.[46]

Book publishing, literary journals, literary societies, and visiting intellectuals all helped to create an atmosphere of genuine refinement and stimulation in the years before the Civil War. Paralleling the developments in art and music, this activity underlined Cincinnati's importance as a regional center of thought and culture. Ironically, the mid-1850s proved a high-water mark for the city's reputation. Although not evident to that generation, Cincinnati's phenomenal growth, and thus its confidence in the future, had already slowed. In the coming decade both Chicago and St. Louis would race past the stagnant Queen as she struggled with a multitude of problems. To be sure, the city's most impressive cultural achievements remained in the future, but her hoped-for dominance in the arts was already fading as the Civil War approached.

Mars and the Muses: The War Years, 1856–1867

*I*t has long been fashionable to link Cincinnati's economic decline to the Civil War's disruption of the city's southern trade, yet as Carl Abbott has shown recently, the signs of "slow paralysis" were evident by the middle of the 1850s. The national shift from water to rail transportation, the failure to bridge the Ohio River, and the emergence of Chicago as a commercial and manufacturing center, all obstructed Cincinnati's continued economic leadership in the West. After 1850 the city's population growth slowed. Smaller communities like Indianapolis took advantage of the new rail network to cut into Cincinnati's regional trade, leading one local editor to ominously note in 1860 that the Queen was now a fallen monarch.[1]

Masking this sobering view was Cincinnati's obvious wealth, and during the 1850s most residents remained optimistic about their city's future. Impressive new public buildings, great retail stores such as John Shillito's "dry goods palace" on Fourth Street, the construction of hotels and opera houses, all suggested prosperity. Gas lights appeared on city streets. A new horsecar system provided the latest in public transportation, and as many as 5,000 steamboats arrived annually at the city's river front. Agricultural machinery, iron and brass products, clothing, whiskey, and, of course, pork products returned millions of dollars each year to the city. To Thomas Nichols, a seasoned traveller, Cincinnati was "one of the most industrious places in the world." In the minds of most Cincinnatians, geographical location and the primacy of river trade guaranteed supremacy among western towns.[2]

Ironically, even local railroad construction, which now appears timid and disorganized, at the time appeared vigorous. By mid-century rails linked Cincinnati to Dayton and Sandusky; seven years later a direct line to East St. Louis had been constructed, and in rapid succession through connections

were secured with Chicago, Detroit, and Baltimore. Considerable talk before the Civil War concerning a major railroad to the South helped reaffirm views of a healthy future. However, the future held a different view, and by 1860 an undertone of concern appeared. Under the threat of secession southern markets became less inviting, and southern debts perhaps uncollectable. The rapidly developing railroad system grew on an east-west axis, with Chicago as its western terminus, and as the iron link to the South failed to materialize, Cincinnati found itself increasingly on the periphery of these trunk lines. In addition, low river levels and a severe winter in 1857, accompanied by a coal shortage, further troubled the local economy. Later that year a financial panic, triggered by the collapse of the Ohio Life and Trust Company, delivered another blow.[3]

In the midst of this economic confusion, Cincinnati's cultural life suffered. Financial support thinned, and the ten years which surround the opening of hostilities in 1861 clearly reveal the effects on the arts of that turbulent period. Shortly before the firing on Fort Sumter, Charles Cist published the third and last of his informative books on the city's growth and prospects. His general enthusiasm notwithstanding, Cist found little in the arts worthy of promotion. The colony of artists had shrunk; the Ladies' Academy had all but disappeared. Music appeared to be solely in the hands of the Germans. Theater had never developed extensive local support, and local literary journals failed to achieve the promise of the previous decade. Cincinnati was clearly passing through a transition, for which the war was only partly responsible, yet these years provide an important understanding for the cultural activity that flourished in the Queen City during the postwar years.[4]

Of all the arts music appeared most promising during the late 1850s. Building on the recent enthusiasm for orchestral performances and the popularity of singing societies, the local musical community awaited a catalyst to carry the city forward. In 1856 Frederic Ritter arrived to perform that function. Only twenty-two years old, Ritter brought a European training, an impressive music library, and unbounded enthusiasm. Within months he organized the Cecelia Society, which included both German and non-German singers, and "a permanent, large and fine orchestra such as never existed in the city" The orchestra, made up of twenty-six German residents, quickly tuned up for a three concert season, and Ritter further promised to bring in eastern artists to strengthen the programs. Ambition Ritter did not lack. He used the New York Philharmonic as his model, and he hinted that he could secure audiences of several thousand. To this end he recruited subscribers, but only three hundred signed, a number insufficient to support a quality orchestra. But the list did include Charles Aiken, Manning Force, Rufus King, Joseph Longworth, Peter R. Neff, Henry Probasco,

William Resor, and Learner B. Harrison—prominent business and professional men important to later musical efforts, and predominantly non-German.[5]

Despite modest support, the Cincinnati Philharmonic, as Ritter named his orchestra, presented the city with the finest outpouring of symphonic music yet heard, including Mozart's *Jupiter Symphony* and the overture to Wagner's *Tannhauser*. "It is truly refreshing for us musical people, after years of panting for some good orchestral performances . . . to have heard this winter three Symphonies of Beethoven and one of Haydn, besides many fine overtures," happily commented the local correspondent for *Dwight's Journal of Music*. "Our city has recently taken quite a start in musical matters," wrote another music lover, and Beethoven's *Pastoral Symphony* kept the audience "spellbound in listening to the heavenly strains . . . there was not a whisper, hardly a breath."[6] The adulations went beyond immediate per-

Program, Second Concert of the Cincinnati Philharmonic Society, 1857; courtesy of the Cincinnati Historical Society.

formances. "Merely a beginning," "equal to anything perhaps you have in Boston," "Let Boston look to her laurels"—these and other comments reflect a new sense of pride within Cincinnati and anticipate the later cultural rivalry with Boston. After its first two sessions, the Philharmonic gave every indication of permanence, as did the eighty-member Cecelia Society. By appealing to all classes, especially to the "best" families of the city who provided much of the financial support, the Cecelia Society inaugurated a new direction for choral groups. Based upon a firm foundation, the Cecelians retained their vigor throughout the war years, a tribute to the popularity of choral music. However, the same could not be said of the Philharmonic.[7]

Despite the exuberant praise of its friends, the Philharmonic Orchestra struggled from the very beginning. Where Ritter had hoped for fifty musicians, the orchestra strained to exceed thirty, and at its peak in the late 1850s, it still lacked quality musicians on oboe, violincello, and horn. Audiences did not reach expectations, and the performance of the *Pastoral Symphony* attracted only five hundred people. By the orchestra's fourth season, decline was apparent. Ritter's youth and brashness apparently irritated several of the players, and the economic slump undermined the always marginal support for cultural activities. Above all, Ritter had miscalculated the community's support for orchestral music. Cincinnatians flocked to the choral performances by the Cecelia and Maennerchor, the new German chorus, but only the most ardent supported the Philharmonic.[8] Ritter departed in 1861, conducting his last program just six days after the firing on Fort Sumter, and he divided the remainder of his life between New York City and Vassar College, where his father-in-law was president. Whatever his personal faults, Ritter awakened a new musical spirit in Cincinnati and clearly aimed the city towards its postwar maturity.

Into the void left by Ritter stepped Carl Barus. A German "Forty-eighter," Barus had been living in Cincinnati since 1851, and for three decades involved himself with most of the German musical organizations. During his long career he directed the Liedertafel, the Turner singing society, and the Maennerchor; played the organ and directed the choir at St. Philomena Church; and provided similar services to St. Patrick's, Bene Jeshurun (Plum Street Temple), and Trinity Methodist Church. For twenty-two years he headed the music department at the Wesleyan Female Academy, as well as directing the national Saengerfests of 1854, 1865, 1867, and 1879. No other Cincinnatian contributed more to the daily musical life of the city, and in 1861 it was Barus who assumed command of the Cecelia Society and the almost moribund Philharmonic Orchestra.[9]

The Philharmonic limped through the war years, sustained largely by Barus's enthusiasm and the strategic coupling of its concerts with the more robust Cecelia Society. The strategy appeared to succeed when in 1867 Lewis

C. Hopkins, a prominent merchant, built a small concert hall on the corner of Fourth and Elm Streets, and subsidized the orchestra for two seasons. Because of evening theater commitments, however, many of the musicians could play only in the afternoons, virtually restricting the audiences to women, and poor attendance continued to plague the orchestra. Financial reversals also nibbled at Hopkins's support, and despite a dramatic (and symbolic) performance of Haydn's *Farewell Symphony* in early 1868, the orchestra slipped into oblivion.[10]

Even before Ritter's dream of a permanent orchestra faded, Cincinnati had welcomed a new setting for musical events and civic gatherings—Pike's Opera House, the finest concert hall west of Philadelphia. Samuel Pike (originally Hecht) had come to the United States in 1827, the five-year-old son of German-Jewish immigrants. Seventeen years later he decided to seek his fortune in the Cincinnati dry goods trade, but the flood of 1847 nearly ruined him. To revive his sinking fortunes he turned to the manufacture of whiskey. "Magnolia"—his brand of spirits—and successful investment in real estate made him one of the city's wealthiest citizens. Pike was of slight build, with a dark complexion, acquiline nose, and heavy black mustache. One newspaper described him as "a man of elegant leisure" who could be seen almost daily ambling along Fourth Street, hands in pockets, observing the city through his "large dreamy eyes." A large diamond stickpin provided his only ornamentation.[11]

Samuel Pike included poetry and music among his interests, and the appearance of Jenny Lind supposedly set him on the path to constructing a concert hall worthy of her voice. The opening of his Opera House in 1859 recalled the festive enthusiasm that had greeted the Burnet House nine years earlier. "The cream of western society" attended the inaugural ball for this "temple to the Muse of Song," which concluded at 2:00 A.M. Pike spent close to a half million dollars on the facility, and the result included three tiers of balconies, an impressive octagonal dome above the center of the auditorium, and tapestried carpets. Three thousand seats, with standing room for an additional one thousand people, made it one of the largest halls in the nation. No wonder local newspapers boasted that the structure would "invest the Queen City of the West with a metropolitan importance." Prior to the opening of Pike's, the city had contented itself with only two theaters, the recently remodeled National, constructed in 1837, and the smaller and more modern Woods Theater, located at Sixth and Vine streets. For recitals or small gatherings Smith and Nixon's Hall or Mozart Hall in the German Institute sufficed, but until Pike built his Opera House, Cincinnati lacked a satisfactory facility for elaborate performances.[12]

Impressario Maurice Strakosch opened the building with an opera festival—a five-week season headed by Flowtow's *Martha*. He followed this

with four works by Donizetti, three by Verdi, including *La Traviata* and *Il Trovatore*, Rossini's *Barber of Seville,* three by Bellini, Meyerbeer's *Robert le Diable,* and Mozart's *Don Giovanni.* Opera lovers reveled in such luxury. Heavily Italian, as contemporary taste required, the festival succeeded both artistically and financially, and Strakosch used the occasion to introduce the city to the matinee performance, where ladies could appear unaccompanied and in "plain promenade costume" rather than "full dress." No doubt many husbands appreciated that! Strakosch's success encouraged additional extravaganzas. Adelina Patti made a triumphant appearance the same year, bringing down the house with her much celebrated "Echo Song," a vocal trick in which she threw her voice off stage to sound like an echo. During the war years, the Opera House continued to host musical entertainment, including annual seasons of opera. The Jacob Grau Opera Company appeared regularly, and in 1864 treated patrons to a dazzling performance of Gounod's *Faust*—"the event of the musical world," pronounced one newspaper. German opera remained largely in the hands of local groups, however. The Maennerchor presented light opera. Lortzing's *Czar and Zimmerman* or von Weber's *Der Freischutz* were always popular in Over-the-Rhine, and on occasion the Cecelia Society and the Philharmonic Orchestra combined to present an oratorio. The ambitious Pike also organized his own theater orchestra, directed by Henry Hahn, attached a ballet corps, headed by the Zavistowski sisters, and established a repertory drama company. The Opera House was also the scene of numerous community events, ranging from a testimonial for actor James E. Murdoch to the public outpouring of grief for the martyred Lincoln.[13]

In 1866, seven years after its opening, Pike's Opera House burned to the ground. Only hours before, a large crowd had attended a performance of *A Midsummer-Night's Dream,* applauding as proud Titania bowed in leave to Bottom. By morning Samuel Pike, black cigar in mouth, silently surveyed the smouldering ruins. Newspapers estimated his loss at close to one million dollars. The tragedy fell heavily on the cultural life of the city, for the building had not only hosted dozens of major performances, but it had provided the physical evidence of cultural maturity as well. To sensitive Cincinnatians the Opera House counteracted the reputation of "Porkopolis." Although Pike rebuilt in 1871, albeit in a more modest style, it was not the same. Eighteen months after the new facility opened, Pike died, and the completion of Music Hall in 1878 immediately eclipsed the second Opera House. Finally, in 1903, it too succumbed to fire.[14]

Samuel Pike made no money on his temple to Orpheus, but he had the satisfaction of providing his city with the bulk of its musical and theatrical entertainment during the war years. Indeed, without Pike's Opera House, it is difficult to imagine what Cincinnati's cultural life would have been like.

Those years, however, did not broaden materially the growth of music in the community. Army enlistments, wartime disruptions, and the steady stream of wounded soldiers set a somber tone for the city. Even before the firing broke out, a note of discouragement had set in. The struggles of the Philharmonic Orchestra to survive have already been mentioned, and even the Cecelia Society appeared less vigorous on the eve of the war. The Maennerchor, founded in 1857, drew increasingly smaller audiences. As one music supporter laconically observed in 1862, "Musical matters are rather dull in our city, this winter."[15]

Under the cloud of Mars the musical community continued to divide and reassemble, mirroring the collapse of the Union. In 1864, dissension over operatic performances led to a schism in the Maennerchor, and Carl Barus left to establish the Orpheus Society. About the same time, another group of musically inclined individuals announced the formation of the Harmonic Society. Largely made up of Anglo- rather than German-Americans, the Harmonic Society numbered a robust 116 members at its inception. L. C. Hopkins served as the society's first president, while the versatile Barus directed the group in singing. Its attraction to non-Germans weakened the binational Cecelia Society, which gradually developed a more Teutonic air. Whatever its effects on the Cecelians, the Harmonic Society provided one of the few bright notes during the often dreary months of the war, and its concerts became important social as well as cultural events.[16]

While the Civil War undermined many musical organizations, it did encourage a variety of individual performances, mostly in support of the war effort. The venerable Joseph Tosso emerged from semiretirement, and his benefit concerts drew appreciative audiences. The various singing societies often joined together to raise funds for various causes, and it was the survival of this choral tradition that prepared the way for the highly successful postwar musical festivals. Thus, the war years did not so much retard musical growth in the city as they forced it to mark time. The general size and quality of the various societies and bands deteriorated as men went off to battle, but the love of music remained, waiting a new set of circumstances that would carry the city into its musical "golden age."[17]

Cincinnati theatrical life continued its own uneven development during the 1850s and 1860s. Although the young Rutherford B. Hayes had found Charlotte Cushman's National Theatre performance in "Meg Merrilies" delightful, more sophisticated theatergoers found much to criticize in the city. William Hancock, an English visitor in the Trollope mold, discovered but one theater and only a single concert hall, in which "no concerts were ever held." Another Englishman, Charles Weld, attended a play at the National and described the acting as "vile," although the rest of the audience apparently loved it, "yelling furiously." Most disturbing to Weld were the

occupants of the pit "who sat in their shirtsleeves chewing and spitting with proper republican liberty."[18] Nothing so disturbed proper Englishmen as chewing tobacco, marauding pigs, and boorish audiences.

During the 1850s John Bates's National Theatre hosted the bulk of the city's dramatic fare; its only real rival being George Wood's "cozy little theatre" at the corner of Sixth and Vine Streets, a 1,240 seat structure not completed until 1856. Thus, throughout the prewar years, the most prominent American actors and actresses frequented the National, although obviously not when Hancock or Weld were in town. Edwin Forrest, Joe Jefferson, Edwin Booth, Matilda Herron, and James E. Murdoch trod its boards. For years people fondly recalled Forrest's "most powerful and truthful personation" of King Lear and the "crowded and fashionable houses" which attended William Macready's exciting performances. After 1859 both the National and Wood's declined in the face of the incomparable Pike's Opera House. In 1862 the *Cincinnati Daily Times* announced that Old Drury (the National Theatre) had at last "succumbed to the taste for the vulgar sensational," and by 1864, no longer owned by Bates, it had become a "Hippo theatron" for animal shows. Although John Bates regained control after the Civil War and restored some of the theater's lost luster, assisted by the fire that destroyed Pike's, the National soon continued its downward spiral. By 1880 it had become a warehouse, and sometime after the turn of the century it was finally torn down.[19]

Wood's Theatre shared a similar fate. Eclipsed by Pike's Opera House until 1866, it revived the following year under the enthusiastic care of Bernard Macauley, a former stock company actor at Pike's. Macauley brought solid dramatic fare to the small theater for ten years, but eventually the building was razed to make room for more profitable ventures. Of course, Pike's Opera House dominated local theater while it existed. Pike pushed the star system and enjoyed bringing in top flight actors to work with his stock company, but even the popular Pike could not entirely dispel the lingering suspicion that theater was immoral. When Moncure Conway, the young, liberal Unitarian minister, moved to Cincinnati in 1856, his passion for theater disturbed several of the more conservative residents. "A dancing and theatre-going preacher" was new to the city, and Conway delighted in publicly defending the actor's world. Over the signature of "Optimist," he instructed concerned citizens on the merits of good theater, even rising to the defense of the more controversial ballet.[20] Despite Conway's eloquence and Pike's ambitions, good theater continued to struggle against the problems of money and organization, as well as the deeply imbedded Calvinism.

In Over-the-Rhine, German-Americans established their own theatrical life. Early in the 1850s Frederick Hassaurek and Karl Obermann, both refugees from the recent political upheavals in their native land, founded the

Pike's Opera House; courtesy of the Cincinnati Historical Society.

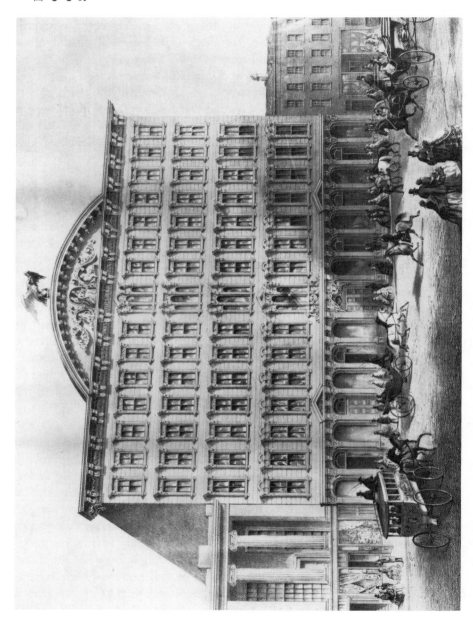

Deutsche Institut, which offered primarily amateur fare. According to newspaper accounts, audiences behaved more politely there, a fact which Mr. Weld might have appreciated. The Deutsche Institut died out in 1861, an apparent war casualty. The war also discouraged professional troupes from appearing in the Queen City, although it does seem to have stimulated increased amateur fare, the Deutsche Institut notwithstanding. Amateur theater delighted thousands, usually to raise money for the war effort, and the city's most famous actor, James E. Murdoch, devoted his efforts entirely to aiding the sick or assisting other charitable activities. Among Murdoch's singular appearances was the October evening in 1864 when he gave the first public reading of Thomas Buchanan Read's stirring poem, "Sheridan's Ride," based on the dramatic exploits of General Philip Sheridan at the Battle of Winchester. A large Pike's Opera House crowd cheered enthusiastically.[21] Despite these activities, the war years in general inhibited the expansion of an art form so closely linked to pleasure.

Even before the outbreak of war, support for painters and sculptors declined. As numerous residents had begun to note, one of Cincinnati's problems was in keeping its artists. Despite the city's regional reputation and the exhortations of its many publicists, the most talented painters and sculptors frequently left the city to pursue their careers either in the East or in Europe. Powers, Beard, and Whittredge attest to this condition. Yet, throughout the century a nucleus of professionals called Cincinnati their home, and a seemingly endless supply of young talent continued to use the city as a stepping-stone to national recognition. One of these artists, the miniature-painter William Miller, described the city's art life during the 1850s in a series of letters to his friend, Isaac Strohm. Miller noted Oriel Eaton's rising reputation as a portrait painter, and attested to Duncanson's "extraordinary promise." In 1854 the eccentric John Frankenstein returned "a totally changed man of sober habits," while James Beard completed his "very respectable" portrait of the L'Hommedieu children.[22]

During these prewar years, Godfrey Frankenstein earned considerable comment for his popular panorama of Niagara Falls, always one of his favorite subjects. Duncanson completed his portrait of Nicholas Longworth in 1858 and painted his most famous canvas, *Land of the Lotus Eaters,* three years later. In 1857 the youthful Alexander Wyant arrived in Cincinnati, carrying on the city's tradition as a training center for artists who later achieved distinction. The Ladies' Academy of Fine Arts, Wiswell's picture gallery, and the newly established school of design of the Mechanics Institute continued to reflect the community's support of the arts.[23]

But disturbing trends could not be ignored. The best artists continued to leave. Sonntag had gone by 1855; Duncanson appeared less frequently after 1861; and in 1859 Charles Cist mentioned only John R. Tait, Eaton, and

the two Frankensteins as keeping studios in the city. William Miller noted another disturbing complication. By the end of the decade photography was ruining many of the city's artists. *The Sketch Club,* a short-lived publication, lamented the effects of photography as well, and, indeed, the camera posed a serious threat to portrait painters. The 1856 city directory had listed only eleven "daguerrean Artists"; eight years later thirty "Photograph Galleries" received mention. Not only was photography popular, but Cincinnati had become an important center for the new "art," and two residents, Ezekiel Hawkins and John Locke, were in the forefront of photographic experimentation in the country. John Frankenstein bitterly concluded that photography would be "highly detrimental to the portrait painter," and he scorned those artists who squandered their talent in coloring photographs. Yet, many found coloring photographs more lucrative than painting, sensing that the great age of portrait painting had come to an end.[24]

Seemingly undisturbed by the shrinking community of artists, or by the raging political winds, a combination of "old timers" and newly arrived talent established a Sketch Club in 1860, patterned after a similar association in New York City. The English-born Henry Worrall—artist, music lover, and "a man of fine wit"—contributed the initial momentum. James Beard, Thomas Buchanan Read, and Godfrey Frankenstein represented the older set of artists, while the newer generation supplied Alexander Wyant, Henry Mosler, Charles T. Webber, and Thomas C. Lindsay. Samuel Pike and the poet William Fosdick were members. Later, the precocious Henry Farny joined, and Oriel Eaton very likely belonged. The monthly meetings consisted of "quaint sketches and . . . literary fancies," which Moncure Conway later recalled with great pleasure. This "brave little band of pioneer artists," as one local newspaper described them, set out to prove the merits of western artists and to encourage regional talent. "We have entered into a conspiracy against ignorance and prejudice, and the mammon-worship for which her ladyship, the Queen of the West, has somehow comeby [*sic*]," announced the first issue of *The Sketch Club,* the society's journal. Art will elevate the citizenry, will "raise your ambition to become the center of something else than the pork trade."[25]

The artists hid their seriousness under a good deal of spoofery. They described themselves as sculptors "who of necessity touch-up an occasional gravestone and chisel out an epitaph under a willow"; as engravers "who achieve wonderful feats of horsemanship on a seven feet circus bill"; or as portrait painters "who by no means disdain an occasional photograph." Their journal lapsed after four issues, and the club itself degenerated into an "association of debauchees." But in October 1862 the *Cincinnati Daily Gazette* reported that the organization had revised its rules and "bids fair to become a really useful institution." The new regulations permitted women

to attend meetings and banned liquor, as members now sought "entertain-
ment in intellectual enjoyments alone"[26] An institution it never be-
came, and except for its participation in the Great Western Sanitary Fair the
following year, the Sketch Club quickly faded from public notice, a victim of
the war and declining support. Or perhaps it merely expired from lack of
spirits.

The Great Western Sanitary Fair, to which Sketch Club members con-
tributed a series of drawings on the theme of "War," opened in December
1863. The fair was established to raise funds for the United States Sanitary
Commission, which had located a major branch in Cincinnati. This quasi-
governmental agency provided medical support for the Union armies. In
October 1863, following a successful fund-raising affair in Chicago, a
number of prominent Cincinnatians launched a drive to establish a fair in
their city. Committees blossomed on all fronts, including one to organize an
art exhibition. Thus, the Sanitary Commission became the underwriter of
the city's lone major art exhibition during the war years. The art committee
included gallery owner William Wiswell, artists James Beard and Almon
Baldwin, architects Samuel Hannaford and James McLaughlin, and the
prominent merchant Henry Probasco, but the man who made it all work
was painter William Brannan. The exhibit, described as "the genius of our
western artists," brought together works by most of the Cincinnati-
associated painters and sculptors. Brannan arranged for canvases by land-
scapists Sonntag, Duncanson, and Whittredge to share wall space with
works by Beard, Eaton, Mosler, Lindsay, and Read. Only a few scattered
paintings by G. P. A. Healy, Emmanuel Leutze, and the popular German
artist, Andreas Achenbach, lent a cosmopolitan touch.

The fair also provided art lovers with a variety of lectures, musical
entertainments, and other cultural events. Actor James Murdoch presented
an evening of dramatic readings at Pike's Opera House, while Alfred Bur-
nett gave readings and dramatic scenes at Mozart Hall. The Union Musical
Association, directed by none other than Carl Barus, performed before a
large audience. Samuel Pike staged a production of *A Midsummer-Night's
Dream,* sharing the bill with a lively farce entitled "The Two Buzzards," and
seats for both cost fifty cents. It is not clear which proved more entertaining.
Another concert featured a public school chorus and a violin solo by Joseph
Tosso. One notable evening the city was introduced to "little Miss Rive,"
soon to be the nationally known pianist, Julie Rivé King.[27]

Art life did not entirely disappear from the city during those years. The
painters and sculptors not directly affected by the strife continued to work in
their studios, often spending their summers on sketching trips. Charles
Webber completed his *Ophelia* in 1862 to considerable local acclaim. Dun-
canson, Read, and Lindsay popped in and out of the city, sharing their time

between the Ohio Valley and the East. James C. Beard, a son of James H., opened an art school, and Thomas D. Jones worked diligently on a bust of the recently deceased poet William W. Fosdick. The *Cincinnati Daily Gazette* reported that leading artists planned a "life-school" (apparently never realized), and that E. C. Middleton, "the portrait publisher," planned a new art gallery on Fourth Street. For the painter, the etcher, the sculptor who remained in the city, life continued much as before, although the war undoubtedly circumscribed their activities. Favorite natural haunts in Kentucky and western Virginia were traversed by rampaging armies, while some artists feared that sketching trips might lead to their arrest as draft evaders. Although Henry Mosler joined *Harper's Weekly* as a war illustrator, interestingly enough none of the more prominent artists apparently heeded President Lincoln's calls for volunteers. For most of them, the war remained distant. If the artists' personal life remained undisturbed, however, patronage all but disappeared, and only something of the magnitude of the Western Sanitary Fair could produce a major exhibition. As it had for music, the Civil War narrowed the artistic stream, and important art developments had to await the burst of energy of the following decade.[28]

Literary and intellectual matters suffered a corresponding decline during the war and the years immediately preceding it. In 1859 Ormsby Mitchel left the city to take a similar astronomy position in Albany, New York, followed a year later by his assistant. The Astronomical Society slid into dormancy. And whatever hopes Cincinnati might have had about bringing Mitchel back ended with his death in 1862. Ainsworth Spofford departed in 1861. Only a handful of nine or ten regulars kept the Historical and Philosophical Society alive, and by 1865 its active membership had slipped to four. The Western Academy of Natural Science suffered a similar contraction, while the public library struggled through a precarious infancy. Once again, Cincinnati's aspirations exceeded its ability to sustain organizational activity. Nor was its ability to sustain individual literary effort any better. The departure of Harriet Beecher Stowe and the Cary sisters in 1850 had robbed the community of its three finest writers, although Alice Cary returned for several years as an assistant editor of *Parlor Magazine*. Of course, there were always the minor poets. William H. Lytle, lawyer and later general, received extensive praise for his romantic "Antony and Cleopatra," which later generations of school children frequently committed to memory. Today, even its most memorable line, "I am dying, Egypt, dying," has long been forgotten, although as late as 1891, William H. Venable still subscribed to the poem's immortality. Other poetic contributions came from the pens of Thomas Buchanan Read, William Gallagher, and, until his death in 1852, William Fosdick, the city's resident poetic "genius."[29]

In the mid-1850s William Coggeshall returned to the Queen City to

take control of *The Genius of the West,* the latest in a long series of literary publications to unabashedly promote western literature. The Carys, Fosdick, Gallagher, and Robert Buchanan head the list of now undistinguished regional authors whose works filled the columns of *The Genius.* Cincinnati at mid-century seemed no more supportive of literary ventures than it had a generation earlier, and Coggeshall's efforts met the same fate as his predecessors'. "Sometimes I'm almost discouraged with *The Genius* in the little interest it awakens among subscribers," he confessed to a friend, "but I'm determined to hold on this year—then we shall see what we shall see." Shortly thereafter, the editor was appointed state librarian in Columbus and *The Genius* ceased publication.[30]

The brightest star in Cincinnati's intellectual firmament, at least during the half-decade leading up to the Civil War, was the Reverend Moncure Conway. A disciple of Emerson and the son of a Virginia slaveowner, Conway had come to the Queen City in 1856 at the invitation of the First Congregational Church. Although reared a Methodist, he had adopted the liberal views of Unitarianism and abolitionism, and his unorthodoxy had earned him dismissals from churches in Falmouth, Virginia and Washington, D.C. Conway's five-year stint in Cincinnati provides an interesting window into the cultural and intellectual life of the city. His first reaction was quite favorable, finding the community both liberal and "gay." His congregation included such distinguished residents as William Greene, Judge George Hoadley, and Alphonso Taft, all of whom became his friends, and before long the literary-minded Conway found himself on the rolls of the Literary Club. Although theater proved his greatest passion, as we have already observed, his autobiography reveals a wide range of interest in all the arts. He noted the fine concerts, the elegant buildings, the book collection of the Mercantile Library; yet, ultimately his years in Cincinnati are best remembered for his attempt to revive *The Dial.*[31]

The original publication of that name, edited by Ralph Waldo Emerson and Margaret Fuller, had trumpeted transcendentalist views in the early 1840s. Always under the spell of "The Sage of Concord," Conway hoped to breathe new life into the fading voice of transcendentalism. "*The Dial* stands before you, reader," he wrote in the first number, "a legitimation of the spirit of the age, which aspires to be free; free in thought, doubt, utterance, love and knowledge." To strengthen the journal's literary content, he procured essays from Emerson, Octavius B. Frothingham, and Oliver Wendell Holmes, Sr., and poems from William Dean Howells. He also contributed many articles from his own pen and reviewed over seventy books, including *Origin of Species, Mill on the Floss, The Marble Fawn,* and *Leaves of Grass,* which "set the pulses of America to music"—all in all, a solid literary output for one year. *The Dial* survived the twelve months of 1860, but the

storm of secession and Unionism that erupted after Lincoln's election swept it away. A year later Conway himself left for the East.[32]

The termination of *The Dial* illustrates the sharpness with which the political issues of the day cut through the border city's cultural and intellectual life. Questions of art and literature paled against the angry torrent of words and emotions which rolled through the critical months of 1860–61. The amiable lectures of Bronson Alcott and the lofty ideals of Emerson disappeared. Instead, packed houses listened attentively to Stephen A. Douglas or the secessionist William Yancey. President-elect Abraham Lincoln passed through the city in February 1861 to great cheers and curious looks. Even the much-heralded visit by the Prince of Wales provided only a temporary respite from the tensions of the day. The news of Fort Sumter's surrender broke the tension. It completely disrupted a public rehearsal of the Philharmonic Orchestra, and a small meeting at Judge Hoadley's, gathered to study German, "silently rose and parted never to meet again for our studies." The Literary Club also broke apart. Its members formed the Burnet Rifles, drilling under the watchful eye of future general John Pope. Fifty-one members eventually saw military service, and for most of the war the club suspended meetings.[33]

Moncure Conway's departure in 1861 points out one of Cincinnati's most serious, yet overlooked problems. Artists were not alone in leaving the city for more promising futures elsewhere. The years beginning with 1850 witnessed a remarkable attrition among the community's most cultivated classes. Various Stowes and Carys had departed by 1850. William Gallagher left the same year, followed during the decade by Coggeshall, Mitchel, Spofford, and Conway. Salmon P. Chase turned to national politics. Frederic Ritter chose New York for his pursuit of music. Death added to this toll. Daniel Drake, Nathan Guilford, and poets William Fosdick and Otway Curray all died between 1852 and 1855. Nicholas Longworth joined them in 1863. The war itself scattered many others important to the city's cultural life. William H. Lytle and Rutherford B. Hayes, along with scores of others, found themselves in distant valleys of Virginia or Tennessee. Nor could the city rely any longer on a steady stream of young men and women from the surrounding region to invigorate its cultural life. Chicago, St. Louis, and even Indianapolis drained off increasingly larger numbers of talented westerners; furthermore, the railroads now allowed many aspiring artists and writers to go directly to New York, bypassing western cities entirely.

Yet, the previous decades had built a solid foundation of institutions, concerned citizens, and, above all, community pride. Cincinnatians had come to expect a certain quality of life that required recognition of the arts, and this civic pride carried the Queen City through the clouds of war. If the war

drained the city of its best people, many would return in 1865; if the previous generation of important art patrons had died, a new generation awaited maturity; if the city's regional influence dimmed, the enlarged population, especially the swelling numbers of Germans, stood ready to supply new musicians and painters. With the news from Appomattox, interest in cultural and educational institutions surfaced again, and once more the city looked to the arts as an expression of itself.

Interlude
D. H. Baldwin and the Manufacture of Musical Instruments

With a darkening pall of war settling over Cincinnati, 1862 appeared to be a poor time to enter the musical instrument business. Dwight Hamilton (D. H.) Baldwin, an already middle-aged music teacher, optimistically hoped otherwise when he opened his new store at the corner of Fifth and Elm Streets. A kitchen chair and an organ case converted into a desk served as his office; his "one piano and two melodeons" shared space with the rolls of stock of a wallpaper dealer. From these modest beginnings rose one of the great names in American manufacturing—the Baldwin Piano Company.[1]

Born in 1821 in Erie County, Pennsylvania, D. H. Baldwin grew up in a devout Presbyterian family whose religious feelings pushed him towards the ministry. But after one year in the Preparatory Department of Oberlin College, declining health ended his ministerial career. Music replaced the ministry as the focus of his life. For the next fifteen years he taught music in the counties south and west of Maysville, Kentucky, moving eventually to Ripley, Ohio to escape the cloud of slavery. In 1856, Baldwin left for Cincinnati to become one of four music teachers in the public schools. His integrity and musical judgment quickly made him a useful advisor to people interested in purchasing a new piano or organ. Determined to turn his knowledge into profits, he took his accumulated savings of $2,000 and entered the world of trade.

Baldwin felt that Cincinnati's prosperity and solid musical reputation provided ample compensation for the risks of war. Besides, the war would not last forever. As the chief financial and cultural center in the Ohio Valley, the city already supported the manufacture and sale of various musical instruments, especially pianos and organs, which were increasingly popular in

middle-class homes. As early as 1808 Adam Hurdus had built an organ for the New Jerusalem Society, and eleven years later he established the city's first organ manufacturing concern. For a decade he remained the principal builder of organs, his only rival being the many-talented Luman Watson, better known as a clock maker and employer of Hiram Powers, whose Christ Church organ was acknowledged as "the best piece of workmanship ever produced in the Western Country"[2]

In the 1830s and 1840s the swelling population of German Catholics and Lutherans, more open to church music than their Calvinistic brethren, provided a growing market for the musical instrument trade. Matthias Schwab, born in Freiburg, Germany in 1808, arrived in the early 1830s to become the first important organ builder in the West. Noted for the high tin content of their pipes, Schwab organs produced a well-blended "sweet sound," and churches from Wheeling to St. Louis engaged his services. His largest instrument, built at a cost of $5,000, for many years served the congregation of St. Peter in Chains cathedral in Cincinnati. Several years before his death, Schwab sold his prosperous business to Johann Koehnken and Gallus Grimm, two more recent German immigrants who had worked for him. For the next forty years Koehnken and Company continued to provide area churches with the same high quality organs.[3]

While few pianos were manufactured in the West before the Civil War, the city did not lack for dealers. William Nixon, who taught the Logierian method, sold pianofortes, and several other musicians and teachers supplemented their incomes by repairing, tuning, or even making instruments. By the time of the Civil War, Fourth Street had emerged as the center of a thriving music business, joined by Baldwin when he relocated in 1863. By 1871 Cincinnati boasted of six other dealers in musical instruments, the largest being the John Church Company, which had established an extensive reputation as a publisher of sheet music and music books. A protégé of Boston's Oliver Ditson, John Church had been in Cincinnati since 1859, where his eastern connections and vast knowledge of music smoothed his path. Success came quickly. He served on the board of the May Festival Association and participated in most of the community's musical enterprises. In 1871 he launched *Church's Musical Visitor,* one of the nation's most important music journals, and it provided the West with a serious journal comparable to the leading Boston publications. It also provided Cincinnati with an important voice in support of its own activities.[4]

Three years before Church's arrival, another important musical name showed up in Cincinnati—Rudolph Wurlitzer. Born in Schoeneck, Germany, the young Rudolph had early on learned the business of music. His father sold instruments, which were often used as legal tender in the handicraft-oriented society of Saxony. Against his father's wishes, Rudolph

left for the United States to make his fortune. His first job in Cincinnati was as a porter in a dry goods establishment at four dollars per week. The ambition that led him across the ocean soon saw him in the banking firm of Heidelbach and Seasongood, where his income doubled. Within a few months, however, his sharp eye discerned an opportunity in music instruments. The high cost of quality instruments resulted from the profits taken by the middleman. If a retailer could deal directly with the craftsman, then he would be able to undersell the competition, and where could one find better instruments than in Saxony? He sent his savings of $700 to Schoeneck, importing a variety of oboes, flutes, clarinets, and flageolets which he was then able to price for average incomes. For three years he sold his German-made instruments while working as a cashier at the bank, but when armies gathered in 1861, he anticipated the new demand for band instruments and devoted all his time to the manufacture of instruments. Twenty years later, he added pianos to his line, followed eventually by "the mighty Wurlitzer" organs that made him famous.[5]

This, then, was the world into which D. H. Baldwin hoped to make his way in 1862. Success came slowly. Moving his location to Fourth Street in 1863, he survived the loss of his stock in the great Pike's Opera House fire (fortunately he was insured), and gradually expanded his line of pianos, melodeons, and "the celebrated boudoir organs." About the time of the fire at Pike's, he hired a young bookkeeper named Lucien Wulsin. Born to a Louisiana French family, Wulsin had lived in the Cincinnati area since the age of seven. Mustered out of the Union army in 1865, weakened by smallpox and limited in education, the twenty-year-old veteran returned to the city unsure of his future. Sensing an opportunity in business, he took courses at a local commercial college, and a year later he approached the genial Baldwin for a position. Seven years later his acumen and energy made him a junior partner and the driving force in the company. It was Wulsin who promoted a system of consigning merchandise to dealers in surrounding towns, a system popularized earlier by the sewing machine industry.

Gradually Baldwin and Wulsin extended their market until they became the largest dealers of organs and pianos in the South and West. They opened retail stores in Louisville and Indianapolis, but their growth did not go unchallenged. In the mid-1880s the eastern manufacturers of the pianos sold by Baldwin began curtailing the company's retail territory, and in 1887 Steinway cancelled its contract with Baldwin altogether. Forced to face a narrowing future, the Baldwin partners (D. H. Baldwin and Lucien Wulsin had been joined by George Armstrong, Albert Van Buren, and Clarence Wulsin) decided to manufacture their own instruments. In 1889 the Hamilton organ, produced in Chicago, appeared, followed a year later by the Cincinnati-built Baldwin piano.

Dwight Hamilton Baldwin, top, and Joseph Tosso, bottom. Courtesy of the Cincinnati Historical Society.

At left, Samuel N. Pike; below, Otto Singer. Courtesy of the Cincinnati Historical Society.

The shift from sales to manufacturing disclosed the talents of John Warren Macy, since 1883 one of the company's outstanding piano tuners. A self-taught cabinet maker, musician, and acoustical expert, Macy had learned the peculiarities of pianos through persistence and curiosity. In 1890 Wulsin entrusted Macy with the responsibility of designing and building the first Baldwin upright piano. It was a fine instrument. The company established production facilities on Gilbert Avenue where they had purchased a three-story planing mill. The next year Macy designed a grand piano, and until his retirement in 1920 he remained in charge of all piano production. Baldwin pianos earned immediate acceptance, and they were soon joined by a more moderately priced instrument, the Ellington piano, giving the company a complete line of pianos and organs. But scarcely had the firm begun manufacturing when the nation was struck by a severe depression, throwing enormous strain on the partners. Lucien Wulsin suffered a breakdown in 1894; his brother Clarence died suddenly in 1897; and in the last summer of the century D. H. Baldwin died at his home on the grounds of Lane Seminary.

Personal tragedy and economic obstacles did not retard the Baldwin Company's rising reputation. Reorganizing after the death of the founder, the surviving partners set their sights on the Paris International Exposition of the Arts and Manufactures, to be held in 1900—the last of the great international competitions where nations vied in scores of categories for the coveted Grand Prixs. Luck smiled on the Cincinnati company. The draw for the only sizeable space allotted American musical instrument makers went to Baldwin. Furthermore, the policy of not granting Grand Prix medals to first-time exhibitors was relaxed; and finally, Henry Krehbiel, a former Cincinnatian, a friend of Lucien Wulsin, and now music critic for the *New York Tribune,* was appointed as the American representative on the music jury. Lucien Wulsin moved his family to Paris months before the exhibition's opening in order to supervise personally the installation of the Baldwin display, which included a scale model of the factory facilities along with the complete line of musical instruments. Baldwin carried off the Grand Prix, the first ever earned by an American-manufactured concert piano, nosing out its eastern rivals, Steinway, Chickering, and Decker. Thus, as the century ended, the Baldwin Company had provided Cincinnati with international renown commensurate with its reputation as an American music center.

Of Musical Matters, 1867–1878

The Civil War initiated a period of relative decline for Cincinnati. In 1860 the city had rested comfortably as the great emporium of the West, and, as the nation's sixth largest urban center, gave promise of overtaking Boston and New Orleans. By 1870 Cincinnati's population had fallen behind Chicago and St. Louis, and by 1880 both Pittsburgh and San Francisco were challenging the Queen City. The causes for this shift in fortune may be traced to a variety of factors, some of which have already been mentioned. Certainly the war's effects on the once prosperous southern trade played a key role. River trade deteriorated badly, never to regain its prewar prominence, and increased competition for southern markets from Louisville—less "Yankee" than Cincinnati and the northern terminus of the Louisville and Nashville Railroad—accentuated this loss. Cincinnati's lack of a direct rail line to the South, a situation not rectified until 1880, reinforced the city's growing isolation. It is true that Cincinnati might have taken the lead in western railroad development in order to secure its commercial hinterland, but that is probably asking too much. Early railroads usually did not parallel navigable rivers, but broke new ground, and the city's principal trade flowed to the south, not to the west. The difficulty of bridging the Ohio River remained a barrier to land trade until 1867, and indeed it was not until the war that the railroad's real potential became apparent. By then the race had already been lost.

Too much has been made of the railroad factor. To a great extent, the city's decline resulted from factors outside its control. As the nation's population moved towards and across the Mississippi River, St. Louis and Chicago reaped the benefits of their locations, the same benefits that had fueled Cincinnati's remarkable growth in the first half of the century. Prairie wheat

and western livestock, the new importance of the Mississippi River and the Great Lakes, and recently discovered sources of iron ore in Michigan and Minnesota pushed the new manufacturing cities of the North past the redoubtable Queen on the Ohio. It is not that Cincinnati shrank, for its population grew by 50,000 between 1860 and 1870, an impressive gain of 30 percent; rather its two rivals grew explosively. St. Louis almost doubled its population during the decade, while Chicago ballooned from 112,000 to 298,000—rates of increase that left Cincinnati looking deflated.

For the most part Cincinnatians failed to note these various shifts until after the war.[1] Increased wartime manufacturing obscured the decline in commerce, and the emotional tie to the Ohio River blinded many to the threat of the railroads. Residents eyed the city's growth and eagerly awaited the return to peace and prosperity. In the months following Appomattox, they assessed the uneven economy as a normal leveling off from the artificial impetus of war. If bankers expressed "great caution" due to the fluctuation in the gold price, local developments did not reflect it. A House of Refuge, a new correctional facility, the Cincinnati Hospital, and the completion of the first bridge across the Ohio River pointed to a new wave of urban growth. In 1867 the city installed a modern fire telegraph system; the same year the Red Stockings baseball club debuted. The magnificient spires of the Plum Street Temple added to the impressive skyline, and by the end of the decade the state legislature had approved legislation enabling the city to issue bonds to finance the long sought railroad to the south. McMicken University prepared to open its doors, and the Northwest Woolen Manufacturers sponsored a highly successful textile exposition—the forerunner of the city's industrial expositions.[2]

However, the vibrant city of the 1840s had begun to take on a somewhat dowdy look. Despite the annexation of Mt. Adams, Walnut Hills, and Camp Washington, which stretched the city's boundaries to the east and north, Cincinnati remained cramped along the river. Third Street still served as the banking center, while Fourth Street was emerging as the major retail center. But buildings along the riverfront appeared shabby, and the disorder common to all American cities of this era could not be ignored. Local government, basic city services, and whispers about the general economy troubled many. To others, the most visible lament was the dirty air that hung over the valley. "A solid, handsome town," observed one visitor, but one covered by a "Stygian pall." Alphonso Taft also recalled the "soft coal smoke which left its sooty mark upon everything—inhabitants included." And the Scotsman, James Macauley, referred to the city as "one of the smokiest and 'Auld Reekie' like in America."[3]

In his promotional book, local resident George Stevens envisioned Cincinnati moving "forward to a magnificent future." "A city fair to the sight,

with a healthy public spirit, and high intelligence sound to the core," he happily quoted one enthusiastic citizen, "the Edinboro' of a new Scotland, the Boston of a new New England, the Paris of a New France." Writing in the *Atlantic Monthly,* James Parton found such effusions unworthy. To him, Cincinnati possessed great wealth, but little beauty—"little taste for art; few concerts were given, and there was no drama fit to entertain intellectual persons." The city appeared at a standstill, and he rather prophetically compared its energy unfavorably to Chicago. There is "no menagerie, no gallery of art, no public gardens, no Fifth Avenue to stroll in, no steamboat excursion, no Hoboken," lamented the New Yorker. Parton clearly expressed an eastern bias in his article, and even took the opportunity to scornfully describe Cincinnati's earliest settlers as plodding, dull, and saving, with "less knowledge and less public spirit" than New Englanders. But he held out a kernel of hope. Honesty in the person of Mayor Charles F. Wilstach now governed the city, and "hunkerism"—"that horrid blending of vanity and avarice"—was receding. If the wealthy in their suburban villas did not leave the city to "its smoke and ignorance," Parton predicted that Cincinnati might yet rise above its stodginess.[4]

At the time Parton scrutinized the city in 1867, it was just beginning to slough off the disruptions of war. Concerned citizens had turned their attention not only towards manufacturing, but to cultural life as well. Especially hard hit by the war had been the many musical organizations, and the months which followed the cessation of hostilities revealed the emptiness of the concert season. The acerbic correspondent for *Dwight's Journal of Music,* who had returned to the city after a four-year absence, found much to fault. Madame Caroline Rivé's voice sounded "no longer fresh" to him, and "her manner of singing not remarkable." Modern piano playing—in the style of Franz Liszt—offended him as well, and even the Harmonic Society revealed a disturbing rustiness. "We dissent altogether from the tempo which Mr. Barus took for the Andante of the *Fifth Symphony* and hope we need never hear the piece again from the same orchestra, played in a manner as crude as it was our misfortune to hear it that evening."[5]

By year's end this gloomy music lover had departed, or at least his signature code [*+] had disappeared from *Dwight's Journal,* and more positive reviews of Cincinnati's musical life began to appear, including a strong endorsement of Charles Kunkel—"the first pianist of the West." Soon Lewis C. Hopkins, president of the Harmonic Society, called on the city's music patrons to join the society as associate members, the resulting revenue to establish a base for the construction of a new music hall, a fine organ, and "a sound reputation for the city." A year later Hopkins Hall furnished a home for serious music. The new facility, "delightfully original and unique in de-

sign," presented a "warm, cozy, and most attractive appearance." Moorish in style, with columns, arches, and a blue ceiling of bright Arabesque figures, Hopkins Hall encouraged more frequent orchestral performances. The same year found *+ back at his post, although considerably less critical. He now praised recent concerts, and even discovered Madame Rivé to have "so much taste and poetic feeling, that to hear her is a pleasure." Perhaps it was the new hall's acoustics! In December 1867 the Boston Mendelssohn Quintette visited the city and received high praise from local music observers, none higher than that of *+. This apparently transplanted New Englander took the occasion to point out condescendingly that the club's visit was a mission to bring "true art and noble beauty" to the provinces. In the same column he ridiculed the *Cincinnati Commercial*'s music critic for suggesting that Cincinnati might produce its own quintette club.[6]

By the end of 1867 musical matters in the city had returned to their prewar pattern. Singing societies and individual musicians entertained the faithful, a new concert hall had been built, distinguished artists again visited, and another attempt at a permanent orchestra had been made. But something more was required to push the city forward. Civic advances in other areas had been made. The public library opened its new Vine Street building in 1870, and scientific-minded citizens established the Society of Natural History the same year. The Historical and Philosophical Society of Ohio moved to new quarters in the College Building the following year, and the gleaming bronze of the magnificent Tyler Davidson fountain graced the heart of the city. Business leaders discussed an industrial exposition that would display Cincinnati's new manufacturing prowess, while local Germans anticipated the return of the North American Saengerfest—as it turned out, the musical catalyst the city needed.

The 1870 Saengerfest awakened a new musical vitality, and its splendor—to say nothing of its financial contribution—appealed to all Cincinnatians. To house the anticipated thousands, the city constructed an elaborate two-story structure between Elm Street and the canal, on the western edge of the Over-the-Rhine district. Two hundred and fifty feet long and one hundred and ten feet wide, the Saengerhalle accommodated 3,000 singers and musicians, along with an audience of 10,000. With appropriate Teutonic spirit, the lower floor was reserved for beer and food.[7] The Germans eagerly decorated the area for the festival, hanging wreathes and garlands from every lamppost and doorway, while portraits of the great German composers left no doubt about the music to be sung. On opening day a steady stream of out-of-town guests arrived, and numerous business establishments closed for the day. Grand Marshall Carl A. G. Adae, the German consul in the city, led the procession of singers through the forty-foot triumphal arches on

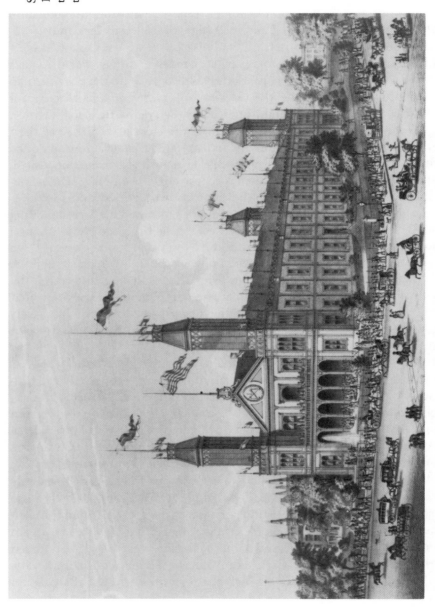

Saengerfest Hall, 1870; courtesy of the Cincinnati Historical Society.

Fourth Street and on Vine Street near the great hall. The *Cincinnati Commercial* estimated the festive crowd at 300,000, many of whom came to hear Governor Rutherford B. Hayes deliver the opening address.[8]

Noticeable in the throngs of people were many non-German citizens who had come to enjoy the fine music, a change from earlier Saengerfests and an indication of the growing cultural maturity of the community. The four-day gathering opened with Handel's popular "Hallelujah Chorus," worked its way through selections by Mozart, Beethoven, Abt, and other favorites, and concluded with a gala Sunday picnic along the river, where 3,000 kegs of beer assuaged parched throats. Despite the usual criticism against the "desecration" of the Sabbath, the unqualified success of the Saengerfest provided Cincinnati with its first national recognition as a musical city, and, as the perceptive John Sullivan Dwight pointed out, the easing of tensions between Germans and older Americans benefited both. The foundation for the May Festivals had been established.[9]

Late in 1869 another powerful musical force reached Cincinnati. As part of his first national tour, Theodore Thomas brought his highly disciplined forty-member orchestra to the Queen City that year. Thomas had emigrated from Germany in 1845 at the age of ten, already displaying signs of unusual musical ability. The eldest son of a *stadtpfeifer* (town musician), the young Thomas demonstrated his virtuosity on the violin by playing at weddings, dances, theaters, and even saloons during his formative years. In 1850 he set out on a personal concert tour of the South, billing himself as "Master T. T." When Louis Jullien put together his orchestra, the eighteen-year-old Thomas served as one of the principal violinists. From the flamboyant Jullien he learned discipline and something about concert management, although he never admired his leader's showmanship. The 1860s saw Thomas directing, with the ultimate goal of having his own orchestra. Uneven support from New Yorkers suggested that only through touring could an orchestra achieve financial solvency, which led to his visit to Cincinnati, one of twenty-one cities on his first national tour.[10]

Gilded Age America required extensive education in the beauty of symphonic music, and to that end Thomas devoted much of his life. Choral music, popular songs, and patriotic airs dominated musical entertainment up to that time, and serious instrumental music frequently irritated the "beer drinking, cigar smoking patrons." One angry Chicago critic referred to Beethoven as "some transcendentalist, spiritualistic Bedlamite," and proudly announced that "the audience bore it [the *Fifth Symphony*] like martyrs." As late as the 1880s Boston concertgoers expressed their own dissatisfaction with Brahms's *First* by walking out between movements. To overcome this narrowness Thomas borrowed from the repertoire of Jullien, mixing in popular waltzes, polkas, gallops, and quadrilles, and deftly placing more

serious music in the middle of the program.[11] Gradually the Thomas high-way, as his annual tours came to be called, took on a Messianic quality, as the extraordinary conductor strove to awaken the entire nation to the beauty of orchestral music. And for the most part he succeeded. Between 1865 and 1875 the Thomas Orchestra presented over two thousand concerts, a stag-gering two hundred per year, spreading the seeds of musical change. Initially he introduced only movements from symphonies and deliberately chose the more popular composers. Soon his audiences confronted the more modern and complex works of Brahms, Beethoven, and Wagner, often in their en-tirety, and the maestro forced them to listen. Discipline became a legend with Thomas. Talking, arriving late, and other rude manners he did not tolerate, and he thought nothing of stopping a performance to turn his angry blue eyes at the offender. For Theodore Thomas music was more than entertainment, it was spiritual enrichment.[12]

The Thomas Orchestra's first appearance in Cincinnati received "a rather cold reception." A small audience in Mozart Hall listened to the first of five concerts, which started promptly at 8:00 P.M. with the overture to *Tannhauser*. Perhaps being sandwiched between visits by the popular actor Edwin Forrest and songstress Carlotta Patti reduced the turnout, for none of the concerts drew a large crowd. Still, "musical excitement" gripped the faithful few, and the *Commercial* described Thomas as "the master baton of America."[13] Each year Thomas returned to the city, where his blunt honesty and unerring good taste paid rich dividends. At the conclusion of his 1872 visit, he responded to the suggestion of Maria Longworth Nichols, the young wife of George Ward Nichols and the granddaughter of Nicholas Longworth, that he direct a major musical festival in Cincinnati the follow-ing spring. Musical festivals were in the air of postwar America. The Boston Handel and Haydn Society had organized a successful four-day affair to cele-brate the conclusion of the war, and then had initiated the much acclaimed triennial festivals in 1868. Large choruses, superb orchestras, and programs of serious music became their trademark. At the same time, bandleader Pat-rick Gilmore organized the great Peace Jubilees, one in 1869 and the other in 1872, where he brought together mammoth choruses and orchestras num-bering in the hundreds. These spectacular events, complete with red-suspendered firemen playing the "Anvil Chorus," joined music to a carnival-like atmosphere.[14] Neither Thomas nor Nichols wanted this. Nor did they want to emulate the German Saengerfests. In the Boston tradition they aimed at loftier goals.

The twenty-two-year-old Maria Nichols used her Longworth connec-tions to induce leading citizens to support the venture. Dry goods merchant John Shillito, lawyer Bellamy Storer, Jr., and publisher John Church quickly lent their support to the proposed feast of song and music, while Carl Adae

served as the German representative on the newly created Musical Festival Association's executive committee. George H. Pendleton, former congressman and civil service advocate, spearheaded a $50,000 guarantee fund subscription to ensure against financial disaster. George Ward Nichols stepped forward to become president of the association, a position he held until 1880.

Nichols was a relative newcomer to Cincinnati. Born in Mt. Desert, Maine, he grew up in Boston, attended public schools there, and developed an interest in art and literature. In 1859 he journeyed to Paris to study art under Thomas Couture; two years later he worked as the art editor of the *New York Evening Post.* The Civil War brought an army commission. He served first on General John C. Frémont's staff and then crossed Georgia with General William T. Sherman. His experience with the latter inspired his popular *The Story of the Great March,* and the number of Ohioans on Sherman's staff may have influenced Nichols to settle in Cincinnati after the war. Confident, competent, and sometimes overbearing, the thirty-eight-year-old Nichols courted and married the nineteen-year-old Maria Longworth, placing him at the center of local society. Something of an artistic dilettante, he joined the Harmonic Society, supported the establishment of the McMicken School of Design, developed a keen interest in handicrafts, and generally impressed the city's social elite with his knowledge and energy. The May Festival gave him an opportunity to display his executive abilities.[15]

While Nichols looked to the financial arrangements, Thomas turned his attention to the music details. If the Gilmore festivals had set the standards by which future music festivals would be measured, and fascinated the American public with their scale and cost (to say nothing of noise and confusion), then Thomas had to map a different strategy. Instead of catering to popular taste, he aimed for artistic excellence—excellence so overwhelming that a deficit would be avoided and he would, thus, "redeem the discredit of the Boston Jubilee." He called on his own talented orchestra, supplemented by a few local musicians, to supply the instrumental music, while he would scour the entire West to secure the finest voices for the chorus. Carl Barus served as the rehearsal director for the Cincinnati members of the chorus, though in March Otto Singer, a friend of Thomas's, replaced him as permanent director. The soloists were carefully chosen. Thomas contracted the nation's best, all from the East, including Myron Whitney and Annie Louise Cary. As a small concession to local pride, he reluctantly included the socially prominent Mrs. Emma Dexter to sing several minor roles.[16]

As preparations advanced, public enthusiasm mounted. The *Cincinnati Times and Chronicle* prophesized that the festival would "eclipse anything ever before attempted on this continent" *Dwight's Journal of Music*

described the affair as "a grand Musical Festival . . . not in the noisy Gilmore 'Jubilee' sense, but a genuine artistic festival." Newspapers in Toledo, Chicago, and Louisville added their own enthusiastic support. Singing societies from Hamilton, Ohio to Des Moines, Iowa expressed interest in participating, and anticipation increased as the nation slowly grasped the extent of Cincinnati's ambition.[17] Not everything flowed easily. Inexperienced managers, a director six hundred miles away, and a chorus scattered across several states created continuous problems. Nichols and Thomas clashed over details ranging from the hiring of soloists to transportation. The board worried incessantly about expenses. And the local press revealed a growing concern over the two dollar ticket price, which seemed to prohibit those who could most benefit from the "refining influence of music."[18]

None of the problems appeared more threatening, however, than the lukewarm support from the city's German community. Irritated by the competition to their own musical affairs, the German press questioned whether a festival devoted to serious music could succeed. Conditioned by the Saengerfest appeal to all the senses, as well as to its ethnic richness and competitive spirit, the Germans clearly felt uncomfortable with new arrangements. They also sensed that they had been deliberately excluded from the management of the festival. Thomas had insisted on no beer, an equal blend of choral and symphonic music, and no pageantry, popular songs, or group competition; and only as a special concession to local German taste had the promoters included an open-air, beer-drinking concert for the final day, to be called a Fete Musicale. The arrangements clearly reflected a combination of Thomas's seriousness and the organizers' Anglo-Saxon values, and Over-the-Rhine residents remained suspicious, with several large singing societies withdrawing from the chorus.[19]

As the weeks narrowed to days, a cloak of discipline settled over the preparations. To reduce the anticipated deficit, the executive committee announced that no complimentary tickets would be issued, except to the press. Requests by others would only lead to "the embarassment of a refusal." In recognition of public opinion, however, general admission was reduced to one dollar, although reserved seats remained at two dollars. Thomas insisted that all concerts begin promptly. "When you play Offenbach or Yankee Doodle," he remonstrated, "you can keep your doors open. When I play Handel's 'Te Deum,' they must be shut," and to that end Bellamy Storer, Jr., announced that latecomers would not be admitted until the end of the first movement. Otto Singer brought his own will to bear on the chorus. Attendance requirements were announced, and over fifty singers found themselves dismissed for sporadic attendance at rehearsals. Soon, out-of-town choral groups began to arrive, to be quickly blended into the Cincinnati

nucleus. With just days remaining Thomas arrived with his orchestra. And then it was festival night.[20]

On May 6, Cincinnati presented a curiously somber appearance. No parades, no noise or show greeted the excited throngs as they walked to their hotels. Streets appeared normal, lampposts ungarlanded, and even the newly refurbished Saengerhalle displayed only a minimum of decoration. Newspaper headlines elaborated on the tragic end of Captain Charles Hall's polar expedition and the death of Chief Justice Salmon P. Chase; festival news could be found only on the back pages. Considering the enthusiasm that had attended the 1870 Saengerfest and the elaborate celebrations that surrounded later festivals, the city's placid face seems surprising. Yet, it was intentional. The executive committee clearly hoped to avoid any parallel with the merrymaking of the Gilmore Jubilees, or even to the recent Saengerfest, and the city's sobriety mirrored the seriousness of the occasion. "No flutter of agitation" must be allowed to detract from the music itself. Only in the excitement generated by five thousand ticket holders could one sense the importance of the event. Seat congestion delayed the opening by fifteen minutes, but at 7:45 Theodore Thomas, unruffled and dignified as always, strode briskly to the stage. With an almost imperceptible nod to the cheering audience, he raised his baton to signal the opening allegro movement of Handel's majestic *Dettingen Te Deum*. The 108-piece orchestra and the almost 800-member chorus swept all before them. An intermission allowed for a brief visit to the lower level refreshment booths, as well as an opportunity to admire the ladies' fashionable apparel, before Beethoven's *Fifth Symphony* recalled the concertgoers to the sublime. Not even the rains which poured through the open windows during Haydn's "The Heavens Are Telling" dampened the spirited evening. Press irritations, local quarrels, personality conflicts—all gave way before the splendor of the music. Everyone in attendance agreed that the opening concert promised success.[21]

Three more evening and two afternoon performances, the second presented by a public school chorus, provided a rich flow of musical delights for the expectant assembly, but the climax of the festival came with the third evening's stunning ninety-minute presentation of Beethoven's *Ninth Symphony*. A whirlwind of applause greeted its conclusion. Six thousand people stood cheering, handkerchiefs fluttering and hats sailing, while "a score of pretty girls from the chorus forced their way into the lady soloist's dressing-room and reaped kisses from the over-joyed *prima donna contralto*." "Glorious beyond description," rhapsodized the editor of *Church's Musical Visitor*. *Brainard's Musical World* could scarcely extol the performances enough, and daily newspapers from New York to Milwaukee sang the festival's praises. The *Chicago Tribune* labeled Cincinnati "the first musical city

of the West." Local enthusiasts wondered why just the West! George P. Upton, writing in the *Lakeside Monthly,* a Chicago journal, contributed the most penetrating analysis of the event. Calling the festival "a new departure in the history of music in the West," Upton noted that the festival had shown what discipline, leadership, community support, and outstanding music could accomplish. Musical charlatanism would no longer be tolerated in the Queen City.[22]

Cincinnatians delighted in the many accolades that came their way. Let the local German press grumble; so what if the *St. Louis Republican* viewed the festival as solace for the city losing its economic position. Cincinnati knew it had produced a winner. More importantly, her citizens understood the significance of the undertaking in the nation's musical development, as well as to the city itself. Cincinnati had carried off the most complex artistic event in the nation's history. The May Festival had won for the city national recognition as a musical center, and the promotional possibilities of that did not escape notice. To be sure, Thomas came from New York, as had most of the orchestra and the soloists, but the chorus—the divine chorus!—drew heavily from Cincinnati. And the intricate arrangements and enthusiastic crowds reflected the local stamp as well. Already a Cincinnati orchestra existed, influenced by the Thomas style. Otto Singer had announced his intention to remain in the city, and the financial success of the festival had set in motion plans to repeat the event.[23]

The first May Festival immediately injected self-confidence into the city. Coming on top of the recent highly successful industrial expositions and the Liberal Republican presidential convention of the previous year, the music festival bode well for the future. With a southern railroad in the offing and hopes for future conventions rising, urban preeminence in the West once again appeared attainable. Other American cities looked to Cincinnati as a model for their own musical development, and around the country a flock of imitative festivals appeared. The Cincinnati festival also initiated a short-lived but intense rivalry for cultural supremacy between the Queen City and Boston. The western press generally conceded that Cincinnati was destined to be the musical capital of the nation, if it had not already achieved that position. "Poor Boston!" jibed Helen Buchanan of the *Chicago Tribune,* "Who shall recover her laurels? Westward the star of musical empire has taken its way, and it will never go back." New York newspapers provided extensive and flattering coverage of the festival, and used Cincinnati's success to deflate Boston's hubris. Proper Bostonians, although troubled by the Gilmore Jubilees, scoffed nervously at such heresy. They acknowledged the festival's merits, but in less glowing terms, and the *Evening Journal* almost ignored it. John Sullivan Dwight expressed little opinion on the quality of the music, but did take offense at the festival program which had stated that

Handel's *Dettingen Te Deum* had never been performed in the United States before. Boston had heard it in 1862, grumbled Dwight.[24]

Of greater significance, the May Festival stimulated musical development throughout the West. Chicago, St. Louis, and Milwaukee may have accepted Cincinnati's ascendency in the arts, but they were not willing to grant it permanent leadership. Praise for the festival often emphasized its "western" characteristics, and each of the aforementioned cities used Cincinnati's success to spur its own musical development. Boston may have been a standard to be reached by all, but secretly each felt capable of surpassing the Queen City. Closer to Cincinnati the festival's influence diminished. Cleveland and Indianapolis recognized its importance, but smaller communities often ignored it. Newspapers in Akron, Dayton, Toledo, and Columbus, as well as those in Lexington, Kentucky, limited their coverage to general announcements, ticket prices, and train schedules, and rural papers often ignored it entirely. Some of this indifference was peevishness, the result of the executive committee's limited policy on free press tickets, but the festival also represented a concept of culture and entertainment remote to rural communities. Thus, the festival influenced the nation's urban network, reinforcing an identification of the arts with the nineteenth-century city.[25]

The remarkable effect of the May Festival on Cincinnati itself requires further elucidation. Originally conceived as a "western" affair, the city quickly appropriated it as its own. By 1878 Cincinnati felt confident enough to announce a permanent biennial festival, with an increased emphasis on local talent, and in 1880 the chorus became an all-Cincinnati organization. Civic leaders perceived the importance of the festival to the broader interests of the city. In appealing to the Board of Trade for financial support, Nichols linked the arts to commercial prosperity. "It would be easy to show that aesthetic culture and education, in the fine as well as the mechanical arts," he stated, "are directly to the advantage of commerce and trade." But more than mammon would benefit. "The civilizing and enlightening powers of music and kindred arts are apparent," wrote one concertgoer who saw in the arts a way to smooth the abrasive qualities of the Gilded Age. The *Cincinnati Daily Gazette* echoed this thought. Calling the festival "a means of education," the editor outlined the importance of cultural exposure in elevating taste and refinement. Thoughtful men, argued the editor, should support the festival in "the interest of the whole city."[26]

Even before the festival, Cincinnati's musical life had displayed signs of renewed vigor. Such renowned vocalists as Carlotta Patti, Parepa-Rosa, Pauline Lucca, and Christine Nilsson performed in the city, and both Italian and German opera enjoyed success. *Church's Musical Visitor* wondered "if even high-toned, classical Boston" could support opera as well as the Queen City. The Thomas Orchestra and the Boston Mendelssohn Quintette ap-

peared regularly, and in December 1872 a concert tour of the highest order further delighted lovers of classical music. Anton Rubinstein, a giant of the keyboard, and Henri Wieniawski, a violin virtuoso, appeared as part of an extensive national tour sponsored by New York piano merchant William Steinway. Cooly received at first, the three concerts drew increasingly larger and enthusiastic audiences. Describing their final appearance as "a dazzling performance," *Church's Musical Visitor* solemnly proclaimed the visit to have been an "epoch in the musical history of Cincinnati."[27]

The early 1870s also witnessed a considerable amount of local activity. The Chicago fire of 1871 brought a rash of benefit concerts for the blackened city, presented by various choral societies and individual musicians. In 1872 Franz Abt's visit helped launch the Germania, a double quartet, later to become part of the Musik Verein. In the same year George Ward Nichols held a series of musicales at his Grandin Road home, largely for his own friends, and similar soirees took place at the home of Dr. and Mrs. Rivé, whose daughter's musical career had just begun. Many of the same people supported a series of afternoon orchestral concerts that Julius Dexter arranged, including John Shillito, Lewis Hopkins, and Learner B. Harrison.[28]

This same Anglo-Saxon elite provided the nucleus of the Harmonic Society, the most important of the postwar singing societies. Active members (that is, singers) paid an annual five-dollar membership fee, while associate members received two tickets for each of four concerts for the same amount. During the society's prime, George Nichols served as president, with Bellamy Storer, John Church, and Joseph Longworth sitting on the board of directors. After 1874 Otto Singer handled the music direction. The Harmonic Society sang in all the early May Festivals, shared the stage with various visiting orchestras, and presented joint concerts with the local Maennerchor, an important step in improved Anglo-German relations. Taking advantage of the May Festival's absence in 1876, the two hundred-member Harmonic Society organized its own spring festival, joined by the Maennerchor, the Cincinnati Grand Orchestra, and several imported soloists. They attempted too much. Mendelssohn's *Elijah* and Handel's *Messiah* ensured a high level of music, but without recognizable stars to supplement bass Myron Whitney, only moderate crowds attended the generally fine performances. Worse, their ambitions left a five hundred-dollar deficit. Still, the size and popularity of the Harmonic Society reflected a strengthening of musical support in the community. Among the German societies, the Maennerchor remained the strongest, although the indefatigable Carl Barus helped bring the more recent Orpheus Society to popular attention. Not to be outdone by the German tradition, the choir of the Welsh Church on College Street provided the nucleus for the beautiful choral festivals that the area's Welsh put on during the decade.[29]

Not all the local activity reflected the strong choral tradition. Although one music critic in 1869 had described orchestral efforts as "a sort of pot-pourri of musicians, from all the theatres," George Brand and Louis Ballenberg determined to make something better. Gathering some forty of the better instrumentalists in the city, the two men organized the Cincinnati Grand Orchestra, directed by Brand and clearly patterned after Theodore Thomas's troupe. The orchestra gave its first concert at Pike's Opera House the week before Christmas, 1872, treating "with ease and confidence" an appreciative audience to an evening of light classics. Later concerts brought more difficult and serious pieces, and with increased experience the Grand Orchestra was pronounced by *Church's Musical Visitor* as "second to that of Theodore Thomas."[30] Ironically, when Thomas came to Cincinnati in 1878 to head the College of Music and to establish an orchestra in connection with the college, the Grand Orchestra disbanded, and only after Thomas's abrupt departure in 1880 did it reappear. During its rather checkered existence, however, it provided important training and experience for later orchestras.

Along with the Grand Orchestra, the city delighted in watching the careers of her talented sons and daughters, the most promising of whom was pianist Julie Rivé, who earned critical acclaim wherever she played. At the same time several small but active music schools, headed by Clara Baur's Conservatory of Music, encouraged those with musical ambition to study in Cincinnati. "There can be no doubt of this being a musical center," one resident wrote proudly, "there certainly has been an unusual number of successful singers and performers from here."[31] Musical matters had indeed turned in a positive direction.

Due to the increasing musical energy in the community, Cincinnatians anticipated the 1875 May Festival with greater enthusiasm and optimism. The principal organizers remained the same: Nichols to oversee the business end; Singer, now a resident, to train the chorus; and Thomas to provide artistic direction. With his usual thoroughness, Nichols had studied the organization of a similar festival in Birmingham, England, and he and Singer devoted considerable attention to chorus selection and preparation. Rehearsals began in September 1874, with Singer confidently expecting full cooperation from the German community. He was not disappointed. In order to "kill everything that had ever been given," Thomas arranged an even more ambitious program, but, Singer warned, to achieve this goal would require "an extra effort, as the choral works were extremely difficult." Otto Singer's presence relieved many of the doubts that people had concerning the complex program. In frequent communication with the New York-based Thomas, Singer brought something of the maestro's drive and determination to the festival preparations. Born in Saxony in 1833, Singer had studied under the great Franz Liszt. In New York he had encountered

Thomas and he came to the first festival as Thomas's personal choice. After making Cincinnati his home, he became musical director of both the Maennerchor and the Harmonic Society, smoothed ruffled German feathers, and earned national recognition as the molder of the festival chorus. Thomas now counted on all of Singer's ability to ensure success of the second festival. To establish a new standard of excellence, Thomas placed at the heart of the program Brahm's *Triumphal Hymn,* Liszt's *Prometheus,* and Bach's *Magnificat,* the latter a premier for America. If Bach anchored the festival in tradition, Brahms and Liszt focused attention on the modern masters, and Thomas further underlined the point by including selections from Richard Wagner's dramatic operas.[32]

Anticipation mounted as May drew closer. Although a touch of skepticism had existed two years before, now the nation's press unanimously heralded the great event. The *Cleveland Leader* called the program "a tribute to the cause of music as no American city has yet given . . . ," while the *Boston Transcript* described it as "a treat worth crossing the mountains to enjoy." Even John Sullivan Dwight managed a favorable comment, although he still grumbled at the implication that classical music had not existed before Thomas and Cincinnati had gotten together. New York newspapers provided the strongest support. The *Herald* saw in the festival "a great gain for music in America," a theme endorsed by the *New York Times,* while the *Tribune* supported the enterprise with a lengthy description of the program.[33] Monthly journals such as *The Scholastic* and *Scribner's* alluded to the ascendency of western music. "With one enormous stride pork-packing Ohio overtook aesthetic Massachusetts, and in the next festival . . . it will rival . . . the most ambitious efforts of New York or Boston, and even the achievements of the great choral festivals of England"—high praise from John R. G. Hassard. With more enthusiasm than analysis, the local press contributed its share of plaudits, and unlike 1873 the German newspapers added their own endorsements.[34]

Reflecting this increased excitement and confidence, Cincinnati prepared for the second festival. Leading businessmen led the drive to dress the Queen in her fancy. An epidemic of gay bunting broke out on Fourth Street, long the home of musical enterprises, and the two large publishing houses of Robert Clarke and John Church, on opposite sides of the street, were "decked out like the front cars in a hippodrome." Over the doorway of Clarke's a green wreath with the motto "Literature Greets Music" beckoned towards the sheet music artistically displayed in Church's front window. The post office adorned its elegant columns with evergreen garlands, and the Gibson House hotel placed shields of all the states and escutcheons bearing the names of great composers along its facade. The chamber of commerce encouraged business support by displaying the motto: "Commerce Lends A

Helping Hand To Art." Given the general economic doldrums of the mid-1870s, the helping hand may have reached the other direction. Evergreen garlands hung from lightposts and house windows, while pictures of Liszt, Beethoven, Wagner, and Schubert lent the appearance of a political convention. Everywhere visitors saw flags—"embryo flags, flags just hatched, and gay, youthful, half-grown ones. Middle-aged flags with the stiffening all out of them flap disconsolately from upper windows. Old battle-scarred veterans wave in dignity over the gay cavalcades on the street." "The Queen of the West in Her Garlands Dressed"—Longfellow's poem had never been more appropriate.[35]

The great festival swept everything before it. From the opening notes of the *Triumphlied,* the audiences sat enraptured. Once again the third evening provided the climax, with the solemnity of Bach's *Magnificat* sharing the stage with the joyous strains of Beethoven's *Ninth*. On the following evening, with fatigue and enthusiasm on a collision course, the festival concluded with Otto Singer's direction of the Liszt cantata *Prometheus*. As the final notes echoed in the great hall, the cheering crowd rose to its feet, crying "bravo" and calling for Thomas, Singer, and Nichols. Music critics shared the enthusiasm. "Memorable," proclaimed the *Boston Daily Globe,* while in the *Chicago Tribune* George Upton singled out the chorus as "the finest vocal organization in the nation." The four-day festival frequently rated front page coverage, even pushing the sensational Henry Ward Beecher–Theodore Tilton adultery trial to back pages. "Cincinnati is entitled to plume itself," concluded the *New York World*.[36]

If the first May Festival had impressed the musical world, the second proved that Cincinnati's musical growth was no flash in the pan. Not only had this second great feast of song gained a profit (it netted $1,500, no small achievement in 1875), but savants recognized a significant step forward in the program. Thomas clearly had perceived a need to introduce more difficult and modern works. If the first festival had borrowed from Boston's Handel and Haydn Society, the second ploughed new soil. To have included the *Magnificat,* the *Triumphlied, Prometheus,* the *Ninth Symphony,* and *Elijah* in successive concerts was both a testimonial to Thomas's genius and a tribute to the ability of the chorus. The performances had unfolded like a series of musical problems, and while a few balked at the modern influence, everyone recognized the importance of the event to the nation's musical maturation. Five years earlier no one would have attempted such a feat.

The festival's overwhelming success encouraged civic pride and promoted considerable editorial puffery concerning the city's future. Few questioned that musical future, although its shape remained obscure. Local boosters demanded an expansion of the community's role in future festivals, led by the *Cincinnati Daily Gazette*'s call for an all-Cincinnati chorus and

orchestra. However, a more pressing concern was the need for a new music facility. As one New York observer reported, "a circle of highly-cultivated and public-spirited people in Cincinnati . . . are making a much better use of their time and money than the corresponding social class in New York." He referred to the recent startling announcement by Reuben Springer, a wealthy retired merchant.[37]

Born in 1800 near Frankfort, Kentucky, Springer had sought his fortune as a clerk on an Ohio River steamboat. His talent and intelligence steered him to the Cincinnati firm of Kilgour, Taylor and Company, one of the larger wholesale merchandise houses in the West. By owning its own boats, Kilgour, Taylor guaranteed fast, efficient service to the South, and the company's success led to several Cincinnati fortunes. In rapid succession Springer became a partner, married Kilgour's daughter, and shared in that financial success. Careful speculation in real estate, with a particular penchant for corner lots, enlarged his personal wealth. In 1840 he retired to devote his life to travel, pleasure, and the generous support of numerous cultural and philanthropic enterprises. Shortly after the conclusion of the 1875 festival, Springer proposed that a music hall be constructed to house future festivals. It was to be on the site of the existing Saengerhalle, and, with appropriate additions, would also house various expositions and conventions. To this end, the modest Springer donated $125,000. He also insisted on two conditions. First, the city must provide the proposed lot in perpetuity at a nominal rent, free of taxation, and second, the citizens of Cincinnati had to match his individual gift. The offer excited great interest. It also brought division.[38]

Scarcely had Springer's offer circulated than several businessmen questioned whether the proposed building was really intended to house industrial expositions as well as musical events. "We are a mechanical people, not a race of fiddlers," angrily wrote one resident, and many others agreed that the city's future lay in manufacturing, not music. Quickly a separate exposition fund emerged and the entire enterprise appeared in jeopardy. Once again Springer stepped forward. Noting the confusion over the proposed name of Music Hall, he reaffirmed his intention of securing a public facility for both exposition and musical purposes. He pledged an additional $50,000—to be matched by $100,000—for suitable exposition buildings to be built adjacent to Music Hall. As this controversy died, the city council attempted to gain greater control over the future facility, but strong criticism from newspapers headed off this threat. When the air finally cleared, leading citizens organized the Cincinnati Music Hall Association to oversee the subscription fund and the eventual construction of the building. Presided over by Joseph Longworth, son of "Old Nick" and father of Maria, the association engaged the architectural firm of Hannaford and Proctor to design

the facility.[39] For the next two years curiosity about the great edifice slowly rising on Elm Street served to keep musical matters before the public eye.

Spurred on by the two festivals and the aspirations unleashed by the construction of Music Hall, the mid-years of the decade witnessed a rich flood of music for the city. New names appeared. Armin Doerner, a fine young pianist, earned a considerable reputation through a series of well-attended concerts, while Michael Brand, the new director of the Cincinnati Grand Orchestra, emerged as a musical force in the community. Julie Rivé, fresh from praiseworthy performances in Philadelphia and New York, received more laurels from hometown audiences. Concertgoers delighted in the matinee musicales arranged by Otto Singer, who revived the chamber quartet tradition. The several music schools displayed their best pupils in an unending series of recitals. Foreign artists continued to visit. Hans von Bulow passed through in February 1876, astonishing the audience with his feats of memory, and providing a rest from the "emotional insanity" that alarmed traditionalists saw in the modern style of piano playing. Soprano Therese Tietjens appeared, as did Ole Bull and Madame Essipoff. The annual concerts of Theodore Thomas's orchestra always drew full audiences. Another in that long line of musical organizations appeared. The Musical Club, made up equally of patrons and musicians, offered evenings of "classical and modern chamber music." Armin Doerner, Michael Brand, Simon E. Jacobsohn, George Schneider, and Henry Andres all belonged, and members did not hesitate to introduce their own compositions—in itself a signal encouragement for music.[40]

The climax of this musical activity came with the May Festival of 1878. The importance of the third festival derived from the new Music Hall, that massive red brick structure which ever since has symbolized Cincinnati's musical heritage. The construction of Music Hall revealed much about the public spirit for things cultural during the Gilded Age. Reuben Springer's generosity has already been noted, but the same decade witnessed the initial effort to establish an art museum, the dedication of the Tyler Davidson fountain—still the centerpiece of the city—the establishment of the College of Music, the opening of the Zoological Gardens, and William Groesbeck's endowment of free outdoor concerts—an impressive list of cultural undertakings that speaks of the confidence of that generation. All of these endeavors drew heavily upon the financial resources of wealthy citizens, made even more noteworthy by the economic difficulties that followed the panic of 1873. Reuben Springer's inclusion of a matching provision in his Music Hall proposal demonstrated that the city's generosity ran deeper than a few philanthropists. Thirty-eight subscribers pledged $1,000 or more to the construction of the building, and altogether 384 separate contributions made up the more than $100,000 amount. One gift of $3,000 represented the

small change of the city's school children. This widespread support helps to explain the attachment that Cincinnatians have always had for Music Hall.[41]

In part because of its physical impact, but mainly because its purpose transcended aesthetic goals, Music Hall captured the public's attention as no other event of the decade. Actual construction began on May 1, 1877, leaving only twelve months before the anticipated opening date. The credit for completing this Herculean task belongs to the untiring Julius Dexter, chairman of the building committee and another in the city's long line of dedicated citizens. Constructed of limestone and faced with cherry-red brick, its architectural style, sometimes referred to as "Sauerbraten Gothic," reflected the eclectic taste of the age. In keeping with Springer's wish, the building retained a basic simplicity. With a 150 foot-high central gable which towered over the narrow three- and four-story houses that predominated in the area, the overall effect of the facility was one of "dignity and purpose." The interior revealed its own impressive features. Upon entering, the visitor was struck immediately by the spacious vestibule which provided a place to remove wraps before entering the main auditorium, or to promenade during intermission. "As broad as a public square," marvelled the *Cincinnati Commercial*. Encircled by a gallery, the vestibule showed off the elegant columns, rich wood paneling, and tile floors that visitors found so inviting. It also served a more practical function. Not only could outer garments be removed there, but the entrance area channeled the immense crowds to the adjacent foyers which housed the staircases to the upper floors. This facilitated entry into the main hall and helped remove noise and commotion, a great improvement over the Saengerhalle.[42]

After passing through the elegant vestibule, one entered the auditorium, the gem of the building. Capable of seating over four thousand people, almost three thousand on the ground floor alone, the main hall was paneled with yellow poplar. The wood contributed to the almost perfect acoustics, and the iron support columns along the sides of the hall were arranged so as not to block the view of the stage. No one questioned that the structure was superbly designed for musical performances. Gas fixtures in the ceiling reflected light on the audience, and a unique system of ducts and small holes beneath the seats circulated fresh air, drawn in through an opening at the top of the main gable. To allow for industrial expositions and other public functions, the main floor seats could be removed, and the pitch of the floor was less than five feet from front to rear. The raised stage ensured sufficient space for the festival chorus and orchestra, while centered at the rear of the stage stood the great Hook & Hastings organ, at the time the largest in America and fourth largest in the world.[43]

An organ had been omitted from the original plans, but festival supporters concluded belatedly that one was a necessity. A separate subscription

fund, with Springer contributing almost one-third of the cost, secured the desired instrument. To highlight the grand organ, students of local wood-carvers Benn Pitman and Henry and William Fry created an ornate housing of cherry wood. Filled with graceful birds, delicate flowers and foliage, and tree-leaf patterns dedicated to the great composers, the carvings symbolized the romantic entwining of nature and art.[44]

This, then, was the splendor which greeted those patrons who attended the third May Festival. Earlier festivals paled in comparison, mere "rehearsals" according to one critic, and, indeed, no other festival captured the exuberance of the city as did the 1878 spectacle. Decorations festooned the downtown shops and stores; hotels were filled to capacity, even in outlying areas; and crowds of residents and visitors alike strolled the streets, admiring the many garlands and banners. George P. Upton described the people as "in a musical whirl." An Indianapolis reporter alluded humorously to hotel waiters wrangling "with each other over the respective merits of the classics and music of the future," while bootblacks warbled "difficult passages from the old masters." "Small boys in the street weep with joy as they bathe in the flood of harmony that pours from the hall when the fiddlers come out to take a glass of beer," he continued, "and old men freely surrender their lives after having seen the chorus wrestle with a fugue. It is wonderful."[45]

The combination of Theodore Thomas, Otto Singer, the great organ, and Music Hall proved irresistible. Serious music criticism dominated the front pages of all the local newspapers, while out-of-town observers searched for new superlatives to describe the music and the management of the festival. The performances were flawless. Using Berlioz's dramatic *Romeo and Juliet* symphony as a bridge, Thomas had carefully linked the music of the past with the so-called "music of the future." Handel's *Messiah,* Gluck's *Alceste,* and Beethoven's *Third Symphony* represented tradition; Liszt's *Grand Mass* and Singer's newly composed *Festival Ode* reflected the present; whereas the various selections from Wagner anticipated the future. Upton and John Hassard led visiting music critics in singling out the power and endurance of the chorus. The Thomas Orchestra received its customary praise, while the chorus basked in the reporters' tributes. All who participated shared in the elation. Even more impressive to many, particularly to the board, was the $25,000 profit, an almost unheard of financial success for a cultural event.[46]

This third festival had far-reaching effects on Cincinnati. Local merchants and businessmen profited from the money spent by thousands of visitors. More culturally oriented citizens saluted the festival's ability to bring the great choral and orchestral works to a wider audience. "It was transcendentally successful . . . covering as it does, a wide area, embracing

the interest of commerce and civilization as well as those of morals and the art of music," gushed one editorial. "It is one of the best of charities to provide refining amusements for the laboring poor," added another. The *Cincinnati Daily Gazette* exulted in the triumph of art over materialism. "There are more and worthier opportunities and issues to human life than to buy and sell and get gain. And this great truth . . . has been the subject of a glorious object lesson this week," pointed out the editor. "The music stole our hearts to make them better . . . but in that hall, in that atmosphere, quivering, throbbing with music, into which, with divine charity, had been poured the very soul of the composers, what was money worth to hoard? Nothing," he solemnly concluded. Romantic encomiums aside, the festival also set in motion a movement to wed the event more closely to Cincinnati. Plans were laid for a permanent resident chorus. Considerable discussion arose concerning the reliance on guest soloists, and a few even questioned the need for the Thomas Orchestra.[47] Nichols, Springer and other prominent supporters saw in this swelling enthusiasm an opportunity to establish a major school of music in Cincinnati, with Thomas at its head, which would further extend the city's reputation. Around this resulting College of Music revolved much of the community's musical life for the next two decades.

The amazing success of the 1878 festival ensured its continuation, of course. Eventually, however, as orchestral music surpassed choral music in popularity, and as the larger cities turned to permanent orchestras, the need for regional or national music festivals declined. Although the May Festivals remain one of the jewels in the Queen's crown, they have become increasingly local rather than national affairs. The real significance of these early festivals, however, lies in the critical era in which they were held. Appreciation of the great music of European masters was entering a transitional stage. Although still firmly in the hands of a social elite, the May Festivals publicized, promoted, and helped introduce the finest in music to wider audiences. No longer would Beethoven have to share a program with the "Anvil Chorus" or some patriotic air. As one newspaper phrased it, sham had been dealt a death blow. Along with the founding of the Boston Symphony Orchestra in 1881 and the unceasing efforts of Theodore Thomas, the Cincinnati May Festivals rank as one of the three major monuments to the nation's musical development in the late nineteenth century.

Harmony and Disharmony: The Growth of Music Institutions, 1867–1900

*O*n a bright October day in 1867, a tiny wisp of a woman, with braided auburn hair and bright blue eyes, disembarked at Cincinnati's public landing, prepared to establish a school of music. Clara Baur, scarcely five feet tall and frail in appearance, had first come to the city in the early 1850s, following the path of her brother Theodor, himself a recently arrived German "Forty-eighter." The Baurs had been born near Stuttgart, children of a prominent Lutheran clergyman, but the internal upheavals of 1848 and the prospect of military conscription persuaded Theodor and his brother Emil to emigrate to the United States. Miss Clara, as she came to be known, followed. As a girl, Clara Baur had studied piano and music theory at the Stuttgart Music School, and shortly after her arrival in the Queen City, she began giving private lessons in her brother's Milton Street home. To one coming from the rich music tradition of Germany, America seemed peculiarly lacking in cultural institutions. Cincinnati's numerous singing societies, successful Saengerfests, and touted cultural eminence paled against the Baur background. She soon discarded the idea of a career as a private teacher of voice and piano, and fixed her ambition on a music conservatory in the European mold. With its growing German population and prewar economic confidence, Cincinnati appeared to be just the place to foster an indigenous love of music. In 1858 this determined young lady, only twenty-three years old, returned to the Stuttgart School of Music to study its instructional methods, following which she spent several years in Paris furthering her voice training. By 1867 she was ready to establish her school.[1]

The city to which she returned had changed remarkably during her nine-year absence. Physically, of course, Cincinnati had expanded, with manufacturing replacing commerce as the foundation of its economy. Local

enthusiasm centered on the great suspension bridge which had just joined the city to its Kentucky neighbor, Covington, and on the continued prospects for a rail link to Chattanooga. The city had begun to creep northward along the Mill Creek Valley, while large estates dotted the hilltops. The area north and east of the Miami and Erie Canal continued to attract Germans, and in the area a few blocks south of this local "Rhine," Miss Clara searched for available space in which to locate her school. On West Seventh Street she found what she wanted, several rooms in a fashionable school for young ladies operated by the Misses Nourse. Here, the Cincinnati Conservatory of Music opened its doors for the first time. In the absence of any competition, Baur managed to bring together a fine faculty, headed by Henry Andres, formerly active in the Philharmonic Society, and Madame Caroline Rivé, the city's finest voice teacher and formerly Baur's own teacher.[2]

For several years the conservatory enjoyed remarkable success. The strength of the faculty and support from many socially prominent families encouraged steady growth. In its third year the school added eight teachers, including Michael Brand, soon to be director of the Cincinnati Grand Orchestra, and Miss Emma Heckle, a prominent local singer. Public concerts displayed the talents of both students and faculty, and the school's reputation quickly extended beyond the Ohio Valley. *Watson's Art Journal* praised the young institution, although incorrectly crediting Henry Andres for its success, while the *London Quarterly,* in singling out Cincinnati for its "high educational position," mentioned its music instructors.[3]

From the beginning Baur insisted on a broad curriculum for her mostly female students. Instruction in literature, language, art, history, and theory supplemented the courses in music, and every graduate was expected to have the equivalent of a high school education. She maintained that music should not be isolated from the other arts, for "without this association the art of music loses much of its innate force and beauty." Soon the conservatory organized programs for children and for prospective teachers, plus a department that focused on the aesthetic and ideals of music.[4] Baur's unswerving energy and executive ability made the school a force in Cincinnati's cultural life, but this early success ended with the financial crisis that followed the panic of 1873. "I cannot speak of the past, it is too full of agony," she later commented about those years. Weathering the worst of the depression, she realized that improving economic conditions favored a move to larger quarters. In 1876, supported financially by her brother Theodor, the conservatory moved into a four-story building at the corner of Eighth and Vine Streets. The larger quarters permitted an expanded program, and the ambitious Baur instituted summer sessions and admitted boarding students, both of which extended the school's influence.[5]

Clara Baur combined strict discipline and personal dignity with a gen-

uine warmth and concern for her students. In keeping with her own strict Lutheran upbringing, the Sabbath was observed rigorously. She admonished her students not to sing or practice on that day, and morning prayers and daily scriptural readings were required. At all times chaperones accompanied the girls, and etiquette and deportment remained important features of the school as long as Miss Clara lived. She instructed her female charges not to don garments on the street, not even to put on gloves. Young ladies did not go out unless completely attired. Male faculty ate in one corner of the dining room, removed as far as possible from the impressionable students. At all times she instructed students to keep their voices low and moderate. Her gentle reproof, "Girls, girls, remember princess pitch and fairy footsteps," brought many an exuberant young pupil up short. Later, when tennis became popular, she forbade mixed doubles, and throughout her tenure the school held to its ten o'clock curfew. While Clara Baur remained a paragon of Victorian respectability, she did not isolate herself from her students. She taught voice classes, tried to meet daily with each of her charges, and occasionally provided financial support from her own pocket to those in need. To the time of her death in 1912, Clara Baur demonstrated an admirable combination of personal reserve and affectionate concern.[6]

During these early years, prominent visiting musicians found much to admire in the conservatory. On one occasion Therese Tietjens, a popular German soprano, singled out a Baur student for public praise, while Anton Rubinstein, during his celebrated 1872 tour, requested performances by advanced students. The report that "the Cincinnati Conservatory was the first musical institution in America where he found scholars who rendered classical music with such marked ability and understanding" helped publicize the school. But it was the famous English impressario, James H. Mapleson, who gave the most welcome endorsement. "It is no longer necessary for students who desire to secure a high position in oratorio, concert or opera to go abroad," he announced, "I shall send scholars who ask my advice to Miss Clara Baur." She could not have asked for more.[7]

Given the current fine reputation of the Conservatory of Music (now the College-Conservatory of Music of the University of Cincinnati), it is difficult to comprehend the numerous difficulties which confronted the fledgling school in the 1870s. Early in the decade two other music schools, along with over eighty private teachers, provided stiff competition, and the success of the May Festival, coupled with rumors of Baur's imminent departure for New York, apparently encouraged still others to follow her pioneering effort. In July 1878 *Church's Musical Visitor* noted ominously that the air was "thick with rumors of new conservatories of music in which several of our prominent musical people are to be interested." Two months later, Hattie Evans, formerly a teacher with Baur, opened the Cincinnati Musical Insti-

tute. Her faculty included Emma Cranch, Annie March, and a Miss Fortman, but her coup and ultimate hope for success lay in hiring the experienced pianist Henry Andres, one of Clara Baur's first and most distinguished teachers. At the same time, another former conservatory teacher, Dora Nelson, announced the opening of the Cincinnati College of Music (not to be confused with the College of Music of Cincinnati, founded by George Ward Nichols and Theodore Thomas). Further competition came from the Cincinnati Wesleyan College for Women, which enlarged its music department to eighteen instructors.[8]

All of this musical pedagogy would have been sufficient competition indeed, but the greatest threat to the conservatory came from the ambitions of Nichols's College of Music. The reputation of Theodore Thomas, the college's first director, and the financial backing of Reuben Springer gave the College of Music a secure base, and several of Clara Baur's faculty left for the new institution. To combat this threat, Baur recruited new teachers from outside the city who possessed European training. In this manner she acquired faculty with strong reputations, and ones without any local prejudice. To supplement her faculty and to encourage loyalty to the conservatory, she initiated a policy of hiring her own graduates as assistant instructors; in addition she started a series of chamber concerts and increased the number of public performances by her students. By the mid-1880s the Conservatory of Music had weathered the storm, relegating all but the College of Music to obscurity. In 1884 Clara Baur once again searched for larger quarters. For several years the school occupied a building on lower Broadway, but the noise and smells of the waterfront eventually forced a move to the old McLean house at Fourth and Lawrence Streets. Finally, in 1902, she found her dream building in a palatial Mt. Auburn home, formerly owned by John Shillito. Here, in the beautiful drawing room, the ageing Miss Clara entertained such luminaries as Enrico Caruso, Madame Schumann-Heink, and Ignaz Paderewski. Clara Baur died in 1912, loved, honored, and respected by all who knew her. Her niece, Berthe Baur, who had assisted in running the school since 1876, maintained the conservatory's exemplary reputation until her own resignation in 1930, giving the school sixty-three years of Baur direction.[9]

Despite the growing reputation of the Conservatory of Music, the success of the 1878 May Festival and the completion of Music Hall the same year elicited local support for yet another school of music. Perhaps the lack of men at the conservatory obstructed national acceptance, and while Clara Baur had achieved recognition as a teacher and headmistress, she lacked a reputation as a musician. Music patrons wanted more. "We have a School of Design, why not one for music?" asked one citizen, and capped his letter with the suggestion that John Knowles Paine, Dudley Buck, or Otto Singer

Theodore Thomas, at right;
George Ward Nichols, below.
Courtesy of the Cincinnati
Historical Society.

At left, Reuben Springer; below, cover illustration from *Puck,* October 9, 1878, showing Thomas conducting before an audience of pigs as a satire on his decision to go to Cincinnati. Both, courtesy of the Cincinnati Historical Society.

be made director. Cincinnati, however, was not alone in considering the possibilities of a major school. Talk of a national school of music had been circulating throughout the country since 1872 when Bostonians had broached the possibility of a National College of Music in their city, with the famed Mendelssohn Quintette serving as the nucleus of the faculty. The next year the *New York Times* endorsed the idea of a "National Musical Conservatory" in New York City, followed a few months later by rumors that Lake Mahopac, New York was to be the site of a new musical and art college, munificently endowed by a public-spirited New Yorker.[10] In 1875 the Washington correspondent for *Church's Musical Visitor* reported talk of a grand college of music destined for the nation's capital. New York countered with yet another rumor the same year, when word leaked out that a wealthy businessman had given one million dollars, with the promise of four million more at his death, for "a great music school." Richard Wagner was to be its director, with Theodore Thomas as his assistant.[11]

Nothing ever came of these schemes, and some, like an earlier one in Washington, may even have been fraudulent. However, the rapidly blossoming cultural nationalism in the country demanded that American musical prowess be recognized through a musical school of national reputation, patterned after the great conservatories of Europe. Cincinnati determined to fill the need.

As early as 1873, *Church's Musical Visitor,* pointing to the recent May Festival as evidence of local "interest and enthusiasm," had asked why the trustees of the University of Cincinnati had not yet established a college of music. Two festivals and one Music Hall later, the concept of a major music school in the city seemed even more appropriate. George Ward Nichols decided to act. After gaining the financial endorsement of his friend Reuben Springer, Nichols discussed the idea with Rufus King and other prominent citizens. Desiring a man of national reputation to head the proposed college, these gentlemen agreed to invite Theodore Thomas to serve as director. The procuring of Thomas appeared a necessity to Nichols, and he immediately set to work to convince the eminent orchestra leader to cast his lot with Cincinnati ambitions. Describing the proposed college as not "inferior to those so celebrated in Europe," Nichols spelled out the advantages to Thomas. Cincinnati's central location and musical prominence, the lower cost of living in the West, the availability of Music Hall, and the security of a permanent position with a fixed salary, were all arguments designed to appeal to Thomas's professional and personal situation. "You may be sure that in Cincinnati we shall contend for musical supremacy," concluded the optimistic Nichols, and "I want you to come here and work with me to organize *a complete and brilliant musical university.*"[12]

Not yet ready to leave New York City, Thomas hesitated. Nichols ap-

pealed to his ambition. "You would be a more influential and useful man at the head of a great college of music than simply as a leader of an orchestra in New York." Furthermore, he continued, "if this scheme becomes what I hope, you can have a great orchestra and take it where you please, provided you are not gone *too* long." Thomas would not have to give singing lessons or perform in quartettes, just lead the orchestra and direct the college, with the help of assistants and teachers. And then Nichols offered the clincher—a salary of $10,000 guaranteed for five years. The official invitation followed, signed by such notables as George K. Schoenberger, Joseph Longworth, John Shillito, David Sinton, Springer, King, and others whose names ensured financial support. "This is a step in the right direction and Cincinnati is the right place to begin," replied Thomas in his acceptance of the arrangement.

The contract called for Thomas to head the college, nominate the faculty, organize and conduct an orchestra, and supervise concerts and performances presented by college personnel; in addition he would receive six weeks' vacation, apparently to allow him to take an orchestra on the road, and 20 percent of any earnings from outside conducting was to go to the college. A sizeable workload, but not overwhelming when one considers Thomas's accustomed schedule. Rose Fay Thomas, his wife, bitterly described the contract as getting the most for the least, and suggested that Nichols had only the "vaguest conception" of what was being asked. However, Rose Thomas's remarks came years later, long after the arrangement had collapsed in acrimony. Furthermore she ignored the salary paid to Thomas—$10,000 was a handsome remuneration for 1878.[13]

George Nichols's offer was sincere, if rather naive in its grandiosity. Was Thomas naive in accepting it? The difficulties of establishing a large music school and the inexperience of all parties allowed for considerable misunderstanding. Yet, Thomas knew in essence what was involved. But a dependable income and the opportunity to shape American musical development overcame what reservations he may have had. Indeed, far from being overworked, Theodore Thomas eventually resigned his position because Nichols did not give him enough control. The Cincinnati offer had caught Thomas at a particularly vulnerable time. Years of intense physical and mental strain stemming from constant travel and thousands of performances had left their mark. A series of summer concerts during the national centennial celebration in Philadelphia had been poorly received, leaving him financially embarrassed; only the public auction of his fine music library saved him from bankruptcy.[14] This humiliation, followed by the failure of New York to adequately support his ambitions for a school there left him further depressed and insecure. The Cincinnati contract offered both finan-

cial security and professional recognition. As Thomas explained it to a New York reporter, the new position was "so entirely congenial that he would have no time to think of regrets."[15] These are hardly the words of a man concerned about his new responsibilities.

Word of the proposed College of Music first broke on August 24 in the *Cincinnati Daily Gazette,* which viewed the new institution as a necessary training school for the May Festival chorus and orchestra. With the success of this "musical project" Cincinnati would become "the great musical center of the world," happily concluded the editor. Theodore Thomas's impending move to Cincinnati shook the nation's musical community to its foundations, and within days newspapers in all the major cities expressed their opinions. For the most part the western press agreed with the *Daily Gazette* that Thomas's residency in Cincinnati was just another expression of the inimitable rise of the West. The *Cleveland Voice* pointed out that Cincinnati had "done quietly" what New York had promised for years, and the city would soon rival Leipzig and Paris. George Upton, writing in the *Chicago Tribune,* boldly stated that Cincinnati had gained the "grand musical prize" because New York had "done nothing for him." The *Indianapolis Journal,* unwilling to allow the Queen City all the glory, reflected that Thomas had come west "because he finds here more devotion to art than in the older and so-called more cultural communities of the East."[16]

Eastern cities, other than New York, viewed the move with favor, perhaps out of a desire to see New York humbled. The *Philadelphia Times* recognized Cincinnati's combination of culture and energy and concluded that she provided Thomas with an opportunity "such as no other of our cities now affords of carrying on the work of musical education" The loss to New York is irreparable," exclaimed the *New Haven Palladium,* "but the city deserves it. . . . It is a disgrace to New York that it allows Cincinnati to establish the first real musical college." Even one of Boston's major dailies acknowledged the importance of the move. In a somewhat bittersweet editorial the *Boston Daily Advertiser* noted the loss to Boston of the Thomas concerts through the "blindness of New York." "While we begrudge to Cincinnati her acquisition, we cannot help congratulate her," the editor concluded,

Certainly she deserves her good fortune. In recent years no city in the country has shown a greater interest in music, or has put forth more energy in promoting the cause. Every year there is something to unite the lovers of music, and enormous sums have been spent in providing a suitable home for music. There have been held festivals which . . . have never been surpassed in this country. If we do not say any more than that, it is because we have a great reluctance

to admitting that Boston is ever to take the second place in musical art. At all events, Cincinnati has fairly won the right to take Mr. Thomas from the East, and will appreciate him, as Boston has always done when the opportunity was afforded her.[17]

The initial reaction in New York was gloomy. *The Nation* called the move "an unbelievable shock." "The greatest musical calamity that has ever happened to the metropolis," groaned the *New York Mail,* while the *Times* headed its editorial, "Musical Bereavement." The *New York Tribune* went into deep mourning. John Hassard described the loss of Thomas as "a catastrophe" for the city, and the disbanding of his orchestra "a misfortune for the whole nation" Remarking on the "strange indifference of our own people," he finally concluded that New York deserved to lose one of its "most valuable possessions." Even the eminent Leopold Damrosch, Thomas's rival orchestra leader, graciously called the move "a real loss to New York, and one that cannot be filled without difficulty."[18]

As the first shocks receded, the New York musical world dramatically shifted its view. The *Journal of Commerce* took a wait-and-see attitude regarding Cincinnati's claims to musical supremacy, suggesting that the "inordinately puffed" reputation of the College of Music rested "too much on one pair of shoulders." Other periodicals called attention to the wealth of musical talent remaining in New York, pointing out that Damrosch or Nuendorff could easily replace Thomas. One prominent New York musician raised the question as to whether Thomas was even "fitted to be the director of a great school for musical instruction." Certainly his departure was "no disaster"; in three years "nobody will regret him." Another observer of the musical scene added that Thomas "not New York will be the loser. . . . We are all very fond of him, but do you think that we will go without good music because he leaves us?"[19]

Cincinnatians blithely ignored Gotham's face-saving comments. Happy in their remarkable acquisition, convinced that the future would see their city the equal of Weimar, Leipzig, or Stuttgart, Queen City residents basked in the glory of the moment. Thomas himself described the West as better suited for a national conservatory because music was more a part of the general culture. Among local newspapers, the *Cincinnati Daily Gazette* contributed the most generous assessment. Citing the move as "a national gain," the editor refused to play up the rivalry. "Thus there is in the real enterprise no feeling that Cincinnati has taken Theodore Thomas away from any place, and no idea that any other place should feel that it has lost him. All this local talk is puerile; the enterprise . . . is national."[20]

Meanwhile, much remained to be done before the College of Music's scheduled opening in mid-October. Thomas did not arrive in Cincinnati

until the end of the first week in October, escaping from New York after a poorly attended farewell concert at Steinway Hall, which the *New York Times* described as "a dismal failure." With New York behind him, the new college director concentrated his energies on hiring a faculty. Relying largely on local talent, he soon had Otto Singer, Carl Baetens, Jacob Bloom, Armin Doerner, Bush Foley, Emma Cranch, and Henry Andres under contract. Simon Jacobsohn, former concertmaster of the Thomas Orchestra, along with three other principal players from that distinguished organization, came from New York to teach and perform in the proposed college orchestra. Thomas also drew George Whiting, a well-known organist, away from Boston. For special courses he called on several individuals to teach in a part-time capacity. Henry Krehbiel, music critic for the *Cincinnati Daily Gazette*, taught the history of music; Dr. Landon Longworth introduced students to the anatomy of the ear and larnyx; while Shakespearean actor James Murdoch taught elocution.[21]

The publicity surrounding Thomas's hiring guaranteed student enrollments, with over one hundred admitted officially by the time he arrived. With the school housed in Music Hall and classes underway, Thomas shifted his attention to the orchestra, to be made up of sixty or seventy musicians, many from the Cincinnati Grand Orchestra. Pleased with the quality of its members, Thomas announced on October 19 a series of twelve concerts beginning on November 7. Symphonic music was to be stressed. A season ticket cost twelve dollars, and one pair of concerts (evening performance plus a Wednesday afternoon "public rehearsal") featured famed violinist August Wilhelmj. "Popular concerts and popular prices," announced the *Boston Post*, condescendingly adding that "for the nonce the people there are forgetting all about the rates of pork."[22]

From the beginning the college's backers had sought to provide the country with "a representative set of musicians, all its own." By developing the musical energy of the nation, the college hoped to eliminate "the weary and often fruitless pilgrimages to the old world" on the part of young American musicians. Nichols and Thomas agreed on the need for evening classes in order to allow working men the opportunity to attend, and, borrowing from Clara Baur's success, they offered summer instruction as well. Later, opera festivals and an opera department extended the curriculum. Public lectures, Whiting's organ recitals, and student choral concerts, often given in conjunction with local singing societies, kept the school before the public eye and contributed no small part to the musical life of the community. The college also offered the first opportunity in the nation to study orchestral playing and directing, and all classes were open to both sexes, although few women enrolled during the first decade. Thomas even hoped "to assist women to enter the orchestra as a profession."[23]

To take advantage of Cincinnati's musical strength, Thomas and Bush Foley of the faculty worked diligently on chorus development, including the provision of special classes for young boys. All voice students received basic instruction in modulation, pronunciation, voice exercises, harmony, and chords, with singers of superior ability attending individual voice classes. The plan of instruction called for two or three years of classes, with emphasis on "*only those who are earnest.*" Drill and discipline marked chorus training. To augment the established curriculum, as well as to provide the faculty an opportunity for personal development, Thomas established a string quartet consisting of himself and Jacobsohn as violinists, Hartdeger as cellist, and Baetens as violist. This talented foursome also took part in the college's showpiece —the orchestra. The college orchestra, still something of a novelty for Cincinnatians, offered a full range of winter concerts, and in the summer entertained with lighter performances at the Highland House, atop Mt. Adams. Thomas also introduced the Christmas tradition of *The Messiah,* combining the orchestra and the May Festival chorus.[24]

During its first year the College of Music surpassed all expectations. Enrollments stretched towards three hundred, mostly from outside the city; the faculty sparkled with talented musicians; and the critical success of the many public concerts augured well for the future. So impressed was Reuben Springer with the rapid strides made by the college that in June 1879 he donated $5,000 to provide gold medals for outstanding students. Success for the college seemed assured.[25]

Underneath the public acclaim, however, a storm brewed. In the spring of 1879, the sometimes overbearing Nichols, searching to increase school revenues, instituted a plan to have the students serve as soloists and organists in area churches. Not only would this provide experience for students, but apparently the college received the wages earned by the students. The plan angered local musicians. Henry Andres, displaced as a church organist, heatedly resigned from the faculty. Henry Krehbiel, who criticized the practice in a local musical journal, was dismissed from the faculty. Other injured musicians vented their irritation in local newspapers. Within weeks Nichols recognized his error and terminated the disruptive practice. Although Krehbiel was not invited back, *Church's Musical Visitor* in May buoyantly announced that all was "serene once more."[26]

Alas, the discord had just begun. Critics began to question the management of the school. One anonymous observer, interviewed in the *Dayton* (Ohio) *Journal,* pointed to the various and sometimes competing styles of instruction, along with the obvious lack of ability exhibited by some of the students, as serious flaws in the college. Furthermore, instruction in the history of music and in anatomy only added to the college's "pretentiousness." All in all, Nichols—"whose judgment is defective"—had promised

more than he could deliver, leaving the city looking "supremely ridiculous." Soon, rumors swept the city that Thomas and Nichols had fallen out, with the former resigning his position. *Church's Musical Visitor,* always alert to attacks on the city's cultural institutions, cautioned its readers that much of the criticism appeared to be personal abuse of Nichols rather than constructive analysis.[27]

Thomas did not leave in 1879, although he and President Nichols had clashed over the operation and direction of the college. A difference of opinion over the philosophy of the institution lay at the heart of their growing antagonism. Thomas stressed artistic excellence above all other considerations. Nichols, supported by a majority of the board, insisted on a financially self-supporting school. To achieve the latter, students at all levels of ability were accepted, admission was attainable at any time during the year, and students were not required to complete a proscribed series of courses. These policies conflicted with Thomas's vision of a national institution for training superior musicians. Throughout the college's first year the issue remained unresolved. More pressing and immediate problems obscured the differences, and the local press, for fear of damaging the school's reputation, refrained from reporting the growing crisis, even printing without comment Nichols's optimistic and self-serving report to the stockholders in January 1880.[28]

The short-tempered Thomas forced the issue. Chafing under the president's control, he submitted to the board a reorganization plan which included a two-term academic year and a more systematic program of instruction. Above all, he insisted that he needed greater control over academic policies. When the board delayed its response, Thomas expressed an interest in presenting his proposal at the January stockholders meeting, a move squelched by the board on the curious grounds that he "might say something which would lead the stockholders to believe that there was a lack of harmony between him and the Board of Directors." While keeping the conflict away from the stockholders and avoiding public disclosure, the board did establish a committee to examine the matter. In a letter to Alfred T. Goshorn, board member and chairman of the committee, Thomas assured him of his desire to remain, but continued to insist that he must have "exclusive direction of the college." The board accepted part of Thomas's reorganization scheme, but understandably balked at making Nichols either a figurehead president or relegating him to the position of business manager. Thomas found the directors' "long-winded letter" unacceptable. Frustrated, he requested in early March that he be relieved of duties as of October 1. "No, we want to get rid of him at once," an angry Reuben Springer replied to a reporter's question. The board voted to terminate Thomas's contract on April 8![29]

The imperious Thomas had overreached himself. It is difficult to see how the board could have responded otherwise. The directors of the college represented conservative business interests and moved in the same social world as George Ward Nichols. By marriage and inclination Nichols was one of them. In addition, most of the board had admired and supported Nichols's successful handling of the May Festivals. To demean the man who had done so much for Cincinnati, and whose brainchild the college had been, was not within the character of these patricians. In gentlemanly fashion, Nichols had submitted his own letter of resignation alongside that of Thomas. But in marked contrast to the maestro's critical and abrasive ultimatum, Nichols presented a smooth, even unctuous, justification of his position. "Dear Friend," he wrote to Reuben Springer, "I remained, trying with all my power simply to perform the *business* part of the office, scrupulously avoiding anything calculated to infringe upon the musical conduct of the college. My explanation for the personal issue made by Mr. Thomas is the prominence of the business of the office, inseparable from the work to be done" Nichols went on to remind Springer of his previous attempts to resign, how he had remained on the advice of Springer and others on the board, and cleverly concluded by suggesting that Thomas was using the quarrel as an excuse to return to New York. If the board overlooked the ambiguity of the phrase, "inseparable from the work to be done," the hint of disloyalty on the part of Thomas proved persuasive. Referring to Thomas's "peculiarities of temperament and of temper," the board requested Nichols to withdraw his resignation, which he did.[30]

Up to this point the quarrel had appeared in public as a difference of professional views. That notion quickly disappeared. Bitter over his abrupt "dismissal," Thomas charged Nichols with "constant annoyances and interferences." According to the indignant music director, the president had interrupted orchestra and choir rehearsals, intruded into examinations, and personally criticized Thomas for running overtime in his classes. Thomas clearly felt that Nichols had overstepped his area of authority and had made the music director appear to be "his hireling."[31] The ill-defined separation of authority between the two headstrong and domineering men invited conflict. As news of the break spread, the city divided. The *Cincinnati Commercial* supported Thomas, advising Nichols that his "usefulness in running the college is at an end." The *Cincinnati Times* first supported Thomas's position but then shifted to the board's side, while the *Enquirer,* professing neutrality, placed most of the blame for the quarrel on the music director's lack of administrative skills. The *Daily Gazette,* home of Henry Krehbiel, supported the college, with or without Thomas, Nichols, or the present board.[32]

Just as Thomas's coming to Cincinnati had elicited widespread news-

paper comment, so too did his departure. As was to be expected, New York papers gleefully reported the Queen City's discomfiture. Several of that city's music journals had been predicting Thomas's return since the autumn of the previous year, and the announcement of his resignation released a wave of smug propriety. Most of the daily newspapers welcomed the prodigal Thomas back, noting that the eastern metropolis was his logical home. While much of the comment focused on the fundamental differences between Thomas and Nichols, the *New York Times* exacted its pound of flesh. Referring to Cincinnati as a "trading and pork butchering emporium," the editor saluted the "Minstrel's Return" from his battle with "the infidels in the city of the unclean beast."[33]

The western press, long irritated over Cincinnati's inflated claims and seeing an opportunity to promote their own, also attacked the fallen monarch. The *Chicago Tribune,* a strong supporter in the past, chose this moment to scoff at Cincinnati's cultural reputation, suggesting that Thomas would find a friendlier reception in the lake city. The *Pittsburgh Dispatch* labeled the city a "beer-guzzling metropolis," while the *St. Louis Post-Dispatch* referred to the "loud yawp" that had emerged from Cincinnati just eighteen months before. In Indianapolis the *Sentinel* described the "considerable bristling, some grunting, and the usual amount of squealing" with which Cincinnati bemoaned its loss. The unkindest cut, however, came in the editorial columns of the *Chicago News.* With unintended irony, since Chicago was just surpassing Cincinnati in pork production, the *News* described Thomas's recent venture as "a Quixotic mission . . . to attempt to establish classical music amongst the pork-packers of Cincinnati." Alas, Porkopolis was a hard label to live down.[34]

The college troubles rapidly faded from the columns of out-of-town newspapers, but this was not the case within the city. It seemed that everyone had an opinion to offer. Reuben Springer, uncharacteristically angry, represented Thomas as a "petulant, impetuous, nervous and impulsive" man who has "treated Colonel Nichols outrageously." Letters in the *Cincinnati Enquirer* signed "Rex" and "M" supported the board's decision to drop Thomas, while that newspaper's editor deplored Thomas's ungentlemanly remarks about Nichols. Thomas supporters, including such prominent citizens as Learner B. Harrison, Edmund H. Pendleton, and Lawrence Maxwell, investigated the possibility of purchasing enough outstanding stock to reorganize the board of directors as a way of saving Thomas. Nothing came of this effort.[35] Most area musicians lined up behind their departing leader. Louis Ballenberg, former manager of the Cincinnati Orchestra, publicly called Nichols "very meddlesome," while an anonymous interviewee described the president as "arrogant, rude and tactless." "All of the leading musicians . . . think Mr. Thomas in the right," wrote one supporter, and

Arthur Mees, Bush Foley, and George Schneider resigned from the college faculty in protest of Thomas's dismissal.[36]

The controversy quickly spread into May Festival preparations. At a March 9 chorus rehearsal, Andrew West, a part-time Latin teacher at the college and long-time chorus member, presented to the assembled singers a paper supporting the festival leader and calling for the resignation of Nichols from the May Festival board. With George Whiting providing resounding blasts on the great organ, the chorus roared its approval. "The answering shout," reported the *Commercial,* "would have put a Democratic convention to shame." The following day Nichols, along with supporters Peter R. Neff and Jacob Burnet, resigned from the May Festival board. The twin pillars of the city's musical eminence had parted company, dividing both the musicians and the social elite who supported music.[37]

How does one make sense of this quarrel? Certainly fault may be generously assigned to both parties. Nichols and Thomas owned prickly personalities. Both were arrogant, inflexible, authoritarian, and used to having their own way—a volatile combination when placed in a situation where lines of authority remained obscure. Thomas had accepted the position of music director with the assumption that wealthy patrons would underwrite the expenses required for a truly national institution. The board of directors, and by extension the stockholders, were prepared to establish the college but considered tuitions to be the primary source of operating revenue. The concern for revenue interfered with Thomas's vision of artistic excellence. Whether the College of Music could pay its own way was a question that neither he nor the board apparently raised. Business experience suggested that there was no other way.

Thomas also found the administrative side of his position far less stimulating than the numerous musical chores to which he devoted his time. As many had observed, he was a born orchestra leader, not an administrator. Nichols recognized the problem, but his clumsy attempts at rectifying matters nettled the music director. Nor can the board be exonerated. Granted ultimate responsibility, it failed to delineate clearly the division of authority between the two men, relying far too much on the judgment of Nichols. Furthermore, the board ignored the conflict too long, and failed to provide a satisfactory hearing for Thomas's views. Its final decision appears based more on friendship and loyalty to Nichols than on the needs of the college. Was Nichols more important to the school's future than Thomas? Probably not, although the board seems to have thought so.

Most of the problems can be traced to hasty preparation. For all the grand pronouncements and ambitious goals, the board gave little thought to the proper means of achieving those goals. Questions of teaching theories, curriculum, and finances remained clouded. The division of labor between

Nichols and Thomas was explored no further than vague comments about "art" and "business" roles. The original promoters assumed that Thomas could provide the city with a major music school simply with his presence, and all efforts in the summer of 1878 had gone to obtaining him. The enthusiasm generated by his acceptance, however, could not overcome this haphazard attention to detail. The very idea of announcing a college in August and opening in October appears absurd today.

Yet, the College of Music survived, if not along the lines originally projected, and this was due in large part to the energetic response of the school's supporters. To offset talk that the college could not survive the loss of Thomas, the board moved swiftly to announce a reorganization. Professional and general music students would be separated into distinct departments, with the professional candidates enrolled for a proscribed course of study. Nichols would continue as president and assume Thomas's administrative duties as well.[38] "*The Faculty of the College remains together unchanged,*" reassured the board. "They are the actual instructors of the pupils; are artists of high standing . . . and with long experience as teachers." Actually, the teaching may have improved, as the *Daily Gazette* observed in an editorial. Although Thomas's departure had deprived the school of its major claim to distinction, his removal led to more balanced salaries and possibly increased devotion to teaching. If nothing else, the college could now settle down to a future of regional distinction.[39]

The shock waves that spread outward from the Nichols-Thomas confrontation shattered the cohesiveness of Cincinnati's musical community. To supporters of Thomas, Nichols was tightfisted and mean spirited; to Nichols's many admirers, the maestro was autocratic, temperamental, and unrealistic. The feelings ran deep. Nichols's resignation from the May Festival board and the emergence of Lawrence Maxwell and Edmund Pendleton as its leaders clearly revealed how the city had polarized. Thomas remained the music director of the festivals until his death in 1905, while Nichols led the college until his death in 1885, and then Peter R. Neff, his friend and supporter, took the position.[40] Since the college was located in Music Hall, the 1880 May Festival, scheduled to open only two months after Thomas's stormy departure, led to immediate conflicts between the two groups, ranging from the rental of chairs to the handling of the $1,000 music prize. And when the May Festival Association announced a performance of *The Messiah,* to be held in Music Hall on Christmas night, surprised college officials talked of an injunction in order to free the facility for their own intended concert. Thomas won that round, but the "open war" threatened serious injury to the city.[41]

Of more immediate concern were the rifts that developed between Thomas and those musicians whom he felt remained loyal to Nichols by

remaining on the college faculty. One month after the original explosion, Simon Jacobsohn, principal violinist at the college and concertmaster of the Festival Orchestra, accused Thomas of "despotic and sometimes savage treatment of musicians at rehearsals." According to the concertmaster, Thomas had urged the entire faculty to resign in order "to break up the college," and those who refused to betray a trust or wreck a "noble institution" were now paying the price. Otto Singer agreed, describing Thomas as "excitable and quarrelsome," not at all like the easygoing Nichols. Thomas's friends rushed to his support. While admitting that the relationship between the conductor and Jacobsohn was not of "an amicable nature," "that has no bearing on the matter." The director had not shown any favoritism, commented one letter writer, nor had he ever publicly criticized the concertmaster.[42]

Under the pressure of festival preparations, the divisive issue submerged, but Thomas had not dropped the matter. On the Friday evening of the festival, he announced a reorganization of the chorus—Otto Singer was out as its director. "Unceremoniously kicked out," the *Enquirer* spluttered. Singer expressed perplexity in the matter, yet he of all people should have expected the blow. Not only had he worked with the autocratic Thomas longer than anyone else in Cincinnati, but just three months earlier his request to conduct one of the festival's choral works had, for the first time, been rejected, a clear sign of Thomas's displeasure.[43] For all of Singer's talent, Thomas was not one to tolerate disloyalty. When Otto Singer chose to remain on the college faculty, his days with the festival chorus were numbered. Under the new arrangement Thomas added the chorus directorship to his other duties, while Arthur Mees, who had resigned from the college faculty, became resident conductor.[44] It would be up to another generation to induce harmony again.

The loss of Theodore Thomas, assumed by many to be a fatal blow, did not damage the College of Music materially. Enrollments remained high. Student concerts and faculty recitals continued to draw sizeable audiences. And Reuben Springer remained a steadfast supporter. As he neared the end of his life, an urgency to ensure the permanency of the college affected the philanthropist. In 1882 he contributed funds for a new building to be constructed adjacent to Music Hall, and the following year saw the completion of Odeon Hall. He influenced the board to change the college to a nonprofit institution by establishing an annual endowment of $60,000 in railroad stock. As he proudly wrote a friend, the college "is *self-sustaining*—it has a permanent endowment of $4,200 a year and over $10,000 surplus cash in the treasury. . . . The organization . . . has been changed from a joint stock company to an Educational Institution, which will free the property from taxation . . . we feel as if the enterprise was on a solid foundation"

Springer continued his munificence in death, providing additional shares of stock through his will. With its four hundred students, thirty-five-member faculty, and its new facilities, the College of Music survived the unpleasantness of 1880 quite adequately, and remains today as part of the College-Conservatory of Music of the University of Cincinnati.[45]

Out of the activity and turmoil that attended the college's first two years, two important and positive developments resulted. In keeping with his aim of encouraging and recognizing American talent, George Ward Nichols had presented in 1878 a plan to the May Festival board, calling for a prize to be awarded to the best musical composition submitted in a competition between John Knowles Paine and Dudley Buck, at that time the nation's leading composers.[46] Since neither Paine nor Buck endorsed the idea of head-to-head competition, the board then decided to open the competition to all native-born composers, with the winning musician to receive $1,000 and the composition to be performed at the 1880 festival. At a time when there existed almost no recognition of American composers, this generous proposal stirred considerable interest. Despite controversy over the judging procedures, the selection of Dudley Buck's cantata *The Golden Legend,* based on a Longfellow poem, received general acclaim. The board repeated the competition in 1882. To avoid some of the previous criticism, Thomas obtained Carl Reinecke of Leipzig and Camille Saint-Saens of Paris to serve with him as judges. With less publicity this time, the three men unanimously agreed upon William Gilchrist's composition based on the Forty-sixth Psalm. Possibly because the 1882 festival failed to produce a profit, or perhaps because the prize was too closely identified with Nichols, the competition was dropped after its second year. Although both Buck and Gilchrist echoed European styles in their works, composing to current taste, the Cincinnati competition focused national attention on American artists and stimulated some interest in the performance of American compositions. That the amount of the award would not be equaled anywhere in the nation until the next century speaks well for the May Festival Association's support. The pity is that the competition was discontinued.

The second important development was an opera festival. During the concert season of 1879–80, a number of opera companies appeared in the city, highlighted by Her Majesty's Opera Company's lavish performances. This general interest in opera did not escape the keen eye of George Ward Nichols.[47] Forced off the May Festival board in 1880, and seeking to reassert the College of Music's reputation, the ambitious Nichols announced an opera festival for February 1881 "on a scale of magnificence unparalleled in this country or in Europe." He engaged James H. Mapleson of Her Majesty's Opera Company to create a musical event to rival the May Festival. Together they planned seven operas to be performed in one week, with Etelka Ger-

119

ster, "the Hungarian Nightingale," as the prima donna. To accommodate the great festival, Nichols converted Music Hall into an opera house. A large proscenium was added to the stage, a curtain was designed, and special satin and gold box seats installed. A. Hamilton Bugher, the son-in-law of *Enquirer* publisher Washington McLean, chaired a citizens committee which arranged an auction of "season tickets." With great fanfare over 1,500 tickets were sold in this way, netting a total of $25,000.

As was his custom, Nichols handled the local arrangements. He promoted the festival effectively, arranged for special railroad excursions to accommodate out-of-town patrons, and hired John Rettig, a young local artist, to paint the scenery. Members of various local singing societies, plus the choir from the college, made up the chorus, and if these predominantly German-American singers found Italian a problem, no one seems to have noticed. Five thousand exuberant opera lovers filled the auditorium for the much-heralded opening performance of *Lohengrin,* with even standing room tickets selling for one dollar. In the tradition of the era, local newspapers paid more attention to fashionable dresses than they did to the productions, and considerable notice was paid to the oysters and champagne repast served during intermission to callers at the private box of the Bughers. By the end of the week no one questioned that Nichols had succeeded in making the opera festival the social event of the year. Mapleson, never blessed with modesty, later described the festival as "the most daring musical enterprise ever attempted in America or any other country." The press agreed. Despite some adverse criticism directed at Gerster's voice, Nichols had once again orchestrated a festival on the grand scale. Following the last performance, he received his due homage. To assuage the wounds of the previous year, he was brought on stage to be "cheered to the last echo" by the exultant audience. More importantly, the sizeable profit guaranteed a repetition the following year.[48]

In 1882 Mapleson returned, bringing the same male vocalists, led by tenor Italo Campanini, while two Americans, the popular Minna Hauck and Emma Juch, headed the female cast. In a stroke of genius, Nichols also arranged for Adelina Patti and her company, under the management of Henry Abbey, to give two performances during the festival. The toast of two continents, the incomparable Patti brought to the stage a commanding presence, dark beauty, and an exquisite voice. Her appearance assured success. Just two days before her scheduled opening in *Aida,* however, she fell ill, generating even more publicity as newspapers provided daily comment on her condition and speculated whether her illness was real or the feigned behavior of a temperamental artist. When she finally appeared on stage, almost seven thousand people jammed Music Hall to see and hear one of the legends of their time. The crowd did not leave disappointed.[49] Although Patti overshad-

owed the other performers, the second festival met with unanimous approval, and again Nichols received public acclaim, certified by a testimonial dinner at the St. Nicholas Hotel. As a by-product of Patti's appearance, the city gained another accomplished pianist. Nichols had been seeking an additional teacher for the college. Patti recommended her young accompanist, Albino Gorno, who accepted the position and remained an important part of the college until his death almost sixty years later.

By the following year a spirited rivalry had developed between the two impresarios, Mapleson and Abbey. To counter Mapleson's position in Cincinnati, Abbey arranged his own opera festival, starring the statuesque Swedish songstress Christine Nilsson, to be held at Robinson's Opera House during the same week as the college's festival. His challenge fell short. The inferior facilities and the smaller auditorium left him with a sizeable deficit. Meanwhile Mapleson, taking no chances, had signed the petite Patti to a contract. Conquering subzero temperatures as well as the rival festival, the Englishman swept all before him. An appreciative city now toasted him with a dinner, from which the impressario left with the keys to the city.

The next year brought a dramatic turnabout. Abbey, fresh from a brilliant and costly opening season for the newly completed Metropolitan Opera House in New York, wrested the coveted College of Music contract away from Mapleson. Abbey and Nichols designed a two-week, twelve-performance festival that was intended to eclipse previous efforts. Nilsson, Marcella Sembrich, and Italo Campanini furnished the necessary European reputations. Mapleson retaliated by renting Heuck's Opera House for the same two weeks, prepared to challenge his rival head-to-head. He never arrived in the city. The muddy, swollen waters of the Ohio kept him in Chicago, leaving irate local backers with deficits of $3,000. "Mapleson will be eternally damned," exclaimed the *Enquirer*. Abbey carried on despite the rising river. With the lower parts of the city inundated, the gas works under water, and national guardsmen patrolling the streets, Cincinnati opera lovers failed to turn out. For the first time the College of Music lost money on its festival.[50]

The next twelve months brought more troubles to the young college. Reuben Springer died in December 1884, followed nine months later by his friend George Ward Nichols, depriving the institution of valuable leadership and halting plans for a fifth opera festival. In the absence of a local season, both Walter Damrosch and Theodore Thomas visited Cincinnati with rival New York based opera companies. Neither succeeded financially. "A sorry comment on the boasted musical culture of Cincinnati," mourned *The Graphic*. In 1886 A. Howard Hinkle, a long-time opera lover, staged a fifth festival, bringing in the American Opera Company for the occasion.

Poor weather, the stress on American talent, and unknown soloists resulted in a financial loss. Hinkle did not attempt another. The idea of local opera festivals receded, leaving the city once again dependent on the whims of touring companies, and thirty-four years elapsed before the idea resurfaced in the famous summer opera seasons held at the Zoological Gardens.[51]

The change in Cincinnati's musical reputation was dramatic. The decade of the 1870s had painted a bright future for the city. The construction of inclines which connected the hilltops to the densely populated basin area below, the rapid progress of the railroad link to Chattanooga, and the arrival of the Democrats to nominate a presidential candidate in 1880 had helped restore the damaged pride of the Queen of the West. The newly opened College of Music had unleashed its own burst of activity commensurate with the new public spirit. Orchestral concerts, faculty recitals, and quiet evenings of chamber music lent an unparalleled sophistication to Cincinnati's cultural life. Superb concerts by the Maennerchor and the Harmonic Society supported the college's efforts. A revived Choral Society, led by Signor Janotta, and newer organizations such as the Musical Club, the Germania double quartet, and the Apollo Club added to the pleasure. Audiences for prominent visiting performers remained large and enthusiastic. In 1879 the North American Saengerbund returned, stirring German hearts and rekindling support for singing societies. The rapid increase in the number of music schools, complemented by scores of private teachers, gave evidence of the expanding love of music in the city on the Ohio.

Even before Theodore Thomas's departure in March 1880, however, one local observer saw a disturbing sign in the declining attendance at the operas performed by Her Majesty's Opera Company. A discouraged Mapleson had vowed never to return to the city, a vow he broke the following year. Perhaps the College of Music had absorbed too much of the community's musical energy; perhaps the weather was bad. Whatever the reasons, "the musical centre of America" embarrassed itself in 1880. The row between Nichols and Thomas cast a gloom over the city that affected all musical activities. Of course, the May Festival breathed its usual vigor into the city; yet even this event dimmed in the shadow left by the Thomas-Singer quarrel. Furthermore, the May Festival Association's decision to organize a permanent chorus sapped the membership of local singing societies, several of which dissolved, including the Harmonic Society. Harmony had indeed deserted Cincinnati.[52]

The aspirations of Cincinnati never fully recovered from the acrimonious events surrounding Thomas's removal. Gone was the dream of cultural supremacy. Gone were the comparisons with Leipzig and Paris. The city's musical cohesion lay shattered; even the year's end brought a discordant note. Thomas had arranged for Adelina Patti to appear in the Christmas

performance of *The Messiah*. News of her $6,000 contract, linked to a hint of scandal surrounding her two divorces, drove ticket prices up as high as twenty-five dollars on the street. A full house attended the concert, but not everyone found the performance satisfactory. It "lacked precision and force," commented the *Cincinnati Daily Gazette*. The rival *Enquirer* used the occasion to criticize Thomas's handling of the event, stirring up old passions, and six weeks later the orchestra director was still angry with the newspaper. Patti herself left town furious, insulted when May Festival Association president Edmund Pendleton had escorted Annie Louise Cary, the American favorite, to the stage, seating her closest to Thomas. The celebrated Patti was not amused. Suddenly nothing seemed to go right for the city.[53]

Successful opera festivals in succeeding years only partly alleviated the situation. Cincinnati's musical life remained stunted, lacking a necessary spirit of cooperation. A transplanted Bostonian, writing to the *Boston Daily Advertiser,* described the general musical fare in 1881 as "dull." The recent, rapid growth, he surmised, had been "a hothouse product of local pride and western enthusiasm." The city had inflated its vision, and the reality could not sustain the expectation. Thomas's departure had left a void, principally in orchestral development. When the College of Music showed no inclination to promote symphony concerts for the 1880–81 season, the Cincinnati Grand Orchestra, joined by the Musical Club, proposed a modest five-concert season. Lucien Wulsin, president of the Musical Club and a partner in the D. H. Baldwin Company, attempted to get seven hundred subscribers at five dollars each to underwrite the series. Despite strong press support, the enterprise failed. Louis Ballenberg attempted similar schemes in 1882 and 1883, neither of which succeeded. As an official of the College of Music stated, "classical concerts do not pay, either here or elsewhere." Queen City music lovers listened to a variety of band concerts, evening programs of light music, choral programs, and piano recitals, but between 1880 and 1884 the majestic tones of symphonic music were rarely heard in Cincinnati.[54]

The year 1884 proved nearly fatal to the flickering hopes of music patrons. The extravagant opera festival ran afoul of the rampaging river, leaving a decidedly unwelcome deficit. Three months later the May Festival faced declining attendance as well. Whether a result of the Court House riot that distressed the city in March or Thomas's emphasis on Wagnerian music, the resulting $20,000 loss not only wiped out the previous surplus, but unleashed a new wave of criticism. Newspapers aired charges that Thomas and his orchestra had lined their pockets and inflated their reputations at the expense of hardworking local musicians and singers. The *Commercial-Gazette* publicized the festival's expenses, and neither Thomas's $5,000 contract nor the almost $12,000 for his ninety-member orchestra

found a favorable reception with readers, especially when compared to the homegrown chorus which sang without pay and the thirteen local orchestra players who received fifty dollars each. The discord generated new activity. The criticism of Thomas launched a campaign to make the festival a truly Cincinnati event. Lucien Wulsin, still nursing ambitions for a permanent orchestra in the city, wrote Henry Krehbiel, then in New York, requesting information on the organization of the New York Philharmonic Society. He liked the response. In June 1884 Wulsin and Peter Neff met with Michael Brand of the Cincinnati Grand Orchestra to explore the possibility of a new organization. The result was the Philharmonic Orchestra under Brand's baton, and an immediate season of five concerts was announced. The opening performance, in the new 1,200 seat Odeon Hall, drew a capacity crowd, and hope for a permanent orchestra rose again. Citing this activity as "a wonder in music," *The Graphic,* the city's latest cultural journal, called the orchestra "the living core of art-life."[55]

The emergence of the Philharmonic also provided a unique opportunity to heal the division that existed between the two principal music institutions. Neff, who had succeeded the ailing Nichols as head of the College of Music, served as president of the new orchestra, while Wulsin sat on the board of the Musical Festival Association. Supported by men of ability, social position, and influence, the Philharmonic's prospects appeared bright. A year later the harmony again dissolved. The orchestra divided over a challenge to Brand's leadership. Always sensitive to criticism, Brand resigned his post, and a trio of violinists immediately sought the position. Henry Schradieck, a recent and highly regarded addition to the college faculty, championed a conservative, traditional approach to music; John Broeckhoven, a Cincinnati resident for many years, was "an ardent supporter of the Wagner school"; while Simon Jacobsohn, orchestra concertmaster and reputed to be the finest musician in the city, had the backing of many musicians. The heated contest brought further disorder to the musical community. Even a plea "to prove they are laborers in the cause of art and not mere vulgar money makers," failed to resolve the issue. The board finally selected Broeckhoven, who in turn agreed to share the podium with Schradieck. The angered Jacobsohn "drew off in a huff." Peter Neff nurtured the orchestra by placing Broeckhoven and several other members on the college faculty, even creating a new department of wind instruments. However, expenses outran support and gradually the college absorbed the entire orchestra.[56]

The return of the May Festival in 1886 brought renewed criticism of Theodore Thomas, especially for his handling of the chorus. Another sizeable deficit encouraged more complaints, but talk of replacing the maestro brought forth a strong defense from William Hobart, the Festival Association's president. Opposed to Thomas's continued leadership, Lucien Wulsin

and Howard Hinkle resigned from the festival board, severing the link that the Philharmonic had forged. At the same time Arthur Mees angrily resigned as chorus director. Once again, it appeared that Thomas's role had divided the community. In the meantime the College of Music orchestra, formerly the Philharmonic, presented an uninspiring concert series under Schradieck's direction. The orchestra soon broke up. Schradieck left the college. For the next several years, numerous individuals called for the establishment of a permanent orchestra, and the *Enquirer* went so far as to print a list of local millionaires, headed by industrialist David Sinton, who might be persuaded to emulate Henry Higginson, the generous patron of the Boston Symphony Orchestra. None came forward. The musical factions discouraged all efforts at unity, and by 1890 Cincinnatians again had to depend upon visiting orchestras for serious concert music. Even the Cincinnati Grand Orchestra, revived once more by Brand and Ballenberg, had deserted serious music for more profitable popular concerts. When criticized by the music critic of the *Cincinnati Times-Star* for the "trashiness" of his programs, Brand tartly replied, "We give the people what they like. They don't want anything better." The truth was bitter. Even more upsetting to proper Cincinnatians, in 1891 upstart Chicago lured Thomas away from New York to serve at the head of that city's newly founded symphony orchestra—even the pretense of musical supremacy in the West had now slipped through the Queen's grasp.[57]

As Cincinnati fell behind Chicago, musical life in the city receded to a succession of pleasant but undemanding performances. In the summers the parks hosted a colorful array of band concerts, while the cooler and airier hilltop resorts delighted patrons with popular evening concerts. The Apollo and Musical Clubs continued the choral tradition, but these activities that had appeared so vital a generation earlier now seemed tepid. As critic John S. Van Cleve pointed out in 1884, the general populace was not really musical, only "drawn out by grand affairs." While all of the nation's cities struggled with this problem, Cincinnati suffered more than most of its rivals. Yet, Van Cleve also spoke of a strong minority in the city who worked to maintain the city's reputation. For these music lovers the light fare of concerts and recitals proved insufficient. Frustrated by the repeated failures of the previous ten years, this minority awaited only a new combination of circumstances. In retrospect, then, the decade of the 1880s may be seen as a period of transition from the exuberance of the early May Festivals to the more realistic plans evident in the establishment of the Cincinnati Symphony Orchestra in 1895.[58]

The effort that led to the establishment of a permanent orchestra began in obscurity.[59] In September 1891 twenty-five musically talented and socially prominent women, devoted "to the study and practice of music and

the promotion of a higher musical taste and culture," formed the Ladies Musical Club. If their name appeared ordinary, their accomplishments proved decidedly extraordinary. Part of a national women's club movement that constructively channeled the vitality and ability of so many middle- and upper-class women, the Ladies Musical Club from the beginning sought to improve the cultural base of the city. The women began in a familiar pattern, presenting a variety of concerts, occasionally inviting musicians from outside the city to perform with them. These small, semipublic gatherings worked well. Sponsorship of a joint singing recital by Mr. and Mrs. Georg Henschel, the director of the Boston Symphony Orchestra and his Ohio-born wife, along with a well-attended concert by the Boston orchestra, brought additional recognition. Active membership in the Ladies Musical Club expanded to fifty, while associate or nonperforming membership soared to three hundred. Encouraged by this reception, and recognizing that old rivalries and antagonisms had receded at last, the women turned their attention in 1894 to the establishment of a permanent orchestra for the city. The club provided a new network of relationships that in large part bypassed the male-dominated connections which had entangled previous efforts, and through this network the club tapped the city's deep, latent musical energies in a new way.

This sixth effort to establish a permanent orchestra differed from its predecessors in that women made up the entire membership of the Orchestra Association and its board of directors. Although men served in an advisory capacity, the responsibility for administration and fund-raising lay in the hands of the women—a situation perhaps unique in the history of major cultural institutions. Of course, by birth or marriage, the fifteen board members represented many prominent Cincinnati families. Names such as Sinton, Taft, Anderson, Forchheimer, MacDonald, Stallo, Herron, Holmes, Fleischman, Roedter, Fechheimer, and Schneider suggest the valuable social and financial connections available to the fledgling organization. Thirty-three-year-old Helen Herron Taft, wife of Judge William Howard Taft, served as the association's first president. As was to be expected, fund-raising proved to be the major concern. The board turned to the competent Helen W. Chatfield to lead a subscription drive, emphasizing that the proposed orchestra would be "distinctly a Cincinnati affair." Harnessing civic spirit with love of music, Chatfield's committee sought support from individuals and business establishments. In spite of the economic downslide that had started the previous year, the drive quickly brought in pledges amounting to over $10,000. *The Cincinnati Times-Star,* published by Charles P. Taft, half-brother to William Howard, gave freely of its support, envisioning the new orchestra as the means of unifying and invigorating Queen City musical life. Lucien Wulsin, Julius Dexter, Nicholas Longworth III, Melville

Frank van der Stucken, left; Helen Herron Taft, at right. Courtesy of the Cincinnati Historical Society.

At left, Lucien Wulsin, courtesy of the Cincinnati Historical Society. Right, Clara Baur, Special Collections, University of Cincinnati.

Ingalls, and other leading business and professional men dispensed both advice and money generously. Staunch support also came from the newly organized Cincinnati Woman's Club, "an organized center of thought and action among women for the promotion of social, educational, literary and artistic growth." The two women's organizations shared twenty-four members, and Annie Laws, the first president of the Woman's Club, had long been active in musical circles.

Encouraged by this backing, the Orchestra Association turned to the critical selection of an orchestra director. Most of the members hoped the prospective orchestra would also serve as the May Festival orchestra as well, and that the individual chosen would direct both. Experience in handling both orchestra and chorus, along with the necessary administrative skills, limited the number of candidates. Of course, Michael Brand's name immediately surfaced, endorsed by many local musicians. Whatever his qualifications, Brand was an old shoe in the community. His name lacked the necessary stature. Furthermore, as several board members suggested, the new musical eminence should be "a stranger to Cincinnati so as not to bring up old feuds." Sensing that a local figure had no chance, Brand gracefully declined consideration, although he later served as assistant conductor and principal cellist.

In their search to identify distinguished candidates, the board sought suggestions from Theodore Thomas, Henry Krehbiel, Walter Damrosch, and others prominent in the music field. Two names soon captured the board's attention: Henry Schradieck and Frank Van der Stucken. Schradieck, active in Cincinnati in the mid-1880s as conductor of the Philharmonic, had recently returned to the United States from several years' study in Europe and currently lived in New York City. Popular with Cincinnati musicians, he had vigorous support from three board members. Van der Stucken, on the other hand, was virtually unknown. Born in Texas, he had been reared in Belgium, his father's native country. Following studies in Antwerp and Leipzig, he had earned an enviable reputation since 1884 as the director of New York's Arion Society.

The final decision proved too difficult for both the stockholders and the board. Thus, Mrs. Taft was appointed chairwoman of an ad hoc committee with the "power to act." She strongly preferred the Belgian. Correspondence began between Mrs. Taft and Van der Stucken concerning a dual position with the Cincinnati Symphony Orchestra and the May Festival Association, but William Hobart, president of the Festival Association, vetoed any hope that the new director would supercede Thomas at future festivals, a situation not realized until 1906, the year following Thomas's death. Negotiations with Van der Stucken eventually stalled over the length of the contract, a serious matter considering the short tenure of "permanent" orchestras. Van der

Stucken also had second thoughts about leaving New York, no doubt having been informed of the Queen City's somewhat clouded past. With time running out for a winter season, the board worked out a makeshift arrangement for a nine-concert season, with the musical direction divided among Van der Stucken, Anton Seidl, and Theodore Thomas. At the insistence of two board members, however, Schradieck replaced Thomas, thus keeping his candidacy alive.

With leadership temporarily solved, the board moved to organize the orchestra. Local musicians made up almost the entire orchestra, and to avoid potential labor difficulties, most, if not all, were members of the Cincinnati Musicians Protective Association, the local union founded in 1881, which had been a prime mover in the establishment of the American Federation of Musicians. Although this required payment of union wages, it ensured higher quality players and a uniform contract. On January 17, 1895, before a modest audience at Pike's Opera House, the hastily organized Cincinnati Symphony Orchestra made its debut. Following opening remarks by William Howard Taft, Melville Ingalls, and A. Howard Hinkle (conservative tradition discouraged public appearances by women), Van der Stucken led the orchestra in a performance of Mozart's *G Minor Symphony.*

Local critics found much to praise. Despite the short rehearsal time (Van der Stucken had arrived in the city only ten days before the opening concert), and a noticeably weak woodwind section, the director's discipline and attention to detail impressed everyone. His engaging personality also captivated Cincinnati society at a series of fashionable dinners held in his honor, a not inconsequential factor in his candidacy. The second series of three concerts, led by the noted Wagnerian interpreter, Anton Seidl, touched off similar plaudits, with several people observing how much local talent could achieve with good leadership. In the meantime Mrs. Taft had reopened negotiations with Van der Stucken, and even before Schradieck took his turn at the podium, she offered her preferred candidate a contract. He accepted and became the orchestra's conductor for the next twelve years.

The Cincinnati Symphony Orchestra came of age during Van der Stucken's tenure. To be sure, money remained a problem, periodically alleviated by the generosity of Mr. and Mrs. Charles P. Taft. A bitter quarrel between the Orchestra Association and the union led to the cancellation of concerts in 1908 and 1909, clouding Van der Stucken's departure in 1907. Still, he left a solid core of musicians, a visible realization of what the city could accomplish, and an orchestral reputation surpassed only by Boston and Chicago. From these shaky beginnings the Cincinnati Symphony Orchestra emerged to become the dominant force in the city's musical life, overshadowing both the May Festivals and the College of Music. Even the dismal

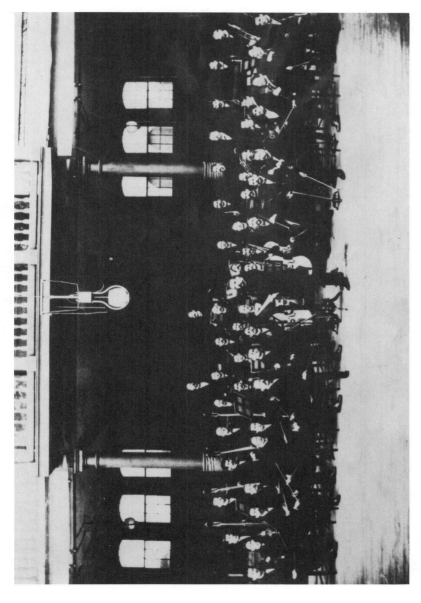

Cincinnati Symphony Orchestra under the direction of Michael Brand, assistant conductor, ca. 1895; from the Collection of the Public Library of Cincinnati and Hamilton County.

interlude of 1908–1909 did no permanent damage, for the Orchesta Associ-
ation, pressured by rising costs and limited time, placed the orchestra's lead-
ership in the unknown hands of Leopold Stokowski. Harmony did not al-
ways prevail, but outstanding conductors helped carry Cincinnati's musical
tradition firmly into the new century.

Advances and Retreats: Literary and Intellectual Currents, 1865–1900

While music flourished in Cincinnati during the post–Civil War decades, the city's reputation as a literary and intellectual center slipped abruptly. The Cary sisters had long since made New York their home; the Beechers had returned to New England; and the Semi-Colon Club had scattered. Following Moncure Conway's attempt to revive the *Dial* in 1860, concerted literary activity faded. Of course, the community still produced a sprinkling of poets and writers, mostly of marginal talent, and the Literary Club maintained its Saturday night tradition, but the promise of the 1850s failed to materialize. Between 1850 and the end of the century, scarcely a single important writer emerged from the "Athens of the West," and for reasons that remain obscure, literary creativity shunned the proud metropolis.

To this disappointing record there was one partial exception. For eight years Lafcadio Hearn lived and worked in the city, serving an apprenticeship in journalism before leaving to secure a reputation, first as a writer of romantic novels and finally as a resident and interpreter of Japan. Hearn's arrival in Cincinnati in 1869 suggested little of distinction. Born Patrick Lafcadio Hearn nineteen years before, he was the son of an Irish surgeon in the English army and a young Greek girl, a resident of the Ionian island of Leucadia. The marriage, a product of loneliness and passion, did not last. Consequently, young Lafcadio spent an uneasy childhood with his father's family in Dublin. Short, swarthy, myopic with protruding eyes, and carrying an accent, the boy made few friends. His mother returned to Greece when he was four; he saw his father, still in the army, for the last time when he was seven. Orphaned and shifted among relatives, Hearn gained a scattered education in Ireland, France, and England. By his sixteenth birthday, he had

earned a reputation for an inquisitive mind and an unpleasant disregard for authority, especially religious authority. On top of his nearsightedness, he also lost the vision of his left eye due to a schoolyard accident, and for the next ten years he wore extraordinarily thick glasses in an attempt to hide his bulbous, sightless eye. The injury also ended his formal education. At odds with his guardian, Henry Molyneux, he spent the next two years destitute in London. Finally deemed incorrigible by his "family," he was packed off to relatives in Cincinnati.[1]

The Cincinnati relations proved no more hospitable than Molyneux, so Hearn decided to fend for himself. Alone in a noisy, dirty, sprawling city, ill equipped for physical labor, the nineteen-year-old immigrant suffered through months of despair and deprivation. During the first summer, he slept in packing boxes, grocers' sheds, haylofts, and an unused boiler. His lack of experience, coupled with his sensitivity about his physical features, pushed him towards the life of a recluse, and only a succession of odd jobs kept him from starvation. Sometime during those early months, he established a lifelong friendship with Henry Watkin, an elderly English-born printer. Watkin initiated the young man into the mysteries of typesetting, listened to his boyish dreams, and served as the father the boy never knew. Through the Englishman, Hearn discovered the world of Emerson, Howell, and Holmes, which the two shared in the pages of old issues of the *Atlantic*. Encouraged by Watkin, Hearn took a position as proofreader in the publishing firm of Robert Clarke & Co., where his meticulous concern for proper punctuation earned him the nickname "Old Semi-colon." The intense work proved too strenuous for his good eye, however. For a while he served as a private secretary to Thomas Vickers, a liberal Unitarian clergyman who later became head of the public library. Perhaps it was Vickers who steered him to that growing institution, for it was there that he developed a fondness for contemporary French romantic novelists. In the meantime he had begun to write for himself, and in 1872 his first efforts appeared in *The Cincinnati Enquirer*. The shy, diminutive Hearn one day had gone to the editor's office and quietly handed him a review of Tennyson's *Idyls of the King*. The editor, John Cockerill, liked what he read, and for the next several years Hearn became a fixture there, writing on a wide variety of subjects, working all hours, with his "great bulbous eye resting as close to the paper as his nose would permit"[2]

Hearn's arrival on *The Enquirer* coincided with publisher John R. McLean's ambitious rejuvenation of the newspaper. Voicing a shrill, combative anti-Republicanism, *The Enquirer* pushed to the forefront of the local press. McLean bolstered circulation through sensationalism, and Hearn's colorful reporting contributed to this rough, often offensive style. Humor, satire, and outrage became his weapons. His articles criticized temperance

advocates, exposed spiritualists, attacked a host of frauds and insincerities, and titillated his readers with accounts of the city's more sordid life. Often he turned toward the exotic or morbid. Attracted to the sensational he deliberately sought out the darker corners of the community, prowling the waterfront or visiting the nocturnal businesses on infamous Rat Row. Without question, his most famous contribution to local journalism was his vivid account of the tanyard murder case, one of the more gruesome crimes in the Cincinnati area. In covering this investigation and trial, Hearn wrote for emotional effect, influenced by the so-called decadent writers of France. Taste, sight, and smell were emphasized, with the horrors of the actual murder reconstructed in grisly detail.[3]

If much of Hearn's early newspaper work possessed a decidedly unsavory cast, it nevertheless revealed an amazing descriptive talent. His final two years in the city, however, indicate a shift away from the sensational, and his finest writing during his Cincinnati years included the warm descriptions of the blacks who lived and worked along the riverbank. He showed an early fascination with folklore long before it became fashionable, and his lifelong curiosity about other cultures first appeared amidst the rich diversity of Cincinnati's people. Hearn's natural inquisitiveness also opened many personal doors for him. An interest in folk music cemented a friendship with fellow reporter Henry Krehbiel, and the two of them once sponsored an unusual concert of Chinese music, performed by three local Chinese men, at the rather sedate Musical Club. Following a lecture by Krehbiel on the history and theory of Chinese music, the club members listened to the ancient music as played by laundryman Char Lee and two friends. What the club members thought of the concert was not recorded. Krehbiel, more serious and calmer than the excitable Irishman, shared with Hearn an ambition that extended far beyond newspaper work. Their friendship served them both well.[4]

Joseph Tunison became another in that coterie of journalists who made Hearn's life interesting. Quiet and literary, Tunison later worked for *The New York Tribune,* and ended his career as editor of *The Dayton Journal.* Another friend, the artist Frank Duveneck, just returned from three years in Munich, once invited Hearn to observe a mysterious and beautiful female model who posed nude for several of the more advanced young artists in the city, and Hearn's humorous newspaper account captured the specialness of that particular evening. Artist Henry Farny, in whose studio the nude posed, not only became a good friend, but for a short time a business partner as well. The boisterous, fun-loving Farny provided the focal point for the city's small Bohemian circle. Honest, openminded, and gregarious, he easily drew the reporter into his world.[5]

Hearn and Farny shared an interest in the human condition. Both em-

pathized with the underdog, and Farny's sketches of the human misery found at the city police station had early attracted Hearn. In their frequent talks they discovered a common frustration with the meager support for artistic expression, deploring especially the prostitution of art to commercial needs. They decided to lead Cincinnati out of its Philistinism. Farny, who had already gained considerable repute as an illustrator for the popular McGuffey Readers, also did the art work for a short-lived literary journal titled *Kladderadatsch*. Started in 1874, "Kladdy" proved an overly ambitious venture for its financial backer, E. A. Austerlitz, but Farny and Hearn convinced him that a similar journal in English could recoup his losses. *Ye Giglampz,* "A Weekly Illustrated Journal Devoted to Art, Literature and Satire," debuted on June 21, 1874, with the front page bearing a cartoon of "Herr Kladderadatsch Introducynge Mr. Giglampz to Ye Publycke." Hearn, still a reporter for the *Enquirer,* contributed almost all the reading matter; Farny drew the illustrations.[6]

Ye Giglampz, meaning "spectacles of a huge and owlish description—just such spectacles as sat upon the intellectual nose of the myopic editor . . . ," failed to reach its intended audience of literati—indeed it failed to reach any audience. Hearn's articles on London poverty, the cruelty of the Spanish people, the hypocrisy of missionary activities, and the fraudulence of spiritual mediums reflected his newspaper training rather than the hoped-for satire. Two short pieces by Farny, one on George Ward Nichols and the other on the McMicken School of Design exhibit, failed to lend much distinction to the first issue. Thirty-five copies were sold. The second issue continued the heavy tone, rescued in part by Farny's devastating cartoon of a stout Henry Ward Beecher, complete with a large scarlet "A" on his chest. Beecher, the brother of Harriet Beecher Stowe and the prominent pastor of Brooklyn's Plymouth Church, had been accused of adultery, and the story and subsequent trial remained one of the sensations of the year. For all of that, the weekly still struggled.

Intended to be "excruciatingly funny without descending to coarseness or salacity," *Ye Giglampz* continued to provide a large dose of Hearn's somber views, soon joined by his own brand of French sensationalism. Farny, alarmed at his partner's assault on Victorian decency, accused Hearn of "pandering to depraved tastes." More in touch with Cincinnati sensibilities, Farny edited his associate's risque contributions, although "Fantasies for Sultry Seasons," a satire on American missionaries in the Pacific, remained far too bold for local taste. The growing division between the two editors foreshadowed the collapse of the magazine, and after several more issues Austerlitz bailed out of the venture. For a few more weeks Hearn and Farny attempted to finance the journal themselves, with Farny contributing most of the money, but after its ninth issue *Ye Giglampz* expired,

Lafcadio Hearn, left, courtesy of the Cincinnati Historical Society. Below, cover of the first issue of *Ye Giglampz,* from the Collection of the Public Library of Cincinnati and Hamilton County.

as much a victim of divided management and limited audience as, in Hearn's sardonic comment, it was of "the bad taste of the great American people"[7]

Henry Farny, of course, went on to a distinguished career as a painter of American Indian life; Hearn returned to *The Enquirer,* where his reputation for the sensational peaked with his account of the tanyard murder that October. The following year he moved to the *Cincinnati Commercial.* His work took on a more serious tone, yet continued to display the powerful descriptive talent which had been evident from the beginning. In addition to news stories, Hearn also served as the theater critic, displaying a frankness and honesty not commonly found in newspapers of that time. He remained with the *Commercial* for two years, developing his mature style, and it was during this time that he wrote his best work. Still, he was not happy. Newspaper work, especially the "Batrachian torpor and chill" of the *Commercial's* newsroom, depressed him. A sensitive man with great intelligence and ambition, Hearn was no longer satisfied with a reporter's life. Literature beckoned. A marriage (nonbinding because of Ohio's miscegenation law) to a mulatto, Althea (Mattie) Foley, had soured, leaving him lonely and guilt-ridden. A second entanglement, this with a middle-aged wife of a prominent physician, became increasingly embarrassing as the woman allowed their friendship to become an infatuation on her part. Weary of cold winters and tired of daily reporting, Hearn's romantic sensibilities took him to New Orleans in the fall of 1877, the next stop on his remarkable career.[8]

Hearn's departure, coupled with the failure of *Kladderadatsch* and *Ye Giglampz,* discouraged similar ventures for the remainder of the decade, although the next decade proved more adventurous, if no more successful in the long run. Percy Procter, a former reporter and a friend of Hearn's, in September 1883 launched *The Week: Illustrated,* a liberally illustrated magazine devoted to art, literature, and news of the entertainment world. Featuring art work by Farny, Alfred Brennan, and John Rettig, *The Week* focused more on gossip and snips of fashion information. "Intended for entertainment," the journal never explored seriously the worlds of art, music, or literature, despite the numerous reproductions of European salon painting and an occasional column on the local opera festival. Less than six months after its first issue, Proctor embarked for France for "rest and recuperation." *The Week* had ended.[9]

The next year the *Cincinnati Graphic* made a determined effort to cover cultural affairs, but columns on local artists, musical activities, and literary events soon gave way to more spectacular news. The illustrations, many depicting the highly idealized female nudes popular at the time, brought considerable distinction to the enterprise. Subscribers remained

few, however, and after two years the *Graphic* ceased publication. In its footsteps came *The Criterion,* the most ambitious of the decade's cultural journals. R. G. Outcalt, the magazine's "Chief of Artists," reported on the city's art doings; Frank Tunison supplied an informative monthly column on musical affairs; while the early numbers provided a ready outlet for regional writers and poets. Literary biographies, travel articles, and local genealogy enhanced the journal's appeal to a cultured audience, but like other literary ventures, *The Criterion* soon shifted its emphasis to less serious but more entertaining pieces. By the decade's end it had followed its predecessors into oblivion.[10]

During the middle years of the nineteenth century, Cincinnati had also served as the literary and publishing center for Germans in the West, an often neglected aspect of the city's intellectual life. A circulating library of some two thousand volumes, a German Reading and Educational Society, several dealers in German books, and a variety of newspapers and literary journals measure the widespread support for intellectual concerns found in the German quarter. Heinrich Rattermann, whose involvement in the local world of music has already been discussed, left a record of much of the German contribution in *Der Deutsche Pionier.* He also wrote over six hundred poems, his masterpiece being the highly romantic *Vater Rhein.* Gustav Bruehl, a physician and author of several articles on medicine, wrote poetry as well and contributed several solid pieces on the archaeology of North American Indians. A third prominent German was Max Burgheim. A onetime bookstore owner who turned publisher, Burgheim wrote on the history of the Cincinnati German community. His major contribution was *Cincinnati in Wort und Bild* (Cincinnati in Word and Picture), a basic reference work on the people, businesses, institutions, and culture of the local German population.[11]

Johann Bernard Stallo, who arrived in 1839 from Oldenburg, Germany, established a national reputation as a philosopher. As a young man he taught mathematics at St. Xavier College; later he turned to law, and he concluded his career as a prominent judge. His work in philosophy, especially his monumental *General Principles of the Philosophy of Nature,* earned him recognition among an important group of mid-century Hegelians in the country, many of them Germans. Stallo's friend, August Willich, also contributed to the Hegelian circle, but he is best remembered as a political radical. A onetime Prussian army officer, Willich had joined with Friedrich Engels and others in the aborted revolution of 1848. No longer welcome in Germany, Willich turned up a year later in Cincinnati, a self-proclaimed Communist. During the Civil War he served with great distinction on the Union side, but his support for America's political system proved short-

lived. Through his many articles in the *Cincinnati Republikaner,* he criticized the nation's capitalist economic system and advocated a worker controlled society based on a Hegelian view of social change.[12]

There were, of course, other German-Americans who contributed to the intellectual life of the German community, but except for the occasionally recognized German Literary Club, their contributions remained isolated from broader movements in the city. Thus, while the literary and publishing activities of these men remained important within a narrow ethnic framework, they failed to enlarge the city's reputation either nationally or in the eyes of those worried about its decline, and a local newspaper editorial in 1883 that plaintively called for Cincinnati to "become a center for literature" unfortunately served more as an epitaph than a call to the future.[13]

As literary activity all but ceased in the Anglo-American community, and after 1890 among German-Americans as well, a similar decline showed up in the city's publishing industry. In earlier days the western printing trade was centered in the city, and by mid-century not only were McGuffey Readers and scores of other instructional works published here, but a host of booksellers like John P. Foote and Ephraim Morgan supported much of the local intellectual ferment. Several factors eventually combined to stunt this publishing growth, but the panic of 1858 and the new railroad links between Chicago and the East were critical. By 1880 only four major firms remained in Cincinnati: the Western Methodist Book Concern, active since 1829; Van Antwerp, Bragg & Co., publisher of the popular McGuffey Readers; Robert Clarke & Co.; and Wilstach, Baldwin and Company.[14]

Of the men who ran these establishments, Robert Clarke proved most active in the city's intellectual circles. Born in Scotland in 1829, Clarke had come to Cincinnati at the age of eleven. After attending the local Woodward College, he became part owner of a secondhand bookstore that served as a favorite gathering spot for literary-minded men. By 1858 he had emerged as the principal partner. Robert Clarke & Co. earned an enviable reputation for its collection of Americana, and Clarke's personal interest in bibliography, archaeology, and local history is revealed in the various books published under his imprint. Clarke actively participated in the city's intellectual life as no other publisher did. He helped organize the Society of Natural History, took an active role in the revitalization of the Historical and Philosophical Society of Ohio, joined the Literary Club, and wrote and edited numerous scholarly works on the region's history. At his death in 1899 he divided his extensive personal library between the Historical and Philosophical Society and the University of Cincinnati.[15]

Along with Clarke, two other bookmen made sizeable contributions to the city and deserve some mention. Peter G. Thomson, for many years Clarke's confidential secretary, established himself as a printer and book-

seller in 1877, while Uriah P. James, active in the city since 1831, continued to hold on to his reputation as the "Harper's of the West." But James did not outlive the eighties and Thomson, without an established clientele, left the business as prospects dimmed. "Cincinnati is not the place to publish anything," he noted discouragingly in 1883. "It is not a book center. The East is the place" Clarke survived because of his broader foundation and greater reputation, but he too recognized the city's shrinking importance, and after 1880 shifted his emphasis to legal books.[16]

As the first generation of bookmen died off and the later group succumbed to economic changes, a burst of organizational activity took place that both strengthened and changed local intellectual life. Paralleling the movements that produced the art museum and various music organizations, residents concerned with the general education and moral improvement of the community lent their support to a cluster of institutions aimed at the general diffusion of knowledge. Chief among these was a public library.

Like other American cities Cincinnati had flirted in its early years with a scattering of libraries, either private or semiprivate. Most of these attempts failed to achieve their announced goals, but around the middle of the century several factors came together to help launch the Cincinnati Public Library. The common school movement stressed the value of universal education, and this, coupled with the need to exert greater control over the rapid changes brought about by industrialization, promoted the idea of a tax-supported library for the general public. In addition, the city now had a population sufficient to support such an enterprise, and an expanding civic identity which demanded appropriate cultural and educational institutions.

The movement for public libraries was nationwide. The year 1853 saw the first national gathering of librarians and bibliophiles, at which several of the participants strongly endorsed the concept. The following year the Boston Public Library opened, extending that city's claim as the "Athens of America." Although the New England states took the lead in library promotion, Ohio did not lag far behind. The state legislature granted local authority to establish public libraries in each school district, with control in the hands of the school boards. The Cincinnati Board of Education resolved to establish one library for all of its schools, and Rufus King, president of the school board, personally helped select and purchase three thousand titles for its first collection. Launched as an auxiliary of the public schools, the new facility struggled to gain identity; it also struggled for funds. In 1860 rural opposition in the state legislature rescinded the tax base, and for seven years no funds existed for enlarging the collection. During the war years the library almost died. King, Dr. Cornelius Comegys, and other friends worked feverishly to save the facility, "without which no city would be honorable." Two years after the war, their efforts succeeded in returning local taxing

power for libraries to larger cities in the state. Although the library's board of managers still served under the authority of the board of education, the question was now no longer one of survival but of growth.[17]

Early in 1869, at the request of the board of managers, William Frederick Poole came to Cincinnati to provide an analysis of the library's needs. One of the first professional librarians in the country, Poole was librarian of the Boston Athenaeum, but, impressed with the opportunities of the western city, he stayed on to take charge of the fledgling Cincinnati Public Library. With his full hair, bushy side-whiskers, and commanding stature, Poole towered over factional interests. During his four-year tenure as head of the library, he more than doubled its holdings, prepared a forty thousand card catalog for the collection, supervised the move to new quarters on Vine Street, increased circulation dramatically, and expanded the fulltime staff from three to eight. In addition he acquired many German books, instituted Sunday hours, established the first departmental library—art, in this case—and, despite considerable alarm from many quarters, expanded the collection of fiction. At his departure in 1873 the Cincinnati Public Library ranked second only to the prestigious Boston Library.[18]

Despite considerable support for Julius Dexter, the Reverend Thomas Vickers succeeded Poole. Under Vickers, the liberal Unitarian who occasionally wrote for the *Commercial,* the library entered a twelve-year period of strife and chaos. The new librarian proved to be controversial. Even before his appointment he had been outspokenly critical of Poole, and in return both *The Enquirer* and the *Daily Gazette* viciously attacked Vickers. *The Enquirer* (Hearn perhaps?) referred to him as a "howling atheist," stating that the position called for "a gentleman, a general scholar, and one who has had some special training in the profession of libraries." The library, it proclaimed, was not "a hospital for decayed clergymen." Although disdaining the *Enquirer*'s slashing, insulting style, the *Daily Gazette* also questioned Vickers's fitness for the position. Vickers survived the attacks, continued to criticize the previous library administration, and instituted a new book classification system, a reproof aimed at his predecessor.[19]

Independent of the Vickers-Poole conflict, another, more public, controversy surrounded the library—the question of acquiring novels. The *Commercial* opposed this practice on moral grounds, a position deeply rooted in the Calvinist view that unwholesome literature corrupted the reader. The *Daily Gazette* shared these views, expressing grave concern that already 74 percent of the collection was fiction, "a sad illustration of the public taste." The even more conservative *Volksblatt,* one of the several German-language newspapers, criticized the purchasing of novels on the grounds that it was not the duty of the state to supply questionable books when most people never read them. The *Enquirer* defended the library,

however, puncturing the *Volksblatt*'s stout Spencerism by pointing out that no books were read by everyone, and responded to the *Commercial*'s fears by stressing that even poor novels promoted reading, a situation certainly superior to no reading. Most public librarians of this era viewed themselves as guardians of their reading flocks, and while expressing concern over the quality of literature, usually accepted even frivolous books as a method of attracting users. Once in the library they could then steer the reader towards better books. Since both Poole and Vickers endorsed the acquisition of everything except immoral works, a broad enough category at the time, the library policy remained intact.[20]

Vickers's aggressive leadership soon came under attack. His efforts at a new catalog proved expensive and inefficient. Complaints concerning library service mounted, and *The Daily Gazette* continued to peck away at the issue of trashy fiction. A decrease in growth coupled with an increase in salaries suggested mismanagement to some. The final blow came when Vickers accepted the rectorship of the University of Cincinnati while still remaining librarian, although on a reduced salary. Public pressure finally forced him to resign his library position. The *Daily Gazette* immediately endorsed assistant librarian Chester W. Merrill for the vacated position, but one knowledgable observer, in criticizing the political atmosphere of the appointment, called Merrill "an acknowledged authority on 'poker', but a patent ignoramus in literature." Merrill got the position anyway. Although the Merrill years lacked the acrimony of the Vickers era, the library continued to be plagued by controversy and charges of mismanagement. Not until Albert Whelpley took over in 1886 did the library return to a calmer atmosphere.[21]

As the public library gradually took its place amidst the general intellectual life of the city, other institutions made similar contributions. The Young Men's Mercantile Library Association, which had been founded in 1835 to promote "a spirit of youthful inquiry" for clerks and young businessmen, now began to edge away from moral improvement books and towards a more general collection of literature, which included numerous journals and daily newspapers. The general interest in scientific knowledge led to the founding of the Society of Natural History, the latest in a series of scientific organizations stretching back to Drake's Western Museum. Robert Clarke, Julius Dexter, Henry Probasco, and Dr. William H. Mussey formed the new society in 1870, acquiring the defunct Western Academy's collection and such of its stalwart members as U. P. James and Robert Buchanan. Dr. John Warden served as first president. During its first thirty years, the society sponsored numerous free lectures, published a quarterly journal, and provided a forum for much of the local debate over the controversial theory of Charles Darwin.[22]

The Historical and Philosophical Society of Ohio also experienced new growth in its efforts at preserving both regional and local history. Founded in Columbus, Ohio in 1833, the society moved to Cincinnati where it merged with the younger and more vigorous Cincinnati Historical Society, itself a product of the intellectual ferment of that earlier decade. Benefiting from "more zeal than money, more affectionate friends than funds," the society struggled through the 1850s, finally emerging at the end of the war with only four members. In May 1868, Robert Clarke, John Wilby, and Julius Dexter breathed new life into the organization. Moving "where charity invited," the society frequently changed locations, finally settling at the beginning of the new century into the basement of the University of Cincinnati's new Van Wormer Library.[23]

Although far less vigorous than the activity of forty years before, a refined intellectualism persisted. Through interlocking memberships, the Historical and Philosophical Society, the Society of Natural History, and the Literary Club joined larger cultural institutions in encouraging a spirit of gentlemanly scholarship. So stimulated was one of these supporters that he called for a Cincinnati Institute, to be patterned after the various European academies, which would provide a permanent place for the city's most distinguished and mature scholars. Such an institution, insisted Dr. Comegys, would lend "freshness and vigor to scientific work and strength and beauty to *belles lettres* and fine arts" Nothing, of course, came from this.[24]

Dr. Comegys's call, while unanswered, attested to the rising spirit of professionalism that had begun to replace the largely amateur activities of the prewar era. A similar process affected the theatrical world. Although several amateur drama groups continued to perform publicly—notably the Shakespeare Club and the Davenport Club, the latter named for the prominent tragedian, E. L. Davenport—professional theater rapidly eclipsed the once popular amateur performances. The last quarter of the century witnessed increased competition for all types of entertainment, and audiences now demanded more elaborate productions, larger stages, more extensive props and, above all, name actors and actresses. Costs accelerated, until only the travelling companies built around a few highly publicized stars could succeed financially. By the mid-eighties most of the amateur groups and local stock companies had disappeared.[25]

The years immediately following the close of the Civil War saw the nadir of dramatic activity in Cincinnati, in part a result of the tragic fire that destroyed the ornate Pike's Opera House in 1866. At the same time, sensational, popular dramas like *Davy Crockett* and *Across the Continent,* the theatrical equivalent of dime novels, all but drove more serious drama off the stage. So low had local theater activity fallen that in 1867 the visiting James Parton described the city as "miserably provided." Local critics gener-

ally shared his view. Visiting companies drew poorly and only such popular stars as Joe Jefferson could consistently draw sizeable crowds. In 1872 *Church's Musical Visitor* predicted optimistically that the opening of John Robinson's new auditorium would revive the city's sagging reputation, and the decade of the seventies did bring renewed interest in serious theater. Along with Robinson's, the new Pike's and the Grand Opera House opened. Pike's, while never achieving the distinction of its forebear, succeeded by combining legitimate drama with less serious fare. The ill-fated Robinson's, which had its finest years in the 1870s under the adroit management of Robert E. Miles, suffered through several disasters during its career, including a panic in 1876 brought about by a false cry of "Fire!" The Grand Opera House, located at the corner of Vine and Longworth Streets, proved the most durable. Often under the management of Miles, who left Robinson's employ in 1874, the Grand remained the city's leading theater until the late 1880s, consciously foregoing the more popular melodramas and the "leg and lager" burlesque entertainments championed by many of the less reputable houses.[26]

For the final quarter of the century, then, Cincinnati did not lack for serious dramatic fare. As one might expect, the leading performers of the New York stage visited the Queen City on a regular basis. Edwin Booth, Maggie Mitchell, Lawrence Barrett, E. L. Davenport, Richard Mansfield, Ellen Terry, Ethel Barrymore, as well as Sarah Bernhardt all entertained local audiences. But the success of the travelling companies had its drawbacks. It discouraged local stock companies, leaving individual players either to seek their fortunes in New York or move into some other occupation. Among the local stock players who went on to achieve some national recognition were Matt Lingham, Julia Marlowe, Anna Boyle, and J. Newton Gotthold. This drying up of local activity led to less experimental and less interesting theater, as the so-called combination companies sought the highest monetary return for their efforts by presenting only the most popular plays. So limited was the repertoire that certain performers became identified with particular roles, and a fickle public would often only pay to see them in that role.

The same economic forces encouraged comedy and sentiment at the expense of tragedy, further restricting variety. Among Cincinnati's favorite stars, only Edwin Booth was a bonafide tragedian. This narrowing of the theater brought a strong rebuke from the *Cincinnati Graphic,* which argued that drama had "not kept abreast of other literary forms." "For some time the tendency has been rather toward entertainments that amuse simply," regretted the editor, "than toward those requiring an intellectual effort." Part of the problem stemmed from the popularity of melodramas and vaudeville performers—that "brood of vile shows that have disgraced the

city . . . ," as the *Cincinnati Daily Gazette* described them—usually offered on weekends. An earlier investigation, in 1880, by the *Daily Gazette* had concluded that ten thousand people attended this form of entertainment on Sundays alone, a fact that was meant to horrify all right-thinking people. In response six hundred women signed a petition against this desecration of the Sabbath, and in 1881 the city fathers officially prohibited operas, dramas, minstrelsy, and athletic events from taking place on Sunday. A year later Heuck's Opera House successfully defied the law, and the return of popular entertainment on Sunday continued to erode support for serious drama.[27]

The *Graphic*'s disappointment resulted in part from a major attempt during the previous two years to revive serious theater in the city. Impressed by the success of the music and opera festivals, interested citizens in 1882 organized a Dramatic Festival to be held the following May. Such prominent business and professional men as John Carlisle, Melville Ingalls, John Simpkinson, and Frederick Alms served on the board of directors, while General Edward F. Noyes was president. To manage the grand affair, the board hired the respected Robert Miles. The festival included six Shakespearean works, along with *The Hunchback of Notre Dame;* leading performers included Mary Anderson, Lawrence Barrett, John McCullogh, Sheridan Knowles (as the hunchback), and the popular, aging veteran, James E. Murdoch. *Julius Caesar* inaugurated the week-long affair. A thousand gas jets, in the shape of an enormous eagle with stars on either side, illuminated the facade of Music Hall, as a crowd of about five thousand, primed by civic enthusiasm, descended on the grand auditorium. Slightly smaller crowds attended the next several evenings, before warmer weather and the appearance of Murdoch as Hamlet jammed Music Hall again on Friday night.[28]

For the most part the festival was a grand success. Certainly the local press considered it so, even with the usual allowances made for civic hyperbole, and, from the point of view of the backers, the net profit justified the event. Out-of-town observers, however, expressed more ambivalence. Criticism ranged from the size of Music Hall (voices and facial expressons were apparently lost in the large auditorium) to the intrusion of "Cincinnati slang" in *Julius Caesar*. However, everyone agreed that the stage settings were first-rate, and most were pleasantly surprised by the seventy-two-year-old Murdoch's performance, although his oratory at times outshone his acting ability.[29]

In retrospect the festival clearly failed to provide great theater; rather it remained an extravaganza that showcased a few stars in popular roles. Rehearsal time was too brief, extras made frequent errors in lines and movements, and the elaborate scenery required lengthy delays between acts. *Julius Caesar* took almost five hours to complete. Local pride, solid entertainment, the elaborateness of the scenery, and Murdoch's presence made the festival

profitable. But, as artistic expression it cannot be compared to the early May Festivals or even the opera festivals sponsored by the College of Music. As the *New York Times* concluded judiciously, "So much has not before been attempted." Whatever its faults, and the faults mostly resulted from attempting too much in too short a time, the enthusiasm demanded that a second festival be given the following year. The *Commercial-Gazette* predicted that the Dramatic Festival would become a regular event, perhaps alternating years with the biennial May Festival, and G. W. Shelden of *Harper's Weekly* even saw it as a portent of an approaching national resurgence in drama, rooted in the popular tradition of ancient Greece or Elizabethan England.[30]

The next May did indeed bring a repeat performance. Disregarding suggestions to introduce more modern plays, and to reduce the number, the festival organizers retained the Shakespeare format. Once again the stars arrived to considerable fanfare: Fanny Davenport, Thomas W. Keane, and Helen Modjeska—but no Murdoch this time. Music Hall still provided the facilities. The same elaborate scenery and props provided the backgrounds. Although fewer out-of-town critics attended, the reviews remained favorable. Individual plays went more smoothly, as experience eliminated many of the previous year's nagging mistakes, and Keane rendered a superb performance as Othello. But the festival soured. The city paid less attention, attendance declined noticeably, and, most seriously, a deficit of $42,000 faced the backers. No one called for a third festival.

What happened? In part, the second time around proved less attractive to those for whom the first festival had been a social happening. Certainly the press showed less interest. Other factors included bad weather on opening night, "tight money," and an exceedingly harsh winter which had resulted in a major flood the previous February. The Dramatic Festival also preceded the May Festival by only a few weeks, which may have reduced its social impact. An intangible factor, but certainly one that weighed heavily on all entertainment in the city that year, was the Court House riot that had left over fifty dead and hundreds injured just weeks before.[31]

The two Dramatic Festivals proved something of a mixed blessing for Cincinnati. While they generated considerable publicity and, at least in 1883, centered the nation's attention on the city, they did not set in motion a general revival of good theater. Both festivals reduced attendance at other local theaters, and by stressing such elaborate presentations may actually have weakened future support of dramatic performances. It is possible that annual or biannual festivals, given enough time, might have stimulated local theater activity, but reliance on the spectacular and dependence on profits did not serve the city well. Perhaps it was no coincidence that Pike's Opera House remained dark during these years, and that at least one local critic just

eight months later referred to "the depression in theatrical business." Travelling companies with their stars remained the principal form of serious dramatic fare until the end of the century, and the two festivals did nothing to retard the rush of less artistic forms of entertainment.[32]

The most touching result of the festivals was the long overdue recognition they brought to James E. Murdoch, for years the most distinguished actor associated with Cincinnati. Born in Philadelphia in 1811, the son of a bookbinder, the young Murdoch showed an early interest in public speaking and acting. At the age of eighteen he played Frederick in *Lover's Views* at Philadelphia's Arch Street Theater. The following year he joined a travelling troupe which included the rising tragedian Edwin Forrest. Early hardship and an almost fatal dose of arsenic did not discourage him from a stage career. He gradually achieved renown for his powerful elocution, and by the mid-century had become an established actor on both sides of the Atlantic, best known for the dignity which he brought to light comedy. During the Civil War, he lent his energies and abilities to a variety of public benefits, hospital benefits, and personal testimonials, including one in 1864 at Pike's Opera House at which he gave a stirring recital of "Sheridan's Ride," written just that morning by friend and poet Thomas Buchanan Read. After the war, Murdoch virtually retired, his deliberate, oratorical style of acting replaced by a modern, faster-paced manner. Thus, his appearance in 1883 served to acquaint a new generation with the Murdoch presence, and to allow his many admirers one last opportunity to acknowledge him. Although Murdoch was past his prime, Lawrence Barrett, himself an outstanding Shakespearean, paid him a final tribute when he described his Hamlet as "a great piece of acting." Murdoch could have asked for no greater compliment.[33]

If Cincinnati did not become a center for theater, the local dramatic activity did send ripples through the city's art community. The major theaters often drew on the creative talents of scores of scene painters and drop curtain artists, of whom John Rettig and William Porter remain the best known. This experience, in turn, helped make the numerous outdoor pageants, especially those sponsored by the Society of Cincinnatus, truly memorable events, and for the struggling artist it provided a much-welcomed source of income. Furthermore, theatrical advertising in the form of posters proved a major boon to the already established lithography industry. Emil Klauprecht had introduced lithography to the city when he arrived from Germany in 1837.

In Cincinnati, all the early efforts at establishing art academies, founding mechanics institutions, and introducing art into the public schools, had focused on the importance of good design to the city's artisans. The gifted Klauprecht chose well when he selected Cincinnati. During his productive

years, he wrote a history of the Germans in the Ohio Valley, operated a German circulating library, took part in the early Saengerfests, wrote a farce on the first German singing festival (titled *Das Saengerfest auf den Bald Hill*), published *Fliegende Blaetter,* the first illustrated German newspaper in America, and later wrote for the *Volksblatt.* He also wrote one of the first German language novels in the country, *Cincinnati oder Geheimnisse des Westens,* which contains a fascinating view of the city's seamier side. Although Klauprecht gained credit as the city's first lithographer, another German immigrant, Otto Onken, left a more lasting legacy for the lithography industry. He not only made numerous prints depicting the growth of the city, but in his workshop a second generation of artisans learned the trade, including such prominent lithographers as Adolph Krebs and Adolphus Forbriger, the latter the first supervisor of art in the public schools.[34]

The growing popularity of art prints in America encouraged others to enter the profession. In 1850 George Gibson arrived from England with his family of nine children; soon his sons, ages twelve to twenty-three, established Gibson and Company in a small shop in Gano Alley, where they turned out an array of labels, business cards, checks, and stock certificates. A year earlier, Elijah Middleton and W. R. Wallace, later to be joined by Hines Strobridge, had also entered the printing business. After several name changes and a costly fire in 1866, the firm emerged as the Strobridge Lithographing Company. In its first decade, the company's chief competition came from Ehrgott and Forbriger, whose use of color and high standards of draftsmanship made them one of the nation's most respected firms, and by 1860 the Queen City boasted of six lithographic firms, which employed a total work force of sixty-six and earned a gross annual business of $165,000.[35]

Fueled by the emotional conflicts of the Civil War, Americans turned increasingly to sentimental art pictures—"the visual equivalent of polite novels." The rapidly emerging urban middle class developed a strong need for household decoration, usually idealized versions of homely truths. Many artists, like James Beard and Lily Martin Spencer, owed much of their success to this Victorian taste, but most Americans could not afford original art. There was always a certain comfort in owning a picture which others had purchased as well. While Americans became increasingly picture conscious, as manifested by the growth of illustrated magazines, Cincinnati lithographers sought to capture the market for sentimental scenes. Ehrgott and Forbriger capitalized on the Civil War nationalism by producing portraits of Union heroes and vivid portrayals of battle scenes, along with religious subjects and sometimes cloying domestic scenes. Middleton and Wallace also

profited handsomely from popular patriotic prints, relying on the use of "warranted" colors to make their prints look as much like oil paintings as possible.[36]

The taste for popular art influenced the world of entertainment. Theater managers turned to posters for advertising, often capitalizing on the same sentimental or sensational images that attracted people to the theaters. Everyone from Bernhardt to burlesque dancers found their faces staring back from the large posters that greeted their arrival in the city. Of all the lithographic firms in Cincinnati, Strobridge achieved singular distinction for its circus and theater posters. Using eight colors or more, sometimes borrowing the latest French influences, their advertising works often achieved a rare combination of visual power and graceful design, giving Strobridge a reputation which rivaled any of its eastern competitors. Shortly after the turn of the century, however, lithography entered a period of decline. Changing taste in household art, the introduction of photoengraving, and a decline in travelling theater troups made the poster dispensible. In their prime, though, by mirroring American life, both the real and the ideal, lithographers served as printmakers to the people—the purveyors of a truly democratic art.[37]

Lithography, along with furniture design, pottery decoration, and the production of art glass, shared the end of the century concern for good design. As will be discussed in a later chapter, Cincinnati blossomed as a center of the American arts and crafts movement. Under the influence of the ideals of John Ruskin and William Morris, a considerable number of the Art Academy's graduates found work in the local art industries. Those who went into furniture design or metal work have disappeared from memory, but a core of lithographers remain known through their work. Most worked for Strobridge. Harry Ogden drew many of that firm's finest circus posters, while Matt Morgan, also a well-known pottery decorator, achieved distinction for his theater posters. Harry Bridewell, unsurpassed for his fine lettering work, Paul Jones, and the Potthast brothers, Henry and Edward, all reached the top rank in their profession. As Joseph Pennell noted in 1898, "the great Cincinnati firm of Strowbridge [*sic*] was a sort of cradle for many of the more distinguished younger American artists"[38]

As the nineteenth century moved toward its end, Cincinnati's general intellectual tone continued to diminish, mirroring the city's sliding economic position in the country. Certainly the promise of the pre–Civil War years never materialized, as the contribution of numerous individuals gave way to a more professional and institutional atmosphere. The flow of distinguished visitors declined, in part because Cincinnati no longer seemed a remarkable city, in part because other avenues opened for both entertainment and education. A host of popular attractions siphoned off local audien-

ces searching for amusement, while the new educational institutions re-
placed those earlier societies which had aimed at self-improvement. The
once dominant role of the gentleman-scholar did not long survive mid-
century, and only a handful of private libraries, the two Literary Clubs, and
the lingering scholarly activities of a few individuals served to remind the
city of its previous mental vigor.[39] Conscious of the city's shrinking reputa-
tion, proud Cincinnatians sought to secure its cultural reputation by support-
ing the arts. The era's efforts in music brought considerable glory to the city,
and these accomplishments, along with similar achievements in painting
and sculpture—those other cultural pillars of pre–Civil War Cincinnati—
ultimately left the most enduring legacy for the Queen City.

Interlude
Mr. Probasco and
His Fountain

"Cincinnati was about losing her diadem as Queen City of the West. You, today, inaugurated the era in which it will probably replace it," exuberantly proclaimed Rabbi Max Lilienthal, one of the principal speakers at the 1871 dedication of the city's Tyler Davidson fountain. In his call for a new metropolitan resurrection, Lilienthal predicted accurately that the handsome fountain, with its shining bronze figure of "The Genius of Water," would reinvigorate Cincinnati's cultural life. Today the fountain still stands, facing westward alongside Fifth Street, the spiritual center of the city, and no spot is closer to the hearts of Cincinnatians than Fountain Square.[1]

Just a few years before the fountain's dedication, Fifth Street appeared an unlikely location for a work of art. In the 1860s the street served as a major artery for the city's commerce, cluttered with streetcars, horse-drawn vehicles, a variety of push carts, and hordes of pedestrians, all channeled between two rows of three- and four-story commercial brick structures, with an occasional grog shop or gambling hall mixed in. Dominating the block between Walnut and Vine Streets was an unsightly, ageing brick and frame markethouse, home to more than fifty tradesmen, mostly butchers. Mingling with the dust, coalsmoke, noise, and the normal city smells, was the pungent odor of freshly slaughtered animal carcasses. As one observer pointed out, a gentleman would never think of allowing a lady to walk there unescorted. How then did this decidedly unfashionable avenue become the site for one of the finest public sculptures erected in nineteenth-century America?[2]

Henry Probasco and Tyler Davidson, business partners and brothers-in-law, had for years discussed ways in which they might return something

to the city which had been so generous to them. From the beginning Probasco, several years younger than his partner, had known what he wanted—a public fountain, both beautiful and utilitarian. The functional nature of a fountain appealed to this self-made man. Born in Connecticut to respectable but unremarkable parents, Henry Probasco had gained employment in Cincinnati at the age of fifteen as a clerk for Tyler Davidson, a successful hardware dealer. Five years later, in 1840, Probasco married his employer's half-sister and became a partner in the firm. The rapid growth of Cincinnati did the rest. In the 1850s Tyler Davidson and Company ranked as one of the largest hardware firms in the entire West, making the two partners wealthy men. Their idea to repay the community by giving it a fountain was side-tracked, first by the Civil War and then by Davidson's death in 1865. Within months of this unforeseen event, Probasco, only forty-five years old, sold the business and retired to "Oakwood," his newly completed suburban mansion in Clifton. Retirement meant travel. The next several years found Probasco in Europe, adding to his collection of paintings, books, and rare manuscripts. He also thought a lot about fountains, and, inspired by the dramatic public fountains of Germany and Italy, decided to make the fountain a memorial to his brother-in-law. But everyone to whom he talked showed him designs filled with Olympian gods, mythical monarchs, Neptunes, Undines, mermaids, and water gods. Nothing crowned, divine, or tailed would do for Probasco. American was not Europe. At the Royal Foundry in Munich he finally found his fountain.[3]

After hours of showing Probasco around his establishment, Ferdinand von Mueller, the foundry director, had almost given up hope of interesting the wealthy American, when he remembered a set of designs that had languished in his office for twenty-five years. They were the work of August von Krehling. In the early 1840s, von Krehling had gathered with other rebellious young artists at von Mueller's home to express their distaste for the current vogue of classicism and historicism in German art. This group was forging the rudiments of a new realism. When conversation turned to statuary, von Mueller mentioned the idea of a fountain representing man's use of water. In response to the questions this generated, von Krehling drew up plans for a realistic and modern fountain expressing the theme of man and water. Considered unconventional and too costly, the plans did not incite much interest. The designs remained with von Mueller, while von Krehling married the daughter of painter Wilhelm von Kaulbach, became a successful artist in his own right, and by 1866 was director of the Nuremburg Academy of Art. Impressed with the designs, Probasco now proposed to make the almost forgotten vision a reality.

While von Mueller commenced the long and difficult task of procuring materials and casting the work, enlarged by Probasco's request to add four

side drinking fountains to the main piece, Probasco turned to the question of convincing the city fathers to accept the gift. To William Lowry, a former business associate, he sent in 1867 copies of the design, photographs, and a letter to be forwarded to Mayor Charles Wilstach. He requested that Lowry place this material in the hands of a first-rate attorney "who has influence in our City Council, and who will prudently and wisely, and secretly (*at first*) present the matter for their immediate action." Probasco authorized Lowry to pay up to $500, "or more if necessary." In the accompanying letter to the mayor, he made a formal offer of the fountain, estimated to be worth $30,000 (American gold). Probasco would provide the fountain if the city would maintain it, protect it, and ensure that the water was used solely for drinking and ornamental purposes. A month later, a delighted city council accepted the gift. And then the problems began.[4]

The city fathers had first considered the block on Fifth Street between Walnut and Main Streets as the most appropriate location, but as Probasco also desired a public plaza surrounding the fountain, the site was shifted one block west.[5] This required the removal of the forty-year-old markethouse. However, the butchers refused to vacate, citing an 1827 land deed which designated that the area be used as a marketplace. To facilitate action, Probasco invited city officials to his home where amidst toasts, speeches, and food, he unveiled a bronze model of the fountain. Council responded by voting not to renew the licenses of the Fifth Street Market vendors. The butchers sued, but as soon as word arrived from Columbus that the Ohio State Supreme Court had upheld the city's position, council voted twenty-five to eight to tear down the old structure. At the same time, a delegation of butchers met with the city solicitor in an attempt to discover the city's intentions. Even as they met, the city acted. In anticipation of council's vote, ninety street cleaners and about fifty policemen began carrying out an early form of urban renewal. With picks, crowbars, axes, and fire ladders, they descended on the market, surprising a handful of vendors still closing up their stalls for the night. Encouraged by a noisy, supportive mob, the street cleaners attacked the roof; forty-three minutes later it was gone, and by six o'clock only an immense pile of rubble remained in the fading light. One large timber, with the message "Born in 1827 and died in 1870" chalked on it, greeted the scores of indigents who moved in to scavenge.

While all this was taking place, Herr von Mueller directed the fountain's construction in Munich. Stone for the huge basin was cut and polished. Cannons were procured from the Danish government from which to cast the many bronze pieces. Colonel Ferdinand von Mueller, the director's son, sketched designs for the four side drinking fountains and for the small figures at the corners of the pedestal. Changes in the original design delayed the work. Then war between France and Germany broke out—"this mad-

ness of two nations," the elder von Mueller called it—and his son and twelve skilled workmen left for the front. Money tightened and transportation became more difficult. The work slowed, expenses mounted, and the January 1871 deadline passed. In Cincinnati, Probasco's anxiety mounted.

In the meantime, on Probasco Place, as the square was now being called, excavation began for the underground compartments, including one large chamber for ice to cool the drinking water during hot summer months. In July 1870 a genteel cornerstone ceremony took place, with Probasco and twenty prominent citizens, each carrying a glass of water, commemorating the event. The plan for a public plaza surrounding the fountain was enlarged, and gradually a raised elliptical esplanade, measuring four hundred feet by sixty feet, with appropriate lighting and shade trees, took shape. Finally, piece by piece, the fountain arrived—first, the great stone basin, weighing eighty tons when assembled, then the cast bronze pieces, culminating in the nine-foot figure of the "Genius." The younger von Mueller arrived to supervise the erection of the fountain, and, at last, with canvas draped over the assembled work, everything awaited the formal dedication.[6]

Early on the morning of October 6, 1871, people began to gather along both sides of Fifth Street. Temporary seats for four thousand invited guests ringed the esplanade, while balconies, windows, and rooftops provided vantage points for hundreds more. By the time the appointed hour arrived, officials estimated the crowd at twenty thousand people. The festivities opened with the arrival of a parade of dignitaries, escorted by the local German batallion, resplendent in Prussian uniforms complete with spiked helmets. Governor Rutherford B. Hayes delivered the main address. Rabbi Dr. Max Lilienthal, a native of Munich, spoke in praise of increased progress. Ferdinand von Mueller paid homage to the public spirit of Americans. Henry Probasco, in a typically modest speech, then officially presented the massive fountain to the people of Cincinnati, and in a somewhat lengthier response Mayor Davis accepted it. Augmenting the noise and excitement was the sound of crashing grandstands, as one by one the temporary seats collapsed. Numerous bruises, several broken bones, damaged nerves, and great clouds of dust competed with the oratory. It mattered little. As one wag commented, "All the speeches had equal merit, for none could be heard." Following the ninety minutes of solemnity, Colonel von Mueller pulled a cord releasing the canvas shroud, and simultaneously water began to stream from the jets, falling in a spray from the outstretched hands of the "Genius." As the dignitaries departed, the public, to whom the fountain was dedicated, moved closer, carrying an assortment of pitchers, buckets, and cups. Iced water was something new.[7]

That evening, Fountain Square, the popular name that quickly took hold, was illuminated by colored lights and fireworks, while the military

Henry Probasco, right, and His Foundation, below, the Tyler Davidson Fountain, ca. 1880. Courtesy of the Cincinnati Historical Society.

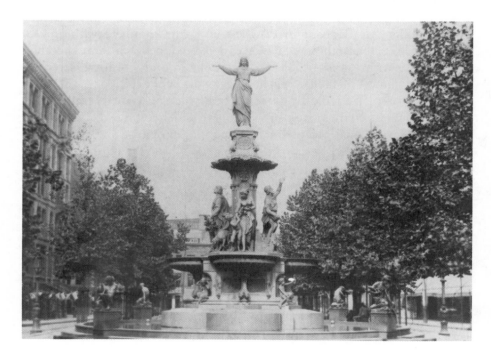

band from Newport Barracks entertained the crowd. German singing societies, flushed with old country pride, serenaded von Mueller and Probasco at the Burnet House, where both were staying. At the center of all this attention stood the great fountain. Forty-three feet in diameter, thirty-nine feet high, and weighing over one hundred tons, the Tyler Davidson Fountain was the first artistic public fountain in the nation. The theme of man's uses of water prevails throughout the work, topped by a robed female figure. Around the supporting shaft are four scenes illustrating man's need of water: drinking, bathing, agriculture, and fire prevention. The four sides of the pedestal display bas-relief representations of the material uses of water: steam power, water power, navigation, and fishing. At the pedestal's corners sit four children occupied in water-related pleasures, while along the basin's outer edge are four young men sporting with animals from whose mouths drinking water flows. Today, well over one hundred years later, the fountain continues to splash the same message. Von Krehling's imagination, von Mueller's craftsmanship, and Probasco's money and vision had brought an enduring symbol to Cincinnati.

In the Studios: Painters and Sculptors, 1865–1890

*T*he quarter century that followed the Civil War has often been described as Cincinnati's "Golden Age" in art, a label which the city adopted proudly at the time. Yet, in retrospect, it is a somewhat misleading and certainly pretentious label. As we have seen, by mid-century the city had earned an exalted reputation based upon its strategic western location and the lack of serious rivals. But the divisive nature of the war, the disruptive transition from river commerce to manufacturing, and the loss of urban leadership to Chicago bode ill for the Queen of the West. In part to offset this economic slide, civic leaders had turned to the promotion of culture. With this in mind they had supported the various festivals, the construction of Music Hall, the establishment of the College of Music, and the acquisition of Theodore Thomas. Citizens took great pride in the recognition achieved during the 1870s, and this national recognition did much to blind them to Chicago's rise as an economic center. Having achieved musical distinction, Cincinnatians now required similar achievements in painting and sculpture, to recapture the artistic reputation that had dimmed since the early promise of Beard, Powers, and Whittredge. City publicists felt obliged to promote local artistic developments, typified by an 1884 editorial in the newly founded *Cincinnati Graphic*: "The growth of art culture and appreciation in Cincinnati, has been for the past few years in accord with the progress in other directions. . . . At present we are developing a number of rising painters and sculptors; we boast of several of the best art schools in the country, while several private collections are accumulating valuable and important works."[1]

The *Graphic*'s prejudice aside, Cincinnatians did witness new art currents in the years after the Civil War, although the city never attempted to

challenge eastern cities. Given an active art market, the secure foundation for patronage and support, and the city's earlier attraction for artists, art boosters saw no reason why Cincinnati should not continue its regional dominance. Two schools, the Ohio Mechanics Institute and the McMicken School of Design, offered instruction in art. Several successful galleries, notably the established Wiswell's and the more recent Closson's, gave the city confidence that it remained abreast of contemporary art trends. Joseph Longworth, Henry Probasco, William Groesbeck, and George K. Schoenberger, all cultivated men of wealth, maintained significant private collections of art, although with a particular affinity for German works. Longworth, the son of "Old Nick" and the father-in-law of George Ward Nichols, had specialized in the carefully detailed paintings of Andreas Achenbach and Carl Friedrich Lessing, two of the leading lights of Dusseldorf. While canvases by Whittredge and other Cincinnati associated artists were included in the collection, Lessing's *Huss Before the Council* and *The Martyrdom of Huss* most impressed visitors to Longworth's Grandin Road estate.[2]

Henry Probasco possessed a more eclectic collection. Works by von Kaulbach, Riefstahl, Achenbach, and Piloti reveal the contemporary taste for German art, while paintings by Bonheur, Millet, Breton, and Troyon reflect his enjoyment of mid-century French styles. Probasco's discerning eye ran to more daring artists as well. His walls displayed Thomas Couture's *Idle Boy* and Eugene Delacroix's *Jerusalem Delivered,* while three landscapes by Theodore Rousseau gave his collection genuine distinction. Along with paintings, Probasco surrounded himself with objets d'art and incunabula, but, ironically, the man who gave the city its most enduring symbol died in reduced circumstances, his fine collection auctioned off in New York to help offset financial reversals.

William Groesbeck, lawyer, politician, and son-in-law of Judge Jacob Burnet, mirrored Longworth's taste. His East Walnut Hills mansion revealed the same affinity for mid-century German art, as did the Clifton home of manufacturer George Schoenberger. Both gentlemen, however, took delight in American landscape paintings, and Schoenberger's acquisition of Thomas Cole's moralistic *Voyage of Life* helped to establish that artist's influence among prewar local painters. Among other prominent collectors, William Scarborough, another wealthy resident of East Walnut Hills, owned two works by Cole, while his half-brother George Hoadley owned works by Jean Corot, Gustave Courbet, and Charles Daubigney, along with a number of drawings by J. M. W. Turner. The taciturn Learner B. Harrison, nephew of Joseph Longworth, possessed Turner's *Mist on the Thames* and paintings by Millet and Rousseau. Reuben Springer, the benefactor of Music Hall and so many other cultural institutions, adorned his modest Seventh Street home with numerous Dusseldorf canvases, but the acknowledged

159

gem of his collection was Benjamin Haydon's *Christ Entering Jerusalem* which he later presented to St. Peter-in-Chains Cathedral.[3]

Nor were private collections the only reflection of Cincinnati's artistic life. The McMicken School of Design, established in 1869 as part of the University of Cincinnati and the forerunner of the Art Academy, quickly earned an enviable reputation for its traditional curriculum and renowned graduates. During the 1870s and 1880s it served as the center for most of the city's art life, and while its conservatism tied much of local art to mid-century taste, there is no question that the McMicken School had a national reputation by the end of the century.

More important than private collections or schools were the several dozen artists who studied and worked in the city between 1870 and 1890, a vigorous and stimulating period in Cincinnati's history. Within those two decades the city produced six nationally prominent painters: John H. Twachtman, Elizabeth Nourse, Robert Blum, Edward Potthast, Henry Farny, and Joseph R. DeCamp. During the same years, Frank Duveneck, Kenyon Cox, and Joseph H. Sharp worked in the city at least part of that time. In addition a supporting cast of lesser artists, including Charles Niehaus, Alfred Brennan, George Hopkins, John Rettig, and Thomas C. Lindsay, contributed importantly to the community's artistic maturation.

The dean of this thriving art community was Charles T. Webber, who had arrived in the Queen City three years before the outbreak of the Civil War. A charter member of the Sketch Club, Webber had been a close associate of the Frankensteins and other artists who had occupied studios along Fourth Street, and in 1867 had been instrumental in securing the cast collection of the Ladies Academy of Fine Arts for the proposed McMicken School. But Webber remained one of the few holdovers from the prewar years. The war scattered the city's artists, for the 1866 city directory listed only twenty-eight artists, with Almon Baldwin and T. C. Lindsay the only known names among them. Three years later the number of artists had risen to forty-five, including Robert Duncanson, Henry Mosler, Thomas Noble, Mary Spencer, and Webber. Although Webber later gained considerable acclaim for his 1890 portrayal of *The Underground Railroad,* his chief importance to the city stemmed from the many art organizations in which he participated, and he no doubt belonged to the short-lived Artist Club which extended the first local recognition to the man identified most readily with Cincinnati's art reputation—Frank Duveneck.[4]

Duveneck, born and reared in Covington, Kentucky, directly across the river from Cincinnati, remains the brightest star within the city's artistic constellation. Born Francis Decker in 1848, the son of Westphalian immigrants, he took the name of his stepfather, "Squire" Joseph Duveneck. An early interest in drawing led him first into sign painting and then into

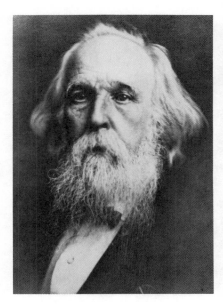

At top, Charles T. Webber, courtesy of the Cincinnati Historical Society; below, Frank Duveneck, by permission of Bedford Arts, Publishers (San Francisco) and courtesy of Robert Neuhaus.

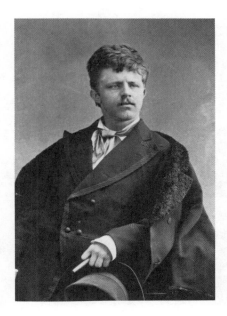

Henry F. Farny, top, Cincinnati Art Museum Library Archives; below, John Rettig, courtesy of the Cincinnati Historical Society.

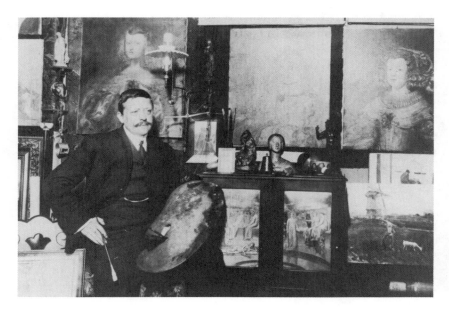

church decoration with two local painters, Johann Schmidt and William Lamprecht, who later established the Institute of Catholic Art in Covington. Under their tutelage the fourteen-year-old boy learned the fundamentals of color and design, as well as something of woodcarving, leaded glass artistry, and fresco painting. Church decorating demanded many skills, and the young Duveneck gained a veritable Renaissance education in the arts. His association with Lamprecht lasted several years, taking him to Louisville; Pittsburgh; Newark, New Jersey; and even Canada. Lamprecht introduced him to the circle of Cincinnati artists who had their studios in the Pike Building on Fourth Street; here he also discovered the gallery windows where the displays changed every Saturday. Indeed, one of the very earliest influences on his artistic outlook came from a strong portrait of "an awful ugly old man," painted with large, free brush strokes—an exciting contrast to his own smooth and pallid madonnas. The artist, Godfrey Frankenstein, never learned of his role in steering Duveneck toward portrait painting.

Frank Duveneck's ability with the brush did not go unnoticed. Supported by Schmidt and Lamprecht, and with his parents' blessing, he travelled to Munich in 1869. Munich had replaced Dusseldorf as the German art center most attractive to young Americans, and for a few years following the Franco-Prussian War and the turbulence of the Paris Commune, it even rivaled Paris. A bustling city of 100,000 people, Munich projected a distinctive personality. Heavily Catholic, with a tradition of leisure and beauty, the city dominated the Bavarian countryside. Under the recent reigns of Ludwig I and Maximilian II, the city had undergone extensive rebuilding, blending the new with the old, and the resultant new cultural spirit centered in the Royal Academy of Art. Wilhelm von Kaulbach headed the academy, but the modern spirit emanated from Wilhelm von Diez and Wilhelm Leibl, whose *alla prima* (all at once) realistic style had evolved from the Courbet display at the Munich art exhibition of 1869. "I paint only what I see, and only from nature," Leibl often stated, and he and his students spurned the idealism and romanticism of an earlier generation. Instead, they rediscovered the dark tones of Hals and Rembrandt, and this was the spirit Duveneck found so attractive. Munich Realism became one of the primary forces in American art during subsequent decades, and no American captured the genre better than the young man from Covington. His instructors concurred, and the affable Kentuckian soon earned "*the highest prize in the gift of the Academy.*"[5]

For three years Duveneck studied amidst the warm and exhilarating atmosphere of Munich, feeling his talent grow. Good lodgings, reduced admissions to opera and theater performances, a stimulating cafe life, the alpine countryside—all brought pleasure to this youthful artist. By 1873 he had almost adopted his parents' native land, his language already a cor-

Frank Duveneck, *Woman
With Forget-Me-Nots,* 1876,
Cincinnati Art Museum, gift
of the artist.

rupted mixture of German and English. Filial loyalty finally brought him home, but his return was less than triumphant. Needing money, he turned to church decoration, but his Munich style clashed with the taste of the Catholic Church. Late in 1873 he shared a studio on West Fourth Street with Henry Farny and Francis X. Dengler, a promising sculptor. Shortly thereafter, an exhibit of his work impressed the members of the Artist Club, and moved the *Cincinnati Commercial* to announce that he would be "a great acquisition to the city." Although he sold at least one painting, *Circassian Soldier,* to Herman Goepper for fifty dollars, his art failed to gain public acceptance. To make ends meet, he taught an art class at the Ohio Mechanics Institute, quickly bringing into his orbit the more talented students there, Blum, Twachtman, and Cox. Duveneck's studio served as a center for the young artists of the city. There, with his cane and cape—proper attire for a Munich artist—and his mixture of German and English, he spoke passionately of art, life, and the glories of Bavaria.

Frank Duveneck's immediate future did not lie in Cincinnati, where few appreciated his slashing brush stroke or his Bohemian manners. In 1875 an exhibition of his work at the progressive Boston Art Club brought extensive praise from, among others, the novelist Henry James. Sales of several paintings from that exhibit brought further encouragement, and life as a Boston society painter offered financial security. However, Duveneck was not ready for that. The siren call of Munich proved irresistible, and with money in his pocket he set sail for Europe in August.[6]

Duveneck took with him his young Cincinnati friend, John Henry Twachtman, the first of a score or more of American painters to fall under his spell. In the late 1870s, as eager Americans flocked to Munich, he found himself the focal point of a rapidly expanding art colony. In 1878 he, along with William Merritt Chase, Walter Shirlaw, J. Frank Currier, and others— all of whom practiced the new, dynamic realism of Munich—submitted their work to the National Academy of Design's annual exhibit in New York. Critics praised their work, and the resulting friction between the "old guard," who found their own canvases shunted aside, and Duveneck's "Young Turks" led to the formation of the Society of American Artists. The publicity attracted by their iconoclastic spirit guaranteed widespread awareness of the Munich style. At the same time that he sent his paintings across the ocean, Duveneck started his own school in Munich. Aspiring Cincinnati artists trekked to the German city to absorb his brilliant, slashing technique, and with this coterie of young Americans, the affable Duveneck lived a Bohemian life of painting, beer, and fellowship. Soon Venice and Florence became as much a part of his world as Munich. William Dean Howells captured the gay antics and carefree life of "the boys" in his novel *Indian Summer,* in which they became the "Iglehart Boys." One of the younger

John H. Twacht-
man, *Bloody Run*,
1882; The Procter
& Gamble Collec-
tion, Cincinnati.

members of the group, Oliver Dennett Grover, has left his own splendid description of life with the charismatic Duveneck:

> But while it did last it was more significant probably than a similar period in the lives of most students, because it was most intensified, most concentrated. The usual student experiences of work and play, elation and dejection, feast and famine, were ours of course, but in addition to that, and owing to peculiar circumstances and conditions, the advantages of the intimate association and constant companionship we enjoyed not only with our leader but also with his acquaintances and fellow artists . . . was unique and perhaps quite as valuable as any actual school work. We lived in adjoining rooms, dined in the same restaurants, frequented the same cafes, worked and played together with an intimacy only possible to that age and such a community of interests.

While Duveneck was the acknowledged leader—called the "old man," even though just thirty—a rare spirit of companionship did exist among the tightly knit group. Bohemian in spirit, they never possessed much money, but the shared growth and excitement made these memorable years for all.[7]

During this time Duveneck made the acquaintance of Elizabeth (Lizzie) Boott, the daughter of prominent Bostonians, Francis Boott and Elizabeth Lyman. As a child, Lizzie had lost her mother, and for the next thirty years she and her father lived in Florence, Italy. Francis Boott saw to her education, sharing with her his own enthusiasm for art and music, creating in the process "a masterpiece of cultivation and refinement." While visiting in Boston in 1875, the Bootts first saw Duveneck's work; three years later Lizzie made "a pilgrimage to [his] studio." As she described her first impression to her friends in William Morris Hunt's Boston class, "He is a remarkable looking young man & a gentleman, which I did not expect. He has a fine head & a keen eye & the perceptions strongly developed." Impressed with the man, she felt more ambivalent about his painting. "I could not see that he had made any step in the direction of beauty, which we hoped he would do—on the contrary the very genius of ugliness seems to possess him. In fact this is a characteristic of the school, & I have been much interested and excited by it." The next summer she became a pupil of Duveneck. "Do you not all envy me?" she wrote. By September her affection for the teacher and the man had become obvious. Their relationship steadily developed—the polished, refined expatriate and the robust, unsophisticated Kentuckian.[8]

The courtship lasted six years, hindered by the vigorous objection of Mr. Boott, who feared the loss of his companion. At last, in 1886, the two decided "to take up life together," with the elderly Mr. Boott to remain with them. Despite Henry James's lack of enthusiasm for the match (for years he had idealized the attractive and talented Lizzie), the Duvenecks shared two

happy years, dividing their time between Florence and Paris. A son, Francis Boott Duveneck, was born just before Christmas, 1887, further extending their happiness. Duveneck continued to paint, his palette lightening under the luminous Italian skies and the exposure to French Impressionism. The winter of 1888 found them in Paris—"a great place for an artist to be"— where Duveneck worked on a full-length portrait of Lizzie, to be shown at the Paris salon that spring. The canvas, now in the possession of the Cincinnati Art Museum, reveals a handsome, dignified woman, staring a bit wistfully at the viewer, fashionably attired in the brown dress and bonnet she had worn on her wedding day. A week after the completion of the portrait she was dead. Never physically strong, she had returned with a chill from a tiring day of shopping, which developed into the pneumonia that killed her.[9]

Duveneck was devastated. Mr. Boott arranged for the fifteen-month-old Francis to be reared in Boston by Elizabeth's aunt and uncle, Mr. and Mrs. Arthur Lyman. Duveneck returned to Covington, to the town of his youth and the family home on Greenup Street. There, he directed his sorrow towards an appropriate memorial to his wife, finally settling on a life-size recumbent figure which he sculpted with the assistance of his friend, Clement Barnhorn. For the next thirty years Duveneck worked at his easel, travelling extensively between Boston, Florence, Paris, Munich, and Gloucester, Massachusetts. But Cincinnati remained his professional home. In 1890 Mrs. Bellamy Storer, formerly Maria Longworth Nichols, arranged to have him teach a life class at the Cincinnati Art Museum, at a salary of $3,600. With an annual income of $12,000 through his wife's will, his teaching salary was inconsequential; more important was the routine of work. It also began a commitment to teaching in Cincinnati that filled the remainder of his life and placed him at the very core of the city's artistic life until his death in 1919.[10]

When Duveneck returned to Cincinnati, fifteen years had elapsed since he had last taught and painted in the city, fifteen years that had witnessed the opening of the art museum, the removal of the McMicken School (now the Art Academy) to a new facility adjacent to the museum, and a renewed awareness of art among cultured Cincinnatians. In 1874 Henry Farny had described the city as "the worst place . . . that a young artist could choose to make his *debut* in. There is not much attention given to aesthetic culture by the public at large, and unless an artist takes to designing tobacco labels, oyster labels, theatrical bills, or such work as that, he will generally find it hard to make a living." Farny knew of what he spoke, for just the year before he had been "obliged to sketch hog-pens and pork houses."[11] While Cincinnati would never compete with New York as an art center, or for that matter with Boston or Chicago any more, it had altered significantly its own art consciousness, a shift which owed much to Duveneck's brief appearance

in 1874–75. At that time, the older artists of the city painted under the spell of Dusseldorf or did studio renditions of Hudson River style landscapes. The freshness that had existed before the Civil War had gone east with Whittredge, or turned into pale imitations of salon art. The younger artists who came of age after the war felt trapped between the declining economic horizon and the shriveled taste that controlled American art. Duveneck's bold realism injected a new vitality into the city.

The new generation of artists owed much to the profusion of talent that emerged from the German quarter. Within a few blocks along Fifteenth Street, and born within a few years of each other, three young men began their search for artistic recognition amidst the teeming life of Over-the-Rhine. Beer gardens, corner saloons, trade fairs, and music festivals, all enlivened by the spirit of German nationalism, gave the district its distinctiveness. There was no end of excitement for boys verging on manhood. Robert Blum, Edward Potthast, and Charles Neihaus shared similar experiences in the German neighborhood, attending local schools, swimming in the old canal, and playing pranks on unsuspecting adults. They shared something else as well, an early interest in drawing, and it was this adolescent display of talent which provided an avenue out of their expected futures as tradesmen.

Robert Blum, son of solid middle-class parents, entered the world of design as a lithographer's apprentice with the firm of Gibson and Sons. Evenings he spent in classes at the Ohio Mechanics Institute, improving his drawing technique. Both here and at the McMicken School of Design where he attended an evening life class conducted by Alfred Brennan, he briefly inhaled the Duveneck vitality. Blum was never to be a follower of Duveneck, however. In 1876 he visited the Centennial exposition in Philadelphia, where he had an opportunity to study Japanese art; he also discovered the work of Giovanni Boldini and Mario Fortuny, two popular European artists of the time. Although Blum returned to Cincinnati, his horizons had expanded. Two years later he left the Queen City, ending up in New York where he established a reputation as a fine illustrator and engraver. In 1880 he joined Duveneck and James McNeill Whistler in Venice, devoting his time to etching. For a while he experimented with *plein air* painting in Holland, but his finest work remained that which was rendered in acid and ink. Although *Venetian Lace Makers* is still his major artistic statement, Blum's two-and-one-half-year visit to Japan in the early 1890s has left the most fascinating glimpse of the artist. Commissioned by *Scribner's Magazine* to illustrate *Japonica,* a book on Japan by the British journalist Sir Edwin Arnold, Blum drew upon his interest in Japan which extended back to the Philadelphia Centennial, and even to the Japanese fans hawked by street vendors at Cincinnati's first May Festival. He was among the earliest of America's artists to visit this country, and his account, "An Artist in Japan,"

stimulated interest in the Land of the Rising Sun. He never returned to Cincinnati after 1878, but his steadily rising reputation, complete with membership in the National Academy of Design, reflected favorably on the city of his birth.[12]

Following Blum's premature death in 1903 at the age of forty-six, Cincinnati came to appreciate his talent even more, although New York art critic Charles Caffin bitterly complained that the city had ignored Blum during his lifetime, but had "secured, with pitiful cheapness, an advertisement for the city from his death." If Cincinnati had failed to do the artist justice, it may have been because he devoted so much time to illustration. As Joseph Pennell pointed out, in describing the fate of another Cincinnati illustrator, Alfred Brennan, "Because this man chooses to illustrate, his work, which the critic does not understand, is dismissed with a line. Had he made a painting of the same subject with the same amount of work in it he would have been known all over the world. As it is he is only an illustrator" But Cincinnati's posthumous appreciation for Robert Blum was genuine, not selfish. Certainly Blum's closest friend and studio mate, William J. Baer, felt this was so, for as executor of Blum's estate he saw to it that most of the artist's etching plates, sketches, and studies found their way to the Cincinnati Art Museum. The museum provided the collection with a permanent gallery, and Frank Duveneck lifted new prints from the old plates, the sale of which provided funds for a Robert F. Blum scholarship to the Art Academy. Blum would have appreciated that.[13]

If Blum is largely forgotten today, it is because he divided his talent between illustration and painting, because he rarely exhibited, and because he sought the now unfashionable Victorian ideal of beauty. His strength lay in technique. Art historian Richard Boyle has described Blum's work as "a love of detail, a touch of sentiment, a delight in the idealization of the female form" His work stopped just short of preciousness, maintaining "those disparate values of gaiety and seriousness which add up to [his] most engaging quality—his charm."[14] As America reassesses the traditional art of the late nineteenth century, the art that Blum's contemporaries found so attractive, Blum's work will gain in appreciation.

Edward Potthast, Blum's Over-the-Rhine neighbor and friend, also launched his career as a lithographer and evening art student. Born in 1857, the same year as Blum, he gained a common school education, during which he filled the margins of schoolbooks with drawings. Apprenticed as a lithographer to the firm of Ehrgott and Krebs, for years he attended evening classes at the McMicken School. In 1882 he travelled to Europe with John Twachtman, spending the next three years studying at the Royal Academy of Munich. Later he studied in Antwerp and Paris, gaining an introduction to Impressionism, but he periodically returned to Cincinnati, continuing his

work as a lithographer. His modesty and diffidence hindered his reputation. He hesitated to show his work, psychologically unable to see himself as an artist. In 1893 Henry Farny encouraged him to submit his work to the Chicago World's Fair, but he refused, claiming that he had only "sketches." In 1896, strengthened apparently by the Cincinnati Art Museum's purchase of his *Dutch Interior,* he left his home for New York where he abandoned the somber palette of Munich for the colorful, breezy beach scenes that became his trademark. During the last twenty years of his life, his painting earned numerous awards and much critical acclaim, culminating in a silver medal at the 1915 Panama-Pacific Exposition in San Francisco.[15]

Two years younger than Potthast or Blum, Charles Niehaus began his training as a woodcarver and stonecutter, two skills familiar among German immigrants. At the McMicken School he won a first prize in drawing, and this encouragement pointed him toward the Royal Academy of Munich in 1878. There, like so many Americans, he found the artistic atmosphere intoxicating. He entered classes in drawing and modeling, earning a prize for a fountain design in his first year, the first American to win a prize in sculpture at the Royal Academy. Two years later he received a silver medal for a four-figure group entitled *Fleeting Time.* In 1882 he returned home, just in time to receive a commission for a James A. Garfield memorial statue. Ultimately Niehaus carved two statues of the recently assassinated president, one of which sits in Cincinnati's Piatt Park, while the other stands in the Capitol in Washington. In an age of public statuary, Charles Niehaus emerged as one of the nation's preeminent sculptors. Numerous commissions came his way, particularly for heroic figures, and the classic simplicity of his work maintained his reputation beyond the end of the century.[16]

An even more important artist, John Henry Twachtman, had preceded Blum, Potthast, and Niehaus from the German quarter. Twachtman's parents, emigrants from Hanover, had met in the Queen City. The father, a jack-of-all-trades, decorated window shades at the Brenaman Brothers Window Shade factory, where his fourteen-year-old son also found employment. Evening classes at the Ohio Mechanics Institute and then at the McMicken School developed the younger Twachtman's interest in painting, an interest discouraged by his father. Talent won out, however. By 1874 Twachtman had enrolled full-time at McMicken, just in time to absorb the full impact of Duveneck's appearance in the city, and he soon became one of several young artists often found at Duveneck's studio. After Duveneck had coaxed permission from John's reluctant parents, the aspiring artist joined the "old man" on his return to Europe in 1875. Munich worked much the same magic on this latest visitor as it had on Duveneck six years earlier. Romantic, cultural, and picturesque, the city of Wagner and "Mad Ludwig" opened a new world of sensuality and creativity to the reserved and intro-

spective Cincinnatian. In the autumn he enrolled in "eine Natur Klasse" at the Royal Academy. Already influenced by Duveneck, Twachtman easily adopted the dexterious brush technique of Wilhelm Leibl and other proponents of the "new realism." After two years of rigorous academic training, he joined Duveneck and William Merritt Chase in Venice, and two of his Italian landscapes from that summer venture comprised his first showings in the United States.[17]

In love with art, in love with Europe, and confident of his ability, Twachtman suddenly found his future circumscribed by news of his father's death. He returned to Cincinnati in 1878. For all of its artistic reputation (this was the year of the third May Festival and the opening of Music Hall), the city now appeared tame and provincial to Twachtman. The slender, somewhat nervous artist found little inspiration in Cincinnati. "An old fogied place," he wrote, "there is no good art influence here and I shall be glad to leave." He tried New York City with more success. An exhibition of his work brought some critical acclaim, along with membership in the recently founded Society of American Artists. Personal finances forced his return to Cincinnati in 1880 to accept a teaching position with the Woman's Art Museum Association, the organization that sought a permanent art museum for the city. However, Cincinnati still failed to stimulate him, and he rejoined Duveneck in Florence, serving as a teacher in his school and becoming one of the "boys." Within the circle of young Americans who followed Duveneck, Twachtman's abilities flowered. Talent and several years' seniority made his advice most "appreciated next to that of the 'Old Man.' " The year 1881 found Twachtman briefly back in Cincinnati again, this time to marry Martha Scudder, the daughter of a prominent physician. The newlywed couple set sail for Europe almost immediately, spending considerable time in Holland with friend and fellow artist, J. Alden Weir.

By the middle of the decade the Twachtmans had settled in Paris where John studied diligently at the Academie Julian. The Paris of the Third Republic had emerged as the new art capital of the continent, and the new favorite of Americans seeking instruction. Impressionism, the avant-garde in French painting, did not yet appeal to Twachtman; what interested him was the discipline and professionalism of the French schools. Increasingly confident of his own abilities, he had become dissatisfied with his Munich training. "I don't know a fellow who came from Munich who knows how to draw or ever learned anything else in that place," he complained to Weir. The Academie Julian stressed precise draftsmanship in the rigorous French tradition. Architect Stanford White found him there one day "hard at work—drawing—slavery—I should think to him—but a slavery he will never forget." Twachtman loved his Paris years, in part due to new friendships with Childe Hassam, Willard Metcalfe, and Edmund Tarbell, all of

whom gradually succumbed to the beauty of Impressionism. Summers Twachtman spent in Normandy or Holland, soaking up the *plein air* style in vogue. His canvases brightened. He experimented with diffusion of light and with simpler compositions. A pensive, sensitive abstraction entered his work. The dark tones and broad strokes of Munich fell away.[18]

Late in 1885 the Twachtmans, now the parents of two children, returned to the United States, but not to Cincinnati. They settled in Cos Cob, Connecticut where, with his father-in-law's support, John continued his progression towards a personal style of landscape. At the same time, proximity to New York allowed him to show his work and teach regularly at the Art Students League, the popular school then dominated by Chase. Recognition gradually followed: the Webb Prize from the Society of American Artists in 1888; the Temple Gold Medal from the Pennsylvania Academy of Fine Arts in 1894; and a silver medal at the World's Columbian Exposition in 1893. Still, his canvases did not sell well, and the financial strains affected his family life. It was during this time that he arrived at his unique and very intimate version of French Impressionism, marked by subdued tones, delicate atmospheres, and a subtle Oriental lyricism. Twachtman's work moved far beyond the accepted styles in American painting. In 1897, in protest of big exhibitions and organization politics, he joined with nine other artists of the Impressionist mold to form "The Ten American Painters," a secession from the Society of American Artists.

"Old fogy" Cincinnati did not disown Twachtman, however. In 1900 the Cincinnati Art Museum sponsored a two-man show—Twachtman and his son, J. Alden, who had just won the Art Academy's coveted foreign scholarship—and the exhibit received much favorable publicity in the city. A year later the museum hosted another exhibition of Twachtman's work. It was his last. In 1902 John Henry Twachtman died, bitter, depressed, and estranged from his family.

If the nation failed to adequately recognize Twachtman's abilities during his lifetime, his position in American art today requires no explanation. His biographer, Richard Boyle, has described him as "the most sensitive and unique of all the American Impressionists." Despite his lengthy stays in Europe, this talented man remained a constant supporter of American art. In his own work he sought not only a personal expression but a genuinely American one as well. He often complained of the country's lack of artistic appreciation, a complaint not limited to Cincinnati. With some bitterness he once told a group of students at the Chicago Art Institute: "You are studying art here now, and some day some of you will become painters, and a few of you will do distinguished work, and then the American public will turn you down for second and third rate French painters." His concern for American art remained a constant theme in his lectures, and his own life of struggle

made him a champion of all aspiring artists. Several years before his death, in speaking to a group of art lovers in Chicago, he startled his audience by saying, "It has been a source of great wonder why you should invite me, an American artist, to deliver an address on 'American art,' a subject in which you are not interested." To underscore his point he noted that the local museum did not possess a single American painting, and with that he refused to proceed with his lecture! Twachtman's death closed the career of "a rare and quiet talent, quietly achieved."[19]

If Twachtman's star, like Edward Potthast's, has continued to rise, the same cannot be said for many of the German-American artists who began their careers in Cincinnati. The rolls of the McMicken School are heavily laced with Teutonic names, the majority of which have disappeared into obscurity. Some turned to the commercial use of art; others remained as artists of limited reputations. Yet, to focus on the Twachtmans and Blums is to ignore the representative contributions of these lesser known individuals. Two artists of this group were Charles Kaelin and William Baer. Another product of the neighborhood around Race and Fifteenth Streets, Kaelin enrolled at McMicken in 1877. After two years of its traditional lessons, he followed in his father's footsteps, designing theater posters and other advertising material for the Strobridge Lithographing Company. Still attracted to painting, he left for New York and the Art Students League in the late 1880s. Although he returned to Cincinnati, where he became one of the minor talents in the Duveneck circle, he spent his summers painting scenes of the New England coast. Occasional exhibitions brought but little attention, despite a silver medal at the Panama-Pacific Exposition. Kaelin gradually withdrew from the world. In 1916 he moved to Rockport, Maine to spend the last thirteen years of his life painting seascapes, a lonely figure against the rocky shoreline.[20]

Robert Blum's studio partner, William Jacob Baer, was yet another product of the Over-the-Rhine area. Almost entirely forgotten today, Baer holds a unique position because of his energetic work as a miniaturist. Born just before the Civil War, Baer took the famiiar path to the McMicken School and then to Germany. Upon his return to the United States, he settled in New York, painting portraits, drawing magazine illustrations, and teaching. Success did not follow until 1892 when, at the request of a friend, he tried his hand at the almost defunct art of miniature painting. Within a few years he had turned exclusively to this form, and several years after his first hesitant beginning he helped launch the Society of American Miniature Painters. His careful draftsmanship and subtle tones brought him considerable attention, but with the passing of the fad, Baer entered the ranks of the forgotten.[21]

The outpouring of Germanic energy during the middle decades of the

century did not provide the only source of talented students who enrolled in the McMicken School. Elizabeth Nourse, a descendent of the Salem "witch," Rebecca Nurse, remains today one of the most important artists in the school's history. In her long career, Nourse achieved distinction in both Europe and America, largely for her portraits of peasant women and children. Although she lived in France from 1887 until her death in 1937, her network of Cincinnati friends ensured that her reputation would not be forgotten, and while she never painted outside the salon tradition, her work retains the spiritual beauty and warm intimacy that underlay her view of life.

The youngest of ten children, Elizabeth and her twin sister Adelaide were born in 1859 in the Cincinnati suburb of Mt. Healthy. Their parents had emigrated from Massachusetts in the early 1830s. Following a dramatic debate between Reverend Alexander Campbell, a prominent Baptist, and Bishop Edward Fenwick, a Roman Catholic, the Nourses exchanged their New England Calvinism for Catholicism. For Elizabeth, as for all the family, religion remained one of the stabilizing conditions of her life. Caleb Nourse prospered in the expanding economy of the West, establishing his own bank in 1856, but the shifting fortunes of the Civil War brought ruin, and the young Elizabeth grew up amidst genteel poverty. The family's strained finances required that the girls, Elizabeth, Adelaide, and Louise, who was six years older, support themselves. Louise became a teacher; the twins enrolled in the McMicken School, where Adelaide studied woodcarving and china painting, both fashionable pursuits for women. Elizabeth tackled the full curriculum of the school. She also benefited indirectly from Frank Duveneck's brief stay in the city in 1874–75, and some of her early work reflects the Munich influence. She knew Potthast and Twachtman as fellow students during this time, and in 1882 she belonged to a short-lived etching club that included Henry Farny and Lewis Henry Meakin, two prominent artists who tied their careers to Cincinnati.

From the very beginning Elizabeth Nourse saw art as a profession, a necessity in a family of limited means, and this slender, attractive woman brought a seriousness unsurpassed by her classmates. As her style evolved she gained a local reputation, and in 1881 Thomas Noble, the head of the McMicken School, offered her a position as a drawing instructor. She declined. Painting required all of her time. Following the death of her parents and the marriage of Adelaide to woodcarver Benn Pitman, she settled in with her older sister, an arrangement which continued until her death. During the 1880s Nourse's work brought in an income sufficient to support the two women. Always hungry for further development, she returned to the classroom in 1885, taking advantage of McMicken's first course permitting women to study from the nude form. As she gained confidence, her ambition looked to Paris, and two years later she and Louise left Cincinnati. "Such a

Elizabeth Nourse, *La Mere,*
1888; The Procter & Gamble
Collection, Cincinnati.

melancholy feeling!" she prophetically recorded. "There is so much we will see and do before we come back—and then will we ever come back?" Except for her twin sister's illness and death in 1893, Elizabeth Nourse never returned to the United States.[22]

A second distinguished artist of Cincinnati's non-German heritage was Joseph R. DeCamp, another product of McMicken, where his classmates included Twachtman and Blum. DeCamp also felt the magnetism of Duveneck. He followed him to Munich and then to Italy, becoming "the breeziest, cheekiest, warmhearted Bohemian in Vienna," according to one associate. In Vienna and Florence, DeCamp shared in that unique experience of intense creativity and intimate camaraderie that remained in the memories of all the Duveneck crowd. Upon his return to Cincinnati in 1883, he joined with several other "modern" painters in an exhibition at Closson's Gallery. For a community largely unprepared for the new forces at work in European art, the paintings were "practically totally misunderstood." Critics accustomed to the meticulous style of Dusseldorf denounced the show, and, under a torrent of adverse comment, the artists removed their work.

Joseph DeCamp moved on to Boston, where he established a reputation as a portrait painter and teacher. Accepted into the Society of American Artists on the basis of his progressive work, he broke away in 1897 as one of "The Ten," along with his boyhood friend John Twachtman. If less artistically adventuresome than Twachtman, DeCamp received greater recognition during his lifetime, including a gold medal at the Louisiana Purchase Exposition in 1904. At an exhibition of his paintings arranged shortly after his death in 1923, a critic described his art as "marked by a certain largeness of style based on the study of the antique, repeated and continued throughout his life. With this he combined the utmost fidelity to nature as he observed the character before him, . . . rarely do we find great skill of execution so restrained in pursuit of frank honesty of purpose." While he made Boston his home after 1883, he visited his native city regularly and Cincinnati followed his career closely. The Cincinnati Art Museum, in line with its policy of purchasing contemporary American art, bought several DeCamps, including a fine portrait of Duveneck and the outstanding *Woman Drying Her Hair*.[23]

In addition to the outpouring of local artists, Cincinnati's cultural reputation enticed young painters from the surrounding region, the most important of whom arrived during the fertile 1870s. Kenyon Cox, son of an Ohio governor and the grandson of the evangelist Charles Grandison Finney, was born in Warren, Ohio. Poor health interrupted his early education, allowing drawing to fill his hours. In 1871 his father enrolled him at McMicken, where he supposedly "spent more time sketching the animals at Robinson's Circus than in classes," but unlike many of his fellow students, he chose not

to go to Munich. Perhaps his family inheritance of politics and Protestant-ism immunized him to the attractions of the Bavarian city, for Cox became one of the first Cincinnatians to study in the Paris of the Third Republic. After five years of McMicken training he entered successively the ateliers of Emile-Auguste Carolus-Duran, Alexander Cabanel, and finally Jean Louis Gérôme, three of the most distinguished salon painters in France.

Although Cox had been considered something of a rebel during his years in Cincinnati, after returning to New York he moved steadily towards academic tradition. In his painting he sought a classical idealism, especially noticeable in the mural work with which he became increasingly identified after 1890. Yet, within that academic tradition he displayed considerable ability. As an art critic for *Scribner's Magazine* and the *Nation,* he contrib-uted a succession of columns on the development and philosophy of art, always stressing refinement and good taste. He wrote several books, pres-ented scores of lectures, and taught for years at Columbia University. In his public comments he emphasized that sound drawing lay at the foundation of all art. To the elegant and dignified Cox, Impressionism was "pernicious" and the Armory Show of 1913, where cubism arrived in America, was simply "insanity." The twentieth century has not been kind to Kenyon Cox, yet turn-of-the-century America had no greater defender of traditional aes-thetics.[24]

The single most important artist to Cincinnati's artistic life before 1890 also came from outside the city. Henry Farny, born François Henri Farny in Ribeauville, France in 1847, arrived in the United States six years later with his parents, refugees from the religious and political oppression which fol-lowed the revolution of 1848. The Farnys settled in the rugged country of western Pennsylvania, where the young Henry had his first contact with Native Americans, members of the Onandaigua tribe. Six years in the wil-derness proved sufficient for the elder Farnys. In 1859 the family arrived in Cincinnati. The early death of his father required Henry to help support his family, and a series of menial jobs followed, ending with his employment as an illustrator for Harper Brothers. The source of Farny's drawing ability remains obscure, and local records provide no clues to his development. The Civil War, however, gave him the opportunity to display his skills as an illustrator, and following the conclusion of hostilities, still in the employ of Harper Brothers, he left for New York. A year later he was in Italy serving as a studio assistant for Thomas Buchanan Read, whom he may have met in Cincinnati. After his relationship with Read deteriorated, he spent a year in Dusseldorf. Sometime in 1870 he returned to Cincinnati, having acquired considerable skill in drawing and a variety of painting experiences, but he still possessed neither a distinctive style nor any reputation.[25]

The Queen City provided a cool reception. Not content with drawing

Henry F. Farny, *Indian Camp*, 1890; Cincinnati Art Museum, bequest of Mrs. W. A. Julian.

circus posters and illustrating schoolbooks, he continued to paint, drifting into a Bohemian lifestyle. In 1873 the chamber of commerce commissioned him to illustrate the city's pork packing industry. With his commission in hand he headed for the Vienna Exposition of that year, where his five-by-thirty-feet pork packing cartoons garnered a medal and some much-needed recognition for the artist. From Vienna he travelled to Munich and several months of study with Wilhelm Diez. Back in Cincinnati by the end of the year, his eclectic interests continued to frustrate his development as an artist. An *Enquirer* reporter, visiting his studio at that time, described it as "a perfect little museum of curiosities." Received by Farny "with Bohemian *bonhomie*," the reporter, Lafcadio Hearn, marvelled at the range of curios that cluttered the studio: antiquated engravings, study heads, books on art, travel, poetry, and romance, beer mugs from Munich, an old-fashioned blunderbuss, Civil War sabers, an Italian stiletto, a Turkish pipe, a pair of Moroccan slippers—everything except a clear path to the future. One wall had been painted to resemble an Egyptian tomb; Etruscan designs decorated a flower pot; copies of old paintings and recent sketches of prisoners at the local police station shared wall space. Romanticism abounded.[26]

In the summer of 1874, Farny collaborated with Duveneck on a large historical painting of Joan of Arc titled *Prayer on the Battlefield,* which received much favorable comment at the Cincinnati Industrial Exposition that year. Duveneck's influence did not go unnoticed. "I cannot help thinking that [Farny] feels doubtful of his ability to make a picture to satisfy himself or us," wrote Manning Force to Governor Rutherford B. Hayes. "A young artist who made some stir in Munich has returned to Covington," Force continued, and "Farny has often spoken of him. If Farny does distrust his own ability, I think he will get Duveneck's aid."[27] Farny returned to Europe a third time, this time in the company of Duveneck, and the influence of Munich realism became increasingly apparent in his brushwork.

As his personal style—a combination of Dusseldorf precision and the freer strokes of Munich—edged towards maturity, Farny discovered his subject matter in the Native American. In 1881 he made his first trip to the West, where style, enthusiasm, and talent joined. "He gazes on his photographs of Indians; he draws Indians, he paints Indians, he sleeps with an Indian tomahawk near him . . . he talks Indian and he dreams of Indian warfare," so one reporter described him after his return. But the illustrator's eye captured more. Farny looked beyond the Indian to the landscape. His canvases portray a mood, a lost sense of place, rather than the more dramatic visions found in the work of Frederic Remington or Charles M. Russell. For the rest of Farny's life the Indian remained central to his art. Although he made numerous western trips, he continued to paint in Cincinnati, relying on many sketches and photographs to refresh his memory. His local reputa-

tion soared; his work brought numerous awards; and his studio served as an unofficial center of local art life.[28]

Much of Henry Farny's contribution to the city's artistic life lay in the role he had in leading other painters towards the American Indian as a subject, for in the last decade of the century Cincinnati artists earned an enviable reputation for their various portrayals of the Native America. Foremost among this group stood Joseph Henry Sharp. Born in 1859 in Bridgeport, Ohio, across the river from Wheeling, (West) Virginia, Sharp was known for his enthusiasm over the novels of James Fenimore Cooper and for the accidental loss of his hearing in a childhood accident. Early evidence of his drawing talent inspired him to go to Cincinnati in 1874, where six months of drudgery as a waterboy in the stockyards provided sufficient funds to attend the McMicken School. He was not yet sixteen. Over the next eight years his skills sharpened. McMicken taught him sound draftsmanship; in Antwerp, where he studied in 1881, he absorbed something of the color and light of Peter Paul Reubens. Back in Cincinnati the following year, he rented a studio in the same building as Farny's and turned his thoughts to America.[29]

In an era of dime novels and travelling equestrian shows, the rapidly disappearing West—a romanticized and commercialized extension of Cooper's vision—guided Sharp's attention toward the Indian. No doubt Farny's recent trip and bubbling enthusiasm added their share in molding the younger man, although Farny initially tried to dissuade Sharp from pursuing the subject. Sharp headed West in 1883, first to the raw New Mexico territory and then up the California coast to the Columbia River valley—a sort of grand tour of western American Indian cultures. Having discovered his future work, Sharp now felt that his abilities remained inadequate to the task. After further training at McMicken, he and John Hauser, another Cincinnatian to use the Indian as his subject matter, sailed for Europe. Munich offered no inspiration. They journeyed to Paris, where the Academie Julian and the spirited atmosphere of France's capital provided the necessary stimulation and training.

Upon his return to Cincinnati, Sharp became a fixture in the city's vibrant art life. He taught at the Art Academy (formerly the McMicken School), joined the activities of the Cincinnati Art Club, exhibited frequently, and, in general, enjoyed his rising reputation. But always the Indian was there. He did his first Indian portrait in 1892, a handsome portrait of Oglala Fire, a Sioux who was passing through the city. The next year Sharp and his wife boarded a train for Santa Fe where they teamed up with Hauser. The two men rented a buckboard and headed for the pueblos north of the city. If the rugged ride "did not leave much spring in the travelers," their stay in Taos made everything right. The clear air, shimmering light, and fasci-

Joseph H. Sharp, *Bill Jones,* ca. 1900; The Procter & Gamble Collection, Cincinnati.

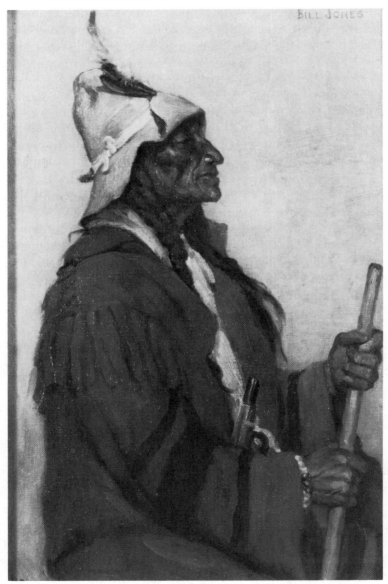

nating Indian culture captivated the two men. Three years later Sharp's enthusiasm remained sufficiently strong to enlist the attention of Ernest Blumenschein and Bert Phillips, who soon made their own pilgrimage to that enchanted and secluded land. The Taos art colony had been born, and Sharp's name remained associated with it for the rest of his life.[30]

These, then, were the men and women who dominated the Queen City's art life during the quarter century after the Civil War, twenty-five years that saw the city gradually surpass its prewar reputation as a cultural center. Yet, a scattering of nationally recognized names does not reveal the difficulties of establishing the artistic base which supported these men and women. As noted earlier, the Civil War proved unkind to art ventures in Cincinnati. With the demise of the Sketch Club, C. T. Webber had organized the Associated Artists of America in 1866, in order to provide "the means for a more thorough knowledge of Art . . . by keeping in operation schools," and "to make Cincinnati—what it should be—the Art-centre of the Great West." Despite these lofty aims and at least one moderately successful exhibition, the organization did not survive. Two years later several prominent civic leaders, interested in stimulating art sales, established the Academy of Fine Arts in order to cultivate "a love for the beautiful and improve the taste for fine arts." Spearheaded by Joseph Longworth, Henry Probasco, and William Groesbeck, this latest enterprise managed but two shows, both at Wiswell's Gallery on Fourth Street. Of a rather different but more influential nature was the Verein fur Christliche Kunst, a Benedictine organization which decorated Catholic churches in the region. In its workshops both Charles Niehaus and Clement Barnhorn began their careers, and, of course, Frank Duveneck received his early training under its auspices.[31]

All of this was insignificant when compared to the robust art life evident in the city before 1860. What Cincinnati lacked was a catalyst. In short order it received two. In 1869 the McMicken School of Design opened its doors, the final outgrowth of Sarah Peter's bold enterprise of the 1850s, the Ladies Academy of Fine Arts. Although the history of the McMicken School is detailed elsewhere, the fledgling institution gave the city a training center and focal point for young artists. Concurrently the city hosted the first in a series of almost annual industrial exhibitions. Searching for a way to pull the city out of its postwar economic malaise, the chamber of commerce, the Board of Trade, and the Ohio Mechanics Institute collaborated to produce a "Grand Industrial Exposition" in 1870. Held in the recently completed Saengerfest Halle, the first exposition attracted over 300,000 people. In the second year the energetic Alfred Traber Goshorn took control, expanding the event to include art, music, and horticultural exhibits. A Fine Arts Committee, which included the painter John Tait, saw to it that exhibitions em-

phasized the work of local artists. Tait, who had studied under William Sonntag, proved particularly helpful in arranging for the loan of works both from private collections and artists' studios. The 1872 show, housed in the just completed Art Hall, featured over six hundred art works, and its popularity even forced the backers to keep the facility open for two weeks following the closing of the exposition.[32]

Intended as a way of "establishing a taste for art here at home," the exposition art exhibits, in the absence of readily available illustrations, also provided art students with an opportunity to study the works of such contemporary European masters as Gérôme, Couture, and Lessing. Veteran local painters enjoyed the opportunity to display their own recent works, and even those with little reputation occasionally had works displayed. Thus, the Cincinnati industrial exposition supplied an important stimulus for all who followed the part of art.[33]

While the McMicken School and the industrial expositions centered public attention on the art community, a third injection of vitality, as previously noted, arrived in the form of Frank Duveneck. For impressionable young art students, Duveneck's appearance was indispensable. Here was an artist not much older than themselves, a man who had just spent three years in one of Europe's finest art academies, achieving recognition beyond belief. He knew what art was all about, and his example opened doors to all their futures. Whether in his studio or in his classes, Duveneck promoted the style of Munich and regaled his followers with tales of an art student's life in Europe. It is no wonder that so many young Cincinnatians followed his path.[34]

Duveneck's lukewarm reception by critics did not damage his reputation among students; indeed, it probably made him more attractive. Lack of understanding was nothing new to artists, and the more talented young men at the McMicken School already chafed under the disciplined and repetitious copywork that served as the heart of the school's curriculum. "Sham work," John Rettig later called it, work that failed to develop the power of the individual. Kenyon Cox and Alfred Brennan even led a move to take over an empty room on the floor beneath the schools' quarters, where rebellious students sketched, heatedly discussed art, and made light of everything else. Thomas Noble, the school's director, on his rare visits to the lower floor "edged his way timidly and quietly around the sketches," before retreating to the more decorous classes above. Only the school's youngest instructor, Will Humphreys, joined the insurgents, but as an equal.[35]

Although Duveneck never attended these sessions, his spirit was there. His own life class at the Ohio Mechanics Institute had provided students with their first exposure to nude female models, a tradition continued by C. T. Webber. Student talk about one mysterious model even captured the

attention of that indefatigable newshound Lafcadio Hearn. Disguised as an artist, he joined the class one evening in order to discover the truth of the stories. The next day his ecstatic description titillated readers of the *Cincinnati Enquirer*. Six feet tall, blond, with "extraordinary loveliness of form," he wrote, she could quote Byron, speak French and German, paint a little, modeled when she felt like it, and refused to discard her anonymity. No one knew her name or where she lived, and, most intriguing, she accepted no payment. The popularity of this life class encouraged the McMicken students to organize their own, and eventually the school itself brought in nude models—but for men only. Almost a decade passed before Victorian standards loosened enough to permit female students to study directly from the female form, and then, of course, in classes separate from the men.[36]

Duveneck's presence also increased discontent among the younger artists in the city. His accounts of Munich, of the new art movements, tarnished the image of their hometown. No longer did Cincinnati appear so bright, so progressive, when compared to the heady atmosphere of the Bavarian capital. The doors that Duveneck opened frequently opened only one way. When Hearn visited a number of local studios in 1874, he found the artists generally dissatisfied with their city. "This is no town for artists . . . and I don't believe I shall stay very long in it," grumbled Will Drake. "I can do far better in the East." E. D. Grafton felt that Cincinnati placed a "comparatively low estimate . . . on art," pointing out that even the talented Farny was obliged to sketch hog-pens and pork houses. Farny himself noted that an artist could survive only if he did hack work. Duveneck's success in Boston and subsequent return to Europe hastened the departure of the city's most promising artists, some of whom returned only when their funds ran out. Some never returned.[37]

This revolving door effect left the community's art life in disarray. The Artist Club which had so enthusiastically welcomed Duveneck in 1873 seems not to have survived mid-decade, and an Etching Club, organized in 1878, remained too limited in scope to last more than a few years. In 1880 an Art Students League met at a Mr. Stahl's studio where the members painted from a live male model. This organization lasted at least two years, but never expanded beyond its original size.[38] On one of his now infrequent visits to the city, Duveneck alluded to this lack of organization. "To speak of [Cincinnati] as an 'art center' is not worthwhile.' There is an appreciative spirit shown to art, but there is not the opportunity for its study that is needed to make the artist." To the conquerer of Munich, annual exhibits and princely private collections were insufficient; artists generated the life of a true art center, but the McMicken School, he continued, is "in the hands of two men and the methods are not right." "It is all Lessing and Achenbach" with "no heed paid to nature." Thus, the artists "have few ideas, their study is not

broad enough. Their associations are too narrow." Cincinnati offered little real encouragement, Duveneck maintained, and "the boards and art committees . . . pay no attention to its artists" In other words the Queen City's much vaunted reputation was really quite superficial—at least when compared to the major art centers of Europe.[39]

Other artists agreed with Duveneck. To revive "a genuine love of art in the city," a handful of local painters, who had returned recently from Munich and Venice, displayed their work at Closson's Gallery in 1883. Critics proved ambivalent; buyers nonexistent. In a letter to a friend, John Twachtman, one of the exhibiting artists, denounced the city's conservative taste. "Only one kind of art is considered good. . . . The old Dusseldorf School comes in for its full share of honor." The *Cincinnati Graphic* concurred. " 'Real artists,' those who follow art for its own sake, are not encouraged much . . . these days. In fact, with one or two exceptions, they are slowly starving." Even the now prominent Farny often struggled to pay his bills, resorting on occasion to exchanging a sketch in payment for services. Cincinnati, it seems, was a far cry from the vital atmosphere of eastern cities. The sluggishness also affected more traditional art sales. *The Week: Illustrated,* the city's latest journal devoted to entertainment and the arts, lamented the failure of art to sell at the 1883 industrial exposition. Pointing to the recent improvements in American art that had resulted from increased European training, *The Week* observed that art patronage in the country lagged far behind European nations. "We go on furnishing our homes with costly profusion—we spend immense sums on upholstery, knick-knacks, earthenware, pug dogs, or the like, but picture buying seems an unknown method of expending our surplus needs."[40]

Cincinnati was not alone. Americans continued to remain suspicious of art, while enjoying the fruits of economic prosperity. The enormous productivity of the industrial revolution produced a seemingly unlimited supply of new and marvelous decorative items, next to which painting and sculpture paled. Even New York City spent little more on art than Lyon, a provincial French city of 50,000 residents, or so claimed *The Week.* Part of the problem lay in the unsettled economic conditions of the time. Between 1870 and 1895 the nation struggled through two lengthy depressions and several recessions. Cincinnati suffered along with the rest of the country. Furthermore, in 1883 a major flood savaged the river-oriented city, followed the next year by an even more serious inundation, the second worst in the city's two hundred-year history. That same year, 1884, social tensions erupted in the infamous Court House riot that left scores dead and millions of dollars in damaged property. Ethnic tensions, class conflicts, congestion, and expansion plagued the city during the last quarter of the nineteenth century, undermining the certainty in progress that had existed among civic leaders. Politics degener-

ated into the years of Boss George B. Cox. Certainly other American cities shared these problems, but Cincinnati also faced a declining growth rate and each decennial census placed it lower in the ranks of the nation's important cities. Against this setting the city endeavored to hold its cultural reputation.[41]

To criticize Cincinnati for not being a Munich or Paris is not fair of course. It never attempted to be. Outside of the editorial puffery surrounding the city's musical development, no one truly compared it to the principal centers of Europe. No one, that is, except those artists who had visited Europe and returned to find their illusions shattered. To them, Europeans provided an ethusiastic endorsement of art, an endorsement rarely found in New York or Boston, and certainly not in Cincinnati. But rare is the artist who has ever found sufficient support from a community, and thousands of European artists remained dissatisfied with patronage in their own countries. Art has always been a fickle mistress.

Hampered by conservative taste and a disappointing economy, as well as a cultural inferiority that hindered support for nontraditional art styles, Cincinnati remained a significant regional center to the end of the century, and then grudgingly gave way to Chicago. If its major artists found greater opportunities in the East or in Europe, the artistic ferment generated during the 1870s and 1880s laid a substantial base for the vital art community found in the city at the end of the century, an important ingredient of which proved to be the many able craftspeople who sought to apply aesthetic taste to functional items.

The Age of Crafts:
Work In Wood and Clay

*I*n 1803 Charles McMicken arrived in Cincinnati, a twenty-one-year-old man in search of a better life, whose worldly possessions included a horse, a bridle, and a saddle. The son of a Bucks County, Pennsylvania, farmer and mill operator, McMicken had left home with a meager education, some knowledge of surveying, and the habits of thrift and industry often associated with the Scots who emigrated to America. Like so many of that post-Revolutionary generation, he saw opportunity in the western country. For a short time he clerked for Ohio senator John Smith, perhaps anticipating a career in law or politics. Commerce proved a greater attraction, however, and McMicken travelled to New Orleans, the great commercial terminus for the Ohio-Mississippi River trade. There, he turned his diligence and hard work into steady employment, establishing himself as a cotton shipper by 1807. Overcoming several financial reversals, a common story in the economically volatile West, he gradually built up a considerable fortune, while dividing his residency between Bayou Sarah, Louisiana and Cincinnati. In the mid-1830s he shifted his interest to real estate in Cincinnati, making his first purchase the northeast corner lot at Third and Main Streets. Steadily and unobtrusively he enlarged his fortune.

Always quiet and reserved, Charles McMicken's commanding physical appearance reflected his solid approach to life. He carried two hundred and fifty pounds on a six-foot frame, and fellow businessmen remarked on his vigorous mind, reserved personality, and inflexible will. Rarely ill, he abstained from all forms of tobacco and alcohol. He had few intimate friends, and conducted all of his affairs personally, refusing the services of lawyers or other professionals. While he contributed quietly to many civic and charitable causes, few of his fellow Cincinnatians knew much about him when he

died of pneumonia in 1858 at the age of seventy-five. Although local newspapers carried announcements of his death, listing his personal fortune at one million dollars, no one was prepared for the contents of his will which made McMicken the city's greatest benefactor, to be rivaled later only by Reuben Springer and Charles West.[1]

Charles McMicken never married and he left all of his extensive land holdings, as well as sizeable railroad investments, to the city of Cincinnati for the establishment of a college where students could obtain a practical English education and learn sound moral instruction. Angry relatives in Louisiana contested the will, eventually removing all Louisiana property from its provisions, and this protracted litigation postponed the legal chartering of McMicken University until December 1859. It was to this embryonic institution that in 1864 the Ladies Academy of Fine Arts bequeathed its collection of pictures and casts, the pride of Sarah Worthington King Peter. The university board, not yet prepared to operate a college, stored the collection in one of the McMicken buildings. Discovering the dust-gathering copies two years later, several artists used them to open a "free art school." The success of this modest venture prodded the university to reclaim the collection and establish its own school.

The McMicken School of Design, the new institution's name, opened its doors in 1868, the first functioning department of a reorganized University of Cincinnati. Lodged in the upper two floors of the old College Building at the corner of Third and Main, the new school admitted students of both sexes, charged no tuition to city residents, and forbade loud talking and the use of tobacco. To direct the new program, the trustees hired a New York artist, Thomas S. Noble, largely on the recommendation of George Ward Nichols, who had shared a room with Noble when the two had studied art together in Paris during the late 1850s.[2]

Thomas Noble was born in Lexington, Kentucky in 1835, but like many other aspiring western artists he crossed the ocean to Europe. In Paris he studied for three years with Thomas Couture, perfecting the polished academic style which remained with him for the rest of his life. In 1859 he returned to the United States, living in St. Louis until the Civil War broke out. Following four years as an officer in the Confederate army, he settled in New York City, where his full beard and curly locks divulged his artistic profession. In 1867 he gained considerable attention with a dramatic portrait of *John Brown,* followed by *The Price of Blood,* a painting of a mulatto boy being sold by his white father—unusual themes for a former Confederate officer. The National Academy of Design, the nation's most prestigious art organization, awarded him a gold medal in 1868 and elected him to associate membership. That same year he came to Cincinnati.[3]

Noble quickly molded the McMicken School in his image. Borrowing

from his own experiences in Paris and Munich, he established a curriculum typical of the traditional European academies. First year students worked on shading and perspective, spending long hours copying from engraved prints of acknowledged masterpieces. In their second year students labored before casts, working on composition and design. The third year allowed students the opportunity to draw from nature and work with color, sometimes drawing from models dressed in costumes provided by Noble. This tedious and often restrictive approach did not deter students. Attracted by the free tuition and the opportunity for economic advancement offered by thorough training in design, enrollments rapidly climbed. Day classes were filled largely by genteel women who were searching for respectable careers. Young, working-class men flocked to the night classes. During the school's first decade, a steady stream of truly talented pupils, many from the heavily German Over-the-Rhine community, matriculated at McMicken.[4]

After opening with only thirteen pupils, the school's enrollment swelled and soon strained the cramped quarters on Third Street, and in 1873 the School of Design joined the rest of the university, which occupied the grounds of the former McMicken estate on the Hamilton Road (now McMicken Avenue). In addition to drawing, the school offered courses in sculpture, woodcarving, and engraving—typical of its focus on applied art. At the center of this interest in applying design to local manufacturing stood Benn Pitman, "a small, nervous, intense man—who talks Ruskinese" The younger brother of Sir Isaac Pitman, the inventor of shorthand, Benn had given up an early interest in architecture to promote his brother's work. In 1853, at the age of thirty-one, he came from England to the United States, settling a year later in Cincinnati. His interest in art returned, fueled by the writings of John Ruskin, England's most prominent defender of sound craftsmanship and good design. By 1858 Pitman had proposed that the Cincinnati public schools provide free drawing instruction for its teachers, and he developed a textbook for that purpose. The school board—"a set of intellectual logs," according to Pitman—turned down his proposal. Searching for a way to bring his own life in line with his developing philosophy, he turned to woodcarving. But he did not stop with carving. Alarmed by the increased production of cheap, shoddy goods, the degradation of labor, and the apparent decline of human creativity—all products of the industrial revolution—he instituted a virtual one-man revival of handicrafts. For the rest of his life, his teaching stressed the fundamentals of good design, and his woodcarving classes at McMicken tapped a latent source of talent in the city already known for its furniture and cabinet makers.[5]

A local influence in Pitman's woodcarving came from the similar work of Henry and William Fry, father and son, who had already gained considerable attention as decorators of the homes sprouting in the city's fashionable

suburbs. Born in England, the Frys reached Cincinnati in 1851, two years before Pitman's arrival. Identified in the 1853 city directory as woodcarvers, they established a reputation for their work on steamboat and church interiors. Neither carpenters nor cabinet makers, the Frys' forte was decoration. During the 1860s they carved the handsome interiors of both Henry Probasco's stately Clifton mansion and Joseph Longworth's elegant "Rookwood" home on Grandin Road. The Frys, and later Pitman, stressed themes from nature, recreating countless birds, flowers, tree branchs, and gracefully twining vines, using the dark woods and massive scale so enjoyed in mid-Victorian America. Blessed with steady hands and sure techniques, these three Englishmen played particularly influential roles in teaching artistic woodcarving to a generation of Cincinnati women, many of whom came from the most refined families in the city. The Frys and Pitman agreed that decoration, especially in the home, not only fit the proper domestic sphere of women, but that women possessed "more refined sentiment" and worked "for less sordid ends" than men. "Let men construct and women decorate," solemnly intoned Pitman in his influential *A Plea for American Decorative Art*.[6]

The excellence in woodcarving did not pass unnoticed. The 1874 industrial exposition displayed over eight hundred pieces done by local carvers, and the resulting sales and publicity set off a boom of interest. Local pride sent numerous examples to the 1876 Centennial Exhibition in Philadelphia, and the enthusiastic reception there thrust Cincinnati into the vanguard of a rapidly expanding national arts and crafts movement. While handcarved objects never provided the much hoped for new vocational field for women, woodcarving remained an important element in the city's artistic life for the rest of the century, and did provide an important outlet for female creativity.

The Frys never ventured beyond woodcarving, but Pitman's interests ranged much wider, and he played an integral role in Cincinnati's infatuation with ceramic design. When visiting Philadelphia in 1876, he obtained a set of colors for china painting. Intrigued with its possibilities, he hired Marie Eggers, a young German woman who had studied at Dresden, to give instruction to a small class of interested women. Clara Newton, Agnes Pitman, Jane Porter Dodd, Mary Louise McLaughlin, Elizabeth Nourse, and others made up this first group of amateur decorators. Independent of Pitman's efforts, a year earlier Maria Longworth Nichols had also discovered the pleasures of painting on china. In her case, Karl Langenbeck, a neighbor who "earned his pocket money making pen and ink drawings," had received a set of colors from an uncle in Germany. Mrs. Nichols and Mrs. Learner B. Harrison joined his experiments in decoration.[7]

Spreading along a network of socially prominent and artistically inclined women, the budding interest in ceramic decoration came to the atten-

Promoters of the Decorative Arts. At right, Benn Pitman; below left, M. Louise McLaughlin; below right, Maria Longworth Nichols Storer. All courtesy of the Cincinnati Historical Society.

tion of the Women's Executive Centennial Committee, the local organization established recently "to secure a creditable representation of women's work at the approaching 'Centennial'. . . ." Seizing on the enthusiasm for china painting and woodcarving, the Centennial Committee sponsored two exhibits in 1875 designed to arouse public interest and to raise funds for participation in the forthcoming national celebration in Philadelphia. Known locally as the "Martha Washington Tea Party" and the "Carnival of Nations," the two exhibits met with success, and the unsold items, joined by other examples of porcelain, stoneware, and wood, made up Cincinnati's major contribution to the Centennial Exhibition.[8]

The 1876 International Exhibition of American and Foreign Arts, Manufactures, and Products of the Soil and Mines—invariably known as "The Centennial"—gave the United States its first occasion to showcase itself through a World's Fair. Americans embraced the opportunity to demonstrate their remarkable achievements, symbolized by the powerful forty-feet-high, fifty-six-ton Corliss engine—"the great pulsating iron heart of the exhibition"—whose 1,500 horsepower drove the mechanical displays in Machinery Hall. Anxious to compare themselves to the rest of the world, and full of a new post–Civil War nationalism, hundreds of thousands of Americans visited the country's one hundredth birthday celebration. A short time after President Ulysses S. Grant and Emperor Dom Pedro of Brazil, the guest of honor, opened the exhibition, Empress Theresa of Brazil opened the Women's Pavilion, a large hall honoring the numerous contributions of American women. Part of the building's main floor was devoted to weaving and spinning machines, all powered by a noisy six-horsepower steam engine, operated by a young Canadian woman. Along the walls were displayed paintings, porcelains, floral decorations, embroidery, and other examples of women's artistry. Few noted the irony of the steam engine against the background of handmade items.[9]

While Americans exulted in their outpouring of ingenuity and invention, beneath the patriotic oratory many visitors recognized the purely functional nature of American industrial products. For this reason the women's decorative contribution received considerable attention. The Cincinnati Room received its own share of plaudits. William Dean Howells, editor of the *Atlantic Monthly,* singled out "the carved wood-work" of the Cincinnati ladies for its refined execution and "charming sentiment." The impressive display of carved furniture, furnishings, painted china, and stoneware stirred considerable interest among visitors, and several noted the employment possibilities for women. "We desire to call special attention to this Cincinnati exhibit," announced the *New Century for Women,* the weekly publication written and produced entirely by women during the Centennial, "opening as it does a broad and remunerative field for artistic talent and

industry." Woodcarving and ceramic decoration promised honorable work, for the beauty and utility of the finished product ensured that a woman's time was not wasted "in the production of some cheap and meaningless thing, to be used for a day and then thrown away as useless." In the background the steam engine labored noisily.[10]

If the Centennial cultivated a national taste for handcrafted forms, it also provided an even more direct stimulus to the youthful ceramic design movement in Cincinnati. National recognition of the city's efforts was heady enough, but a greater impact came from the displays of other nations. Several Cincinnati craftswomen visited the exhibition, and both Mary Louise McLaughlin and Maria Nichols returned fired by the work of foreign artists. McLaughlin discovered the distinctive underglaze faience pottery produced by Haviland and Company of Limoges, France, and she directed her own efforts to this process. The Japanese display of pottery and lacquered ware captured Mrs. Nichols's attention. Charmed by the rich colors and delicate contours, both she and her husband came to believe that Japanese design promised "to exert a wide and positive influence upon American art industries." Led by these two dynamic women, the Queen City witnessed unparalleled activity in pottery decoration, activity which quickly earned national and even international recognition.[11]

Through his woodcarving classes at the McMicken School, Benn Pitman had pointed Cincinnati towards the unfolding crafts movement; through her untiring energy and restless experimentation, Mary Louise McLaughlin propelled ceramic decoration to the forefront of that movement. In the year following the Centennial, she published her first book on the subject, *A Practical Manual for the Use of Amateurs in the Decoration of Hard Porcelain,* and that summer at the Coultrey Pottery she anxiously began experiments with underglaze painting in an effort to reproduce the Haviland faience. McLaughlin's work embellished an already existing pottery industry in the city. Since early in the century Cincinnati had housed numerous small but thriving potteries which turned out plain, inexpensive, utilitarian earthenware. By mid-century English-born potters controlled local production, and by the 1870s both Patrick Coultrey and Joseph Bailey, Sr., had achieved recognition at the local industrial expositions. These experienced craftsmen advised and assisted the design-conscious women, and without the use of their facilities, no pottery movement could have existed in the city. In the early years women did little work at the wheel, choosing to emphasize decoration rather than shape. Coultrey's Pottery, for many years on Dayton Street in the West End, served as the center for the work of McLaughlin and her friends, as they worked on the new underglaze technique. Their initial efforts led to an exhibition in early 1878, which evoked one reporter to describe McLaughlin's work as "the sensation of the hour."[12]

As the women improved their skills, "the best workers" organized the Pottery Club. McLaughlin served as president, with Clara Chipman Newton as secretary and Alice Holabird as treasurer. Eight other friends formed the rest of the membership. As the original intention had been for an even dozen, one vacancy remained for Mrs. Nichols, whose invitation had gone astray. Laura Fry, the daughter of William Fry, the painter Elizabeth Nourse, and Mrs. M. V. Kennan were included as honorary members in the new society. United by friendship and common interests, the Pottery Club met three times a week at Coultrey's, where the members experimented in ceramic decoration. Not to be outdone, Maria Nichols, choosing to interpret her undelivered invitation as a slight, decided to work independently. She contacted Frederick Dallas, owner of the Hamilton Road Pottery, and arranged to have pieces made and fired there. She also rented a small room on the pottery grounds, which she shared with Jane Porter Dodd, one of the members of Pitman's china painting class.[13] Arriving on her "small yellow Indian pony," which remained tethered in a corner of the yard, Maria Nichols embarked on her first serious experiments in pottery decoration, working diligently in the small, sparse room on the second floor of a wagon shed. Her first efforts failed. The "hard fire of the granite kilns" destroyed her overglaze colors, limiting her to cobalt blue, dark green, and black. The delicate Japanese hues and tints remained beyond her reach. While she struggled with color variations, the Pottery Club, searching for more space as well as access to white clay, moved its own work to the Hamilton Road Pottery. Working in a large room in the former home of Mrs. Trollope, the club members continued their work with underglaze decoration, maintaining an awkward estrangement from Mrs. Nichols.[14]

While McLaughlin and Nichols travelled their separate paths, the city awakened to the fact that something significant was taking place in the potteries. Despite the absence of industrial exhibitions (none was held in 1876 or 1877 while Music Hall was being constructed), local ceramic decoration received important recognition. In *Art Education Applied to Industry,* a book destined to become a philosophical pillar of the city's design movement, George Ward Nichols stressed the importance of proper design for manufactured goods. Not unnaturally, he used pottery as one of his principal examples. A year later, in *Pottery, How It Is Made,* he discussed the technical details of the subject, going far beyond the information in McLaughlin's earlier publication. At the same time, the Women's Art Museum Association (WAMA), encouraged by the artistic stirrings in the city, launched the movement which led to the founding of the Cincinnati Art Museum (see chapter 9). To promote the relationship between art and industry, WAMA organized several classes, including one on china painting. Separately, John Rettig, local artist and scene painter, and Albert Valentine opened a class in

the Limoges style of pottery decoration, a class which grew to over sixty pupils by the summer of 1880. "Cincinnati is nothing, if she is not artistic, and she is artistic in a very genuine sense," concluded one visiting journalist who observed the expanding interest in the decorative arts.[15]

The 1879 industrial exposition provided a major forum for local talent. Citing the decorative arts as "perhaps the most striking feature of the Exposition," the *Cincinnati Commercial* singled out the remarkable progress made with native clays. Of equal importance, commercial potteries now displayed their own decorated ware. For several years the women involved in the crafts movement had viewed their work as leading towards a new and permanent art industry in the Ohio Valley; now for the first time the commercial potters agreed. Impresssed by the reception given the elaborately decorated pieces, ceramic manufacturers began shifting away from unadorned ware. The Hamilton Road Pottery employed a full-time decorator for the first time in 1879, while Thomas J. Wheatley, formerly associated with Coultrey, opened his own pottery the same year, devoted exclusively to decorated work. In turn, Coultrey provided the facilities for the class of Rettig and Valentine, and worked closely with them in producing something called "Cincinnati Faience." By 1880 all the commercial potteries had turned to the use of the underglaze process first developed by McLaughlin, a turn of events which led to later legal complications.

Success brought increased competition. The Cincinnati Art Pottery, managed by Frank Huntington, first produced its distinctive dark blue ware in 1879. Matt Morgan operated an art pottery for several years during this time, providing experience for Matt Daly, later one of Rookwood Pottery's most distinguished artists, while Karl Langenbeck, Maria Nichols's early partner, operated the Avon Pottery during the next decade.[16]

Interest in ceramics extended well beyond the city. The mania for pottery brought women from communities throughout the region to study in Cincinnati, and ceramic pieces from as far away as New York and Iowa arrived almost weekly to be fired at the commercial potteries. At one time almost two hundred amateurs, mostly women, used the Hamilton Road Pottery. "Everyone had gone a little daft on the subject," noted a writer in *The Criterion*. Pen and pencil had given way to clay; even woodcarving appeared "in danger of passing away." Louise McLaughlin aptly described it as "a wild ceramic orgy." *Harper's New Monthly Magazine* observed "the wide range of age and conditions of life" evident among the decorators. From young girls to grandmothers, from those in need of additional income to those of comfortable means, ceramic decoration opened new vistas.[17]

During this outpouring of creativity, the Pottery Club continued its adventuresome work, including McLaughlin's famous "Ali Baba" vase, reputedly the largest made in the country at that time. To display their progress

and to discourage the increasing number of random visitors, the club held an open house at the pottery in the spring of 1880. Invitations were "eagerly sought," and the affair took on a decidedly social tone. Club members decorated their workroom with seasonal flowers, creating a "floral bower." In the yard the kilns were set up to display the various stages of pottery making. Clara Newton described the day some years later:

> Up and down the narrow stairs, the art and fashion of the city surged from 12 to 5 o'clock. Hamilton Road had never seen such a sight. Triumphant and exhausted when the guests were all gone, Mr. Dallas rushed into the room to tell us that the carriages had been standing up and down both sides of the street and clear around the corner. Nothing meant so much to the old gentleman as those carriages—they were the outward and visible sign of whatever inward grace the Pottery possessed.[18]

If the carriage trade brought welcome financial support for the Pottery Club, the exhibit drew considerable artistic attention as well. New methods, new colors, and new shapes revealed the progress made during the previous year. The display of vases, cups and saucers, bowls, pitchers, and ornamental tiles, most of them decorated with fashionable naturalistic themes, received extensive praise in the newspapers. More importantly, *Harper's Weekly* praised the exhibit to a national audience. "It is characteristic of Cincinnati art pottery that it is not amateurish. It looks like that of a professional potter." And it was professional. The alliance of skilled potters and talented decorators produced work both popular and aesthetically attractive. Though self-taught and unpaid, the members of the Pottery Club helped make Cincinnati the nation's leading center of art pottery for the next twenty years.[19]

Success and recognition also brought troubles. As the commercial potters realized the potential profits in art pottery, they began to compete more and more with the independent designers. While this proved advantageous to those who worked full time at a commercial pottery, many of whom had studied at the McMicken School, it strained the relationship between the "amateur" decorators and the skilled craftsmen who worked the wheels. In 1880, partly to resolve this difficulty and partly to gain greater independence from the hard fires and overworked kilns, both Louise McLaughlin and Maria Nichols paid for the construction of special kilns at the Hamilton Road Pottery. McLaughlin and her associates continued to work there, but Mrs. Nichols became dissatisfied with the arrangement.

Since the Philadelphia Centennial, this enthusiastic and tireless woman had longed for a place of her own where art pottery would be the major product. Opportunity arrived in the form of an old schoolhouse which her father had just purchased. Located on Eastern Avenue, at the edge of the city,

the future Rookwood Pottery began its new life in an empty building situated on a low bluff along the river. Mrs. Nichols determined to make the most of her opportunity. First, she consulted with Joseph Bailey, Sr., the head potter at the Hamilton Road concern, about the necessary equipment and material needed for a commercial pottery. Then she set to work. Kilns were constructed; lathes and other tools purchased; glazes and clays ordered. Her first purchase was a secondhand steam engine, a necessity for turning the grinders and wheels. She next installed a hand-operated wheel for turning individual vases. Convinced initially that woman power was "more easily controlled than steam," she later conceded that steam had become "more docile." Calling on her father's generosity, she had the pottery in operation by November 1880, almost six months to the day after she had learned about the property.[20]

Maria Nichols named her enterprise "Rookwood," both to honor her father's estate and because the name reminded her of Wedgwood. To superintend the daily operations, she engaged Joseph Bailey, Jr., the son of the Hamilton Road potter. A longtime friend and part-time decorator, Edward P. Cranch—a relic from the days of the old Semi-Colon Club—assisted with the books. This "quaintest and most delightful of men" became a fixture around the pottery until his death twelve years later. James Broomfield, Ferdinand Mersman, and Henry Farny assisted with the decorating during the first year, which saw several unsuccessful attempts at Indian portraits by Farny. Farny also contributed Rookwood's first trademark, a framed kiln superimposed upon a tree branch on which two rooks perched. Mrs. Nichols continued to work at her own unique Japanese-styled pieces, while other women designers had at least limited access to the kilns. But from the beginning Rookwood produced commercial ware and undecorated pieces in order to achieve financial success.[21]

The pottery fronted on the street, with the ground at the rear sloping down to the river. Off the main entrance hall, a large room to the left provided space for potters to work; to the right were two rooms, one for decorating and one for display of the finished products. On the second floor Mrs. Nichols maintained a combination office and studio, while Cranch used an adjacent room for his multiple duties. Joseph Bailey and his family lived across the hall, making it possible for him to serve as night watchman and to oversee the kilns during nonbusiness hours. The basement, which was at ground level in the rear of the building, housed the machinery, tubs, and storage vats. Two kilns in the yard completed the facility. The riverside location at first had seemed desirable, permitting clay to be shipped by barge, but after the first shipment all clay arrived by railroad from Tennessee. Thus, the nearby railroad tracks proved more important, although the frequent train whistles, combined with the noise of the mule-drawn streetcars

on Eastern Avenue, often exasperated the designers. Located in an area long devoted to manufacturing and downwind from the heart of the city, Rookwood also suffered from an excess of dirt, "appalling even for Cincinnatians."[22]

The assorted nuisances did not dampen the spirit of adventure that surrounded the enterprise. The avuncular Cranch served as a genial companion for all who worked at Rookwood. He designed many of the ginger-colored tiles in the early years, in addition to turning his whimsical talent to molded ware occasionally. Next door in her own studio, Maria Nichols worked with complete absorption. A small gas stove permitted hot lunches for the upstairs staff, and Clara Newton received her first cooking lessons there from the versatile Maria, who "could prepare all sorts of dishes." The new pottery also drew its share of the curious. Individuals and groups visiting the city frequently toured the facilities, drawn either by their interest in art pottery or the singularity of an industry operated by a woman. Not everyone left impressed. A prominent English etcher, Seymour Heydon, "accompanied by some charming and well-known Cincinnati men," found the painted ware not to his liking, but waxed enthusiastic over several vases decorated by Annie Aukland, the twelve-year-old daughter of one of the workmen. The celebrated Oscar Wilde also visited. Escorted by Mrs. Clara Devereaux, a journalist and the future social arbiter of the city, Wilde arrived one morning wearing a "calla-lily leaf green overcoat" and a "shrimp pink necktie." As Clara Newton entered the display room, she found the eccentric poet "chuddering visibly over a vase which he was pronouncing 'too branchy.' " The Dublin-born aesthete found little to his taste at the pottery, and his celebrated wit failed to impress the dour, practical Mr. Bailey, "who had not *much* sense of humor and no comprehension of figures of speech."[23]

When the pottery's administrative details began to encroach upon Mrs. Nichols's creative time, she employed Clara Newton to act as her assistant at a generous salary of twenty-seven dollars a week. Miss Newton had first learned of the Rookwood venture in a letter from a friend. At the time she wondered "whether anything will come of it," little realizing how great a role Rookwood would play in her own life. She and Maria Nichols had been classmates and friends at Miss Appleton's school and later at the McMicken School of Design. Now they became associates in what each viewed as a glorious adventure.

Clara Newton was part of that circle of Cincinnati women who found in the design movement an enormously important outlet for their creative energies. She had learned woodcarving from Pitman, and had joined his first china painting class in 1874. She became a close friend of Louise McLaughlin as well, and her engaging personality helped deter an open rupture between the two leaders of the pottery movement. An "unusually capable" woman,

her "very distinct handwriting" encouraged her associates to elect her secretary of both the Pottery Club and, in 1894, the newly founded Cincinnati Woman's Club. Devoted to craftwork, she also played important roles in the Porcelain League, the Handicraft Exhibition League, and the Crafters Company, the latter two organizations established after the turn of the century. At Rookwood Clara Newton served as confidante and general assistant, using the title of "secretary," which sounded impressive, yet sufficiently elastic to cover her myriad duties. For several years she lived with Mrs. Nichols, and the two of them drove to the pottery together, where Miss Newton kept the records, learned to cook, and contributed her own designs to the pottery's salesroom.[24]

Within a year of Rookwood's opening, two new buildings were added, one to serve as a combined salesroom and workroom for Mrs. Nichols and Miss Newton, the other to serve principally as a school for pottery decoration. Clara Newton taught two classes a week on overglaze painting; Laura Fry gave instruction in the Limoges method of underglaze work. Class size was limited to twenty-five pupils, and tuition was set at three dollars per week, a charge equal to several days wages for female decorators at the pottery. This discouraged anyone from enrolling who needed to work for a living. Private lessons at one dollar per hour were also available, although

Rookwood Pottery, ca. 1892,
courtesy of the Cincinnati
Historical Society.

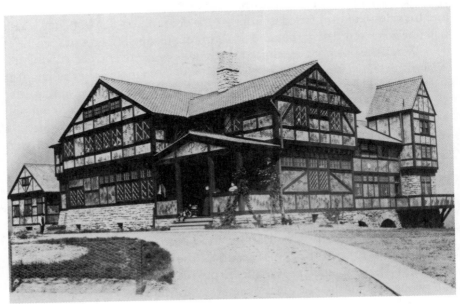

Rookwood Pottery Workers, photographed about 1890. Left to right, front row: Grace Young, Harriet Wilcox, Sallie Toohey, Carrie Steinle, Louella Parsons, Emma Foertmeyer, Mary Shanahan (salesroom supervisor), and Amelia Sprague. Back row: Matt Daly, Albert Valentien, Anna Valentien, and Artus Van Briggle. Courtesy of the Cincinnati Historical Society.

there is no record that anyone chose the individual instruction. Students' work, if approved by the two instructors and Mrs. Nichols, could be offered for sale alongside the regular Rookwood ware. Established to provide much-needed income for the pottery, as well as to train future designers, the Rookwood school failed to do either. Enrollments were not sufficient to offset costs, and the largely upper-middle-class students were not interested in careers as factory workers. In 1883 teaching ceased and the school was closed.

Laura Fry remained on the pottery staff as a decorator. Born in White County, Indiana in 1857, she found herself at the center of the Cincinnati crafts movement by virtue of her father's woodcarving contributions. As a girl she had enjoyed copying patterns from *Godey's Ladies Magazine* on her slate, bringing requests from her friends to make them "a pretty too." Around the age of twelve, her father enrolled her at the McMicken School, where her talent for drawing and design flourished. Guided toward the feminine arts, she soon fell in with Louise McLaughlin, became a charter member of the Pottery Club, and displayed her ceramic work at all the local exhibitions. In 1878 she assisted her father in the design and carving of the great organ case in Music Hall. By the time she reached her twenties, her developing reputation enabled her to rent a studio in the city. At Rookwood she earned twenty dollars a week and proved to be an outstanding decorator and teacher. Among her contributions to the pottery was the development of a method for applying pigment evenly through the use of an atomizer, a process which the pottery used successfully for many years. Fry eventually patented her process, and later, in an unpleasant dispute with the current Rookwood president, William Watts Taylor, she sued the pottery. Judge William Howard Taft ruled against her claim. Long before this quarrel, however, Laura had left the pottery to study at the Art Students League in New York, and she settled eventually in West Lafayette, Indiana, where for many years she taught as a professor of industrial design at Purdue University.[25]

Not everything went smoothly for Rookwood. Production of ceramic ware was only marginally profitable during the best of times, and the competition of recent years had become quite fierce. Frederick Dallas had tried to discourage Mrs. Nichols at the beginning. Another local potter, Thomas J. Wheatley, adopted a different tactic. He applied for a patent on the Limoges method of applying color under a transparent glaze. Claiming that he had developed the process while in New York in 1877, Wheatley, backed by an unnamed local businessman, sought to corner the growing market for the Limoges-style ware. In an article titled "War Among the Potters," an enterprising reporter from the *Cincinnati Daily Gazette* explained the shallowness of the claim through interviews with the concerned parties. The fore-

man at the Coultrey Pottery, where Wheatley formerly worked, along with Mrs. Nichols and George McLaughlin, Louise McLaughlin's brother, all agreed that Miss McLaughlin had first developed the process in Cincinnati. Wheatley's maneuver was absurd. "He might as well get out a patent for wood carving," chortled the amused Mrs. Nichols.[26]

These initial problems proved minor in comparison to the financial difficulties Rookwood faced. Haphazard accounts make it difficult to determine the extent of the pottery's indebtedness, but it seems clear that without Joseph Longworth's ample support, Rookwood could not have survived. Once, during its second summer when Nichols and Newton were vacationing together in the East, Joseph Bailey, Sr., who had joined the staff earlier that year, described a particularly vexing situation. Informed that the pottery had over eighty dollars in its account, he had sent a utility boy to cash a check. The bank refused and the boy returned "a perfect pictur [*sic*] of despair." It seems that the account actually held less than thirty dollars. "I have come to the conclusion today," Bailey wrote in his untutored manner, "considering that we are looked upon as smartish sort of foulkes in our way, we don't know much about finance and don't seem to be able to get anybody that doze, however it ain't very serious." At the conclusion of the letter, however, he returned to the theme: "It seems a Burlesque to talk about profit wen it as ben all going out, but we will hop for the better. It must be Better. We make fine goods and must have a Markett."[27]

Determined to make a success of her venture, Mrs. Nichols sought assistance. In the spring of 1883 she asked a longtime friend, William Watts Taylor, to take charge of the pottery's operations. Taylor had come to Cincinnati from Louisiana as a boy. Poor health prevented him from attending Harvard University beyond one year; instead he joined his father's commission house, Taylor and Brother, as a clerk. Following his father's death in 1869 he became a copartner with his uncle, a position he held until he joined Rookwood. Taylor knew nothing of the pottery business. He did, however, possess a keen business mind, sound administrative skills, and a flair for public relations. Rookwood needed all three.

Taylor's first move was to eliminate the school and replace the part-time female decorators with full-time people, mostly men. This decision brought complaints, as many women had seen the pottery in terms of a new vocational opening for women. But this had never been Mrs. Nichols's primary concern. In opening Rookwood she had indulged her own desire to operate a successful art pottery, and any threat to Rookwood's existence required action. Furthermore, as she explained, the female decorators had become something of a problem. "My lady friends tell me they have lost interest in Rookwood because men are employed; that they had hoped it would open a new field for women's work. The field is still there, but the

workwomen are not to be found. I cannot get women decorators to do the work, and do it satisfactorily . . .," she elaborated. "I have not been able to find women who combined the proper artistic ability and sufficient energy to come day after day and do a day's work. . . . They come 'just as soon as they could,' and after a few days work . . . one would say very sweetly, 'I can't come tomorrow, I am going shopping, or to visit a friend.' "[28]

This first generation of women decorators was not interested in full-time employment, for this would have undermined the Victorian sensibilities of what constituted a lady. What the women decorators sought was a recognized outlet for their creative energy which, at the same time, would not damage their social positions, and this required a more casual approach to work than a successful business could tolerate. In subsequent years, Rookwood employed many female decorators, but these women came largely from a different social class, with far less restricted views on the role of women in art industries.

Placing the pottery on a solid financial footing required more than just a dependable work force. Taylor also instituted a series of efficiency measures, ranging from new purchasing procedures to better sales distribution. He examined production layout for ways to reduce handling of fragile ware. He encouraged Bailey to extend his experiments with the firing process in order to find solutions to the problems of cracking and crazing. He replaced the principal salesman, who received a salary plus commission and expenses, with a sales agent who worked strictly on commission. Taylor also reduced the number of national outlets handling Rookwood ware, allowing only one franchise per major city. He believed that single outlets would lead to stronger promotion for the Rookwood line. Following an examination of sales records by the efficient Clara Newton, he discontinued unpopular shapes and those which broke easily. These administrative measures soon showed up in the account ledgers, and Maria Nichols and Clara Newton were delighted when Joseph Longworth, on what turned out to be his last visit to the pottery, remarked jokingly that he had come "to see what is the matter," since they had asked for "no money for the pottery for some weeks." But the optimism of 1883 soured with Longworth's death that December, leaving Mrs. Nichols grief-stricken and the future of the pottery uncertain.[29]

No sooner had the rumors of the pottery's eminent demise subsided than the waters of the Ohio River rose. The previous spring's flood had lapped at the base of the kilns, forcing the pottery to shut down. Now the water threatened the very existence of Rookwood. The river crested in 1884 at seventy-one feet, highest in its history at that time, and the swollen waters paralyzed the city. At the pottery, rising waters limited office access to foot traffic. The river water spread across Eastern Avenue both to the east and to

the west of the establishment. Kilns were damaged and fouled with mud; stored clay was contaminated and equipment ruined by the flood. Taylor steered the company through these discouraging weeks, and in the following months he led Rookwood from an awkward, struggling personal enterprise to a solid business concern. The mid-1880s saw the last of the "lady amateurs" depart. The Pottery Club, which had rented a studio on the premises since 1881, also vacated under Taylor's prodding. Clara Newton ended her association in June 1884; Laura Fry in 1886. Except for Maria Nichols and the ageing Cranch, the individuals who had shaped Rookwood's first years were now gone. The age of romantic individualism had ended.[30]

In September 1885 George Ward Nichols died, and following Maria Nichols's marriage to Bellamy Storer six months later, the owner's interest in clay and color waned. In her increasingly frequent absences, Taylor extended his control. New designers joined the staff. Albert R. Valentien (originally Valentine), who had learned the rudiments of ceramic decoration under Thomas Wheatley, became Rookwood's first full-time decorator in 1881. Three years later Taylor appointed him head of a new decorating department, a position he held for over twenty years. In 1887 the Japanese-born Kataro Shirayamadani started his long and successful association with the pottery, underlining Mrs. Nichols's (now Mrs. Storer) and the city's continued fascination with Japanese forms and designs.

Shirayamadani had first visited the Queen City in 1886 as part of a touring "Japanese Village," the major attraction of the city's Thirteenth Industrial Exposition. American curiosity about Japan had led the Deakin Brothers and Company to transport an entire "authentic" village, comprised of numerous buildings and over sixty people, all participating in dozens of traditional crafts and trades. The *Cincinnati Enquirer* described it as "original, wonderful and novel." Novel it must have been. The exotic display offered visitors a view of Japanese cabinet making, silk weaving, metal working, painting, and pottery decorating. Shirayamadani was one of the decorators. Six months later Taylor persuaded him to join the Rookwood staff, where he served as principal designer until his death in 1948. Other artists joined the staff also. Matt Daly, Anna Marie Bookprinter (later Mrs. Albert Valentien), Carolyn Steinle, William McDonald, Artus Van Briggle, and Sara Toohey all made their first Rookwood vases during this decade, and through their talented hands the pottery achieved distinction. Many of these artists had studied at the McMicken School (after 1886 the Cincinnati Art Academy), revealing the close relationship between the school and the pottery, a relationship endorsed wholeheartedly by both Taylor and Joseph Henry Gest, the assistant director of the art museum at that time and later president of Rookwood.[31]

Less than ten years after its founding, Rookwood Pottery earned inter-

national acclaim. In 1889 Paris hosted the Exposition Universelle, the World's Fair that introduced the Eiffel Tower. The American display of ceramic ware included pieces from Rookwood. The judges' early enthusiasm for the colorful pottery, however, was tempered by the belief that the delicate glazes represented an accident in the kiln rather than a tried process. A quick telegram to Cincinnati led to the shipment of additional pieces, resulting in a coveted gold medal. Overshadowed by this remarkable achievement was the gold medal awarded to Rookwood the same year at the Exhibition of American Art Industry in Philadelphia. These two awards laid the foundation for the success and recognition that carried the firm well into the next century.

The awards also symbolized the end of an era. The brisk increase in production which followed the new recognition strained the already crowded and inefficient facilities. Taylor used the opportunity to move to higher ground, selecting a site on Mt. Adams, the bluff that rose sharply on the north side of the pottery. Reasonably close to the railroad yards along the river, within easy walking distance of the recently opened art museum and academy, and linked to the downtown area by the incline plane which carried an array of vehicles and people to within a few yards of the chosen site, the Tudor-styled Rookwood building quickly became a city landmark. The new facilities provided three oil-fired kilns, larger work areas, a chemical laboratory, one large decorating room, individual studios for senior artists, a variety of staff offices, and a landscaped garden. Mt. Adams offered a location visibly above "the seething town, wrapped and veiled in clouds of evil smoke"—a location quite in keeping with Rookwood's vision of beauty.[32]

The change in location signaled a change in leadership. Under the demands of her recent marriage, and strongly supportive of her new husband's political ambitions, Mrs. Storer spent progressively less time at the pottery. She had fulfilled her own ambition of establishing an art pottery, and in 1890 she turned the business over to William Taylor. Taylor served as president and chief stockholder until his death twenty-five years later, and under his firm management Rookwood continued its reputation for beauty and excellence.

The design reform movement that flowered in Cincinnati between 1880 and the early years of the twentieth century has received considerable attention, and there is no question that in ceramic design the city played an integral role in a national movement. Cincinnati women had been far more enterprising in their response to art than had similar groups in other cities. They had recognized, if only intuitively, a need both within themselves and within American society for tastefully designed functional items. The women also benefited from the guidance of two unusually outspoken male supporters. George Ward Nichols not only supported his wife's interest in

pottery, but he also wrote and lectured extensively on the relationship of art to manufacturing. Benn Pitman, of course, was the other important influence. He contributed his inspirational teaching and gave to the local design movement a philosophical foundation.

Pitman supported the aesthetic ideals of John Ruskin, the eminent English art critic whose writings influenced both English and American cultural values. Ruskin had turned away in horror from the industrial revolution, disturbed by its effects on man and production. To his discerning eye, the industrial revolution replaced beauty with vulgarity; pleasure in work had given way to an unwholesome and spiritually deadening labor. For Ruskin, the Medieval world of craftsmanship offered a healthy antidote to the present barbarity, and like other romantics of the nineteenth century he found solace in the spiritual beauty of nature. Pitman agreed. Acceptable decoration, he argued, derived from "the correct and appropriate representation of the facts and forms of nature" While Pitman roamed the more lofty corridors of Ruskin's mind on occasion, more often he narrowed his own intellectual strolls to the field of decorative arts. "The expression of the Beautiful as applied to the Useful," is how he once described decoration, and he argued that an organic relationship existed between design and function.[33]

Like other cultivated Americans, Benn Pitman had come away disappointed from the Philadelphia Centennial, because he felt American design suffered by comparison with the products of other industrial nations. Along with Nichols, he lectured frequently on the need for a distinctive American decorative style, drawn from native surroundings, and the Cincinnati outpouring of carved wood and decorated pottery displayed a profusion of naturalistic forms and symbols. Individual craftsmanship, he was convinced, would offset the cheap and tawdry tendencies of machine production, but training craftsmen was only part of the solution. What good were products without appreciative buyers? He emphasized the need to "educate the rich to the appreciation of art work" above any attempt "to prepare workers who would meet with no appreciation." Proper design provided the beauty and taste that established the home as a sanctuary of harmony in an increasingly strife-torn society. As the guardians of truth, beauty, and family nurture, it was imperative that women be given proper instruction. Pitman championed the view that beauty and morality were intertwined; that an understanding of sound aesthetic principles ennobled the soul.[34]

For Benn Pitman, then, the new concern with correct design reflected a philosophical view that encompassed art, religion, and the growing social crisis of industrial America. For others the movement opened new vocational opportunities, without jeopardizing industrial progress. The McMicken School of Design was viewed by many Cincinnatians as a way of

applying the "secrets of art to mechanical forces." George Ward Nichols had called for a unity of art and design. He argued that the separation of fine and applied art was not aesthetically justifiable. In his *Art Education* he stressed the need for an educational system for workingmen, at the heart of which would be instruction in drawing. "It is the province of art to invest production with an ideal of perfection," he stated, but unlike those who sought a retreat into preindustrial crafts, Nichols confidently looked forward to harnessing proper design to machine production. He viewed art institutions, good design, and industrial production as necessary ingredients of national progress.[35]

Yet, for all its apparent success, the design reform movement in Cincinnati failed to establish significant links with local industry. The *Daily Gazette* had prophesized that the city's industries would soon reap the benefits of trained workmen.[36] It never came to pass. Of course, Rookwood succeeded as an art pottery, but no other local pottery survived more than a few years. Woodcarving remained the preserve of amateur ladies who carved for themselves and their friends, ignored almost completely by local furniture manufacturers. If Pitman's designs turned up in locally produced goods, it was due to the general acceptance of Victorian ornateness. The market for handcrafted items remained quite limited. Nor did other industries benefit directly from the design reform movement as it was expressed through the McMicken curriculum. An important exception to this was lithography, which had a more fundamental association with drawing and design and is discussed elsewhere in this book.

The emphasis on craftwork in the United States reflected an almost desperate attempt to recapture the creativity of production. A restoration of beauty, as defined through handmade items, would help to restore social stability and human happiness. At a minimum it would undermine "the Age of Shoddy," to use William Morris's apt phrase. Yet, the American arts and crafts movement lacked the focus and intensity of its English counterpart, as well as its social message, and it achieved primarily personal rather than social goals.

To that extent Pitman's objective of educating refined women was reached more readily than those goals which stressed training design-conscious workers. Only Rookwood, and to a lesser extent other potteries in the city, provided any tangible connection between art and industry. Of course, Rookwood is not to be dismissed lightly. It became one of the bright spots in the national decorative arts movement at the turn of the century, and its distinctive glazes and shapes proved to many that not all Americans were Philistines. The success of art pottery lay at the center of a new design awareness that bloomed with the work of artists Louis Tiffany and John La Farge and the architect Louis Sullivan. But by 1890 New York had cap-

208

tured the movement, as it had done in other areas of American art, and Cincinnati's considerable contribution faded. At a provincial level, however, Rookwood became another landmark in the city, extending the city's reputation as a cultural center. All Cincinnatians basked in its fame. Yet, the movement for proper design had an even more enduring outcome—it lent support and encouragement to the establishment of an art museum, the next major cultural institution to appear in the city.

Interlude
Alfred Traber Goshorn,
A Portrait

he Grand Hotel's dining room welcomed the one hundred formally attired gentlemen, the social elite of the city, as they arrived to honor one of their own. Light from the blazing chandeliers reflected from the wealth of china, silver, and crystal that covered the long banquet tables. Vases of flowers and a bank of potted plants which screened the musicians added to the festive atmosphere. At the center of the head table sat the chairman of the evening, Alphonso Taft, flanked by former governor Edward F. Noyes, Mayor George Johnston, Carl Adae, the ubiquitous Julius Dexter, and other dignitaries, including the man of the hour, Alfred Traber Goshorn, director-general of the recent Philadelphia Centennial—America's first World's Fair.[1]

The early months of 1877 proved quite eventful for Cincinnatians. Awakening interest in the city's cultural development, triggered by the first May Festivals and the construction of majestic Music Hall, helped offset the disturbing unrest among area railroad workers—an unrest which led concerned citizens that year to purchase a gatling gun for the city's police. In March former president Ulysses S. Grant visited the Queen City, and the community honored the hero of the Union with a public reception. One week later, Goshorn's return brought forth his friends and admirers to the dinner at the Grand Hotel. Following tradition, the meal proved a sumptuous affair, made all the more enjoyable, as the *Daily Gazette* pointd out, because the menu was "made up in a language easily understood." No French for these good citizens. After the tables were cleared, Alphonso Taft gave the principal address, a gracious tribute to the guest of honor, in which he enumerated Goshorn's many civic contributions. A standing ovation then brought Goshorn to the podium. He responded by thanking the people of

Cincinnati and ended with a call for the city to move forward by establishing an art museum, a topic being discussed at that time. The evening concluded with a series of toasts in Goshorn's honor.[2]

Alfred Goshorn was born in Cincinnati in 1833, the son of a prominent businessman, and he spent his early years happily in the Goshorn homestead on the western edge of the city. After attending Woodward High School, he enrolled at Marietta College, graduating in 1854. Three years later, he earned a degree from the Cincinnati Law School, and for several years he practiced law in the partnership of Mills and Goshorn. Outraged by the attack on Ft. Sumter, he joined his fellow Literary Club members as a private in the Burnet Rifles, followed shortly by his election to captain. He emerged from the war with the rank of major in the 137th Ohio Volunteer Infantry, and returned home to resume the practice of law, this time with Drausin Wulsin. In 1867 Goshorn and his brother took control of the Anchor White Lead Company. His new career in business did not keep him from pursuing other interests, including baseball. He helped organize and became the first president of the Cincinnati Baseball Club, largely a collection of enthusiastic lawyers. In 1868 he helped arrange for Harry and George Wright to join the club as paid players, and, as the first professional baseball team, the newly named Red Stockings achieved an undefeated season the following year. Goshorn also served as the first president of the recently organized Board of Councilmen of the city. In 1872 his political leanings led him to become one of the organizers of the Liberal Republican national convention which nominated Horace Greeley for president. As a young businessman, he became active on the Board of Trade, and served as one of five representatives from that body which helped organize the first Cincinnati industrial exposition.[3]

The idea of trade fairs or expositions was not new. The Ohio Mechanics Institute had staged such exhibitions intermittently since 1838, its last being held in 1860. The Western Sanitary Fair of 1864, a product of the war effort, had extended the idea, and, of course, successful World's Fairs in 1851 (London) and 1867 (Paris) had generated great interest. Although a "Grand Industrial Exhibition" promoted by the Mechanics Institute in 1867 never materialized, a very successful trade convention by the Woolen Manufacturers of the Northwest revived the idea in 1869. The following year, on Goshorn's recommendation, the Board of Trade, the Cincinnati Chamber of Commerce, and the Ohio Mechanics Institute established a joint committee on industrial exhibitions. While his position on city council prevented Goshorn from serving as president of the first industrial exhibition, he shared the speakers' platform at the opening ceremony with Senator John Sherman and Mayor Charles Wilstach, thus demonstrating his support for the exhibition.[4]

The 1870 industrial exhibition, held in the newly constructed Saenger-

halle, mirrored the organization of the recent Paris World's Fair, which Goshorn had visited. This first display of regional industrial products promoted the Queen City to a national audience. Everyone involved agreed that it was a grand event. Goshorn served as president of the next three exhibitions, each one larger and more successful than its predecessor, and he enlarged the events to include scientific displays and cultural exhibits. The 1873 exhibition even netted a profit of $10,000 and led directly to Goshorn's involvement with the United States Centennial Commission. At a small dinner gathering for President Grant, who was visiting the Cincinnati exhibition, Goshorn had spoken eloquently of the benefits derived from such events by manufacturing concerns. Grant had come away impressed with both the message and the man.[5]

The idea of a national centennial celebration first surfaced in 1868, when John Campbell, a Wabash College professor, broached the subject. It was not until 1871, however, that the United States Congress adopted the idea. Doubts as to the country's ability to accomplish such an event coupled with the projected cost discouraged many people. In particular congressmen from the South and West felt little sympathy for what amounted to a celebration of northern industrial products. Yet, as a nation, America wanted to display her many achievements, and what better opportunity than her one hundredth birthday. After lengthy debate Congress selected Philadelphia as the most appropriate site and established a United States Centennial Commission, on which every state was represented. Appointed to the Ohio delegation by Governor Noyes, Alfred Goshorn became a leading voice on the commission's executive committee, and in 1873, as one of the few commissioners with any administrative experience in this area, found himself elected director-general of the great celebration.[6]

The Philadelphia Centennial, with its multitude of pavilions and exhibits, captured the imagination of the country. Americans by the hundreds of thousands thronged to the Quaker City in the summer and autumn of 1876, breaking the attendance record set at Paris nine years before. This fact alone convinced many Americans of the superiority of their nation. For others the fair signified something more profound. Despite the disparaging remarks concerning the quality of the nation's industrial design, the Centennial symbolized the nation's coming of age, its emergence as a world leader. On a more fundamental level, the fair helped heal the Civil War's sectional wounds, and revealed the nation's ability to organize successfully an international exposition on the grand scale. Much of the credit for this belongs rightfully to Goshorn, who not only supervised the event but also surrounded himslf with outstanding executive talent. At the conclusion of the Centennial, foreign governments recognized the director-general's role by awarding him a chestful of medals and decorations, including a knighthood

from Queen Victoria. The city of Philadelphia honored him with a testimonial dinner and presented him with a handsome leather-bound library representing the great books of the past and present. To house this fine collection, Philadelphia architect Frank Furness designed oak bookcases, a mantle, an escritoire, and matching center-table desk, all of which fit neatly into a designated room in Goshorn's Cincinnati home.[7]

Alfred Goshorn returned to Cincinnati in 1877 to public appreciation. Not yet forty-five years of age, he now found himself in the midst of the city's cultural awakening—an awakening for which he had been partly responsible. His sound judgment, wide managerial experience, patience, and discretion made him a valuable resource for the emerging cultural institutions, and he soon sat on the boards of the Music Hall Association and the College of Music. However, art, not music, remained his real interest. Frequent trips to Europe had enabled him to accumulate a fine art collection, and his support of local art brought him early into the movement to establish an art museum in the city. One of the original trustees of the Cincinnati Museum Association, he agreed in 1882 to serve as the first director of the museum, a position he held without pay until his death.[8]

In the meantime, the urbane, dignified Goshorn married (in 1887 at the age of fifty-four to Louise Langdon, the widow of Captain James Bugher), built a large fashionable home in the suburban village of Clifton, served as mayor of that community, and became a fixture in Cincinnati's social life. This almost idyllic situation ended with the unexpected death of his wife a year later. From bachelorhood to widower in a matter of months, Goshorn remained in Clifton, surrounded by his paintings and library. The establishment and operation of the Cincinnati Art Museum consumed his energies, and, as he had done with other enterprises, he steered the institution towards permanency. In the last decade of his life, he gradually turned over the daily operations of both the art museum and the Art Academy (which affiliated with the museum) to his capable assistant, Joseph Henry Gest. In February 1902 Alfred Traber Goshorn died quietly at his Clifton home, just months before the death of his close friend and neighbor, Henry Probasco.[9]

213

Institutionalizing Art: The Museum and the Academy

*T*he enthusiasm engendered by the Cincinnati Room at the Centennial Exposition had promised a new economic future for American women. The ladies of the Women's Centennial Executive Committee (WCEC), who had organized the Cincinnati contribution, shifted their vision quickly in "the direction of industrial art," and suggested that a combination museum and training school was essential to the city's future.[1] The concept was hardly original, however. Mrs. Sarah Worthington King Peter had pursued a similar goal in 1854, and the Ladies Academy of Fine Arts' collection of casts and copies eventually linked that earlier effort to the founding of the McMicken School of Design.

Other citizens had labored towards similar ends. In 1868 Joseph Longworth had tried to establish a Cincinnati Academy of Fine Arts (the third such organization to use that name). Intended "to establish a permanent gallery of paintings and sculpture," the academy sought financial stability by issuing shares of stock at one hundred dollars each. Annual memberships were set at five dollars, with all artists recognized as associates "free of charge." As he did for so many cultural institutions, Julius Dexter served as treasurer. His meticulous reports tell the story. The first exhibition lost $1,500, managing to sell only eight paintings; the second continued the trend. "It would seem as if the appreciation of art existed among us with a very parsimonious spirit," he concluded sadly. In the troubled postwar economic climate, art patronage languished, and the Academy of Fine Arts followed the path of its predecessors.[2]

The next decade proved more promising. The McMicken School of Design stirred the art currents; the May Festivals advertised the city's cultural maturity; and the industrial exhibitions reawakened interest in art as ap-

plied to industry. The success of the Cincinnati Room at the Philadelphia Centennial further promoted the arts. And recent successful efforts to establish art museums in New York and Boston also served to push Cincinnati toward the same objective.

In April 1877 the organizers of the Cincinnati Room, led by Mrs. Elizabeth Perry, established the Woman's Art Museum Association (WAMA). Sharing mutual respect and friendship, this remarkable group of women displayed a new confidence in their ability to reach difficult goals. But not alone. They created an all male committee to assist them in the actual promotion of an art museum. The "general hard times," coupled with the recent solicitation for Music Hall, discouraged any immediate fund-raising efforts. Instead, the women set out to educate the people of Cincinnati on the need for such an institution. They organized a lecture series emphasizing the application of art to industry. "It is the intention to spare no pains to attract public attention to these lectures," announced Mrs. Perry. "It is no part of the plan to appeal to the public for money," she concluded, "but to interest all classes of the community—the industrial class as much as any other—in the subjects treated, and also to make practical application of them to the Art Museum project."[3]

Sidney Maxwell, president of the chamber of commerce, inaugurated the lecture series with a talk on "The Manufacturers of Cincinnati," in which he emphasized the necessity of good design. A sizeable audience at Pike's Opera House listened attentively to his comments, although it is questionable how many people from the "industrial class" attended. Nine days later, George Ward Nichols spoke on the application of good design to certain industries. Singling out pottery decoration and furniture production, he noted "the general advantage to all classes . . . in their business and social life, and especially to women, which would result from the educational means furnished by an art museum with schools for technical training." With the link between good design and productive industry outlined explicitly, attorney Charles P. Taft concluded the lecture series, selecting London's South Kensington Museum as his topic. The South Kensington Museum (now the Victoria and Albert Museum) had been founded in response to concern for the state of applied art in England following the Crystal Palace exhibit in 1851. By 1877 the young museum had already come to stand for industrial design and art education. Taft blamed the sorry state of American artistic standards on four causes: (1) the separation of the artist from the workingman; (2) the social prejudice entertained by the higher classes against any form of industrial labor; (3) the eagerness of the manufacturer to spread his cheap goods and increase his trade; and (4) the great ignorance of the masses of consumers in matters of taste and art. Following this sweeping indictment, he suggested that the lack of art industries in America

drained the country of millions of dollars, and that there was no reason "why that money should not be expended in our country."[4]

The leaders of WAMA could not have agreed more. The South Kensington Museum had always been their model, as it was for museum movements in other American cities. In a letter to Taft, written before his lecture, Mrs. Perry commented:

> It is hard to disabuse the public mind of the notion that the intended Art Museum is to be simply a gallery of sculpture and painting. Of course, the application of art to industries is fine art modified, and applied to the common things in life—and a museum of the masterpieces of *industrial art* would not be complete without presenting also copies (or originals) of the masterpieces of art in sculpture and painting, from which the artist and workman have in all ages drawn their inspiration.

To raise the general standards of taste and "to educate and develop the genius of the masses" became the twin goals of WAMA, and during the nine-year existence of the organization its members never lost sight of the fact that their purpose was educational not financial. To achieve this end, the women worked diligently to gain general support for their cause, fearing that overreliance on the wealthy would encourage the stereotype of art for the elite.[5]

In support of its aims WAMA next sponsored a display of loaned objets d'art in the West Seventh Street home of John Cochnower. Held in May 1878 to take advantage of the May Festival crowds, the exhibit displayed the standard Victorian taste of the city's most prominent families. Exhibits of glass and porcelain, decorated pottery, carved furniture, jewelry, and textiles gave evidence of the importance of design to manufactured goods. Paintings and pieces of sculpture remained scarce. Thirteen thousand visitors passed through the house during the exhibit's month-long run, leaving the association with a handsome and unexpected profit of $1,000. More importantly, the exhibit publicized successfully the relationship between art and industry and accelerated the drive for a museum. It also showed that the women were in earnest.

Either encouraged by the vigor of WAMA, or troubled by its female dominance, Julius Dexter recommended to Mrs. Perry that "an attempt should now be made to raise a fund to establish a museum." In actuality Dexter had already been busy. Charles West, Joseph Longworth, and he had previously subscribed $10,000 each to that end, with lesser sums promised by fifteen other gentlemen of the city. However, Dexter made two conditions quite clear. An additional $125,000 had to be raised by public subscription, and the subscribers would ultimately determine "the form of the organ-

ization to whose control and direction the Museum shall be committed
. . . ." In other words, the men were to control the future museum. Sensing
that the fund-raising effort might be premature, and not willing to relin-
quish control, WAMA declined Dexter's offer.

For the next two years WAMA continued its work quietly. During that
time the swelling interest in handicrafts led to a suggestion from Benn Pit-
man that WAMA seek control of the McMicken School of Design, a sugges-
tion wisely declined by the women. Instead, in March 1879 they rented two
rooms on Fourth Street for classes in watercolor, china painting, and artistic
embroidery. They also established a selection committee to oversee the
acquisition of a permanent museum collection. Engravings, etchings, watercol-
ors, pen and ink drawings, decorated china and pottery, embroidered cur-
tains, linens, decorated menus, note papers, dinner cards, and fans were
welcome; specifically excluded were "wax flowers and fruit, feather flowers,
leather, hair and shell work, skeletonized leaves, knitting, crochet and Berlin
woolwork." These items, considered inartistic and too stereotypical of
"women's work," did not pass the good-taste test.

WAMA also took full advantage of the 1879 industrial exhibition,
where its display of handcrafted items gathered fulsome praise in local
newspapers. As a result of this participation, the organization acquired
rooms in the south wing of Music Hall for the establishment of a permanent
loan collection, the rent paid by Reuben Springer. Classes also moved to
Music Hall, and Preston Powers, the son of Hiram Powers, taught "Model-
ing and Pictorial Anatomy." Other WAMA instructors included Mary Vir-
ginia Keenan, Henry Muhrman, and John Twachtman, the latter two re-
cently returned from study in Munich. With classes based on the South
Kensington model and the beginnings of a permanent collection, WAMA
confidently faced the 1880s.

The new year and the new decade opened with a festive Leap Year
reception, followed by "a social and informal gathering" of local artists. In-
tent on drawing together "all who are interested in the association and its
work," the reception provided local artists with an opportunity to show
their work free of any jury. Success led to a second reception in May, where
paintings by Henry Farny, John Twachtman, and Alexander Wyant drew
considerable attention from both visitors and the press, and sketches and
studies from Farny's students indicated that the city still retained a number
of promising artists. As usual, samples of pottery decoration filled out the
display.[6]

WAMA's vigorous espousal of local art in 1880 proved unknowingly to
be something of a swan song for the organization. In September of that year,
at the opening of the Eighth Cincinnati Industrial Exposition, Charles W.
West announced his gift of $150,000 toward an art museum for the city,

contingent on a matching amount through public subscription. Incredibly, by the close of the exposition the required amount had been more than reached, aided by the persuasive efforts of railroad magnate Melville Ingalls who is supposed to have locked various dinner guests in his dining room until they agreed to contribute up to $1,000 each. Major contributors, among the almost five hundred individual subscribers, included Julius Dexter, Reuben Springer, Joseph Longworth, and David Sinton. In honor of the occasion Mayor Charles Jacob proclaimed October 9 "Museum Day," urging that "all public offices be closed . . . and that all public and private buildings be decorated with flags, etc., and that the day be otherwise celebrated as a public holiday." The long months of preparation had paid handsome dividends indeed.[7]

With building funds available, a dispute arose concerning the proper location for the facility. Numerous citizens supported a Washington Park location, which would place the museum near Music Hall, creating a cultural center within walking distance of both downtown and several working class neighborhoods. However, the increasing congestion and pollution of the basin area worked against that suggestion. Both Burnet Woods and Eden Park found numerous champions. They inspired a vision of an art museum situated amidst the verdant beauty of the city's fashionable hilltops, long a point of local pride. Future expansion also favored an outlying site, and the recent success of the inclines in carrying people and carriages to the hilltops had eased the once formidable problem of transportation. Henry Probasco, the donor of the great fountain, strongly favored a Burnet Woods location, perhaps because of its proximity to his Clifton estate, but Charles West preferred Eden Park with its spectacular views and superior air and light.[8]

Once West's wish became known, the city donated the necessary acreage, exempting the site from future taxation. With the location secured, the Cincinnati Museum Association (CMA) was organized to build and operate the museum. Set up as a stock company in the same manner as the earlier music institutions, the CMA issued individual shares at twenty-five dollars each. The stock was nontransferable without board approval, noninterest bearing, and nonredeemable. Shares were limited to one per person. The intention was to restrict control of the museum to the city's social elite, while perhaps intentionally creating an all male board of trustees. Joseph Longworth served as the first president, with active support from Melville Ingalls, Julius Dexter, and Alfred Traber Goshorn.

But what of the women? The shift from promotion to construction came too abruptly, leaving a bittersweet residue. Long had WAMA labored. It had carried the museum torch for three years, now to become a mere appendage of the new organization. With the emergence of the Cincinnati Museum Association, WAMA's chief reason for existence had disappeared,

Left, *Portrait of Joseph Longworth,* by Thomas S. Noble, 1884, Cincinnati Art Museum, gift of Nicholas Longworth. Right, Joseph H. Gest, Cincinnati Art Museum Library Archives.

Alfred Traber Goshorn, left, and Melville E. Ingalls, both courtesy of the Cincinnati Historical Society.

yet many of its members felt pushed aside by the male force, and only by a slim majority did they "suspend their ordinary work, and preserve for future use the funds now in hand." Although they kept their exhibition rooms open, proudly declining an offer from Ingalls, Dexter, and Hoadley to assume the rent, they discontinued their art classes and transferred those rooms to the Museum Association.

With its promotional activities curtailed, WAMA shifted its attention to collecting suitable materials for the museum. The women put together a fine collection of historic and contemporary pottery, with the idea that the pieces would serve as models for local craftsmen, and to the same end, they voted unanimously in 1883 to purchase from the South Kensington Museum a historical collection of sixteenth- and seventeenth-century laces and textiles. Despite their limited funds, the women continued to promote a museum collection centered around applied art, but the greater resources of the CMA eventually shunted the women aside. When the museum finally opened in the spring of 1886, WAMA dissolved, using its remaining money to publish a history of itself, written by Mrs. Perry. As Dr. Carol Macht has written, these women "had triumphed with grace and style," and the Cincinnati Art Museum stands today as a monument to their energy and vision.[9]

As the women's role subsided, the Cincinnati Museum Association moved to the forefront. In essence, the men agreed with WAMA's emphasis on the industrial arts and on the educational role of the museum. "Interesting objects of every kind and nature" were to be preserved and used for education "through the establishment of classes and otherwise, as may be found expedient." The CMA continued the search for examples of both fine and applied art, along with archaeological and ethnological material. The museum stood for more, however. Art, like music, according to contemporary cultural standards, should "awaken the love of the beautiful among men." It should "elevate and purify their thoughts," and "wean them from the earthly and sensual." Art should "quicken them into the privilege of seeing." Cincinnati's cultural circles shared the widely held romantic view of art as a pathway to the ennoblement of man, and the increasing social unrest—witnessed locally in the Court House riot of 1884 and the May Day demonstration of 1886—spawned considerable thought concerning the ameliorating influence of the arts. The democratization of culture implied the education of the working classes to middle-class values. Industrialization, under proper guidance, would not lead to class division, but to improved social harmony. Museums, concert halls, libraries, and zoological gardens became the new ornaments of an enlightened community—"the heart of the city's best life," as one newspaper phrased it.[10]

None of this could come to pass without acquisitions for the new museum. WAMA could be counted on for examples of pottery, porcelain, and

textiles, but what of other areas of art? Concern for the cost of maintaining the museum had been reduced by a second gift from Charles West, but the compilation of an art collection required greater effort and money. In its first year CMA acquired a broad collection of objects, ranging from oil paintings to fossils of gigantic bird tracks. The purview of the institution seemed undefined. The most impressive acquisitions were the Hillingford collection of arms and armor (the museum's first major purchase) and Joseph Longworth's gift of an extensive collection of drawings by Carl Friedrich Lessing. Longworth also contributed Benjamin West's celebrated painting of *Ophelia and Laertes*.[11]

To take charge of the museum's daily affairs, the trustees turned to one of their own, Alfred Traber Goshorn, and the new director quickly sought the support and advice of other museum executives. From L. P. di Cesnola of New York's Metropolitan Museum of Art he secured a collection of ancient glass and bronze pieces. The director of the new Boston Museum of Fine Arts, Charles G. Loring, shared views with Goshorn concerning their respective negotiations to purchase Peruvian pottery from the apparently "unreliable" W. F. Lee.[12] Later, Goshorn sought opinions on a variety of subjects from museum officials in Chicago, Philadephia, and London. If he had a mentor, however, it was Sir Philip Cunliffe-Owen of the South Kensington Museum. Sir Philip had been responsible for the fine collection of fabrics acquired by WAMA. He had also arranged for the Hillingford armor collection to travel across the Atlantic. Sir Philip, whose friendship with Goshorn dated from their collaboration at the Philadephia Centennial, remained a constant advisor, assisting in various acquisitions and providing frequent suggestions for museum operations.[13]

Given the limited funds at Goshorn's disposal, the new museum relied heavily on the generosity of its friends, a reliance that was not misplaced. Melville Ingalls contributed Eastman Johnson's portrait of Charles West, and George Hoadley gave a set of J. M. W. Turner's *Liber Studiorum*. It was from Hoadley as well that the museum received Gustave Courbet's *Sunset, Vevay,* along with a letter cautioning Goshorn that the picture might displease him as "the works of the impressionist school are not likely to give much pleasure." Rufus King, another long-time supporter, donated the *Holy Family,* reported to be "an original by Reubens," while Archbishop William Henry Elder turned over as a permanent loan Robert Haydon's *Christ Entering Jerusalem.* A Mr. Gunnison contributed a Rembrandt painting and a Sèvres cup and saucer, all of which later proved to be copies, a common enough occurrence in the late nineteenth century. Manning Force presented Henry Farny's *Silent Guest,* the first of that artist's works to find a museum home. No one contributed more than the great public benefactor Reuben Springer, whose death in 1884 released to the museum his exten-

sive personal collection, along with an endowment of $40,000. This predominantly Germanic collection also included works by American artists Rembrandt Peale, Dwight Benson, and Worthington Whittredge, and these canvases served as the foundation for the museum's collection of nineteenth-century American painting.[14]

News of the museum brought a multitude of inquiries from individuals with items to sell. To an unsophisticated public, the definition of art stretched to whatever people's attics held, and offers ranged from an autograph collection to mounted deer heads. One earnest Illinois farmer inquired whether the museum was interested in purchasing a well-preserved "CALF with EIGHT LEGS, one perfect body and head." More appropriate offers arrived also. The widow of Wilhelm von Kaulbach inquired about selling her late husband's work, while a Covington, Kentucky man offered a seven-foot daguerreotype of the Cincinnati waterfront, taken in 1848. Paintings by little-known artists, Civil War relics, and Indian curiosities abounded. To all of those expressing interest, museum officials sent polite regrets, citing lack of space, insufficient funds, or the inappropriateness of the item.[15]

Fortunately, Goshorn had more serious matters on his mind. Of primary concern was the building. The board had selected local architect James McLaughlin, a follower of Henry H. Richardson and the brother of Mary Louise McLaughlin. His fashionable Romanesque design attracted great attention. Highlighted by "a spacious arched entranceway" that opened into "a lofty hall with a double stairway," the new facility provided ample space for the still modest collection, with room for casts and workshops in the basement. Less dramatic than Music Hall, the museum nevertheless supplied the city with another symbol of pride, the first structure west of the Allegheny Mountains built specifically as an art museum. Plans called for future additions, including an art school. "The finest museum and the best adapted to the purpose of any in the country," explained one observer, and it may have been.[16]

The dedication of the new facility on May 17, 1886 provided Queen City residents another gala affair and an opportunity for further civic promotion. The CMA invited scores of dignitaries, and Julius Dexter had the honor of delivering an invitation to the White House. President Grover Cleveland listened "with courteous impatience," interrupting Dexter several times to say "Congress is sitting—it's not worth their [the official Cincinnati committee's] while to come." Wryly Dexter summed up his presidential appointment: the invitation "took in preparation 149 minutes, and in realization 1¼ minutes." Invitations to cabinet members, former president Rutherford B. Hayes, Senator John Sherman, Governor Joseph B. Foraker, and the governors of neighboring states all met the same response.[17] If the museum board had hoped to emulate the opening night of

Music Hall eight years earlier, it was disappointed. A few out-of-town directors, numerous local officials, and the venerable William Holmes McGuffey made up the list of dignitaries. Nor did the occasion trigger the same festive atmosphere, although the ceremony was held on the eve of the Seventh May Festival. The appropriate flags flew, portraits of West, Springer, and Longworth looked on the assemblage, and the College of Music orchestra sup-

Cincinnati Art Museum and Academy, ca. 1900; courtesy of the Cincinnati Historical Society.

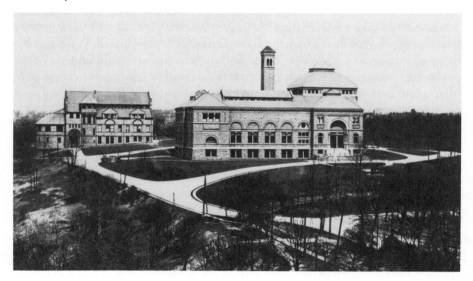

plied ceremonial music. Downtown merchants did not respond noticeably, however, and the occasion itself was distinguished principally by a speech from board president Melville Ingalls, who took the opportunity to plead for further financial support. Local newspapers provided only modest coverage.[18]

Among the vexing problems immediately confronting the museum were those of free admission days and Sunday openings, both of which were connected to the broader issue of an art museum's purpose in a democratic society. WAMA had stressed the link between the museum and the industrial arts, emphasizing that the chief beneficiary of the museum would be the working classes. Alfred Goshorn endorsed this concept. In theory then, the museum should attempt to reach the widest possible audience. However, without tax support museum authorities felt that some admission fee was

necessary to pay operating costs, but even the designated twenty-five-cent charge represented about one hour's wage for an industrial worker.

Anticipating a "long and bitter discussion" over the Sunday question, Goshorn turned to other museum directors for advice. John Sartain supported Sunday openings strongly, urging Goshorn to consider no admission charge on that day. This would allow working people and their families to benefit most from the collection. "The young folk of such families," he argued, "are likely to have their taste and manners improved, and superior aspirations awakened by such opportunities being open to them." William Pepper of the Pennsylvania Museum concurred. Although his museum's policy had been dictated by the acceptance of an annual $10,000 from the city of Philadelphia, Pepper pointed out that over half the museum's admissions came on Sunday, and "a better behaved, more orderly lot of people have never been seen together in a public building. There has never been the slightest disorder," he maintained, and "only *three men* were put out of the Museum for being rude to ladies." An opposing view arrived from L. P. di Cesnola. Citing the opposition of many museum supporters and trustees, as well as the additional expense involved, the Metropolitan Museum's director capped his advice by emphasizing "the great crowds" that would invariably descend upon the museum every Sunday.[19]

"Great crowds," a euphemism for the undesirable poor, represented only part of the Sunday controversy. Conservative churches feared that Sabbath breaking on the museum's part would lead to other Sunday amusements, a continuing controversy amidst the city's ethnic and religious factions. Linking the proponents of Sunday openings to "the Bund for Liberty and Right," a derisive term for German saloon keepers, the *Western Christian Advocate* denounced the idea of a Sunday opening. Both Sartain and Pepper recognized the strength of this opposition, and Sartain urged a one o'clock opening in order to ease the conflict with those clergy "who would oppose any rivalry hurtful to the attractions of their own places of entertainment." Pepper placed the benefits of the museum on the side of the churches. He suggested *"that if Grog Shops are open,* and people will go to the park on Sundays, it is better to give them *a refined and attractive* place to pass part of their afternoon, and thus avoid the temptation which strong drink offers to many." Supported by the major Cincinnati newspapers, the museum board approved Sunday hours at a reduced admission of ten cents. By 1890 the issue had died, interred by Goshorn's observation that "the most effective part of the work of the Art Museum in education is being done on that day."[20]

With the art museum's existence assured by Charles West's gift, pressure mounted for bringing the McMicken School of Design under its control. Although Benn Pitman's earlier suggestion to this effect had found little

favor with WAMA, now the time was more propitious. The school, a part of the University of Cincinnati, had not escaped criticism. The invasion of new art styles and teaching methods from Europe led to considerable student dissatisfaction, and by 1880 some observers questioned the practicality of teaching so many women (who lacked "perserverance"). Others complained that the school catered to the rich. One former student, Kenyon Cox, now studying in Paris, expressed both these concerns and more in a letter to his father in 1879. "There is a great deal of money spent there in all sorts of useless ways, and the real ends of an art school are left unanswered through the poverty and prudery of the board," he lamented. Pitman's "Carving School" he described as "of no earthly use except to enable a few ladies to pass their spare time pleasantly" Furthermore, he argued that the "flat" department should be abolished, and with it, "the salaries of three or four young ladies" who have not "the faintest notion of drawing" Cox

Photograph of Thomas S. Noble, ca. 1890; Cincinnati Art Museum Archives.

then called for the introduction of regular life classes, a staff of two professors (Noble and a "younger . . . more energetic man") who would critique students twice a week only. He concluded his critique by suggesting himself as an appropriate person to reform the school.[21]

In 1881 a more serious quarrel erupted during the academy's annual exhibit. While most newspapers provided friendly, if unsophisticated, coverage of the show, one Roger Wilson came away astonished and mortified. He had been out of the city for eight years, living in New York and Philadelphia; now he had returned to find no progress or merit in the students' work. Asking where "all the excellence that had been talked about" was, he raked the city for its "utter destitution of taste for art" For special criticism

he singled out the "ignominious failure" of the modeling department, and, like some of the more advanced students in the school, he deplored the continuing emphasis on copying from casts. This, he argued, restricted true expression and allowed the academy to become the "worst blot on Cincinnati's artistic name." He reserved his most savage assault for the city's pride. "Art Center!!!! Paris of America!!!! These are terms applied to it by some enemy," he exclaimed, "[who] knew that Cincinnati had not the bottom to hold very long such titles."[22]

The next day brought replies. A letter from "H," apparently a student at McMicken, supported Wilson's views. The school is managed for the "personal interests of a little clique," he informed readers, and the "petty rules and regulations" have driven out many students. After praising the work of two instructors, Will Humphreys and Louis Rebisso, he decried the general lack of "independent thought." In the same issue of the *Cincinnati Commercial,* several of Rebisso's students rushed to defend him and his modeling class from Wilson's aspersions. Another concerned citizen, "Trebor," contributed his own critique of the school. He implied that Humphreys was incompetent and that "all modern ideas of teaching are rigorously tabooed." Less red tape and concern about "salary business," in his opinion, would improve the school immensely. "Trebor" acknowledged the value of the modeling class, but felt that woodcarving was "an unnecessary encumbrance." He expressed disappointment in the displayed work of the life class, which held the most advanced students, and recommended a general overhaul of the school, implying that Thomas Noble was too inflexible and dogmatic.[23]

Two days later, the veteran artist Charles T. Webber joined the debate. In yet another letter to the *Commercial,* he charged that a letter critical of the school which he had written to the board of trustees had been "pocketed by someone." He called for its publication. The following day's issue of the *Commercial* brought a defense of the school. "A Pupil" criticized the school's detractors, suggesting that the rancor emanated from an artist who had been passed over when Noble was selected as director (Webber, perhaps?). "Festus" then zeroed in on another sore point, the lack of nude models in the life classes, concluding that the graduates of McMicken all seem to feel that "they began to learn when they left the school and studied from nature" Finally, Henry Lord, father of one of the school's more talented students, endorsed Noble's leadership and criticized "Trebor" for remaining anonymous.[24] All in all, the sharp tone of the quarrel cast no credit on anyone.

The controversy soon left the pages of the newspaper, but many unsettling questions remained—questions that many felt could be better resolved if the McMicken School were placed under the control of the art museum.

Artists as Teachers. Top: Caroline Lord and Class, ca. 1895, Cincinnati Art Museum Library Archives. Below: Frank Duveneck with His Class, ca. 1890, courtesy of the Cincinnati Historical Society.

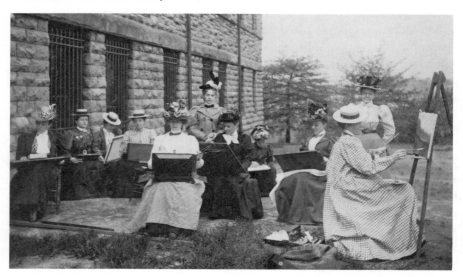

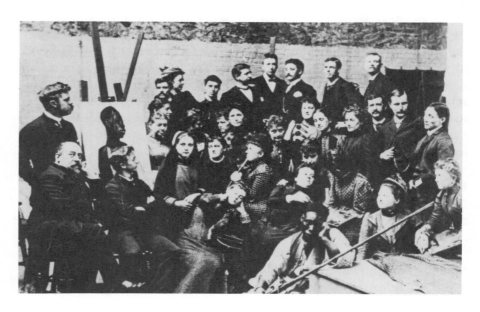

Joseph Longworth spearheaded a move to transfer the school. The only son of "Old Nick," Longworth had inherited his father's wealth and enthusiasm for art. His personal art collection included numerous works by local artists, along with the conventional German and French schools. A man of simple tastes, the short, heavyset Longworth was distinguished by his lionesque beard and rather ordinary clothes. He has never received the recognition that has gone to his more eccentric father, his strong-willed daughter Maria, or even to his grandson, the Nicholas Longworth who married Alice Roosevelt. Yet, his contribution to Cincinnati's cultural life may have exceeded any of them. Beginning with the ill-fated Western Art Union of the late 1840s, Joseph Longworth had generously and quietly given of his time and money to every significant new art institution that appeared in the city. The McMicken School of Design shared in this generosity, and during the school's years as part of the University of Cincinnati, he remained its chief benefactor. In 1881, when WAMA and the museum board endorsed the idea of attaching the school to the museum, he directed his energy to that end.[25]

The unseemly public quarrels about the internal operation of the art school alarmed Longworth. The university, in his opinion, was too political, certainly a highly questionable atmosphere for a school devoted to the belief that art was the source of the ideal. "The great end is to awaken the love of the beautiful among men," he explained to the university board of trustees, "to elevate and purify their thoughts, to wean them from the earthly and sensual and to quicken them into the privilege of seeing." Longworth requested the university board to permit the transfer. A major obstacle arose, however. Several university trustees balked at the suggested arrangements. They were concerned about legal issues stemming from the conditions of Charles McMicken's will. To circumvent this difficulty, local legislators pushed special enabling legislation through the Ohio General Assembly, and in early 1884 the university agreed to the move. It came too late for Joseph Longworth. Just weeks before the agreement was reached, he died, and his son, Nicholas II, handled the final details of the transfer.[26] With the school now safely in the hands of the same principled gentlemen who controlled the museum, conservative supporters breathed more easily. The merged institutions could now become "the center and controlling force" in the city's artistic direction, or so the CMA's next annual report announced. "A most important integer in the sum of civilization," added one friendly well-wisher, while *The Courier* described the new art academy as "the most thorough school in the United States for art education"[27] Interestingly enough, it did not call it the most advanced.

As the original concept of the museum had included instruction, there was no question that the school would move to Eden Park where construction of the museum was underway. Admirers of the city's recently aban-

J. H. Sharp's Art Academy Class, ca. 1895, Cincinnati Art Museum Library Archives.

doned post office building campaigned to relocate that handsome neoclassic structure for use as a school, and Reuben Springer and David Sinton promised $25,000 each to that end. Rising cost estimates and the difficulties of remodeling the building to meet teaching needs convinced the board that a new building was more practical. Sinton then donated $75,000 towards a new facility, to be designed by McLaughlin in the same Romanesque style as the museum.[28]

Eden Park's breezy air brought little internal change to the Art Academy, as the school now called itself. Thomas Noble remained at the helm. Tuition continued to be free for city residents. The curriculum retained its conservatism, and the seven-member faculty continued to be headed by sculptor Louis Rebisso. Petty quarrels still disrupted the school, with salaries a particular sore point. While the veteran Rebisso commanded a salary of $1,500, Caroline Lord and Henrietta Wilson, younger and less experienced—and also women—received only $500 a year. The equally inexperienced Vincent Nowottny earned $800. William Humphreys, the most popular instructor, complained that his $1,200 contract was insufficient to maintain a family, but his request for a $300 increase was refused. The quality of teaching also remained uneven. Alfred Goshorn twice had to personally warn Martha Keller that complaints "of so serious a nature" had been lodged against her instructional methods, and a year after the move to new quarters she was released. A part-time anatomy lecturer, Dr. William Rothacker, took offense with Louis Lutz, a drawing teacher, for the latter's praise of a Dr. Cilley's proposal of an anatomy course. Rothacker, unliked by the regular faculty, complained to Goshorn of "coolness and indifference," and blamed the faculty for declining enrollments in his course. The museum director attempted to soothe the doctor's ruffled ego, assuring him that all involved disclaimed any "discourtesies." His "confidence" destroyed, Rothacker resigned anyway.[29]

More serious were the continued rumblings concerning basic teaching methods. In the spring of 1886, Ripley Hitchcock visited the new museum and academy while preparing an article for *Century Magazine*. Somewhere during the visit he apparently disagreed with Noble. In sending the galleys of the article to Goshorn, Hitchcock tried to justify his occasional criticisms of the school by leaving "unsaid much which might have been appropriate, if unpalatable." Goshorn remained troubled by the negative tone and suggested that the journalist modify his comments about "the lack of influence by the art school upon the artists who have come from Cincinnati." Hitchcock complied, leaving only a veiled hint that the school remained isolated from the more progressive tendencies in art.[30]

If Goshorn fought to protect the academy's reputation, he was not insensitive to the basic problem. But he chose not to replace the dutiful Noble.

Rather, he sent him East to examine various art schools in New York and Philadelphia. Noble's subsequent report to the director reveals much about the man who shaped the early years of the school. His concerns ranged from appropriate student lockers to the use of zinc coating on clay models. The industrial art classes at the Philadelphia School of Design impressed him greatly, and he described its classes at considerable length. Noble placed great emphasis on improving design curriculum, recommending that the Art Academy add an evening class in woodcarving. Comments regarding drawing and painting instruction remained more guarded. He did visit life classes with nude male models—an "exceptional privilege"—but "did not ask to see the woman's nude nature class as I regarded it as an indelicacy to ask." The separation by sex, which precluded "moral contamination," found favor with Noble, and he now recommended a similar plan to Goshorn, stressing that advanced students should work every day from nude models. If the board saw fit to adopt the principal's numerous proposals, Noble assured them, the school would become "the very *first* in this country."[31]

While changes crept gradually into the academy, Goshorn worked steadfastly to strengthen the museum. He continued to correspond at length with the country's leading museum directors, acquiring information and advice on everything from display cabinets to appropriate office forms. No one was more helpful in this regard than the Metropolitan's exuberant and opinionated L. P. di Cesnola. In 1889 Goshorn visited New York to examine at firsthand his friend's achievements. He came away impressed. "We felt small indeed when we compared what we saw to our own little museum," he wrote his assistant, Joseph Henry Gest. "We are but an infant" Although he would not conclude better management to the New York museum, Goshorn became more than ever aware of Cincinnati's limited resources.[32]

Publicly museum officers presented an optimistic, even inflated assessment of the institution, but knowledgeable outsiders were not deceived. One unidentified local critic, not impressed by the annual announcements of pride and self-satisfaction, described rather sadly the limits of the collection. The art museum lacked sufficient sculpture, did not possess a single reputable old master, owned mostly "indifferent" modern works, and daily exhibited several paintings "too bad to be hung anywhere." A few reasonable comments about the etchings, the decorative arts collections, and the armor did little to offset his gloomy appraisal. What was worse, he concluded, he could see few signs of growth. The country may have had few museums superior to Cincinnati's, but they were, in his opinion, far superior.[33]

Neither Ingalls nor Goshorn cared for this assessment, yet the appraisal did not disagree substantially with their own. Money continued to be the single most pressing problem. Annual memberships never reached initial

expectations, and donations of both money and objects all but disappeared after the generosity of the first years. And several of the acquisitions during this time, notably the Cleanay bequest of American Indian archaeological items and Carl Steckelman's collection of African art objects, appeared less significant then than today. Ingalls took every occasion to remind the museum faithful of their responsibilities. At the festive dedication of the academy building, he solemnly warned the audience that they must not assume that the director and the board would provide the necessary support. Alluding to the lack of memberships, he stated bluntly, "This will not do." "Why do you stop just when your aid is needed most?" he asked. Nor did board members escape his censure. In a letter to treasurer Julius Dexter, Ingalls called for Judge Nicholas Longworth's resignation, stating that he had never attended a meeting. He observed further that the secretary of the board had failed to notify Dexter of his election as treasurer, leaving the critical finance committee inoperative. Even the faithful Dexter did not avoid the president's critical eye, for he strongly hinted that museum business must take as much of the treasurer's time as any of his professional responsibilities. "I would like to keep the friends we have, and keep them up to the mark," he concluded.[34]

The lack of progress brought about another public controversy in 1890. At a board meeting, Learner B. Harrison, supported by some twenty stockholders, proposed that Maria Longworth Storer be elected to the board. With considerable arrogance, the trustees refused to consider the proposal, pointing out that when the CMA had been established, the trustees had deemed it "inexpedient" to have a woman on the board. One trustee went so far as to suggest that stockholders had no right to question a decision of the trustees. Angry stockholders aired their feelings in the columns of the *Commercial-Gazette*. Referring to "bull-dozing tactics," one Storer supporter called for a change in management. "J. R. S." scored the board for its decision. "Mrs. Storer was a woman, and worse than that, a woman with ideas . . . ," he pointed out, who thought the museum was "for the art education of the people." More pointedly, he continued, she might have objected to paying the director $6,000 a year, and might have replaced Noble with Leon Van Loo, a popular local artist and photographer.[35] After the protests died away, a disappointed Mrs. Storer soon found another way of expressing her displeasure, at least with the management of the academy. She arranged for Frank Duveneck to teach in the city, thus upstaging Thomas Noble, the principal artist at the academy.

The art museum made its own special contribution to Cincinnati's art life. Despite its increasingly cramped quarters, the decade saw steady growth in the number of exhibitions, and Cincinnati artists showed regularly there. Ferdinand Lungren, Vincent Nowottny, Joseph Sharp, Lewis Meakin, and

Charles Kaelin all had one-man shows during the 1890s, while former Cincinnatians Twachtman, Nourse, and Henry Mosler were also honored. The Cincinnati Art Club, the Woman's Art Club, and the Society of Western Artists used the museum facilities for their exhibits as well. Local artists took great interest in the exhibits of contemporary European and American art. In 1895 paintings by Claude Monet and Puvis de Chavannes, along with works by American Impressionists Childe Hassam and Robert Reid, lent a thoroughly modern touch. A selection of contemporary Swedish art showed later that year, and in subsequent years the museum exhibited works of Theodore Robinson, William Wendt, and the German Hans Enke.

The dominant event of each year was the museum's own Spring Show, which by 1897 had replaced its original regional emphasis with a strong national perspective. J. Alden Weir, Robert Reid, John Singer Sargent, Childe Hassam, William Merrit Chase, Kenyon Cox, and Dwight Tryon joined the many area artists who submitted work to these exhibitions. By the first years of the new century, Cincinnatians not only were regularly exposed to Impressionism, both French and American varieties, but the new realism found in the canvases of Thomas Eakins, Everett Shinn, and Robert Henri had found acceptance as well. Outside of New York and Boston, no American city received better exposure to current American painting. Much of the attention focused on the museum's yearly show came from the decision to purchase two paintings from it each year, thus making the Cincinnati Art Museum one of the first in the nation to actively build a contemporary American collection.[36]

Just as he provided leadership in the Art Academy, Joseph Gest was instrumental in the new direction of the museum. In 1890 Goshorn reduced his responsibilities in order to devote more time to his private affairs. Gest replaced him as the administrator of the museum's daily operations, and his executive skills, coupled with his broad view of art, paid rich dividends. Not only did artists appreciate the new vigor of the institution, so did art lovers. Attendance, which had remained sluggish during the first decade, began to rise. Acquisitions increased. Husbanding their limited resources, Ingalls and the board decided to direct money from the annual memberships towards the purchase of new works, and Gest knew exactly what to do with these funds. In 1897 the museum purchased the first of its many Farnys, followed shortly after by works representing Sharp, Tarbell, Potthast, Edward Rook, Joseph DeCamp, Hassam, and William Picknell. Lewis Henry Meakin served as Gest's unofficial advisor, reinforcing the assistant director's natural instinct to support contemporary American art. "I think it is a pity that our Cincinnati Museum is so behind the other important galleries in this country," Meakin had written in 1892. "The Lessings, Achenbachs & Guides are all right, but we need to see something else." He pointed out that the

Boston museum already had six Monets. "It is rather amusing to see how history is constantly repeating itself in the case of the critics you speak of in your letter," he continued. "Those who today swear by Corot and roundly abuse Claude Monet would have been in exactly the same position regards Corot if they had lived during his struggle for recognition." Gest listened to his friend, and the Monet exhibit in 1895 was in part a result.[37]

Despite this flurry of acquisitions and exhibitions, the museum's annual reports reveal constant frustration over limited financial resources. Each year President Ingalls called on the community's art supporters to be more generous. The building, new in 1886, already strained under the size of the collection. Additional space, especially for larger exhibitions, remained an important need, and increased funds for acquisitions was a constant plea. For the most part these requests went unheeded. After the initial drive to build the museum, cash donations narrowed to a trickle, and donations to the collection added little to the breadth of the museum's holdings.

To celebrate the museum's tenth birthday in 1890, Ingalls forwarded a plan to Goshorn for a festive dinner, to be held at Ingalls's cost. "We will get the mayor to make it a holiday and try to have a big 'blow-out.' " This plan never materialized. The dinner shrunk to a three-hour reception at the museum, without the public holiday, to honor the civic generosity of ten years before. No doubt Ingalls hoped that this decennial celebration would encourage a similar response from the one thousand guests who passed through the massive entranceway. "One of the greatest art gatherings of the year," announced the *Cincinnati Commercial-Gazette* in describing the gay throngs that wandered through the galleries. But the hoped-for generosity never materialized. Disappointments continued for the next decade, helped along by the financial crisis that struck the nation in 1893. On top of these problems, death claimed several staunch friends, including Julius Dexter, Learner B. Harrison, and in 1902 Alfred Goshorn.[38]

The financial gloom of the 1890s dissipated with the new century. Jacob C. Schmidlapp announced that he would fund a new addition in memory of his daughter Emma Louise; a few years later Mrs. Thomas J. Emery contributed $100,000 to allow for free admission in perpetuity on Saturdays. In 1908 the John J. Emery collection of paintings came to the museum, supported by a $200,000 endowment.[39] Thus, a quarter of a century after its opening, the Cincinnati Art Museum looked to the future with a cautious confidence. If it never quite lived up to its appellation of the "Art Palace of the West," and the Art Academy never quite reached the national distinction promised by Noble, the two institutions achieved steady, if undramatic growth. They also supported considerable art activity during the last years of the century—the most active years for Cincinnati artists.

The Golden Years: Art Life in the Nineties

Duveneck, Farny, Blum, Twachtman—these are the artists most associated with late nineteenth-century Cincinnati, yet only Farny lived in the city during most of that period. Thus, the Queen City's faintly Bohemian "Golden Age" depended more on a cluster of lesser known artists who stayed in the area to paint and teach. The city had never enjoyed such artistic vitality, nor such good relations with its artistic community. And at the center of this art life stood the Sketch Club and its successor, the Cincinnati Art Club.

Established in 1884, the Sketch Club traced its lineage to the art organizations of the early part of the century. These clubs and societies had supplied each generation of artists with opportunities for socializing, mixed with more serious goals. Most importantly, they had provided their members with a sense of identity in a not always hospitable world. This latest Sketch Club evolved out of the rebellious nature of John Rettig and several other male students at the McMicken School of Design. Dissatisfied with Noble's conservative regimen, which excluded drawing from the nude female, Rettig had arranged to have a female model, attired only in trunks and a mask, pose in the school one evening a week. One night the board of trustees, tipped off by a janitor, paid a "surprise visit," intent upon exposing this immoral practice. But the class had been forewarned. Joe Wheeler, one of the students, posed instead, and the somewhat red-faced trustees walked in on a sober group of students working diligently to keep from laughing. Later, however, the students, with model, moved their class into Rettig's studio and the Sketch Club was the result.[1]

Established "for the promotion of an artistic feeling and a better organization among the artists of our city," the Sketch Club brought together the

major artists who worked in the city. The venerable Charles Webber, architect James McLaughlin, and the aristocratic Belgian-born photographer Leon Van Loo, represented the link to the Civil War Sketch Club. Rettig, Vincent Nowottny, Joseph Sharp, Lewis Lutz, and Lewis Henry Meakin are the more recognizable names among the younger artists. Van Loo's residence served as the first meeting place, and from the beginning each member was expected to contribute a monthly sketch on a previously announced subject. Serious criticism competed with copious amounts of local lager for the high-spirited artists' attention. The Sketch Club remains obscure, reflecting its informality, but it did hold occasional exhibits, and one newspaper account even mentioned the work of three women artists—Louise McLaughlin, Caroline Lord, and Maria Storer—as being included in one show. Whether they were actually members is not clear.[2]

John Rettig is the most fascinating of all the Sketch Club members. The son of a brewmaster, he was born in the Over-the-Rhine community. As a choirboy at St. Francis Church, he had admired the decorations done by Johann Schmidt, who had influenced the early development of Duveneck, and by the age of fifteen Rettig had enrolled at the McMicken School. There, between 1873 and 1880, he joined fellow students Matt Daly, Charles Niehaus, and Albert Valentine in following the path of Blum, Twachtman, Cox, and DeCamp. In the late 1870s, Rettig's interests carried him in a multitude of directions. He wrote stories and plays, played the violin, and learned to decorate pottery, even teaching a class with Valentine in 1880. For a while he considered a career in music. In 1880, however, George Ward Nichols, in need of a scene designer for the College of Music's operatic production of *Cinderella,* steered the twenty-two-year-old Rettig permanently into the fold of art.[3]

Although he had earlier painted a curtain for Heuck's Opera House, the *Cinderella* commission led to the first real emergence of Rettig's talent for stage design. For years he did much of the theater design in the city, painting many of the sets for the College of Music's highly acclaimed annual opera festivals. As his reputation spread, he accepted similar commissions from cities as distant as Baltimore and St. Louis. Time did not permit much easel painting during these years, but his "cozy and interesting studio," with its Oriental rugs, European armor, painted Japanese silks, and all the rest of the trappings that served him as models, quickly became an informal center for artists. During the 1880s he also became identified with the outdoor parades organized by the Order of Cincinnatus. These grand, pre–motion picture pageants—each one more elaborate than its predecessor—made him, in the words of one admirer, "the greatest scenic artist in the country." The dramatic spectaculars consisted of horse-drawn floats conveying scenes depicting an historical of Biblical event such as "The Fall of Babylon" or "Rome

Under Nero." To achieve historical accuracy, Rettig spent weeks in Italy and Egypt, photographing and sketching temples, monuments, and ruins, giving scene painting "a new value and significance."[4] Not until the 1890s, when he became a close friend and follower of Duveneck, did Rettig return to easel painting. It was also in 1890 that the Cincinnati Art Club was organized.

For reasons that remain obscure, although one possibility may have been the admission of women, thirteen Sketch Club members concluded that a new organization was needed. Open both to artists and interested supporters, the Cincinnati Art Club sprang to life in the studio of Clarence Bartlett, where the host's dog joined the membership in order to avoid the number thirteen. The personable Rettig served as the first president. The Art Club offered a more formal structure for the art community. Early meetings were held at members' homes or in rooms above Haguer's Cafe. Later they moved from one "permanent" location to another, before coming to rest in their present home on Parkside Place in lower Mt. Adams. The propensity of the members to push aside the furniture and bowl, regardless of the meeting's location, may account for the frequency of their moves.

A list of the club's early members reads like a Who's Who of turn-of-the-century Cincinnati artists: Henry Farny, Leon Van Loo, Frank Duveneck, Harry Meakin, Clement Barnhorn, Joseph Sharp, Edward Potthast, John and Martin Rettig, Charles Niehaus, Paul Eschenbach (later Ashbrook), and James R. Hopkins. From the beginning the club adopted the Sketch Club tradition of submitting figure studies for monthly criticism, for it served the instructional purpose of the organization. John Rettig provided the commentary just as he had done for the Sketch Club. In 1897 Duveneck took over the teacher's role and these Sunday morning classes with the "old man" at the easel became cherished events. Later the club added sketching trips and, eventually, it acquired a clubhouse on the Little Miami River. Their exhibitions became annual spring events, eagerly awaited by the art community. The show held in 1894 drew over two thousand viewers on opening night, possibly attracted by John Dunsmore's *Expectations,* listed in the catalog for an astounding $1,500. Whatever Dunsmore's expectations, the art museum selected Sharp's *Harvest Dance* for its own collection, but not before offending those who believed Potthast's *French Peasant Women* to be the finest picture in the exhibit.[5]

Art Club life was more than exhibitions and classes. The members' exuberance led to a series of entertainments, usually held during holiday seasons, although parties might erupt at any time. At their first Christmas dinner the artists celebrated "Mikado" style, perhaps in tribute to Kataro Shiryamadani, the popular Japanese decorator at Rookwood who became a member about that time. The following year the club held a dinner in honor of "The Ladies of the Columbian Association," where the guests received

attractively decorated fans as souvenirs. More memorable were the "histori-cal" costume dinners, the first of which honored Leif Erikson, a sly way of spoofing the soon-to-open Chicago World's Fair honoring the four hun-dredth anniversary of Columbus's voyage. Each year these entertainments became more elaborate, leaning frequently towards the burlesque. The 1897 affair required members to arrive in seventeenth-century Dutch costume, a theme much to the liking of Leon Van Loo, whose dapper bearing and elo-quent beard had already earned him the title of burgomeister. The members also enjoyed satirizing each other, sometimes masking serious aesthetic dif-ferences in this fashion. At one dinner John Rettig poked fun at the several painters of American Indian life with a good-natured parody of a Sharp Indian portrait. However, Potthast struck much closer to the bone when he drew a mournful Van Loo gazing at an Impressionist canvas of purple and yellow blobs, a reference to the Belgian's notably conservative taste.[6] As the Art Club increased in size and its founding members aged, it became increas-ingly conservative, first hanging on to the mantle of Duveneck and then, after his death in 1919, hanging on to his memory. Although the club still exists, and many fine artists belong to it, sometime after 1910 it lost that boisterousness that contributed so much to the art community of the 1890s.

Not to be outdone, and resenting the male only restriction of the Art Club, local women artists formed the Woman's Art Club in 1892 in order "to stimulate its members to greater efforts in their work." More serious in its artistic objectives than the men, the Woman's Art Club limited membership to practicing artists and spurned the levity exhibited by their male counter-parts. Mary Spencer, dean of the city's female artists, launched the idea for a separate organization at a meeting held in her studio. Now approaching her sixtieth birthday, Spencer had come to Cincinnati from Springfield, Ohio in 1860 to study with Charles T. Webber. Ten years later, after selling a paint-ing for three hundred dollars, she opened her own studio, at that time an unusual occurrence for a woman. Her colorful still lifes and carefully ren-dered portraits secured for her a steadily growing reputation. In a traditional male world, she made a vigorous statement for female independence. To supplement her income she taught lessons, serving as an inspiration for aspiring women artists. While scarcely remembered today, Mary Spencer played an important role in Cincinnati's art life for half a century, capped by her participation in the Woman's Art Club, and as that organization's first president she helped bring women into the mainstream of the community's artistic life.[7]

Cincinnati also benefited from several other art activities during the decade. Charles Meurer, a popular trompe l'oeil painter, made two attempts at starting art schools, and concerned citizens founded the Municipal Art Society in order to provide appropriate sculpture and decoration for public

buildings and parks. Led by a board consisting of two architects, two paint-
ers, one sculpturer, and the mayor, the Municipal Art Society quietly secured
for the city the James A. Garfield statue in Piatt Park, the Theodore Thomas
statue in Music Hall, and murals for the new city building. They also encour-
aged the board of education to display more art in the public schools.[8] The
city enjoyed an increasing number of art exhibitions, which added to the
cultural tone of the community. The annual shows by the two art clubs,
various independent exhibitions, the shows by the Society of Western
Artists, the annual display of student work from the Art Academy, and the
numerous exhibitions sponsored by the museum provided a steady diet of
contemporary art.

The Society of Western Artists, founded in 1896 to combat "the general
feeling amongst the artists of the Western states that they were at a disad-
vantage as compared to those of the more closely connected communities of
the East," owed much to Cincinnati artists. Although organized in Chicago,
Queen City members dominated the early years. Hopes that western artists
who had moved to New York or Boston would join the newly formed society
never materialized, but the organization did serve the interests of many
younger artists searching for recognition. The by now venerable Duveneck
served as its first president, while both Farny and Meakin played instrumen-
tal roles in the society's establishment. Its annual exhibition, which travelled
among the region's principal cities, was open to all "western artists," and
over a third of the first year's exhibitors came from the Cincinnati area.

Of the Cincinnati members, none supported the organization more
faithfully than the personable Lewis Henry Meakin. Born in England in
1850, he was related to the poet John Keats and the Wedgwood family. After
his arrival in Cincinnati in 1863, the slender, scholarly looking "Harry"
Meakin followed the well-worn path from McMicken to Munich, absorbing
a solid training in design and composition. His canvases remained anchored
to the style of Corot, emphasizing tonal values and subtle harmonies of
color. Bolstered by visits to Europe and influenced by the works of Alfred
Sisley and William Picknell, around the turn of the century his palette
shifted to the lighter colors of Impressionism. His paintings reveal a confi-
dent, if not overly imaginative, handling of New England and Ohio Valley
landscapes. Yet, he did not circumscribe art. In his teaching he voiced a
broadmindedness that served his students well. As he once stated, "Every
artist . . . must have a song to sing, or he has no claim to the title."[49]

Despite Cincinnati's substantial contribution to the Society of Western
Artists, the location of the society reflected the emergence of Chicago as the
West's new cultural center, an emergence symbolized by the great Columbian
Exposition held there in 1893. The planning for a world's fair to mark the
four hundredth anniversary of the discovery of the New World had begun in

Lewis H. Meakin, *In Eden Park*, ca. 1910; the Procter & Gamble Collection.

the 1880s. Early discussions had mentioned both St. Louis and Chicago as potential sites. When Cincinnati newspapers had dared to suggest that the Queen City, despite its recent sluggish growth, offered a more appropriate location, the *Chicago Tribune* scoffed at "the toothless, witless old dotard of American civilization"[10] Eventually the spirited competition centered on New York and Chicago, with the vigorous western city gaining the coveted prize in 1890. The Chicago World's Fair, dubbed the Great White City from its neoclassic architecture, gave the nation an opportunity to display how far it had progressed culturally since the somewhat embarrassing Philadelphia Centennial less than twenty years before. Under the critical eye of architect Daniel Burnham, the spectacular grounds presented an array of basins, lagoons, fountains, and imposing sculptures. Even for those disappointed with the almost complete dominance of classical style, the overall effect of the exposition was one of magnificent splendor. The physical relationships between the many buildings, the effective use of landscaping, and the imposing statuary created a harmony that, for the first time, allowed Americans to observe the complementary nature of beauty and design. Rather than an architectural retreat into the past, the fair gave visitors a dynamic look into the future. Both in conception and execution, it was a triumphant celebration of America's coming of age.

In American terms it was also a triumph of western energy and vision over eastern tradition and power; a triumph of Chicago over New York. If the rumbling city along Lake Michigan deserved most of the glory, Cincinnati's cultural reputation did not pass unnoticed—or at least not the reputation of its women. In an age of artistic crafts, the prominence of the city's woodcarvers and pottery decorators had led the fair's Board of Lady Managers to set aside for Queen City women a second floor reception room in the Women's Building. Determined to make the most of this opportunity, Cincinnati women decorated the room and displayed a collection of needlework, carved furniture, pottery, paintings, and books, all of which disclosed the range of feminine talent found in the city. A divisive quarrel between Louise McLaughlin and Maria Storer concerning proper credit for the Cincinnati style pottery never became public, and the tastefully decorated ceramic ware accentuated the warmth and beauty of the popular room.[11]

Although Cincinnati's male artists received no such recognition, many of them took advantage of the opportunity to visit the fair and to observe the collection of world art that hung in the Fine Arts Building. Meakin, Lutz, Barnhorn, and Noble all made the trip. Henry Farny served on the jury which selected the paintings in the American exhibit, and he saw to it that Cincinnatians were not neglected. Alfred Goshorn and Learner B. Harrison of the museum board visited the exposition with the aim of purchasing works for the museum collection. And even for those artists unable to attend the grand event, the fair served as a major topic of conversation. Leon Van

Loo, who did not attend, offered his advice regarding museum purchases: "Do these gentlemen [Goshorn and Harrison] want the works of the masters of 1830! or would they prefer the canvases by the great men of today! Regarding myself, I am in favor of purchasing good examples of strong men now living, either French or German." Barbizon paintings, then quite popular, he expected to decline in value, but good pictures of recent years would undoubtedly increase. Of course, Van Loo had in mind the prominent Salon painters of Paris and Munich.[12]

Where Van Loo gravitated toward contemporary, if traditional, European art, Meakin proudly discovered that "America holds her own remarkably well" The paintings by his countrymen, he observed, seemed "healthier" than the German or English or French canvases, which he did not feel were "up to what [they] might be," although he liked the Dutch exhibit with its "directness, sincerity, and freedom from affectation." The fair itself dazzled him. The preponderance of outdoor sculpture recalled memories of his recent trip to Europe, and Daniel French's colossal *Republic* he termed "a grand piece of work." To Meakin, the Columbian Exposition made an important statement about the new role of art in American life, and he was proud that Cincinnati artists had made a significant contribution to that statement. Heading the list of works shipped from Cincinnati were Frank Duveneck's portrait of William Adams and Farny's *Sioux Camp,* and almost all the leading artists of the city had at least one piece on display. When one adds this to the first-rate material in the Cincinnati Room, it is not surprising that all Cincinnatians took enormous pride in their city's contribution.[13]

Cincinnati's enthusiasm for the Chicago World's Fair reflects the new art awareness found in the city, as well as the vitality of local artists. Unlike the aspiring artists of the 1870s who looked to New York and Boston for their futures, this generation was more content to remain in the city. In part these artists were less talented and less adventurous, but Cincinnati also provided more encouragement during the last decade of the century. The city's cultural base had grown disproportionately to its economic position. The growth of musical institutions, the establishment of the art museum, and the expansion of the Art Academy gave area artists a real sense of belonging to a genuine art center. Unless one wished to pursue new directions in painting or sculpture—and few Cincinnati artists did—the city offered a reasonable place to work, and the Art Academy supplied the common thread which tied the local art world together. Most of the city's artists had either trained or taught there, including the members of both art clubs. This shared experience lent a sense of unity to area artists not often found in larger cities, particularly New York, where factions were the rule. On the other hand, this shared background discouraged innovation.

Although several artists, Farny and Duveneck among them, com-

plained of Cincinnati's limited opportunities, the local art market at the turn of the century appears to have been better than at any previous time in the community's history—good enough to allow several dozen artists to live in reasonable comfort. Teaching at the academy, private lessons, and the sale of work provided sufficient income to keep artists in the city and even to permit considerable travel to the East and Europe. Buoyed by the successes of Twachtman, Cox, Blum, and DeCamp, the Art Academy's national reputation reached its peak at this time, and Frank Duveneck's association, which began unofficially in 1890, gave the institution a major art personality. *Vouga's Art Folio, Cosmopolitan, The Century Magazine,* and *The New England Magazine* all published favorable accounts of the school's program. While the accounts reflect the generally conservative tone of those journals, the Cincinnati Art Academy did furnish a thorough training in art, similar to many of the most respected European academies. If the curriculum now appears overly conservative, there is no question that the school's graduates left with a solid grounding in fundamentals.[14]

Much of the vitality found at the academy came not from its principal, Thomas S. Noble, but from Joseph Henry Gest, who had assumed administrative control when the Cincinnati Museum Association took over the school. Gest was one of those rare human beings whose executive skills did not interfere with the personal warmth he felt for subordinates. Born into a prominent local family, he revealed an early interest in art. At the age of sixteen he spent a year studying in Europe with his mother, spending considerable time visiting major museums. As his more practical-minded uncle Erasmus Gest commented ruefully, "I imagine Harry's artistical taste will develop into a long haired parted in middle young man." When the young Gest returned, he enrolled at Harvard University, where he absorbed Professor Charles Eliot Norton's love of art. He also brought back to the Queen City President Charles Eliot's dictum that the spirit of Harvard "is the spirit of service."[15]

When Gest returned to Cincinnati in 1880, he took a position with his father's soap manufacturing company, but a life in business left him unfulfilled. For several years he tried dairy farming, managing his uncle's farm just south of Newport, Kentucky. Still not satisfied, he became clerk and then assistant director of the art museum. Slender and dignified, Gest quickly advanced and was placed in control of the school. As head of the academy, he revealed a personality at once shy and forceful. His home remained open to students and faculty alike, and for those who came from outside the city, holiday festivities and Mrs. Gest's cooking helped ward off homesickness. He had a capacity for accepting people as they were, enjoying what they offered, and his voluminous correspondence displays a generosity of spirit that made him universally loved and respected. Although never a

"radical" in art matters, during his long association with the museum (assistant director, 1886–1902; director, 1902–1932), he helped dilute Noble's steadfast conservatism. Joseph Gest's gentle spirit served the city well.[16]

Under Gest's direction, the academy maintained a pleasant balance between the fine and applied arts. In a talk given to the Commercial Club in 1894, he emphasized the importance of art to the economic growth of the city by alluding to the number of academy students who remained artisans, but better artisans because of their training. Local manufacturing of pottery, glassware, furniture, and lithographs was enhanced greatly by the work of the school, he asserted. Of course, he was using the occasion to elicit support from the business community, but he never let go of the opinion that industrial art was integral to the Art Academy's purpose. In 1902, the same year he became director of the museum, he inaugurated a long relationship with Rookwood Pottery, serving eventually as its director, thus strengthening the association between art and industry.[17]

Among Gest's more important contributions to the academy was the enlargement of the faculty. Lewis Lutz and Vincent Nowottny joined the teaching staff soon after the school moved under the museum's control, while Meakin, Sharp, William Fry, Ferdinand Lungren, and Caroline Lord all taught there during the last years of the century. In 1900 Frank Duveneck joined the faculty officially. Thus, the most important local artists strengthened the impact of the academy on the city's art life. With the exception of Duveneck, all of these instructors had started their training at the McMicken School, and for many years the Art Academy dipped regularly into the ranks of its own graduates for new teachers. This practice ensured teaching competency and a generally close-knit faculty, while helping to retain some of the better artists in the city. But at the same time, the practice restricted the growth of new ideas, extending the Art Academy's traditional views well into the new century.

The closeness of the faculty was shattered by the tragic death of Lewis Lutz, a somewhat shy man from Indiana who had been a popular teacher since the mid-1880s. Lutz's letters reveal a kindly man of modest talent who was insecure about his artistic abilities. A year in Paris (1891–92) literally overwhelmed him, both stimulating him and feeding his personal sense of inadequacy. Lutz suffered frequently from various health problems, and in the summer of 1893 he returned to the family farm near Cambridge, Indiana in an attempt to rid himself of the general depression and debilitating headaches that had plagued him for the past year. The familiar environment helped. In a cheerful note, he wrote to Gest that he had "found a remedy for the blue devils"—spelled "W O R K." By August he had discovered new enjoyment in painting the Indiana countryside, and he looked forward to touring the Chicago World's Fair with Gest in September. Plans for his wedding

over the Christmas holiday went forward.[18] Then suddenly he was dead, the result of an accidental overdose of the morphine prescribed for his headaches. "The news seems so sad and terrible that I can yet scarcely bring myself to realize that it is really true, and that I shall never see the poor fellow again," Meakin wrote from France. "He has been so much a part of the academy, and he and the academy have always been so associated together in my mind that I can scarcely think of it and him away and gone forever. I feel that more than ever now that he has gone. What an earnest, conscientious & valuable teacher he was. . . . It is *very, very* sad that he should be cut off just as he seemed on the threshold of doing something." Lutz was thirty-eight.[19]

Despite the faculty's competence and gradual liberalizing trend, continued criticism came from Maria Storer, who after 1890 was free from active management of Rookwood Pottery. As one of only four students in Thomas Noble's oil painting class, Mrs. Storer buttressed her strong opinions with considerable inside knowledge, and her views of the school's conservatism were widely known. Nor did she like or respect Thomas Noble. Extensive correspondence, some of it quite sharp, passed between her and various school officials. In 1890 her attempt to secure a seat on the Cincinnati Museum Association board met with rejection. Several days later she publicly criticized the board's recommendation to establish a foreign scholarship program for academy students on the grounds that none of the four advanced students was sufficiently prepared to benefit from study in Europe. She also argued that, when trained properly, academy students should be sent to Europe to study from museum collections, not to do copy work at one of the academies as suggested in the board proposal.[20]

Not content with verbal attacks, Mrs. Storer toyed briefly with the idea of establishing a rival academy in the city, headed by Duveneck, in order "to show what an art school should be." This may have been nothing more than a scare tactic, for she soon worked out a far simpler scheme. To Alfred Goshorn she proposed that Duveneck teach a six-month oil painting class at the art museum, to be open to a maximum of forty pupils. "We have never had a man here who could give more of an impetus to the enthusiasm of the students," she wrote, "and his reputation in New York and Boston would, I think, bring pupils from outside." She estimated the cost at $4,000, half for the instructor, and all to be paid by tuition at $100 per student. The board liked the idea. Duveneck would be provided space in the museum, and the Art Academy would offer six scholarships to the class for its most promising students, all funded by prominent citizens. Mrs. Storer promised to purchase three places in the class, one for herself and two for friends. The most deserving student each year, as determined by a competition, would receive a two-year scholarship for study in Europe. In October the class opened to

considerable national attention. Attracted by the emphasis on painting from both male and female models, either nude or partially draped, students filled the class rapidly. The majority of students were women, as was true of Art Academy classes as well, but Lutz, Meakin, and Nowottny of the faculty all availed themselves of the opportunity to learn from the much-heralded master.[21]

Maria Storer not only participated in the class but monitored closely its operation. When Learner Harrison proved slow in sending his one hundred dollars for a class scholarship, she sent a sharp note to Gest requesting that he promptly notify the tardy Harrison. The following spring, when Music Hall directors balked at providing free space for a week-long exhibition, she again informed Gest that she was "not *inclined* to go to any further expense about the class." "I supposed there would be no doubt getting the room in a building which was put up for the advancement of art and to which my father so largely contributed." And when the class reached the end of its first year, she joined other students in submitting testimonials to the importance of retaining it. Duveneck did teach the class for another year, but his decision to go to Europe late in 1892 led to its termination, and except for periodic guest appearances at the Art Academy, he did not return to regular teaching until 1900.[22]

Having helped install Duveneck in the city, Maria Storer next turned her attention to the Art Academy's leadership. In a lengthy letter to board president Melville E. Ingalls, the only man on the board in her opinion who "is keeping up and even leading the advance . . . when there is any," she outlined a reorganization of the school. First reminding Ingalls that her late father's generosity had provided the $16,000 which subsidized tuition, she went on to complain that "the outgo in teaching does not begin to be sixteen thousand dollars worth!" The New York Art League struggles for money, she argued, has inferior facilities, but provides superior training. "Where is the difference in the schools? It is solely on the method and the teaching," she answered. Her proposal called for the hiring of one "great man" at a salary of $10,000 per year. Under this master there would be four teachers at $1,000 each—"young men fresh from Paris & who would be only too glad to come for that." This "upper school" would admit one hundred and sixty students (forty per instructor), allowing for one strong criticism per week for each student. The remaining $2,000 (of the annual $16,000) would go towards two permanent Chamber scholarships which guaranteed five years of European study. The scholarship money would come back to the academy "as each recipient would have to give to the school two years teaching free of charge." Just how these artists would support themselves during the two years was not explained by Mrs. Storer. To cover the operating costs of the program, a twenty-dollar tuition fee would be charged. She also called for a

self-supporting primary department which would serve as a "feeder for the upper school." The result, she was confident, would be "the greatest Art School in the world," with the industrial design courses left "to the Technical School where they belong."[23]

The present academy has "too many idle and inefficient pupils, too many *tolerably* good teachers," she maintained. "Art is like eggs—it can't be 'pretty good'—and all the work done by our school is like that." Then she cheerfully offered "a large contribution to pension Mr. Noble." What Ingalls made of this proposal is not known, but the plan was apparently never discussed seriously and Noble remained for another decade. Yet, it may have struck home, for changes began to appear about the same time as the letter. These included the shifting of all industrial design classes to the afternoon, "making the Academy primarily an *Art* Academy"; the strengthening of classes in painting and life drawing by stressing the use of models; and the enlargement of the scholarship program. In the middle of the decade, greater emphasis was placed on individual development and self-reliance. The principal teachers organized themselves as The Faculty, placing themselves individually in control of class admissions and the matriculation of students. Students could now select their own instructors, with that person's permission, and the general morale of the school improved markedly. Control gradually slipped away from Noble. As it had in so many other areas of Cincinnati's cultural life, Maria Storer's directness brought results.[24]

The changes, however, did not satisfy Mrs. Storer entirely. As long as Noble remained, she kept up her attack. In a later letter to Ingalls, she returned to the subject of the principal's retirement. Dispensing with any pleasantries, she bluntly opened, "I am sure that you must be aware of the utter inefficiency of Mr. Noble as director of our art school." Having refrained in the past from saying anything "which might injure his welfare," she now felt called upon to speak out. "Not one man or woman of talent that has ever left our school does not deplore his fitness artistically. It would be worth a large sum of money to the school to pension him." And, of course, Maria had a replacement in mind, a German painter named Fedor Encke. Undismayed by the lack of results, two years later she pushed to have a young Italian artist, "with a firm mastery of color," hired for the academy. Not as a replacement for Noble, she made clear this time, but merely to improve the faculty. As she had argued on previous occasions, a variety of instructors provides "a liberal education and prevents mannerisms and imitation." Whatever her faults, Maria Storer certainly had the best interests of the school at heart.[25]

Of all the developments at the Art Academy during the decade, the most exciting involved support for both students and faculty to study in Europe. The foreign scholarship program, first proposed in 1887, was estab-

lished in 1891 following the success of the Duveneck class scholarship. In its first year six prominent citizens each contributed one hundred dollars to send a student abroad. The following year museum trustees established the program on a regular basis. The selection process included a competition based on a drawing from a nude model and a painting of a head. After narrowing the field to ten applicants, the finalists submitted another nude figure, a half-length figure in oils, and an original sketch executed in one day—all three to have been completed without the aid of any professional criticism. The winner then spent three years in Europe, each year sending back samples of his or her progress, including in the last year an oil copy of a museum painting which became the property of the Cincinnati Art Museum. Total cost of the scholarship program, which included several "home" scholarships for study at the academy, ranged from $1,000 to $1,800 per year, depending on the cycle of students in Europe. The board estimated that $600 would be sufficient for the first year in Europe.[26]

With unfortunate timing the program was implemented in 1893, the first year of a major economic crisis in the country. To reduce the expense for the student, Thomas Noble arranged for a two-year tuition-free scholarship to the Academie Julian, the cost to be born by Rodolphe Julian. The award was called "le prix Julian" and it automatically went to the individual who won the foreign scholarship, although he was not required to use it. It was the only scholarship of that type offered through an American art school. Despite this award, which saved about $150 in tuition, the program struggled through the depression years. In 1897 the Art Academy awarded the scholarships according to financial need rather than on a competitive basis, and no longer made public the names of recipients. Due to diminishing revenues, the academy apparently ended the program shortly after the turn of the century, although Ingalls personally established a separate fund in memory of his daughter, which generated about $600 a year for home scholarships.[27]

While the foreign scholarships lasted, and they were not offered every year, they drew considerable praise from within and outside the city, and at least four academy students received them: Clement Barnhorn in 1891, Charles Winter in 1894, Mrs. W. B. Newman in 1896, and Solon Borglum in 1898. Mrs. Newman was the only female student (or instructor, for that matter) to be sent to Europe. One of the reasons was that the École des Beaux-Arts in Paris and the Royal Academy of Art in Munich did not admit women, and the Academie Julian charged women more than twice as much as men, for which they received half as many criticisms. This raised the question as to whether a woman could benefit as much as a man from the scholarship. Furthermore, Victorian attitudes required that a woman be chaperoned. Thus, a year or two in Europe became a far more complicated

procedure for women. It is significant that the only woman sent by the academy was married.[28]

The Cincinnati Museum Association board also subsidized a year of foreign study for faculty. With this encouragement, quite innovative at the time, the Art Academy's most gifted students and several of its senior faculty managed at least one major trip to Europe during the decade. Paris became their center of study. Twenty years earlier Duveneck had led the way to Munich, but by 1890 the French capital had replaced the German city as the great art attraction of Europe, and a surprising number of Cincinnati artists travelled there. As one local artist commented proudly upon his arrival in Paris, there were enough fellow townsmen there to form a club. John Twachtman had signalled the switch to Paris in 1883 when he enrolled at the Academie Julian. Elizabeth Nourse made Paris her home in 1887, never having considered any other place, and in the same year even Duveneck was dividing his time between the French city and Florence.

Paris in the nineties—the phrase almost a cliché—set the cultural and intellectual tone for much of Europe and America. France's bitter defeat at the hands of Prussia in 1871 and the wounds of the Commune had been followed by a cultural ferment rarely exceeded in the history of Europe. Art Nouveau, Symbolism, the completion of Napoleon III's grand architectural vision, the construction of the Metro and the Eiffel Tower, new fashions in clothing, and the explosion of post-Impressionism gave to the decade its label of "La Belle Epoque." Paris offered something for every type of artist. For the avant-garde there remained the excitement of Impressionism, then at its height, and the hint of major new directions in art; for the traditional there was the lure of the many fine academies where one could study with such distinguished painters as William Bouguereau and Jean-Leon Gérôme; and for the summer visitor the city provided broad boulevards, graceful parks, glorious architecture and, of course, the Louvre. For American artists lured by this excitement, Paris also meant the Academie Julian. Founded in 1868 by Rodolphe Julian, the Academie catered to foreign students. By not requiring competency in French or requiring first-year students to draw from nude models, it found a special attraction among Americans. Indeed, by the 1890s Americans outnumbered even the French at the school, and classes reflected considerable linguistic confusion.

The international array of hopeful artists entered the Academie through a large archway that opened into a courtyard—"the home of cats of low social standing, and of a dozen or so chickens hobnobbing with a pair of rabbits," so one artist described it. In the far corner a well-worn stairway led to several large studios in which over two hundred students, oblivious to the street noises below, labored at their easels. New students met with a barrage of "paint tubes, stools, cigar butts, oaths (in several languages), and rude

comments on their appearance." George Biddle colorfully recalled his first introduction to the Academie: "Three nude girls were posing downstairs. The acrid smell of their bodies and the smell of the students mingled with that of the turpentine and oil paint in the over-heated, tobacco-laden air. The students grouped their stools and low easels about the model's feet. While they worked there was a pandemonium of songs, catcalls, whistling and recitations of a highly salacious and bawdy nature." Such was life as an art student in Paris! Despite the tumultuous atmosphere, the Academie's conservative instruction and high standards appealed to those artists pursuing the detailed realism still fashionable at the time. Under the weekly criticisms of Gustave Boulanger and Jules Lefebvre, the principal instructors, Cincinnati artists labored diligently to improve their techniques and refine their styles.[29]

The Cincinnati artists who travelled to Europe provided a unique view of the French art world through their descriptive correspondence with Joseph H. Gest. Lewis Meakin was the first to go. In 1890 his several months of study in Munich did not prevent him from spending part of his time in Antibes and Paris. He found Antibes "very picturesque" but "all shut inside the walls with very narrow dirty streets and an assortment of smells more varied and emphatic than I ever experienced before." He found Paris more to his taste. Drawn to the major salon exhibitions, he lavishly praised works by Meissonier and Munckasy, as well as many traditional landscapes, already Meakin's particular interest. His conservative bent was further revealed by his admiration for "the great Dagnan, now the most talked of man in Paris." Although Meakin was most comfortable with traditional art, he did find in the "new Salon" some works that "were daring to the point of being startling & some of the most eccentric things were marvelously clever."[30]

Three years later, a more sophisticated Meakin returned to France. "Have an excellent room and the eating only too good," he wrote from Calvados. "Five and six courses for lunch and seven to nine for dinner. The cooking pretty near perfection. The host, who sits with us and treats us more [like] guests than mere boarders, seems more particular about having everything of the best than he is about the profit he may make of it." Along with food he sampled the Paris salons again. Impressionism, he noted, had had a great influence, but fortunately "the spirit of violent Impressionism" was in decline. America, in his opinion, had the Impressionist fever "very much worse" than France, and he only hoped that a reaction against the excesses would not damage the good in the movement.[31]

Lewis Lutz had preceded Meakin's trip by two years. Before enrolling in the Academie Julian in September 1891, he spent the summer painting in the south of France where he visited Boran, Etaples, and Montreuil, "a de-

251

lightful old town." At Amiens he found the cathedral "magnificent on the inside" but decidedly out of proportion on the outside. The local museum collection received a similar mixed review. The sculpture and woodcarving he found inferior to what was in the Cincinnati museum's collection, but the paintings surprised him, especially a fine canvas by Gérôme. Several "wall decorations" by Puvis de Chavannes exhibited marvelous color effects but the drawing struck him as only "passably good." Several months of living and studying in France did not noticeably improve Lutz's opinion of French art. He expressed surprise that "in *the* great art centre one sees so many really bad pictures displayed in shop windows" On the other hand, exhibitions were often well worth attending, although "the ordinary, every-day window shows are . . . not equal to what we see at home."[32]

The first Cincinnati student to earn the coveted academy foreign scholarship was the sculptor, Clement J. Barnhorn. Already nearing thirty-five years of age, Barnhorn had acquired considerable training and experience. At the McMicken School he had studied under Louis T. Rebisso, assisting him in sculpting the William Henry Harrison equestrian statue in Cincinnati's Piatt Park and the Ulysses Grant monument in Chicago. A skilled woodcarver and potter as well, Barnhorn represented the best in the city's art tradition, and for him the opportunity to study in France repre-sented a dream of a lifetime. Arriving in Paris in September 1891 he mar-velled at the loveliness of the city with "works of art to be seen everywhere." The Louvre simple stunned him. While in New York he had found the Metropolitan Museum wonderful, and he thought the museums of Amster-dam beyond comparison, but after visiting the Louvre, he "made up his mind never to praise anything again as though its equal could not be found. The collection is simply marvelous," he wrote Gest. Fellow Cincinnatian Vincent Nowottny shared Barnhorn's reaction. "Simply overwhelmed," he ex-claimed when he arrived in Paris the following year. "Stood today in front of the Grand Old Titian portraits. How I wish we could always see such gems. . . . Such a world of art is there."[33]

While Barnhorn and Nowottny agreed on the charms of Paris, they disagreed on the value of studying at the Academie Julian. Disappointed with the general instruction, Nowottny referred to a criticism by Bougu-ereau as sounding "like a fortune cookie." Meakin echoed Nowottny's disen-chantment, complaining about the brevity of the criticisms—"less than twenty minutes to sixteen students yesterday." Barnhorn, on the other hand, praised the instruction he received from Professors Mercie and Donat. Another foreign scholarship recipient, Charles Winter, agreed with the sculptor. There could be "no better place for study" than Paris, and he de-scribed Bouguereau's comments as "direct to the point."[34]

The year 1894 saw the high water mark of the Cincinnati inundation. In June of that year, Melville Ingalls took time from a European tour to look in on the Art Academy's representatives. He found Thomas Noble, on the continent for the summer, "brushing up wonderfully," and Clara Newton "as happy a little body as you ever saw." Meakin looked well, while Barnhorn wanted desperately "to stay another year." Artus Van Briggle, one of Rookwood Pottery's leading designers, studied in Italy that year, and Frank Duveneck, as was his custom, spent that summer in France. Both Charles Winter and Joseph Sharp arrived in France toward the end of the summer, while Ernest Blumenschein had just finished a year at the Academie Julian. The Cincinnati connection supplied an apparently inexhaustible supply of artists anxious to develop their talents.[35]

But the end was near. The second half of the decade saw only a few scholarships awarded, and the opportunity for faculty study ended with Sharp's leave in 1894. Everyone agreed on the value of both programs, however. Faculty members returned refreshed and stimulated; students experienced an enormous encouragement to their education; while the Art Academy's reputation grew. Yet, as long as the expenses came out of general operating funds for the museum, the programs operated under tight financial restraints, and the economic troubles that settled over the nation in 1894 doomed the two programs. Of course, Cincinnati artists continued to visit Paris, but they never gathered there in such numbers, nor with the chumminess that permeated the nineties. No longer could they form a club.

In many ways the 1890s proved deceptive to the Queen City. Hungry for a cultural reputation, Cincinnatians read more into the decade than it merited. Although few engaged any longer in the pretentiousness of such labels as "Paris of America," the emergence of solid art institutions, the establishment of a symphony orchestra, the reputation of local artists, and especially the return of Frank Duveneck created a local enthusiasm that exceeded reality. In truth Cincinnati was already settling into a comfortable, less ambitious middle-age. If the museum collected contemporary American art, it ignored, and would continue to ignore for many years, the more radical movements that stirred the European art world. If academy teachers profited greatly from their European experiences, they remained tied to mid-century traditions in their own work. If local artists enlivened the life of the community, few were willing to go artistically beyond a tepid Impressionism. Part of this conservatism, a conservatism that could be found to some extent in all American cities, may be attributed in no small part to Thomas Noble's influence on the Art Academy.

Both as an artist and as an administrator he willingly shied away from change. A product of that era which saw art as timeless and unchanging, he

viewed the school's role as maintaining that standard. He clearly detailed his teaching philosophy in 1895 for the *Cincinnati Tribune*:

> We must let talent follow its own inclination but not to allow it to proceed faster than is consistent with thoroughness. . . . Occasionally I have a pupil who wants to soar, but after I have held him back for a while he will thank me for teaching him thoroughness. That is what gives strength. Insufficient rudimentary training leaves the artist weak, when he begins to compose and sketch, his compositions and sketches are weak. Hence we do not let our pupils go faster than they are prepared to go.

Up to this point Noble had voiced a conservative but not necessarily harmful point of view. But then he went on to outline a curriculum that frustrated those students in search of freer expression:

> We keep the pupils upon the simplist [*sic*] forms, drawing in outline until the greatest possible accuracy is secured before we begin to teach the effects of light and shade. The next step is still life, involving the heads, and then the antique and so upward. The last stage before the academic course is portraiture. Then comes the study of the human form.[36]

Unfortunately, Noble was also something of an autocrat, a characteristic reinforced by his long tenure as head of the academy. He revealed this inflexibility in making recommendations for Lewis Meakin's first trip to Europe as a faculty member. On the artist's arrival in Paris, Noble instructed him to visit the Salons, the Louvre, and Luxembourg museums; then, "without greater delay than is necessary for this, proceed directly to Munich." At the Royal Academy he should study drawing, and when not at the academy, study etching with Professor Unger. After mid-July, and before sailing for home on September 1, he was to visit Nurenburg, Dresden (for old masters), Berlin (for "modern German work"), then on to Ghent, The Hague, and Amsterdam, where he should get instruction "from some of the very able landscapists of that country." For an established forty-year-old landscape painter, who had already studied four years in Munich, this must have been a trying nine months indeed. But this was not all. Three years later, when Meakin returned to Europe for a year of study in Paris, Noble's instructions were just as rigid. In a letter to Gest, he advised the assistant director to instruct Meakin "to enter the Academy in Paris, & work steadily from the figure from Jan. 1st to June 1st, a period of five months—He will have time enough after that for his landscape studies." Is it any wonder Mrs. Storer wished to pension off Noble![37]

Thomas Noble's approach to the operation of the Art Academy reflected this same authoritarianism. Threatened by the growing criticism of

him within the school, in 1890 he outlined a reorganization plan to Goshorn. Citing the need for greater discipline as used in such "time honored institutions as the Ecole des Beaux Arts [*sic*] and the Royal Academy at Munich," he asked the trustees to confer upon him "enlarged powers." The principal should be allowed to "de-grade" students, he argued. "A feeling of insecurity would do more to stimulate execution than any other incentive." The use of life models should be regulated "by a system of competitive exercises and a graduated system of ranking" Furthermore, "the *winning* of privileges . . . would institute a rivalry for precedence" If his emphasis on competition may have had some merit, certainly the stress on "exercises" (copy work) and the reference to enforced insecurity sound almost Draconian today. As we have already seen, the academy was slowly moving towards a more liberal curriculum, and while Goshorn and other trustees never considered dismissing the faithful Noble, they steadily removed much of the control from his hands. Noble's last fifteen years at the school could not have been pleasant for him. When he finally stepped down in 1904, after thirty-five years of service, the kindly Meakin noted that much of Noble's difficulty stemmed from his refusal "to recognize the fact that the world was moving along in art matters as in other directions."[38]

Ironically, Meakin's observation might serve as an epitaph for much of the city's cultural development after the turn of the century, for Noble was certainly not the only factor in Cincinnati's generally declining art reputation after 1900. In part, the city's shrinking economic base continued to favor Chicago and other western rivals, and the role of local artists in the Society of Western Artists mirrored this decline. Chicago artists rapidly eclipsed the Cincinnati influence after the early years of the society. As Ferdinand Lungren pointed out, "art in Cincinnati needs a revival . . . which will bring new converts to its shrine and reawaken public interest in its devotees."[39]

No revival occurred. Cincinnati continued to cling steadfastly to the old century. Nothing revealed this conservative tone more than a heated debate in 1895 over the merits of Impressionism—a rather imprecise word as used by the newspapers, which included everything from Manet to Cezanne. Disturbed by the museum's exhibit of contemporary Swedish art, the *Cincinnati Commercial-Gazette* called these "ultra impressionists" a "menace to true art." The majority of local artists agreed. Although Duveneck, Meakin, and Farny lent reserved support to the broad theories of Impressionism, more traditional views prevailed in the studios. Noble believed the modern movement had a deleterious effect on art because it was not true to nature. William McCord, Thomas C. Lindsay, John Dunsmore, and Charles T. Webber shared this view. Dunsmore went so far as to argue that the new concepts would no more change art than the "so-called new woman will

change the beauty and purity of true womanhood." When in Paris, Clement Barnhorn had described pictures displayed at one exhibition as "perfect howlers," while Leon Van Loo referred to Impressionist paintings as "erratic symphonies of vapory mists." Not content with that, he divided modern artists into "the weak, effeminate, namby-pamby dreamers" and "the crude, raw, commonplace followers of Renoir, Sisley and Pisarro." To these staunch defenders of tradition, the Impressionists and those who followed had moved into a dangerous area, that of the artificial rather than the natural, where they hid their deficiencies in drawing behind blobs of bright color. For most Cincinnati artists, good art began and ended with solid draftsmanship.[40]

Still, the 1890s proved to be the richest decade for the city's art life, due to the increasing appreciation shown to those who stayed. This heightened recognition grew from the generally conservative tone of Cincinnati's cultural elite. Artists and art supporters shared similar views on what was good art. The community's art life, while extensive, reflected a "clubby" atmosphere—warm, congenial, quaintly Bohemian, but aesthetically dull. Even the broad-minded Joseph Gest did not stray far from the traditional. In other words, the city got what it wanted, painting in the by now comfortable tradition of Munich or a rather weak Impressionism. The works of Farny, Meakin, Barnhorn, and Duveneck were good, but not demanding.

Frank Duveneck's return in 1890 had established him as the resident "master." His two year class at the art museum, his commanding presence in the Cincinnati Art Club, and his presidency of the Society of Western Artists expanded his influence. Young and established artists alike turned eagerly to this generous and sympathetic man, who in 1904 succeeded Noble as chairman of the Art Academy faculty. One cannot question Duveneck's excellence as a teacher or his importance to the city's reputation. Yet, his lengthy tenure with Cincinnati was two-edged. As Meakin had observed about Noble, art matters were moving along. The Duveneck of 1900 was not the Duveneck of 1875. The world of art had already started along that explosive path into the twentieth century, a path that neither Duveneck nor his followers could take. If Duveneck seemed progressive and modern in the 1890s, it was because the city refused to recognize more recent currents in art. Indeed, the city scarcely knew they existed. Duveneck was a hometown boy, an accepted artist on both sides of the Atlantic, and most importantly his paintings were understandable, comfortable, and in the realist tradition. In paying homage to him, Cincinnati turned to its past, not to its future.

The End of One Era,
The Foundation of Another

The closing of one century and the opening of another invariably brings forth both an examination of the past and a look towards the future. Cincinnatians proved no exception, for the years surrounding the turn of the century saw a variety of publications proclaiming the city's advantages and prospects. The typical presentation gave a brief, rather glorious history of the city, and then launched into an argument on behalf of the future by listing all of the community's major business establishments. Abundant favorable statistics added to the promotional nature of these works, but beneath this facade of optimism, one cannot fail to note a sense of decline. *Cincinnati's Business Proclamation,* a pamphlet published in connection with the 1904 Louisiana Purchase Exposition in St. Louis, proved typical of these publications. With few exceptions, the major buildings and landmarks singled out for comment were the same as those highlighted in *Illustrated Cincinnati: The Queen City of the West: Its Past, Present, and Future,* published thirteen years earlier. The Cincinnati Art Museum, Music Hall, the Grand Hotel, a variety of parks, the Zoological Gardens, Spring Grove Cemetery, the public library, Fountain Square, and the Grand Opera House—these were the gems in the city's crown, and all had been completed by 1886.[1]

Cincinnati's physical sluggishness reflected the decline in its cultural position. The May Festival, so important a quarter century before, no longer captured national attention, while the founding of the Cincinnati Symphony Orchestra, however important to local musical development, was just another orchestra in a rapidly lengthening national list. In addition, not until 1920 would the city acquire another major music organization—the Summer Opera. The trend in theater towards syndicated companies, a pro-

cess which long before had undermined local drama activity, would itself soon succumb to the rise of movies, leaving New York with a virtual monopoly on theater life. Sustained intellectual activity had been moribund since the Civil War years, symbolized by the demise of Moncure Conway's *Dial.* As we have already seen, Cincinnati produced no important literary talent after mid-century, encouraged little intellectual stimulation to match its earlier years, and its once vaunted publishing reputation had been reduced to professional books, religious materials, and the lingering McGuffey Readers. Painting and sculpture, while supported, had narrowed to a comfortable cult of Duveneck.

As one leafs through the turn-of-the-century assessments of Cincinnati, the past is laid out as a series of breathtaking cultural achievements; in turn, the future beckons promisingly. What is missing is any sense of the present. George Mortimer Roe alluded to some future literary "Elizabethan Age," and Melville Ingalls claimed to see the city at last shaking off "the dust and cobwebs" of the recent past, but there is little to suggest that much was currently going on. The most common note sounded by these men was their praise of the city's slow, steady growth—what can now be seen as a euphemism for stagnation. In the face of burgeoning Chicago, to say nothing of Pittsburgh, Cleveland, St. Louis, and Detroit, this was faint praise of the most obvious kind.[2]

What happened to the "Paris of America?" How had Cincinnati's once promising future become so clouded? To understand the city's situation in 1900, we must first briefly reassess the past. The city's mid-century cultural position had resulted from an economic boom unprecedented at the time. As the major urban center of a rapidly developing region, Cincinnati could scarcely fail to achieve cultural distinction. The barriers of time and distance required that a young nation develop regional centers, and the Queen City had the good fortune to dominate the western country during the middle third of the century. No other western city could rival Cincinnati's wealth, central location, and civic leadership. To these early advantages two other developments joined to push the city beyond mere regional importance between 1870 and 1885. A heavy German immigration added a reservoir of talent which brought real artistic distinction to the city. At the same time, the personal fortunes accumulated before the Civil War helped secure the necessary institutions for supporting cultural and intellectual activities. Few cities of similar size could boast of a Springer, a West, a Sinton, or a Probasco. Even New Yorkers envied the Queen City's public-spirited gentlemen of property. Thus, Cincinnati achieved its reputation as a cultural center in part by chance, in part from the quality of its people—a fortuitous combination which encouraged the city to dream its dreams.

Between 1870 and 1885 Cincinnati harvested the fruits of its early la-

bors, and the city's Centennial Exposition in 1888 served as a capstone to its achievements. The birthday celebration, which proved to be the last of the city's industrial expositions, brought the usual inflated views of the future. However, a more accurate assessment could have been obtained from the financial losses suffered by the affair.[3] In many ways, the Centennial celebration signaled the end of Cincinnati's adolescence—a century of rapid growth, easy achievements, and little thought of the future. Of course, the cultural momentum had not yet spent itself. The symphony orchestra and the artistic activity of the 1890s were not only the direct outgrowth of the previous era, but they also served to obscure the city's sliding position. Unable, or unwilling, to compare themselves objectively with cultural activity in other cities, Cincinnatians in the 1890s viewed local art developments as signs of vigorous growth. It was a growth that proved chimerical.

The establishment of a symphony orchestra did not become the catalyst for sustained musical activity. Despite a succession of outstanding musical conductors, including Leopold Stokowski and Fritz Reiner, the orchestra represented the final stage of earlier developments rather than the springboard for the coming century. No one in 1895 predicted that Cincinnati would now become the focal point of American musical development, as many had suggested two decades before.

Frank Duveneck's contributions proved even more elusive. Henry James's assessment of John Sargent as "a talent which at the very threshold of its career has nothing more to learn" could easily apply to Duveneck. He loved painting and was an extraordinary teacher, but he was not an inquisitive artist who searched for new directions. He contributed a welcome broadening influence for those who studied with him, and he remained a "name" for another decade, but when he returned to Cincinnati American art had already passed him by. Impressionism, "Ash-can Realism," and finally the Armory Show of 1913 pushed the once radical Munich style into obscurity. When Duveneck was honored in 1915 at San Francisco's Pan-Pacific Exposition, his name came as an echo from the past. A generation of Cincinnatians studied under him. They learned their craft well, and some went on to important careers, but Duveneck did not lead them into the new century as he had once led "his boys" into the vanguard of American art.[4]

In 1889 the perceptive Charles Dudley Warner alluded to Cincinnati's cultural situation when he described the city as "a solid city, with remarkable development in the higher civilization," while ominously noting that the current growth reflected "a pause rather than excitement since 1878–79–80." In comparison, Warner observed, Chicago displayed a powerful atmosphere of growth and vitality—a factor which would not change for half a century.[5]

In retrospect, Cincinnati confronted a rapidly changing environment.

Her early growth and influence could not be sustained as river transportation receded in importance and the frontier edged westward. The Civil War brought short-term government contracts but damaged the community's long-standing prosperous southern trade. After the war the new national economic prosperity rested on the more muscular iron and steel industries, tied to a pool of unskilled labor arriving from Europe. In what some historians call an "Age of Energy," the energy proved more evident in Carnegie's Pittsburgh and Ryerson's Chicago. By 1900 a ring of fast growing cities had reduced the Queen City's importance in every direction, except to the South, and even there the emergence of Atlanta and other southern communities offered stiff competition. And Cincinnati's diversified manufacturing base, supposedly less vulnerable to economic swings, failed to keep the city competitive with its new urban rivals. Several of its principal industries verged on the edge of obsolescence. Carriage and wagon manufacturing, boiler and valve production, leather products, and the packing of meat were all on the downhill side of their importance. Add to this the effects of prohibition, enacted in 1918, and one recognizes a central reason for decline.[6]

Cincinnati's population growth also slowed. Projected in 1860 to become the nation's great inland metropolis, by 1890 the city's population of 296,000 placed it ninth in the nation; a decade later it had dropped another notch. City boosters attempted to mask these disturbing statistics by adding population from contiguous suburbs, thus enlarging the total figure to one-half million. Even more self-serving, the frequently presented manufacturing figures were often given without any comparative figures from other cities or other years, in order to impress the reader with an array of six- and seven-digit numbers. In 1914 the chamber of commerce issued a corrective set of statistical charts which clearly illustrated Cincinnati's economic slump, and most telling was the 13 percent drop between 1899 and 1904 in the total number of manufacturing establishments. During the same period Chicago's rose 27 percent. By the century's end Cincinnati was clearly suffering from a hardening of her economic arteries.[7]

Leading citizens did not remain unaware of the situation. Indeed, the promotional literature represented the first response to the city's troubles. Although a considerable part of the decline resulted from conditions outside the city's control, still Cincinnatians displayed an unusual torpor. As one local historian observed in 1912, "Take into consideration every conceivable disadvantage, many of which were very real, and it is yet impossible to understand how anything but a lack of comprehension and of determination in our people can explain our loss of supremacy."[8] As early as the 1850s, the city had failed to respond energetically to the emergence of western rivals. Early success and a misguided faith in geography had created a confidence, even an arrogance, that Cincinnati would forever remain Queen. In public

comments and newspaper editorials, a distinct snobbishness surfaced regarding both Chicago and St. Louis. Often disturbed by Boston's condescending attitude towards "Porkopolis," Cincinnatians, in turn, viewed other western cities as boorish and rustic. The remarkable cultural life that flowered after the Civil War helped convince Cincinnati that it would long remain superior, if not larger, to more crass rivals. In retrospect, one can only view the city's "Golden Age" as the bright flare of a spent candle.

By 1900 every major American city had virtually duplicated or surpassed Cincinnati's cultural accomplishments. Museums, orchestras, concert halls, and schools for the arts dotted the urban landscape, and as a national center of the arts, New York reigned supreme. With its greater wealth, its more solid cultural base, its immense population, and its proximity to Europe, New York was beyond compare with any other American city. Artists, actors, writers, and musicians all saw their opportunity for recognition and expression in the eastern metropolis, and the country's completed network of railroads and communication lines eliminated the need for regional centers such as Cincinnati. An aspiring artist from central Ohio could travel to New York almost as easily as he could go to Cincinnati, and if he dreamed of greatness, then New York was the only place to go.

Western rivals, the dominance of New York, the loss of a favorable geographic location—these were the external changes that affected Cincinnati. A subtle internal change took place as well, a change that may best be described as a crisis of confidence. Cincinnatians observed disturbing cracks in their community's image. Proud of their parks, their cultural institutions, the industriousness of their fellow citizens, and the harmony of the city's diverse peoples, the city's upper classes had long accepted the widely shared opinion that the arts elevated and refined the public. Strengthen the arts and virtue would supplant vice; the nobility of man would triumph over "the savage brute in human shape. . . ."9 The theory proved hollow. During the last quarter of the century, Cincinnati was beset with complicated internal divisions. A series of particularly brutal murders triggered the Court House riot of 1884, and hard on the heels of this traumatic event came the labor disturbances of 1886, disturbances that troubled the city for years to come. The collapse of local government into the sordidness of Boss Cox, and the myriad number of social problems which plagued all American cities of that era, seriously weakened the belief that art could ameliorate modern life. Alarmed by their city's loss of status and questioning art's curative powers, Cincinnatians appeared confused at the end of the century.

The city struggled with the stresses brought about by physical expansion and industrialization. To be sure, other American cities faced the same changing world, but their expanding economies helped offset internal strains. Troubled by slums, inadequate streets and transportation, deterio-

rating schools, and corrupt government, Cincinnati failed to develop any coherent strategy to combat her problems. Amidst these rapidly changing circumstances, the city sought to hold what it had rather than to risk new ventures.

Although the skyline inched upward, Cincinnati's overall appearance at the end of the century was one of retreat, a situation recognized by at least one of the city's outspoken supporters. "In the early nineties," wrote George Englehardt, "strangers entering Cincinnati after living in such towns as Boston, Chicago, New York and Philadelphia, could not comprehend the mental attitude of its citizens. They never heard a boast about the beauties or possibilities of the metropolis of the Ohio Valley. Nobody *apologized;* but nobody *bragged!* It seemed to be taken for granted that Cincinnati had dropped behind in the race for pre-eminence . . . and that its inferiority was predestined. . . . Nobody seemed to care that the city was enveloped in a pall of smoke; or that the drinking water was muddy; or that the parks were not adequate, or that the streets were poor, or that business was being stolen away."[10] This apathy carried over to the arts. Content with existing cultural institutions, the community's artistic growth leveled off. Second generation wealth proved less adventurous—and less public-spirited—than the first. While other cities reaped the benefits of a new and much greater philanthropy, Cincinnati struggled to maintain the cultural organizations established twenty years earlier.

Yet, it would be wrong to conclude that the city's leveling off meant cultural extinction. New growth and vigor emerged in the 1920s with the return of seasonal opera and the establishment of the exquisite Taft Museum. An even greater spurt of energy has surfaced in more recent years. As Englehardt had envisioned, the "fertile seeds" of the 1870s did germinate in another "renaissance," if somewhat later than he had anticipated. The current cultural revitalization has resulted in large part from a new civic awareness which has channeled interest and money into Cincinnati's image as a livable city. A rash of new art galleries, the founding of the Contemporary Arts Center, summer concerts at the new Riverbend facility, the move of the summer opera to Music Hall, and the founding of the Cincinnati Ballet Company and the Playhouse in the Park have added immeasurably to the city's cultural life. Financial support has come as well, principally from the generosity of Mr. and Mrs. J. Ralph Corbett.

Still, the heart of this artistic rejuvenation remains those institutions that were founded in the last century. Clara Baur's conservatory and the College of Music continue as the College-Conservatory of Music of the University of Cincinnati. Music Hall, recently refurbished by the Corbetts, still houses the Cincinnati Symphony Orchestra, the annual May Festivals, the opera, and the ballet. The art museum, the original building almost ob-

scured by numerous additions, and the Art Academy still carry on their work in Eden Park. The public library maintains its national reputation; the Historical Society and the Museum of Natural History anticipate moving into a new Heritage Center; even the Rookwood Pottery building survives as a home for art studios, offices, and a restaurant.

No longer concerned with a place in the national firmament, Cincinnati has learned to live within its abilities, and the result is a thriving city of solid cultural achievements. If fatuous labels such as "Paris of America" have long since fallen into deserved obscurity, Cincinnatians still fondly embrace their city's most enduring symbol, Fountain Square, and its most enduring nickname, the Queen City, and together they link past achievements to present pride.

Notes

Prologue

1. The best descriptions of the city, the opening night crowd, and the inaugural performance are found in the three principal morning newspapers of the city: the *Cincinnati Commercial,* the *Cincinnati Daily Gazette,* and the *Cincinnati Enquirer.* See issues for May 13, 14, and 15, 1878.

2. *Cincinnati Enquirer,* May 15, 1878, 1.

3. Ibid.

4. *New York Tribune,* May 18, 1878, 5. A more extensive treatment of the importance of the third May Festival to the nation's musical development may be found in Robert C. Vitz, " 'Im wunderschoenen Monat Mai': Organizing the Great Cincinnati May Festival of 1878," *American Music* 4 (Fall 1986):309–27.

5. *Cincinnati Commercial,* May 14, 1878, 8.

Chapter 1

1. Rhea M. Knittle, *Early Ohio Taverns: Tavern Signs, Stage Coach, Barge, Banner, Chair and Settee Painters* (Portland, Maine: The Southwest-Anthoensen Press, 1937), 38; Ophia D. Smith, " A Survey of Artists in Cincinnati, 1789–1830," *Bulletin* of the Cincinnati Historical Society, 25(January 1967):4.

2. *Cincinnati Liberty Hall,* April 8, 1812, 1; *Cincinnati Western Spy,* August 12, 1812; Smith, "Survey of Artists," 7; *Cincinnati Inquisitor-Advertiser,* February 29, 1820, 2; *Liberty Hall and Cincinnati Gazette,* February 4, 1820, 2; see also Edna Mae Clark, *Ohio Art and Artists* (Richmond: Garrett and Massie, 1932) for a still valuable account of the early art life in Cincinnati. John Audubon's career with the Western Museum was affected by the bank panic of 1819, or, as he phrased it, the museum directors were "splendid promisers but very bad pay masters." While in the city, however, he drew five sketches which later appeared in his monumental *Birds of America,* a copy of which was purchased by Nicholas Longworth

and later given to the Cincinnati Public Library; see Owen Findsen, "Cincinnati's Famous Bird-Watcher," *Cincinnati Enquirer,* April 7, 1985, section E, pp. 1, 11.

3. Richard C. Wade, *The Urban Frontier: Pioneer Life in Early Pittsburgh, Cincinnati, Lexington, Louisville, and St. Louis* (Chicago: Phoenix Books, 1964), 105.

4. *Cincinnati Inquisitor-Advertiser,* August 11, 1818, 2; September 2, 1818, 2; September 29, 1818, 2; Edward Dwight, "Cincinnati Artist, Aaron Corwine," *Bulletin* of the Historical and Philosophical Society of Ohio, 17(April 1959):103–8.

5. Elizabeth Baer, "Music: An Integral Part of Life in Ohio, 1800–1860," *Bulletin* of the Historical and Philosophical Society of Ohio, 14(July 1956):197–210; F. E. Tunison, *Presto! From the Singing School to the May Festival* (Cincinnati: E. H. Beasley Co., 1888) 4–6.

6. Harry R. Stevens, "Adventure in Refinement: Early Concert Life in Cincinnati, 1810–1826," *Bulletin* of the Historical and Philosophical Society of Ohio, 5(September 1947):8–12; Charles T. Greve, *Centennial History of Cincinnati and Representative Citizens* (Chicago: Biographical Publishing Co., 1904), 1:916; Baer, "Music," 199.

7. Ophia D. Smith, "The Early Theatre of Cincinnati," *Bulletin* of the Historical and Philosophical Society of Ohio, 13 (October 1955):234–42, 247.

8. Charles Frederic Goss, *Cincinnati, The Queen City, 1788-1912* (Cincinnati: S. J. Clarke & Co., 1912), 1:107; Wade, *Urban Frontier,* 145; Clara Longworth de Chambrun, *Cincinnati, The Story of the Queen City* (New York: Charles Scribner's Sons, 1939), 238; Henry A. and Kate B. Ford, *History of Cincinnati, Ohio* (Cleveland: L. A. Williams & Co., 1881), 369. The famous Shellbark Theatre earned its name from the rough bark left on its exterior walls.

9. Smith, "Early Theatre," 253–56.

10. Ibid., 270–82; Joe Cowell, *Thirty Years Passed Among the Players in England and America* (New York: Harper & Brothers, 1844), 90; Frances Trollope, *Domestic Manners of the Americans,* ed. Donald Smalley (1832; reprint, New York: Vintage Books, 1960), 129–35.

11. Smith, "Early Theatre," 270–82; Cowell, *Thirty Years,* 90; Trollope, *Domestic Manners,* 129–35.

12. Stevens, "Adventure in Refinement," 8–22; Harry R. Stevens, "The Haydn Society of Cincinnati, 1819–1824," *Ohio State Archaeological and Historical Society Quarterly* 52(April 1943):95–119.

13. Tunison, *Presto!,* 19–20; Harry R. Stevens, "New Foundations: Cincinnati Concert Life, 1826–1830," *Bulletin* of the Historical and Philosophical Society of Ohio, 10(January 1952):28–9; Ophia D. Smith, "Joseph Tosso, the Arkansas Traveller," *The Ohio State Archaeological and Historical Society Quarterly* 56(January 1947):16–35.

14. Stevens, "New Foundations," 32–35. The chiroplast was invented by J. B. Logier, a French pianist and teacher who influenced Robert Schumann. The chiroplast achieved considerable popularity in Europe at this time, and the Nixons had apparently been introduced to it there.

15. Harry R. Stevens, "The First Cincinnati Music Festival," *Bulletin* of the Historical and Philosophical Society of Ohio, 20(July 1962):186–96.

16. Ford and Ford, *History of Cincinnati,* 249–50. The Musical Fund Society attracted an interesting cross section of the city's cultural and business elite. Morgan Neville, Peyton Short Symmes, and John P. Foote provided the leadership, while the "managers" included such wealthy notables as Robert Lytle, Nicholas Longworth, William Greene, and Robert Buchanan.

17. Tunison, *Presto!,* 38–42; Greve, *Centennial History,* 1:921.

18. For one person's view of the city's musical life, see Frederic Louis Ritter, *Music in England and Music in America* (London: William Reeves, 1884), 2:375–76.

19. Ford and Ford, *History of Cincinnati,* 273; James F. Dunlap, "Queen City Stages: Highlights of the Theatrical Season of 1843," *Bulletin* of the Historical and Philosophical Society of Ohio, 19(April 1961):128–30.

20. Dunlap, "Queen City Stages," 128–42; William Charles Macready, *The Diaries of WIlliam Charles Macready, 1833–1851,* ed. William Toynbee (New York: G. P. Putnam's Sons, 1912), 1:270.

21. R. Carlyle Buley, *The Old Northwest: Pioneer Period, 1815–1840* (Bloomington: Indiana University Press, 1951), 2:559–64; Drake is quoted in "Remarks on the Importance of Providing Literary and Social Concert in the Valley of the Mississippi," *Cincinnati Mirror* 3(February 15, 1834):143.

22. Emmet Field Horine, *Daniel Drake (1785–1852), Pioneer Physician of the Midwest* (Philadelphia: University of Pennsylvania Press, 1961), 138–39; Edward D. Mansfield, *Memoirs of the Life and Services of Daniel Drake* (Cincinnati: Applegate and Co., 1855); Henry D. Shapiro, "Daniel Drake's *Sensorium Commune* and the Organization of the Second American Enlightenment," *Bulletin* of the Cincinnati Historical Society 27(Spring 1969): 43–45; Zane L. Miller, "Daniel Drake, the City, and the American System," in Henry D. Shapiro and Zane L. Miller, eds., *Physician to the West: Selected Writings of Daniel Drake on Science and Society* (Lexington: University Press of Kentucky, 1970), xxiii–xxxiv. The best study on the significance of the Western Museum is M. H. Dunlop, "Curiosities Too Numerous to Mention: Early Regionalism and Cincinnati's Western Museum," *American Quarterly* 36(Fall 1984):524–48.

23. Bernard F. Engel, "Poetry of the Early Midwest," manuscript in Cincinnati Historical Society, 8–11; Anna Shannon McAllister, *In Winter We Flourish: Life and Letters of Sarah Worthington King Peter, 1800–1877* (New York: Longmans, Green and Co., 1939), 94–96; Louis L. Tucker, "The Semi-Colon Club of Cincinnati," *Ohio History* 73(Winter 1964):13; Greve, *Centennial History,* 1:798.

24. William H. Venable, *Beginnings of Literary Culture in the Ohio Valley* (1891; reprint, New York: Peter Smith, 1949), 417–18; McAllister, *In Winter We Flourish,* 94–6; E. D. Mansfield, *Personal Memories: Social, Political, and Literary, With Sketches of Many Notable People, 1803–1843* (Cincinnati: Robert Clarke & Co., 1879), 261–66; Tucker, "Semi-Colon Club," 13–20; Frank R. Shivers, "Robust Life and Freedom: A Western Chapter in the History of American Transcendentalism, 1830–1841," manuscript in the Cincinnati Historical Society, 35–37; John P. Foote, *Memoirs of the Life of Samuel E. Foote* (Cincinnati: Robert Clarke & Co., 1860), 179–80. A copy of the Semi-Colon Club's constitution is located in the William Greene Papers, box 5, item 734, Cincinnati Historical Society. Other members of the club included Reverend E. B. Hall and his wife, Judge Timothy Walker, Nathan Guilford, Charles W. Elliot, Benjamin Drake, Charles Stetson, Edward D. Mansfield, Thomas D. Lincoln, William P. Steele, George C. Davies, James W. Ward, Davis P. Lawler, James F. Meline, Charles P. James, Wolcott Richards, D. Thew Wright, J. Newton Perkins, and Charles D. Drake.

25. Ishbel Ross, *Child of Destiny: The Life Story of the First Woman Doctor* (New York: Harper and Brothers, 1949), 60; Venable, *Literary Culture,* 420; Judge Hall in quoted in Wade, *Urban Frontier,* 243.

26. *Western Monthly Review* 1(May 1827): 9; other contributors included E. D. Mansfield, James Hall, and Micah Flint, the editor's son. Trollope, *Domestic Manners,* 313.

27. Venable, *Literary Culture,* 357–59, 376–78; Kathryn Kish Sklar, *Catharine Beecher: A Study in Domestic Tranquility* (New York: W. W. Norton & Co., 1976), 110; Buley, *Old Northwest,* 2:528–30; see also John T. Flanagan, *James Hall, Literary Pioneer of the Ohio Valley* (Minneapolis: University of Minnesota Press, 1941), and Randolph C. Randall, *James Hall, Spokesman for a New West* (Columbus: Ohio State University Press, 1964).

28. Venable, *Literary Culture,* 71–79; Shivers, "Robust Life," 35–37; Buley, *Old Northwest,* 2:531.

29. Ophia D. Smith, "Frederick Eckstein, The Father of Cincinnati Art," *Bulletin* of the Historical and Philosophical Society of Ohio, 9(October 1951):266–82; John P. Foote, *The Schools of Cincinnati, and Its Vicinity* (Cincinnati: G. F. Bradley & Co., 1855), 207–9; *An Act of Incorporation of the Cincinnati Academy of Fine Arts, With an Address to the Members of the Institution by John P. Foote* (Cincinnati: G. T. Williamson, 1828).

30. Louis L. Tucker, "Hiram Powers and Cincinnati," *Bulletin* of the Cincinnati Historical Society, 25(January 1967):21–26; Smith, "Survey of Artists," 15–16.

31. Tucker, "Hiram Powers," 26–32; Buley, *Old Northwest,* 2:578; Trollope, *Domestic Manners,* 62–3. See also the extensive correspondence between Powers and Nicholas Longworth in Powers Papers, Cincinnati Historical Society (hereafter cited as CHS). Powers's gratitude and affection towards his wealthy patron is plainly revealed in these letters, and he honored Longworth by naming his first son Longworth Powers.

32. Longworth to Powers, August 31, 1836, Powers Papers.

33. Foote, *Schools of Cincinnati,* 204–6; Longworth to Powers, August 31, 1836, Powers Papers; Sylvia E. Crane, *White Silence: Greenough, Powers and Crawford, American Sculptors in Nineteenth Century Italy* (Coral Gables: University of Miami Press, 1972), 172–80. Thomas D. Jones, John King, Charles D. Brackett, John Whetstone, and John Frankenstein were other sculptors who established at least local reputations before the Civil War.

34. Longworth to Powers, June 26, 1838, April 23, 1837, Powers Papers; Harriet Martineau, *Retrospect of Western Travel* (London: Saunders and Otley, 1838), 256–57; "James Henry Beard," in *The Golden Age: Cincinnati Painters of the Nineteenth Century Represented in the Cincinnati Art Museum* (Cincinnati: Cincinnati Art Museum, 1979), 35.

35. Powers to Longworth, May 1, 1837, Powers Papers. James Beard's brother William also achieved considerable prominence as an artist, and James's son, Daniel Carter Beard, besides being something of an artist himself, founded the Boy Scouts of America.

36. Longworth to Powers, April 23, 1837, January 6, 1838, October 23 and November 20, 1841, Powers Papers.

37. Longworth to Powers, September 15 and October 23, 1841, Powers Papers; Edith R. Reiter, "Lily Martin Spencer," *Museum Echoes* 27(May 1954):37; Robin Bolton-Smith and William H. Truettner, "Lily Martin Spencer (1822–1902): The Joys of Sentiment," in *Lily Martin Spencer, 1822–1902: The Joys of Sentiment* (Washington, D.C.: Smithsonian Institution Press, 1973), 11–83.

38. Miner K. Kellogg, "Private Journal and Other Papers, 1835–1848," Indiana State Historical Society (microfilm, Cincinnati Historical Society); "Miner Kilbourne Kellogg," in Cincinnati Art Museum, *Golden Age,* 76–7; E. H. Kellogg to Cincinnati Art Museum, April 18, 1895, Kellogg file, Cincinnati Art Museum (hereafter cited as CAM).

39. T. Worthington Whittredge, *The Autobiography of Worthington Whittredge,* ed. John I. H. Baur (New York: Arno Press, 1969), 7–41.

40. Hadley Baldwin, "Thomas Buchanan Read," *Literary Club Papers,* December 4, 1920, 43:152, The Literary Club, Cincinnati, Ohio; "Letters of Thomas Buchanan Read," *Ohio State Archaeological and Historical Society Quarterly* 46(January 1937):71.

41. Guy H. McElroy, "Robert S. Duncanson (1821–1872): A Study of the Artist's Life and Work," in Cincinnati Art Museum, *Robert S. Duncanson, A Centennial Exhibition* (Cincinnati: Cincinnati Art Museum, 1972), 5–15; Longworth to Powers, April 18, 1853, Powers Papers; Edward H. Dwight, "Robert S. Duncanson," *Bulletin* of the Historical and Philosophical Society of Ohio, 13(July 1955):203–11.

42. William Coyle, *The Frankenstein Family in Springfield* (Springfield, Ohio: Clark

County Historical Society, 1967), 3–12; John Frankenstein, *American Art: Its Awful Attitude* (Cincinnati, 1864; "Godfrey Nicholas Frankenstein" in Cincinnati Art Museum, *Golden Age,* 73.

43. Anthony F. Janson, "The Cincinnati Landscape Tradition" in Cincinnati Art Museum, *Celebrate Cincinnati Art,* ed. Kenneth R. Trapp (Cincinnati: Cincinnati Art Museum, 1982), 11–27. For additional information on Cincinnati's minor artists, see the Artists' Files in the Cincinnati Art Museum library.

44. Mansfield, *Personal Memories,* 146; Whittredge, *Autobiography,* 17; Denny Carter, "Cincinnati as an Art Center, 1830–1865," in Cincinnati Art Museum, *Golden Age,* 15.

45. See the numerous letters from Longworth to Powers in Powers Papers; Leonard Louis Tucker, " 'Old Nick' Longworth, the Paradoxical Maecenas of Cincinnati," *Bulletin* of the Cincinnati Historical Society, 25(October 1967):246–59.

46. Longworth to Powers, January 16, 1844, Powers Papers.

47. *Act of Incorporation,* 7–12. See also Lillian B. Miller, *Patrons and Patriotism: The Encouragement of the Fine Arts in the United States, 1790–1860* (Chicago: University of Chicago Press, 1966), 192–95.

48. Smith, "Survey of Artists," 9–20; Foote, *Schools of Cincinnati,* 207–9; Miller, *Patrons and Patriotism,* 192–95.

49. Anne B. Shepherd, "Peyton Short Symmes of Cincinnati's First Family," *Bulletin* of the Cincinnati Historical Society, 27(Spring 1969):223–37; Kellogg, "Private Journal"; Carter, "Cincinnati as an Art Center," 18.

50. Miller, *Patrons and Patriotism,* 195; Foote, *Schools of Cincinnati,* 207–9; Charles Cist, *Cincinnati in 1841: Its Early Annals and Future Prospects* (Cincinnati: E. Morgan & Co., 1841), 142; "Letters of Thomas Buchanan Read," 72. The movement to provide the city with a collection of casts took several interesting turns during this period. In 1836, on the eve of his departure for Europe, Hiram Powers planned to create "models and casts" while in Italy, which would form "the basis of an Academy of Fine Arts." This academy never materialized, for the next year Longworth considered purchasing the Western Museum as a repository for whatever statuary Powers could collect in Europe. In the mid-1850s the Ladies Academy of Fine Arts pursued a similar objective and acquired a collection of casts and copies, which eventually became the property of the McMicken School of Design, now the Cincinnati Art Academy.

51. Cist, *Cincinnati in 1841,* 133–36; Miller, *Patrons and Patriotism,* 195–96; Foote, *Schools of Cincinnati,* 192–94.

52. Carter, "Cincinnati as an Art Center," 13; Cist, *Cincinnati in 1841,* 132–36.

53. Miller, *Patrons and Patriotism,* 196; Foote, *Schools of Cincinnati,* 128.

54. *New York Star* quoted in Donald R. MacKenzie, "Collections and Exhibits: The Itinerant Artist in Early Ohio," *Ohio History* 73 (Winter 1964): 46; *New York Tribune* quoted in *Cincinnati Daily Gazette,* March 3, 1845; William Adams quoted in Miller, *Patrons and Patriotism,* 196.

Chapter 2

1. Charles Dickens, *American Notes and Pictures from Italy* (London: Macmillan & Co., 1893), 140; Charles Cist, *Sketches and Statistics of Cincinnati in 1851* (Cincinnati: William H. Moore & Co., 1851), 49–51. For other favorable accounts of the city made by visitors, see Greve, *Centennial History,* 1:674–76; Frank Blackwell Mayer, *With Pen and Pencil on the*

Frontier in 1851: The Diary and Sketches of Frank Blackwell Mayer, ed. Bertha L. Heilbron (St. Paul: Minnesota Historical Society, 1932), 46.

2. Cist, *Cincinnati in 1851,* 45–46, 285.

3. Rutherford B. Hayes. *Diary and Letters of Rutherford B. Hayes,* ed. Charles R. Williams (Columbus: Ohio State Archaeological and Historical Society, 1922), 1:280; Fredrika Bremer, *The Homes of the New World: Impressions of America* (New York, 1854), 167; Henry Howe, *Historical Collections of Ohio* (Cincinnati: C. J. Krehbiel & Co., 1908), 1:756–57.

4. Greve, *Centennial History,* 1:697; Hayes, *Diary and Letters,* 1:285; Ivan D. Steen, "Cincinnati in the 1850s: As Described by British Travellers," *Bulletin* of the Cincinnati Historical Society, 26 (July 1968):257–62; Mayer, *With Pen and Pencil,* 47.

5. Horace Greely is quoted in Cist, *Cincinnati in 1851,* 257; for J. C. Scott's comment, see Howe, *Historical Collections,* 1:758; *Cincinnati Daily Gazette,* March 3, 1845, 2. For a general look at Cincinnati at this time, see Cist, *Cincinnati in 1851,* 33–35, 306–20.

6. Both quotations may be found in *Dwight's Journal of Music,* 1(July 17, 1852):115.

7. *Leading Manufacturers and Merchants of Cincinnati and Environs* (Cincinnati: International Publishing Co., 1886), 59.

8. William A. Baughin, "The Development of Nativism in Cincinnati," *Bulletin* of the Cincinnati Historical Society, 22(October 1964):240–55.

9. Steen, "Cincinnati in the 1850s," 272; George Mortimer Roe, *Cincinnati: The Queen City of the West* (Cincinnati: Cincinnati Times-Star Company, 1895), 225; Henry E. Krehbiel, *An Account of the Fourth Musical Festival Held in Cincinnati, May 18, 19, 20, & 21, 1880,* (Cincinnati: Aldine Printing Works, 1880), 11–12.

10. Albert Bernhardt Faust, *The German Element in the United States* (Boston: Houghton Mifflin Co., 1909), 2:273–74; *Cincinnati Daily Gazette* quoted in Tunison, *Presto!,* 41; *Dwight's Journal of Music,* 1(June 19, 1852):85.

11. Faust, *German Element,* 2:254; *Indianapolis Journal* quoted in Eva Draegert, "Cultural History of Indianapolis: Music, 1875–1890," *Indiana Magazine of History,* 53(September 1957): 265–67; *Dwight's Journal of Music,* 20(February 8, 1862):85.

12. Sister Mary Edmund Spanheimer, "Heinrich Armin Rattermann, German-American Author, Poet, and Historian, 1832–1923" (Ph.D. diss., Catholic University of America, 1937), 15–19, 51.

13. Henry A. Rattermann, "Early Music in Cincinnati," reprint of a paper read before the Literary Club (Cincinnati), November 9, 1879, Public Library of Cincinnati and Hamilton County (hereafter cited as PLCH); George P. Upton, "Reminiscence and Appreciation," in Theodore Thomas, *A Musical Autobiography,* ed. George P. Upton (Chicago: A. C. McClurg & Co., 1905), 1:9.

14. Fletcher Hodges, Jr., "Stephen Foster—Cincinnatian and American," *Bulletin* of the Historical and Philosophical Society of Ohio, 8(April 1950):96–104; Raymond Walters, *Stephen Foster, Youth's Golden Dream: A Sketch of His Life and Background in Cincinnati, 1846–1850* (Princeton: Princeton University Press, 1936), 26–37, 82–83.

15. Ritter, *Music in England,* 2:375–76; Charles L. Gary, "A History of Music Education in the Cincinnati Public Schools" (Ed.D. diss., University of Cincinnati, 1951), 12–13; Edward Bailey Birge, *History of Public School Music in the United States* (Boston: Oliver Ditson Co., 1928), 65–75; "Charles Aiken," *Biographical Encyclopaedia of Ohio in the Nineteenth Century* (Cincinnati: Galaxy Publishing Co., 1876).

16. Tunison, *Presto!,* 33–34; *Dwight's Journal of Music* 3(May 7, 1853):39; Rattermann, "Early Music," 4–5.

17. *Dwight's Journal of Music* 2 (January 1, 1853):103; Greve, *Cincinnati History,* 1:738; *Dwight's Journal of Music* 2(May 30, 1857):70.

18. David Ewen, *Music Comes to America* (New York: Allen, Towne & Heath, Inc., 1947), 4–6.

19. Joseph E. Holliday, "The Cincinnati Philharmonic and Hopkins Hall Orchestras, 1856–1868," *Bulletin* of the Cincinnati Historical Society, 26(April 1968):158; Tunison, *Presto!,* 33.

20. Holliday, "Cincinnati Philharmonic," 160–61.

21. Ritter, *Music in England,* 2:376.

22. *Transactions of the Western Art Union, for the Year 1847,* (Cincinnati: Ben Franklin Printing House, 1847); *Cincinnati Daily Gazette,* April 28, 1847, 2.

23. Cist, *Cincinnati in 1851,* 121; Roberta H. Dean, "The Western Art Union, 1847–1851," (master's thesis, George Washington University, 1978), 35–36. For a complete list of the paintings distributed by the Art Union, see Appendix G in Dean's thesis.

24. *Transactions,* 17, 21. In 1847 the Art Union purchased 74 paintings, representing 27 artists, at an average cost of $38.20, with the single most expensive canvas being $175.

25. Dean, "Western Art Union," 31–35; Kenneth R. Trapp, "The Growth of Fine Arts Institutions in Cincinnati, 1838–1854," a paper read before the Ohio-Indiana American Studies Association, April 2, 1978, p. 12, copy in the author's possession.

26. Dean, "Western Art Union," 38–40; Miller, *Patrons and Patriotism,* 196–98; "Art Clubs—Western Art Union," Scrapbook, Cincinnati Historical Society.

27. *Transactions,* 5.

28. *Cincinnati Enquirer,* March 18, 1851, 2; Cist, *Cincinnati in 1851,* 205; *Western Art Journal,* 1 (January 1855), advertisement inside front cover; *Cincinnati Daily Gazette,* May 28, 1853, 2; Ford and Ford, *History of Cincinnati,* 239; *The Pen and Pencil,* 1(January 1853).

29. Cist, *Cincinnati in 1851,* 119; Mayer, *With Pen and Pencil,* 41–44.

30. Osgood Mussey, "The Fine Arts in Cincinnati and the West," *The Western Lady's Book,* 2(January 1855):47–8, 67–8; *Western Art Journal,* 1(January 1855):2.

31. John Tait to Hiram Powers, December 1, 1856, Powers Papers.

32. Lea J. Brinker, "Women's Role in the Development of Art as an Institution in Nineteenth Century Cincinnati," (master's thesis, Marquette University, 1968), 7–25; Margaret Rives King, *Memoirs of the Life of Mrs. Sarah Peter* (Cincinnati: Robert Clarke & Co., 1899), 265–75, 291–93; Heather Pentland, "Sarah Worthington King Peter and the Cincinnati Ladies' Academy of Fine Arts," *Bulletin* of the Cincinnati Historical Society, 39 (Spring 1981):7–16.

33. Pentland, "Sarah Worthington King Peter," 12–14; Brinker, "Women's Role," 9.

34. Miller, *Patrons and Patriotism,* 198–99.

35. Ladies' Picture Gallery Scrapbook, CHS. This important source of information on the Ladies' Academy of Fine Arts contains minutes of board meetings and some of the correspondence involving the financial crisis; see also Miller, *Patrons and Patriotism,* 198–99; McAllister, *In Winter We Flourish,* 217–18; Brinker, "Women's Role," 7–25. The Brinker thesis is the most comprehensive and accurate account of the history of the Ladies' Academy. Board members included Elizabeth Appleton, Margaret Burnet, Sarah Carlisle, Louise Este, Mary Kilgour, Harriet Hosea, Margaret Rives King, Susan Longworth, Mary Burnet Resor, Katherine Kilgour Springer, Sarah Scarborough, Sarah H. Schoenberger, and Baroness von Soden.

36. Sarah Peter to Charles McMicken, n.d., in Ladies' Picture Gallery Scrapbook, CHS; this is either a copy or a draft of the letter.

37. Miller, *Patrons and Patriotism,* 198; see also Frankenstein, *American Art,* 24.

38. Brinker, "Women's Role," 7–25; Miller, *Patrons and Patriotism,* 198.

39. Carl Abbott, *Boosters and Businessmen: Popular Economic Thought and Urban Growth in the Antebellum Middle West* (Westport, Conn.: Greenwood Press, 1981), 148.

40. Robert L. Black, "The Cincinnati Telescope," in *The Centenary of the Cincinnati Observatory* (Cincinnati: The Historical and Philosophical Society of Ohio, 1944), 19–46.

41. David Mead, *Yankee Eloquence in the Middle West: The Ohio Lyceum, 1850–1870* (East Lansing: Michigan State College Press, 1951), 15–18; Walters, *Stephen Foster,* 82–3; Eleanor M. Tilton, *Amiable Autocrat, A Biography of Dr. Oliver Wendell Holmes* (New York: Henry Schuman, 1947), 206.

42. John Y. Cole, "Spofford in Cincinnati, 1845–1861," in *Ainsworth Rand Spofford, Bookman and Librarian,* ed. John Y. Cole, (Littleton, Colo.: Libraries Unlimited, Inc., 1975), 17–24; Hayes, *Diary and Letters,* 1:303–5; Gay Wilson Allen, *Waldo Emerson* (New York: Penguin Books, 1982), 535–37; Virginius C. Hall, "Historical and Philosophical Society of Ohio: A Short History," *Bulletin* of the Historical and Philosophical Society of Ohio, 14(April 1956):90–91.

43. Robert R. Jones, *Papers Read Before the Literary Club* (Cincinnati: n.p., 1922), 13–14; Eslie Asbury, "Club Traditions and Myths," in Literary Club, *The Literary Club of Cincinnati, 1849–1874* (Cincinnati: n.p., 1874), 6–14. Other prominent early members were Manning Force, Henry Blackwell, Stanley Matthews, George B. McClellan, and John Pope, the latter two being well-known Civil War generals.

44. Walter Sutton, *The Western Book Trade: Cincinnati as a Nineteenth Century Publishing and Book-Trade Center* (Columbus: Ohio State University Press, 1961), 38–41, 67–70.

45. Ibid., 88–103.

46. Ibid., 157, 196–97.

Chapter 3

1. Abbott, *Boosters and Businessmen,* 148–67.

2. Thomas L. Nichols, *Forty Years of American Life* (1864; reprint, New York: Stackpole Sons, 1937), 114–16; Works Projects Administration, *Cincinnati: A Guide to the Queen City and Its Neighbors* (Cincinnati: Wiesen-Hart Press, 1943), 52, 59.

3. Abbott, *Boosters and Businessmen,* 20–2, 161–3; Carl W. Condit, *The Railroad and the City: A Technological and Urbanistic History of Cincinnati* (Columbus: Ohio State University Press, 1977), 5–29; Charles Cist, *Sketches and Statistics of Cincinnati in 1859* (Cincinnati: n.p., 1859), 341–45.

4. Cist, *Cincinnati in 1859,* 200–205.

5. Ritter, *Music in England,* 2:376–78; Holliday, "Cincinnati Philharmonic," 158; Cecelia Society, *Programs, 1857–1870,* in August Wilde Scrapbook, CHS.

6. Tunison, *Presto!,* 44; Holliday, "Cincinnati Philharmonic," 166; *Dwight's Journal of Music* 10(March 14, 1857):189.

7. *Dwight's Journal of Music* 11(May 9, 1857):44, and 11(April 4, 1857):5; Tunison, *Presto!,* 42–43.

8. Holliday, "Cincinnati Philharmonic," 167–68; *Dwight's Journal of Music* 10(March 14, 1857):189, 11(May 9, 1857):44, and 13(August 7, 1858):150.

9. Holliday, "Cincinnati Philharmonic," 167–68.

10. Ibid., 169–72.

11. *Cincinnati Commercial,* December 8, 1872, 2.

12. Joseph E. Holliday, "Notes on Samuel N. Pike and His Opera House," *Bulletin* of the Cincinnati Historical Society, 25(July 1967):165–70.

13. Ibid., 172–77; Greve, *Centennial History,* 1:741–42.

14. Holliday, "Notes on Samuel N. Pike," 178–83.

15. *Dwight's Journal of Music* 14(March 26, 1859):415, 16(December 24, 1859):309, 17(May 19, 1860):64, and 20(February 8, 1862):357.

16. Tunison, *Presto!,* 39; *Dwight's Journal of Music* 26(July 21, 1866):280. Among the members of the Harmonic Society were Jacob Burnet, Jr., Victor Williams, Charles Aiken, H. Wilson Brown, and George Ward Nichols; the latter two served on the board of trustees for the May Festival Association.

17. Smith, "Joseph Tosso," 38.

18. Hayes, *Diary and Letters,* 1:280; Steen, "Cincinnati in the 1850s," 265–66.

19. Russell James Grandstaff, "A History of the Professional Theatre in Cincinnati, Ohio, 1861–1886" (Ph.D. diss., University of Michigan, 1963), 1:16–48; Walters, *Stephen Foster,* 79–81.

20. Grandstaff, "A History of the Professional Theatre," 1:22–27; Moncure D. Conway, *Autobiography, Memories, and Experiences of Moncure Daniel Conway* (Boston: Houghton Mifflin & Co., 1904), 1:255–59.

21. Carl Wittke, *Refugees of Revolution: The German Forty-Eighters in America* (Philadelphia: University of Pennsylvania Press, 1952), 289–90; Greve, *Centennial History,* 1:845.

22. William Miller to Isaac Strohm, April 10, July 30, October 3, 1854, and January 7, 1859, Isaac Strohm Papers, CHS.

23. Coyle, *Frankenstein Family,* 9; Janson, "Cincinnati Landscape Tradition," 18.

24. Cist, *Cincinnati in 1859,* 200–205; Janson, "Cincinnati Landscape Tradition," 13–15; Miller to Strohm, January 7, 1859, Strohm Papers; *The Sketch Club* 1(April 21, 1860):2, located in The Sketch Club Scrapbook, ed. T. Langstroth, PLCH; Miller to Strohm, February 25, 1855, Strohm Papers; Frankenstein, *American Art,* 89–90. On photography see William Welling, *Photography in America: The Formative Years, 1839–1900* (New York: Thomas Y. Crowell, 1978), 7–94.

25. Charles T. Webber, "Pioneer Art in Cincinnati," in Howe, *Historical Collections,* 1:855–59; Davis Shaffer to Hiram Powers, April 16, 1860, Powers Papers; Conway, *Autobiography,* 1:292; *Cincinnati Enquirer,* May 3, 1860, 2; *The Sketch Club* 1(March 31, 1860):2.

26. *The Sketch Club* 1(March 31, 1860):2; "Art and Art Matters in Cincinnati," *Cincinnati Daily Gazette,* October 17, 1862, 2.

27. United States Sanitary Commission, *History of the Great Western Sanitary Fair* (Cincinnati: C. F. Vent & Co., 1864), 41–49, 403–15, 489–94; *The Ladies Knapsack* 1(December 22, 1863):3.

28. "Art and Art Matters in Cincinnati," 2.

29. John E. Ventre and Edward J. Goodman, *A Brief History of the Cincinnati Astronomical Society* (Cincinnati: The Cincinnati Astronomical Society, 1985), 5; Greve, *Centennial History,* 1:903–8; Venable, *Literary Culture,* 87–89, 154, 284–85.

30. William D. Andrews, "William T. Coggeshall: 'Booster' of Western Literature," *Ohio History* 81(Summer 1982):211–12; Venable, *Literary Culture,* 110–11.

31. Conway, *Autobiography,* 1:255–85.

32. Venable, *Literary Culture,* 118–22; Conway, *Autobiography,* 1:306–16; *The Dial: A Monthly Magazine for Literature, Philosophy, and Religion* 1(January 1860):517.

33. Greve, *Centennial History,* 1:747; Conway, *Autobiography,* 1:324.

Notes to Interlude: D. H. Baldwin

1. Unless otherwise indicated the information in this section comes from Lucien Wulsin, *Dwight Hamilton Baldwin (1821–1899) and the Baldwin Piano* (New York: Newcomen Society, 1953).

2. Kenneth Wayne Hart, "Cincinnati Organ Builders of the Nineteenth Century," *Bulletin* of the Cincinnati Historical Society, 31(Summer 1973):81.

3. Ibid. The most famous organ built by Koehnken and Company was the great "chorus organ" built in 1873 for the first May Festival. This instrument required four men to work the bellows. Other Koehnken organs were installed in Calvary Episcopal Church, Isaac M. Wise Temple, St. Francis Seraph Church, all of Cincinnati, and Grace Episcopal Church in Newport, Kentucky.

4. Charles Frederic Goss, *Cincinnati, The Queen City, 1788–1912* (Chicago: S. J. Clarke and Co., 1912), 2:262–63; John W. Leonard, *The Centennial Review of Cincinnati: One Hundred Years of Progress in Commerce, Manufactures, the Professions, and in Social and Municipal Life* (Cincinnati: J. M. Elstner & Co., 1888), 34; Roe, *Cincinnati*, 227–28. See also *Church's Musical Visitor* 1(October 1871):4.

5. *Wurlitzer World of Music, 1856–1956: One Hundred Years of Musical Achievement* (Chicago: The Rudolph Wurlitzer Company, 1956).

Chapter 4

1. For an exception to this view, see Alphonso Taft, *A Lecture on Cincinnati and Her Railroads, Delivered Before the Young Men's Mercantile Library Association* (Cincinnati: D. Anderson, 1850).

2. Cincinnati Chamber of Commerce, *Annual Review for the Commercial Year Ending August 17, 1865* (Cincinnati: Gazette Steam Printing House, 1865), 7; Goss, *Cincinnati, The Queen City,* 1:220–26; Greve, *Centennial History,* 1:848–50.

3. George Stevens, *The City of Cincinnati* (Cincinnati: George Stevens and Co., 1869), 20–27; Nichols, *Forty Years,* 113–17; James Parton, "Cincinnati," *The Atlantic Monthly* 20(August 1867):235; Macauley is quoted in Greve, *Centennial History,* 1:869.

4. Stevens, *City of Cincinnati,* 10–11; Parton, "Cincinnati," 231–37.

5. Tunison, *Presto!,* 56; *Dwight's Journal of Music* 24(February 4, 1865):2, 25(May 13, 1865):28–29, 25(May 27, 1865):37, and 25(August 5, 1865):75.

6. *Dwight's Journal of Music* 25(December 9, 1865):152, 25(February 17, 1866):192, 26(February 16, 1867):397, 26(March 2, 1867):404, 26(March 16, 1867):413, and 27(December 7, 1867):152.

7. Joseph Sagmaster, "Cincinnati's Golden Age of Music," January 2, 1939, paper read before the Literary Club, copy in the Public Library of Cincinnati and Hamilton County; see also Robert Thomas Gifford, "The Cincinnati Music Hall and Exposition Buildings," (master's thesis, Cornell University, 1973).

8. *Dwight's Journal of Music* 30(July 16, 1870):280; *Cincinnati Commercial,* June 12, 1870, 8; June 15, 1870, 4; June 16, 1870, 1.

9. *Cincinnati Commercial,* June 14, 1870, 4; June 20, 1870, 1; *Dwight's Journal of Music* 30(July 16, 1870):279–80.

10. *Dictionary of American Biography,* s.v. "Thomas, Theodore."

11. John H. Mueller, *The American Symphony Orchestra: A Social History of Musical*

Taste (Bloomington: Indiana University Press, 1951), 34; Theodore C. Russell, "Theodore Thomas: His Role in the Development of Musical Culture in the United States, 1835–1905," (Ph.D. diss., University of Minnesota, 1969), 68; Charles Edward Russell, *The American Orchestra and Theodore Thomas* (New York: Doubleday, Page and Co., 1927), 34; *Musical Herald* 8(March 1887):71.

12. Russell, "Theodore Thomas," 111; "Theodore Thomas," *Scribner's Magazine* 9(February 1875):466; *Church's Musical Visitor* 4(May 1875):6.

13. *Cincinnati Commercial,* December 8, 1869, 8; December 9, 1869, 8; December 11, 1869, 6.

14. Thomas, *A Musical Autobiography,* 1:78–79; Charles Hamm, *Music in the New World* (New York: W. W. Norton, 1983), 307–11.

15. *Dictionary of American Biography,* s.v. "Nichols, George Ward"; *The Week: Illustrated* 1(February 9, 1884):370.

16. For a more detailed account of the first May Festival, see the author's "Starting a Tradition: The First Cincinnati May Musical Festival," *Bulletin* of the Cincinnati Historical Society, 38(Spring 1980):33–50.

17. *Cincinnati Times and Chronicle,* October 11, 1872, clipping in George Ward Nichols, Scrapbook, CHS; *Dwight's Journal of Music* 32 (January 25, 1873): 376; see also Vitz, "Starting a Tradition."

18. See correspondence in Cincinnati Musical Festival Association Papers, CHS, especially Jacob Gosche to Theodore Thomas, April 28, 1873 (telegram), box 2, folder 35; Thomas to Nichols, January 20, 1873, box 1, folder 7; and A. N. Chrystie to Executive Committee, May 3, 1873, box 2, folder 40. See also *Cincinnati Daily Gazette,* May 2, 1873, 8, and various unidentified newspaper clippings in Nichols, Scrapbook.

19. Festival Association Papers, box 1, folder 14, CHS; *Brainard's Musical World* 10(June 1873):84.

20. *Cincinnati Enquirer,* May 6, 1873, 4; *Cincinnati Daily Gazette,* May 7, 1873, 4; May 1, 1873, 8; George P. Upton, "The Cincinnati Musical Festival," *Lakeside Monthly* 9(June 1873):473.

21. *Church's Musical Visitor* 2(June 1873):8.

22. "The Cincinnati May Festival," *Rochester Musical Times* 5(May 15, 1873):1; *Church's Musical Visitor* 2(June 1873):8; *Brainard's Musical World* quoted in *Church's Musical Visitor* 2(July 1873):9; Upton, "Cincinnati Musical Festival," 472–77.

23. *Cincinnati Daily Gazette,* May 11, 1873, 4; *St. Louis Republican* quoted in *Cincinnati Enquirer,* May 8, 1873, 4.

24. Helen Buchanan quoted in *Cincinnati Daily Gazette,* May 8, 1873, 1; for the comments of the New York newspapers, see *New York Tribune,* May 7, 1873, 5; May 9, 1873, 5; May 10, 1873, 7; the *New York World* is quoted in the *Cincinnati Daily Gazette,* May 8, 1873, 2; the *Boston Evening Journal,* May 8, 1873, 2. For John Sullivan Dwight's somewhat petulant remark, see *Dwight's Journal of Music* 33(May 17, 1873):17.

25. For responses to the 1873 festival found in various Ohio newspapers, see the collection of the Ohio Historical Society, Columbus, Ohio.

26. George Ward Nichols to Directors of the Board of Trade, reprinted in unidentified newspaper clipping, March 1873, in Nichols, Scrapbook, CHS. The unidentified letter to the editor is in *Cincinnati Daily Gazette,* May 5, 1873, 8; see also that paper's editorial for that day.

27. *Church's Musical Visitor* 1(March 1872):8, 1(November 1871):6, and 2(January 1873):9; Theodore Steinway, *People and Pianos: A Century of Service to Music* (New York: Steinway and Sons, 1953) provides an interesting account of the Rubinstein-Wieniawski tour; Tunison, *Presto!,* 40.

28. *Church's Musical Visitor* 2(July 1873):10; Tunison, *Presto!*, 40; Clara Longworth de Chambrun, *The Making of Nicholas Longworth: Annals of an American Family* (New York: Ray Long and Richard R. Smith, Inc., 1933), 95; Julius Dexter Afternoon Orchestral Concerts, account ledger, CHS.

29. Harmonic Society, "Minutes," 1874–80, CHS; *Church's Musical Visitor* 5(May 1876):206; 2(March 1873):9; Frank Grayson, "Singing Cincinnati," *Cincinnati Times-Star,* January 21, 1937, 33.

30. *Cincinnati Commercial,* December 5, 1869, 8; *Church's Musical Visitor* 2(November 1872):7; *Cincinnati Enquirer,* December 18, 1872, 4; *Church's Musical Visitor* 2(January 1873): 9; 2(February 1873):9. After George Brand's death in 1873, his brother, Michael Brand, succeeded him as director of the Cincinnati Grand Orchestra.

31. *Church's Musical Visitor* 2(February 1873):9; 2(January 1873):8; 3(February 1874):7; E. Gest to "Dear Sister," May 2, 1875, Gest Family Papers, box 2, CHS. Other young Cincinnatians who attracted notice in the East or in Europe included Laura Woolwine (Laura Bellini), Jennifer Sullivan, Emma Cranch, Armin Doerner, Miss von Elsner (Mademoiselle Letta), Emma Dexter, and Marie Van.

32. Richard Peyton to George Ward Nichols, August 23, 1873 in Nichols, Scrapbook, CHS; Harmonic Society, "Minutes," September 1, 1874, CHS; *Church's Musical Visitor* 4(June 1875):6–7.

33. *Cleveland Leader* is quoted in *Cincinnati Daily Gazette,* May 10, 1875, 3; *Boston Transcript* is quoted in *Church's Musical Visitor* 4(May 1875):11; *Dwight's Journal of Music* 35(April 17, 1875): 7; *New York Herald,* May 11, 1875, 6; *New York Times,* May 10, 1875, 4; *New York Tribune,* May 8, 1875, 7.

34. *The Scholastic* is quoted in *Church's Musical Visitor* 4(May 1875):11; John R. G. Hassard, "Theodore Thomas," *Scribner's Monthly* 9(February 1875):463–64.

35. *Church's Musical Visitor* 4(June 1875):7; *Chicago Tribune,* May 17, 1875, 4; *Dwight's Journal of Music* 35(May 29, 1875):25; *Cincinnati Enquirer,* May 12, 1875, 4.

36. *Church's Musical Visitor* 4(June 1875):9–10; *Boston Daily Globe,* May 13, 1875, 4; George Upton quoted in *Cincinnati Daily Gazette,* May 14, 1875, 1; *New York World* quoted in *Cincinnati Daily Gazette,* May 14, 1875, 4.

37. *Chicago Tribune* quoted in *Church's Musical Visitor* 4(June 1875):7; *New York Daily Tribune,* May 15, 1875, 7.

38. Edward J. McGrath, "Reuben Springer: Cincinnatian, Businessman, Philanthropist," *Bulletin* of the Historical and Philosophical Society of Ohio, 13(October 1955):271–85; Joseph S. Stern, Jr., "The Queen of the Queen City, Music Hall," *Bulletin* of the Cincinnati Historical Society, 31(Spring 1973):13–14; *Cincinnati Daily Gazette,* May 10, 1875, 4; "There's Something in a Name," in *Golden Jubilee: Cincinnati Music Hall, 1878-1928* (Cincinnti: Cincinnati Music Hall Association, 1928), 15–19.

39. "Something in a Name," 17–20; Gifford, "Cincinnati Music Hall," 38–42.

40. The best source for the general musical happenings in the city during this period is *Church's Musical Visitor.* For Julie Rivé see Draegert, "Cultural History of Indianapolis," 265–304; *Dwight's Journal of Music* 36(September 16, 1876):304; Ford and Ford, *History of Cincinnati,* 257; *Musical Review* 3(December 23, 1880):168.

41. Judith Spraul, "Cultural Boosterism: The Construction of Music Hall," *Bulletin* of the Cincinnati Historical Society, 34(Fall 1976), 189–202; Stern, "Queen of the Queen City," 16–18.

42. *Cincinnati Daily Gazette,* March 12, 1878, 8; *Cincinnati Commercial,* May 20, 1878, 8. One individual's concern for the efforts of Julius Dexter in overseeing the construction of Music Hall is revealed in a letter from Mrs. E. M. Appleton to Eugene Bliss: "I think Julius needs your care and supervision—he acts like a demented person. . . . If I tell you how he

passes his day you will believe me when I say he is crazy. First he refuses to stay in the country, with the Nichols people because they do not have breakfast early enough to enable him to be on the Music Hall grounds at eight o'clock—So he takes an early breakfast at the St. Nicholas and rushes up to the corner of Elm and Twelfth Streets—There he stays till ten, then comes to his office, and reports to me quarrels he has with Mr. Blair, the brick contractor, who, though he does not furnish brick, persists in demanding money, and strenuously objects to Julius' getting brick elsewhere." And, according to Mrs. Appleton, the other board members were not very helpful. Alfred Goshorn had "gone East"; Longworth "looks at the ground sometimes but never says anything"; Harrison was "displeased with the management, and has not been there for two weeks"; so "the whole responsibility rests with Dexter, and he is glad of it." This letter, dated July 15, 1877, is in the Julius Dexter Miscellaneous Papers, CHS.

43. Stern, "Queen of the Queen City," 18–23; Robert T. Gifford, "Cincinnati's Music Hall: A Century of Continuity and Change," *Bulletin* of the Cincinnati Historical Society, 36(Summer 1978):80–83.

44. Cincinnati Music Hall Association, *Golden Jubilee,* 93–104.

45. *Cincinnati Daily Gazette,* May 11, 1878, 3; *Chicago Tribune* quoted in *Cincinnati Enquirer,* May 15, 1878, 2; *Indianapolis Journal,* May 17, 1878, 4.

46. *Cincinnati Daily Gazette,* May 15, 1878, 6; *Chicago Tribune,* May 20, 1878, 5; *New York Daily Tribune,* May 15, 1878, 5.

47. Unidentified newspaper clippings in Cincinnati Musical Festival Association, "Minutes," June 14, 1878, CHS; *Cincinnati Daily Gazette,* May 18, 1878, 1; Clara Maxwell, *Memories,* (privately printed, 1916), 134; *Church's Musical Visitor* 7(July 1878):262, in which the editor noted that several critics felt the city was not supportive of American composers because the festival relied on European music.

Chapter 5

1. Helen Board, *Berthe Baur: A Woman of Note* (Philadelphia: Dorrance and Co., 1971), 53–58; John Lewis, "An Historical Study of the Origin and Development of the Cincinnati Conservatory of Music" (Ph.D. diss., University of Cincinnati, 1943), 70.

2. Board, *Baur,* 59; "The Cincinnati College of Music," *The Musical Courier,* undated clipping in author's possession.

3. *Church's Musical Visitor* 2(June 1873):10; *London Quarterly* quoted in *Cincinnati Enquirer,* May 25, 1875, 4.

4. Roe, *Cincinnati,* 223; "Cincinnati Conservatory of Music," *American Musician* 7(June 1903):8–9.

5. Board, *Baur,* 60–65; Lewis, "Historical Study," 75.

6. Board, *Baur,* 35, 65; Lewis, "Historical Study," 85–86. When Berthe Baur became head of the school, she changed much of the Victorian emphasis on deportment and behavior.

7. *Church's Musical Visitor* 2(January 1873):11.

8. Vernon D. Schroeder, "Cincinnati's Musical Growth, 1870–1875," (master's thesis, University of Cincinnati, 1971), 11–18; *Church's Musical Visitor* 7(May 1878):210; 7(July 1878):264; 7(September 1878):322; *Cincinnati Daily Gazette,* September 10, 1878, 4; *Cincinnati Saturday Night* 14(April 12, 1879):7.

9. Lewis, "Historical Study," 311–12; Board, *Baur,* 64–67.

10. *Cincinnati Commercial,* May 19, 1878, 3; "National College of Music," *Church's Musical Visitor* 2(June 1872):6; *New York Times,* March 8, 1873, 6; *Church's Musical Visitor* 2(August 1873):9.

11. *Church's Musical Visitor* 4(July 1875):6; 4(May, 1875):10; the *New York Times* seemed dubious concerning the proposed "American College of Music," finding fault with its title, the curriculum, and the architectural plan, and called the idea "raw, pretentious, and unpromising," *New York Times,* March 21, 1875, 6.

12. *Rufus King in the Development of Cincinnati During the Last Fifty Years* (Cincinnati: Robert Clarke & Co., 1891), 46–47; Rose Fay Thomas, *Memoirs of Theodore Thomas* (New York: Moffat, Yard and Co., 1911), 144–46.

13. Rose Fay Thomas, *Memoirs,* 146–52; *New York Times,* August 27, 1878, 5.

14. Russell, "Theodore Thomas," 101–17. Theodore Thomas's frustration had been clearly recognized within the musical fraternity. See John R. G. Hassard, "Theodore Thomas," *Scribner's Monthly* 9(February 1875):458–66; and *Church's Musical Visitor* 8(October 1876):8.

15. *New York Times,* August 25, 1878, 1. This article also pointed out how disappointed Thomas had been in the failure of New York to establish a college of music after so many attempts.

16. *Cincinnati Daily Gazette,* August 24, 1878, 4; *Cleveland Voice* quoted in *Church's Musical Visitor* 8(October 1878):8; *Chicago Tribune,* August 26, 1878, 4; *Indianapolis Journal,* August 28, 1878, 4.

17. *Philadelphia Times* quoted in *Church's Musical Visitor* 8(October 1878):8; *New Haven Palladium* quoted in *Cincinnati Daily Gazette,* September 3, 1878, 5; *Boston Daily Advertiser* quoted in *Dwight's Journal of Music* 38(August 31, 1878):293. Cincinnati journals took great pleasure in quoting this apparent abdication on the part of proud Boston.

18. *Nation* quoted in *Cincinnati Daily Gazette,* September 9, 1878, 5; *New York Mail* quoted in *Church's Musical Visitor* 8(October 1878):8; *New York Times,* September 1, 1878, 6; *New York Tribune,* August 26, 1878, 4; Leopold Damrosch was quoted in the *New York World,* reprinted in *Church's Musical Visitor* 8(October 1878):8. At a time when newspapers regularly reprinted editorials from other newspapers, the Cincinnati press savored the discomfiture of the various New York journals; see especially the *Cincinnati Enquirer,* August 28, 1878, 5, and the *Cincinnati Daily Gazette,* August 28, 1878, 7.

19. *New York Journal of Commerce* quoted in *Cincinnati Daily Gazette,* September 11, 1878, 7; *Folio* 17(November 1878):411; *Dexter Smith's Pictorial, Musical and Fashion Magazine* 14(October 1878):100.

20. *New York Tribune,* August 28, 1878; *Cincinnati Daily Gazette,* September 5, 1878, 4.

21. *Cincinnati Enquirer,* October 11, 1878, 5; *New York Times,* October 4, 1878, 5; *Cincinnati Enquirer,* October 13, 1878, 9; October 15, 1878, 2. Other faculty included Jacob Bloom (violin), J. Broeckhoven (violin and theory), Madame Fredin (French), Adolph Hartdegen (violin cello), Carl Huber (German), Emma Langenbeck (German), Paolo La Villa (voice), Madame La Villa (Italian and voice), Louise Rollwagen (voice), Georg Schneider (pianoforte), Patti Thorndick (pianoforte), Mrs. Catherine Westendorf (elocution), and Thomas (advanced chorus, conducting, ensemble, and score playing).

22. *Cincinnati Enquirer,* October 19, 1878, 4; *Boston Post* quoted in *Cincinnati Enquirer,* October 25, 1878, 4. For a detailed account of the beginnings of the College of Music, see Louis R. Thomas, "A History of the Cincinnati Symphony Orchestra to 1931" (Ph.D. diss., University of Cincinnati, 1972).

23. *Church's Musical Visitor* 8(October 1878):10–11; Vincent A. Orlando, "An Historical Study of the Origin and Development of the College of Music of Cincinnati" (Ed.D. diss., University of Cincinnati, 1946), 78–79, 159; *Dwight's Journal of Music* 39(December 30, 1879):200.

24. Rose Fay Thomas, *Memoirs,* 161–67; *Musical Record,* May 31, 1879, 132; *Dwight's*

Journal of Music 39(February 15, 1879):31; Joseph E. Holliday, "The Musical Legacy of Theodore Thomas," *Bulletin* of the Cincinnati Historical Society, 37(Fall 1969):197–99.

25. *Church's Musical Visitor* 8(February 1879):135; Roe, *Cincinnati,* 217; *Cincinnati Daily Gazette,* January 13, 1880, 4. See also the *Musical Review* 1(November 20, 1879):82 for a favorable assessment of the college's first year.

26. *The Score* 4(April 1879):389–90; *Folio* 18(July 1879):251; *Church's Musical Visitor* 8(April 1879):190, and 8(May 1879):217. The rapid growth of the College of Music's chorus depleted local singing societies and church choirs, several of which disbanded at this time, providing further cause for irritation. Henry Krehbiel remained with the *Cincinnati Daily Gazette* for one more year and then left the city to take a position with the *Musical Review* in New York. He eventually wound up on the *New York Tribune* as the eminent music critic for that newspaper.

27. *Dayton Journal* quoted in *Cincinnati Daily Gazette,* November 6, 1878, 5; *Church's Musical Visitor* 8(June 1879):244. A similar rumor circulated during the summer of 1879 which brought a sharp rebuttal from *Church's Musical Visitor;* see 8(September 1879):330.

28. Rose Fay Thomas, *Memoirs,* 167–74; *Cincinnati Daily Gazette,* January 13, 1880, 4; *Cincinnati Enquirer,* January 13, 1880, 4; *Church's Musical Visitor* 9(February 1880):134.

29. George P. Upton, "Reminiscences and Appreciation," in Theodore Thomas, *Musical Autobiography,* 1:181–85; *Cincinnati Daily Gazette,* March 6, 1880, 1; March 4, 1880, 4; *Cincinnati Enquirer,* March 11, 1880, 4. An outline of Thomas's reorganization proposal is in *Cincinnati Daily Gazette,* March 6, 1880, 1.

30. *Cincinnati Daily Gazette,* March 6, 1880, 1; *New York Times,* March 3, 1880, 1.

31. *Cincinnati Daily Gazette,* March 6, 1880, 1.

32. *Cincinnati Commercial and Times* quoted in *Cincinnati Daily Gazette,* March 8, 1880, 4; *Cincinnati Enquirer,* March 6, 1880, 4.

33. *New York Graphic* quoted in *Cincinnati Enquirer,* March 14, 1880, 4; *New York Times,* March 15, 1880, 4.

34. *Chicago Tribune* quoted in *Cincinnati Enquirer,* March 6, 1880, 4; *Pittsburgh Dispatch* and *Indianapolis Sentinel* quoted in *Cincinnati Enquirer,* March 7, 1880, 4; *St. Louis Post-Dispatch* quoted in *Cincinnati Daily Gazette,* March 8, 1880, 4; *Chicago News* quoted in *Indianapolis News,* March 10, 1880, 4.

35. *Cincinnati Enquirer,* March 6, 1880, 4; March 8, 1880, 4; March 9, 1880, 4; *Cincinnati Daily Gazette,* March 5, 1880, 4; March 6, 1880, 4; March 10, 1880, 10.

36. *Cincinnati Commercial,* March 10, 1880, 4; *Cincinnati Daily Gazette,* March 5, 1880, 1; March 10, 1880, 10. See also Orlando, "Historical Study," 200.

37. *Cincinnati Daily Gazette,* March 11, 1880, 6; Orlando, "Historical Study," 60; *Cincinnati Commercial,* March 10, 1880, 8.

38. *Cincinnati Enquirer,* March 21, 1880, 6; *Cincinnati Daily Gazette,* March 6, 1880, 4. Rumors concerning Thomas's successor as music director of the college included the names of Klaus von Bulow, Anton Rubinstein, Johannes Brahms, Otto Singer, and Carl Zerrahn; see *Musical Record* 3(March 6, 1880):357, and 3(May 29, 1880):549.

39. *Musical Record* 3(March 27, 1880):405; *Cincinnati Daily Gazette,* March 4, 1880, 4.

40. The Musical Festival Association's new board of directors consisted of Edmund Pendleton, Lawrence Maxwell, Carl Adae, Charles P. Taft, H. Wilson Brown, and A. Howard Hinkle.

41. Cincinnati Musical Festival Association, "Minutes," April 9, 1880, and April 17, 1880, CHS; *New York Times,* May 25, 1880, 2; *Cincinnati Daily Gazette,* May 25, 1880, 3. In an apparently unrelated issue, Julius Dexter, chairman of the Music Hall building committee and the man who had done so much to have that structure completed on time, resigned from

the Music Hall Association board over an "unpleasant controversy" with Nichols; see *Cincinnati Daily Gazette,* May 4, 1880, 4.

42. *Cincinnati Enquirer,* April 11, 1880, 4; April 13, 1880, 4; *Cincinnati Daily Gazette,* April 14, 1880, 4. Signers of the open letter supporting Thomas included Michael Brand, Louis Ballenberg, Charles Baetens, John Broeckhoven, Louis Brand, Arthur Mees, and some twenty others. In general *Enquirer* readers expressed hostility towards Thomas, while letters in the *Daily Gazette* tended to favor the Thomas position.

43. *Cincinnati Daily Gazette,* May 22, 1880, 4; *Cincinnati Enquirer,* May 23, 1880, 4; Cincinnati Musical Festival Association, "Minutes," May 6, 1880.

44. Cincinnati Musical Festival Association, "Minutes," March 17, and May 11, 1880, CHS. Michael Brand and Otto Singer presented their respective views of Singer's dismissal in the *Cincinnati Commercial,* May 25, 1880, 8. *The New York Times* also published the quarrel, placing it on the front page of its May 24, 1880 issue. Originally Thomas had appointed Michael Brand as the new resident director of the festival chorus, but by June Arthur Mees had replaced him; see Krehbiel, *Fourth Musical Festival,* 79–80.

45. College of Music of Cincinnati, "Copy of Legal Agreement," November 25, 1882, College-Conservatory of Music, box 3, folder 30, Special Collections, University of Cincinnati Library; Reuben Springer to Mrs. Cassilly, March 8, 1883, Scrapbook of Newspaper Clippings, Old Letters, Etc., 12, PLCH.

46. For a detailed account of the festival prize and its importance to American music, see the author's "Supporting the Arts: The Cincinnati Musical Prizes of 1880 and 1882," *The Old Northwest* 7(Summer 1981):95–110.

47. *Cincinnati Daily Gazette,* February 12, 1880, 4; April 16, 1880, 3; April 17, 1880, 4; *Folio* 19(June 1880):215.

48. *Dwight's Journal of Music* 40(November 6, 1880):176; Thomas, "History of the Cincinnati Symphony," 72ff; James Henry Mapleson, *The Mapleson Memoirs: The Career of an Operatic Impresario, 1858–1888,* ed. Harold Rosenthal (New York: Appleton-Century, 1966), 141–42; Tunison, *Presto!,* 69–72; Joseph E. Holliday, "Cincinnati Opera Festivals During the Gilded Age," *Bulletin* of the Cincinnati Historical Society, 24(April 1966):132–34. Unless otherwise indicated, the information on the College of Music's opera festivals is taken from Holliday's account.

49. Included in the audience was the visiting Oscar Wilde, attired in "knee breeches, with black silk stockings and a clawhammer coat" with a boutonniere of lilies-of-the-valley; see *Cincinnati Daily Gazette,* February 21, 1882, 3.

50. Mapleson, *Memoirs,* 164–65; *The Week: Illustrated* 1(November 10, 1883):63; Milton Goldin, *The Music Merchants* (New York: Macmillan Co., 1969), 94–95. Cincinnati's refusal to adopt standard railroad time may have confused out-of-town opera lovers, a situation lampooned by a cartoon in *The Week: Illustrated* 1(February 9, 1884):381.

51. Tunison, *Presto!,* 74–80; *Cincinnati Graphic* 3(March 7, 1885):151; John S. Van Cleve, "Cincinnati as a Music Center," *Cincinnati Graphic* 1(October 4, 1884):3.

52. *Cincinnati Enquirer,* February 14, 1880, 4; Harmonic Society of Cincinnati, "Minutes," 1874–1880, September 27, 1879; May 15, and September 28, 1880, CHS. Harmonic Society members included George Ward Nichols, John Church, Jr., Lawrence Maxwell, Henry Brown, and William Watts Taylor; in its last official action the society, in existence since 1864, sold its piano and library to the Musical Festival Association.

53. *Cincinnati Daily Gazette,* December 27, 1880. Because of her divorces, many questioned how Patti could sing in good conscience "I Know that My Redeemer Liveth." Theodore Thomas to Lawrence Maxwell, February 16, 1881, Musical Festival Association Papers, box 5, folder 6, CHS; Clara D. Maxwell, *Memoirs* (privately printed, 1916), 180–83. An

interesting note from this concert is that two local soloists, Emma Cranch and Annie Norton, had family ties to the city's early cultural life. Cranch was the daughter of E. P. Cranch, prominent in the Semi-Colon Club of the 1830s, while Norton's great-grandfather was Mr. Burt of the old Harmonical Society; see Krehbiel, *Fourth Musical Festival,* 27.

54. *Boston Daily Advertiser* quoted in *Dwight's Journal of Music* 41(March 26, 1881):48–49; Thomas, "History of the Cincinnati Symphony," 71; *Cincinnati Commercial,* April 30, 1882, 13. The Musical Club had been founded in 1875, with A. Howard Hinkle serving as its first president.

55. Thomas, "History of the Cincinnati Symphony," 77–83.

56. *The Graphic,* 4(July 18, 1885):111; 4(August 1, 1885):143; 4(November 21, 1885):413; Tunison, *Presto!,* 58–60. One of Simon Jacobsohn's pupils during this time was Nicholas Longworth III, who later became speaker of the House of Representatives and son-in-law of Theodore Roosevelt.

57. Thomas, "History of the Cincinnati Symphony," 83–88; "The Musical Criterion," *Criterion* 2(July 1888):510–15; *Cincinnati Times-Star,* September 6, 1893, 4.

58. Tunison, *Presto!,* 83–86; "Cincinnati Musical Societies," *Criterion* 1(December 1887):185–86; *Cincinnati Graphic* 1(October 4, 1884):2. The best running accounts of the general musical activities during this time are in *Church's Musical Visitor* and the *Cincinnati Graphic.*

59. The following account of the founding of the Cincinnati Symphony Orchestra is taken from Louis R. Thomas's excellent study, "A History of the Cincinnati Symphony Orchestra to 1931," 92–120.

Chapter 6

1. Unless otherwise indicated, the biographical material on Lafcadio Hearn's early life and career is from O. W. Frost, *Young Hearn* (Tokyo: The Hokuseido Press, 1958).

2. John Cockerill, "Lafcadio Hearn: The Author of Kokoru," *Current Literature* 19(June 1896):476.

3. For the most complete account of the tanyard murder case, see Jon C. Hughes, *The Tanyard Murder: On the Case with Lafcadio Hearn* (Washington, D.C.: University Press of America, 1982).

4. "A Remarkable Episode at the Musical Club," *Cincinnati Commercial,* October 1, 1877; "Letters of a Poet to a Musician: Lafcadio Hearn to Henry E. Krehbiel," *The Critic* 48(April 1906):309–18.

5. "Beauty Undraped," *Cincinnati Enquirer,* October 18, 1874, 1.

6. Jon Christopher Hughes, "Ye Giglampz; Devoted to Art, Literature and Satire," typed manuscript (1982), PLCH; also see Frost, *Young Hearn,* 90–104. Unless otherwise indicated, the material on Hearn's role with *Ye Giglampz* is taken from these two sources.

7. Elizabeth Stevenson, *Lafcadio Hearn* (New York: The Macmillan Co., 1961), 52. The only complete set of *Ye Giglampz* (with the first eight issues containing handwritten comments by Hearn) is in the collection of the Public Library of Cincinnati and Hamilton County.

8. Frost, *Young Hearn,* 160, 120–24, 170–71.

9. *The Week: Illustrated* 1(September 1883–February 1884). In particular see the issues for September 1 and February 16, the first and last issues.

10. *The Cincinnati Graphic* 1(September 1884); *The Criterion* 1(August 1887) and subsequent issues.

11. Robert C. Cazden, "The German Book Trade in Ohio Before 1848," *Ohio History*

84(Winter-Spring 1975):73–76; Don Heinrich Tolzmann, "Muskenlange aus Cincinnati," *Bulletin* of the Cincinnati Historical Society, 35(Summer 1977):115–29.

12. Lloyd E. Easton, "German Philosophy in Nineteenth Century Cincinnati—Stallo, Conway, Nast, and Willich," *Bulletin* of the Historical and Philosophical Society of Ohio, 20(January 1962):15–28.

13. *Cincinnati Commercial-Gazette,* April 13, 1883, 5.

14. The standard account of Cincinnati's contribution to the nation's publishing trade is Walter Sutton, *The Western Book Trade: Cincinnati as a Nineteenth Century Publishing and Book-Trade Center, 1726–1880* (Columbus: Ohio State University Press, 1961).

15. Sutton, *Western Book Trade,* 297–302; Goss, *Cincinnati,* 2:510–11.

16. Sutton, *Western Book Trade,* 88, 302–4.

17. *The Decline and Fall of the Public Library of Cincinnati* (Cincinnati, 1886), 3–5; Rufus King, "Report on the Cincinnati Common Schools," June 1861, PLCH; Greve, *Centennial History,* 1:906–12. Rufus King, son of Sarah Worthington King Peter, not only served as president of the board of education, but also contributed his abilities to the College of Music, the Cincinnati Public Library, the Cincinnati Art Museum, the University of Cincinnati, the Southern Railroad, Spring Grove Cemetery, the Cincinnati Bar Association, and served as dean of the Cincinnati Law School.

18. William L. Williamson, *William Frederick Poole and the Modern Library Movement* (New York: Columbia University Press), 1–3, 55–63. Poole, the compiler of *Poole's Index to Periodic Literature,* wrote a fine account of the Tyler Davidson Fountain, which remains the best record of that magnificent piece of public statuary. He also participated in the Literary Club and later became a dominant figure in the newly established American Library Association—all in all, an extraordinary man. His genteel background was best revealed during his Cincinnati years when he instructed his assistants "to deliver no periodical or book into unclean hands"; see Dee Garrison, *Apostles of Culture: The Public Librarian and American Society* (New York: Macmillan Co., 1979).

19. *Cincinnati Enquirer,* November 27, 1873, 4; December 1, 1873, 4; Williamson, *Poole,* 62–63. For the drive to make Julius Dexter head of the library, see Julius Dexter Miscellaneous Papers, CHS.

20. For the arguments concerning the appropriateness of fiction in public libraries, see the various issues of the *Cincinnati Commercial, Cincinnati Enquirer,* and the *Cincinnati Daily Gazette* between May 20, 1873 and June 6, 1873; the several editorials from the *Volksblatt* were reprinted in the *Cincinnati Enquirer.* The "unwholesome" nature of fiction was discussed extensively within the budding library profession as well, and most city libraries wrestled with these concerns.

21. *Cincinnati Daily Gazette,* January 1, 1880, 4; *Decline and Fall of the Public Library,* 9–22; *Cincinnati Daily Gazette,* June 5, 1880, 4.

22. Young Men's Mercantile Library Association, *History of the Young Men's Mercantile Library* (Cincinnati: Ebbert & Richardson Co., 1935); William H. Venable, "The Cincinnati Society of Natural History," *The McMicken Review* 4(February 1890):24–26; Ford and Ford, *History of Cincinnati,* 230–34.

23. Joseph Wilby, "The Historical and Philosophical Society of Ohio," a paper read before the Society of Colonial Dames of America, Resident in Ohio, 1902, copy in the Public Library of Cincinnati and Hamilton County; Greve, *Centennial History,* 1:904–6.

24. C. G. Comegys, "Cincinnati: A Plea for an Institute," an address read before the Historical and Philosophical Society of Ohio, March 29, 1889, copy in the Public Library of Cincinnati and Hamilton County.

25. Charles T. Greve, "Clubs and Club Life," *New England Magazine* 6(September 1888):479–83; Laura Aldrich, Scrapbook, vol. 1, CHS; *Cincinnati Commercial,* July 7, 1878, 6.

26. James Parton is quoted in Greve, *Centennial History,* 1:859; *Church's Musical Visitor* 1(August 1872):7. The most thorough account of the city's theater life is in Russell James Grandstaff, "A History of the Professional Theatre in Cincinnati, Ohio, 1861–1886," (Ph.D. diss., University of Michigan, 1963).

27. *Cincinnati Graphic* 3(May 30, 1885):343; Grandstaff, "History," 95–97; *Cincinnati Daily Gazette,* March 13, 1880, 4. For a rather unusual but fascinating glimpse of local theater activity, see the Scrapbook of Programs, compiled by Lucille Rawson, PLCH.

28. Dramatic Festival Association, *Official Handbook of the Dramatic Festival,* ed. Montgomery Phister (Cincinnati: H. C. Hall, 1883), 12; Grandstaff, "History," 191–217; *Cincinnati Commercial-Gazette,* May 1, 1883, 1; May 2, 1883, 1. Unless otherwise indicated, the material on the Dramatic Festivals is taken from the Grandstaff dissertation.

29. The various out-of-town critics are quoted in *Cincinnati Commercial-Gazette,* May 1, 1883, 1; May 4, 1883, 1–2.

30. *Cincinnati Commercial-Gazette,* May 4, 1883, 4; G. W. Sheldon, "The Cincinnati Dramatic Festival," *Harper's Weekly* 27(May 5, 1883):279.

31. Unidentified newspaper clipping, May 19, 1884, in John Rettig Scrapbook, vol. 1, PLCH.

32. *Cincinnati Graphic* 2(January 17, 1885):39.

33. "Life of James E. Murdoch," in Dramatic Festival Association, *Official Handbook,* 43; "The Murdoch Testimonial Last Night," *Cincinnati Daily Gazette,* November 1, 1864, 4; *Cincinnati Commercial-Gazette,* May 5, 1883, 1.

34. Werner Sollors, "Emil Klauprecht's *Cincinnati, Oder Geheimnisse Des Westens* and the Beginnings of Urban Realism in America," *Queen City Heritage* 42(Fall 1984):39–48; Peter C. Marzio, *The Democratic Art: Pictures for a Nineteenth Century America* (Boston: David R. Godine, 1979), 131–32; *Lithography in Cincinnati* (Cincinnati: Young and Klein, Inc., n.d.), vol. 1, unpaged.

35. Marzio, *Democratic Art,* 131–33; Gibson Art Company, "Faith in America," typed manuscript, CHS.

36. Marzio, *Democratic Art,* 127, 134, 145–47; *Lithography,* vol. 1, unpaged.

37. Marzio, *Democratic Art,* 134–45; John W. Merton, "Stone by Stone Along a Hundred Years With the House of Strobridge," *Bulletin* of the Historical and Philosophical Society of Ohio, 8(January 1950):9–30; Alden N. Monroe, "Bigtop to Bijou: The Golden Age of the Show Poster," *Queen City Heritage* 42(Summer 1984):3–14. The Hennegan Company, founded in 1886 and still active in the city, built its future on movie posters, producing promotional art from 1900 up to the present day.

38. Joseph Pennell is quoted in Merton, "Stone by Stone," 3.

39. For an interesting appraisal of Cincinnati's intellectual contributions, which inadvertently revealed the slightness of that contribution, see "Literary Cincinnati," *Literary World* 13(July 29, 1882):249–51.

Notes to Interlude: Mr. Probasco

1. Unless otherwise indicated the information on the Tyler Davidson Fountain comes from William Frederick Poole, *The Tyler Davidson Fountain* (Cincinnati: Robert Clarke & Co., 1872). Poole was head of the Cincinnati Public Library at this time.

2. For the comment about Fifth Street, see Joseph S. Hill to Henry Probasco, July 22, 1869, Tyler Davidson Papers, box 2, folder 6, CHS.

3. "Henry Probasco," *Biographical Encyclopaedia of Ohio of the Nineteenth Century* (Cincinnati: Galaxy Publishing Co., 1876), 521.

4. Because of the legal difficulties surrounding the Fifth Street location, Probasco considered several other sites, including the corner of Race and Eighth Streets, Pearl Street between Plum and Elm, and an area next to the Isaac M. Wise Temple on Plum Street; see Davidson Papers, box 2, folder 6.

5. Probasco to William Lowry, February 14, 1867; Probasco to Charles Wilstach, February 15, 1867, reproduced in Chalmers Hadley, "A Famous Landmark," typed manuscript, PLCH.

6. See the correspondence from Frederick von Mueller to Probasco, Davidson Papers, box 1, folder 4.

7. Greve, *Centennial History of Cincinnati,* 1:872; Marian Knight, "The Fountain: Rededication to a Second Century," *Bulletin* of the Cincinnati Historical Society, 29(Summer 1971):100–115.

Chapter 7

1. *Cincinnati Graphic* 1(September 20, 1884):2.

2. George Ward Nichols, "Private Picture Collections in Cincinnati," *The Galaxy* 10(October 1870):511–20; Joseph E. Holliday, "Collector's Choice of the Gilded Age," *Bulletin* of the Cincinnati Historical Society, 28(Winter 1970):295–312; Henry Hooper, "Art and Music in Cincinnati," *The New England Magazine* 6(September 1888):462.

3. Holliday, "Collector's Choice," 295–312; Edward Strahan, *The Art Treasures of America* (Philadelphia: George Barrie, 1880), 75–80. Several Cincinnatians relied on the advice of Moncure Conway, a Unitarian minister and former resident of the city, in selecting contemporary European works. Conway was at that time residing in London; see Conway's letters to Learner B. Harrison in Art Museum Records, Record Group 3, series 3, box 1, CAM.

4. James H. Rodabaugh, "Charles T. Webber," *Museum Echoes* 27(August 1954): 59–62; *Cincinnati Enquirer,* December 18, 1873, 4. A brief but insightful account of the city's art life during this period is Bruce Weber, "Frank Duveneck and the Art Life of Cincinnati, 1865–1900" in Cincinnati Art Museum, *The Golden Age,* 23-32.

5. Billy R. Booth, "A Survey of Portrait and Figure Painting by Frank Duveneck, 1848–1919," (Ph.D. diss., University of Georgia, 1970), 8–28; Josephine Duveneck, *Frank Duveneck, Painter-Teacher* (San Francisco: John Howell—Books, 1970), 27-48; *Cincinnati Commercial,* December 18, 1873, 4. The fourteen panels in Covington's Mother of God Church, painted in 1862–63, attest to Duveneck's early talent.

6. Duveneck, *Frank Duveneck,* 49-60; *Cincinnati Commercial,* December 18, 1873, 4; Booth, "Survey of Portraits," 55–60. Herman Goepper later sold *The Circassian Soldier,* now in the Boston Museum of Fine Arts, for $800 and then sent Duveneck $200. See *Cincinnati Daily Times,* March 18, 1876, 2.

7. Duveneck, *Frank Duveneck,* 73–88; Norbert Heerman, "Frank Duveneck" in *Paintings by Frank Duveneck* (New York: Whitney Museum of Art, 1938), 3–8; Oliver Dennett Grover, "Duveneck and His School," typed manuscript, Frank Duveneck file, CAM.

8. Duveneck, *Frank Duveneck,* 76–91; Elizabeth Boott to William Morris Hunt's Class, July 25, 1878, Elizabeth Duveneck Papers, box 1, folder 16, CHS.

9. Elizabeth Boott to "My Dear Bessie," February 22, 1886, Elizabeth Duveneck Papers, box 1, folder 3, CHS.

10. Duveneck, *Frank Duveneck,* 123–28; Booth, "Survey of Portraits," 197–205.

11. "Our Artists," *Cincinnati Enquirer,* March 22, 1874, 7.

12. *Cincinnati Times-Star,* September 4, 1929, clipping in William J. Baer file, CAM; Richard J. Boyle, "Introduction," in *Robert F. Blum, A Retrospective Exhibition* (Cincinnati:

Cincinnati Art Museum, 1966), 3–7; Robert F. Blum, "An Artist in Japan," *Scribner's Magazine* 13(April 1893):399–428.

13. Charles H. Caffin, "Robert Frederick Blum," *The International Studio* 25(December, 1903):cxcii; Joseph Pennell, *Pen Drawing and Pen Draftsmanship* (New York: Macmillan Co., 1920), 296; Lida Rose McCabe, "The Robert Frederick Blum Scholarship: A Productive Memorial," *Form,* November 1913, 16–17, 29.

14. Boyle, "Introduction," 7.

15. Corcoran Gallery of Art, *Edward Potthast, 1857–1927* (Washington, D.C.: Corcoran Gallery of Art, 1973); Arlene Jacobowitz, "Edward Henry Potthast," in Brooklyn Museum of Art, *Annual Report,* 1967–68 (New York: Brooklyn Museum of Art, 1969), 113–28.

16. *Cincinnati Graphic* 4(October 10, 1885):313; *Cincinnati Enquirer,* June 21, 1935, 15; Lorado Taft, *The History of American Sculpture* (New York: Macmillan Co., 1930), 399–401; Albert Bernhardt Faust, *The German Element in the United States* (New York: Houghton Mifflin Co., 1909), 2:312–13.

17. John Douglass Hale, "The Life and Creative Development of John Henry Twachtman," (Ph.D. diss., Ohio State University, 1957), 1:6; Richard J. Boyle, *John Twachtman* (New York: Watson-Guptill Publications, 1979), 9–12.

18. Boyle, *John Twachtman,* 13–15; Hale, "Life and Creative Development," 37, 52; Norbert Heerman, *Frank Duveneck* (New York: Houghton Mifflin Co., 1918), 46.

19. Boyle, *John Twachtman,* 16–20; Hale, "Life and Creative Development," 88; Carolyn Mase, "John H. Twachtman," *The International Studio* 72(January 1921):lxxi; William P. Teal, "Cincinnati's Preeminence in Painting and Sculpture," *The Contribution of Cincinnati to Modern Art* (Cincinnati: Board of Education, 1923), 16; Richard J. Boyle, *American Impressionism* (Boston: New York Graphic Society, 1974), 166; Richard J. Boyle, "The Second Half of the Nineteenth Century" in *The Genius of American Painting,* ed. John Wilmerding (New York: William Morrow Co., 1973), 184.

20. *Cincinnati Enquirer,* April 2, 1929, 24.

21. Gustav Kobbe, "Portraits and Ideals by William J. Baer," *New York Herald,* June 26, 1910, Magazine section, 11.

22. Mary Alice Heekin Burke, *Elizabeth Nourse, 1859–1938; A Salon Career* (Washington, D.C.: Smithsonian Institution Press, 1983), 15–50; Mary Alice Heekin Burke, "Elizabeth Nourse: Cincinnati's Most Famous Woman Artist," *Queen City Heritage* 41(Winter 1983):65–66.

23. Grover, "Duveneck and His School," CAM; "A Review of Cincinnati's Past in the Field of Art," *Cincinnati Enquirer,* May 19, 1915, section 3, p. 7; Cincinnati Art Museum, *The Works of Joseph R. DeCamp: Special Exhibition, October, 1924* (Cincinnati: Cincinnati Art Museum, 1924).

24. Richard Murray, "Kenyon Cox and the Art of Drawing," *Drawing* 3(June 1981):1–6; "Kenyon Cox" in Cincinnati Art Museum, *Golden Age,* 40; *Cincinnati Commercial Tribune,* March 22, 1915, 8; "Kenyon Cox," *Biographical Sketches of American Artists* (East Lansing: Michigan State Library, n.d.), clipping section, 3; *Dictionary of American Biography,* s.v. "Cox, Kenyon"; Kenyon Cox, *An American Art Student in Paris: the Letters of Kenyon Cox, 1877–1882,* ed. H. Wayne Morgan (Kent, Ohio: Kent State University Press, 1987).

25. Denny Carter, *Henry Farny* (New York: Watson-Guptill Publications, 1978), 15–17; Denny Carter, "Henry Farny," *The American West* 15(November–December 1978):36–38; Carolyn M. Appleton and Natasha S. Bartaline, "Henry Farny, 1847–1916," in *Henry Farny, 1847–1916* (Austin: University of Texas Press, 1983), 9–10; "In Farny's Studio," *Cincinnati Commercial Tribune,* October 6, 1895, clipping in Farny Papers, box 1, folder 10, CHS. Unless otherwise indicated, the material on Farny is taken from Carter's fine biography.

26. *Cincinnati Enquirer,* March 22, 1874, 7.

27. Carter, "Henry Farny," 39.

28. Ibid. The gregarious Farny included among his many acquaintances Sarah Bernhardt, Mark Twain, Ulysses Grant, Oscar Wilde, Sitting Bull, Geronimo, Robert Louis Stevenson, and Theodore Roosvelt, and the writer F. Hopkinson Smith who immortalized the artist as the character "Marny" in several of his short stories.

29. Forrest Fenn, *The Beat of the Drum and the Whoop of the Dance: A Study of the Life and Work of Joseph Henry Sharp* (Santa Fe: Fenn Publishing Co., 1983). Unless otherwise indicated, the material on Sharp is taken from this biography.

30. Other Cincinnati painters of Indian life were John Hauser, Ernest Blumenschein, and Ferdinand Lundgren, the first two of whom remained linked to the Taos group; see Arrell Morgan Gibson, *The Santa Fe and Taos Colonies: Age of the Muses, 1900-1942* (Norman: University of Oklahoma Press, 1983), and Laura M. Bickerstaff, *Pioneer Artists of Taos* (Denver: Sage Books, 1955).

31. Cincinnati Academy of Fine Arts, *Catalogue of the First Exhibition at Wiswell's Gallery, 1868* (Cincinnati: Robert Clarke & Co., 1868); Holliday, "Collector's Choice," 295; *Cincinnati Commercial Tribune,* April 18, 1915, 7.

32. Philip D. Spiess II, "Exhibitions and Expositions in Nineteenth Century Cincinnati," *Bulletin* of the Cincinnati Historical Society 28(Fall 1970):171–92; Holliday, "lector's Choice," 295–99. The most thorough account of the city's industrial expositions is in Philip D. Spiess II, "The Cincinnati Industrial Expositions (1870–1888): Propaganda or Progress?" (Master's thesis, University of Delaware, 1970).

33. *Church's Musical Visitor* 1(May 1872):7.

34. Duveneck, *Frank Duveneck,* 56–58; *Cincinnati Enquirer,* December 18, 1873, 4; E. H. Austerlitz, *Cincinnati, From 1800 to 1875, A Condensed History of Cincinnati Combined With Exposition Guide for 1875* (Cincinnati: Block & Co., 1875), 62–63.

35. Unidentified newspaper clipping, June 17, 1876, in John Rettig Scrapbook, vol. 1, unpaged, CHS; *Cincinnati Commercial,* March 21, 1915, 8; *Cincinnati Enquirer,* October 18, 1874, 1.

36. Burke, *Elizabeth Nourse,* 22; *Cincinnati Enquirer,* June 18, 1930, Magazine section, p. 3.

37. "Our Artists," *Cincinnati Enquirer,* March 22, 1874, 7.

38. *Cincinnati Enquirer,* December 18, 1873, 4; *Cincinnati Graphic* 1(November 1, 1884):7; *The Scientific, Literary, Social, Art and Public Education Institutions and Collections of Cincinnati and Vicinity* (Cincinnati: Robert Clarke & Co., 1881), 22.

39. *Cincinnati Daily Gazette,* November 18, 1887, 5.

40. *Cincinnati Enquirer,* February 6, 1883, 8; *Cincinnati Commercial Gazette,* February 6, 1883, 8; Twachtman's letter is reproduced in Boyle, *American Impressionism,* 164–65; *Cincinnati Graphic* 3(May 2, 1885):279; for Farny's struggles to make ends meet, see the many letters in Farny Family Papers, CHS.

41. *The Week: Illustrated* 1(October 6, 1883):82.

Chapter 8

1. Reginald C. McGrane, *The University of Cincinnati: A Success Story in Urban Higher Education* (New York: Harper & Row, 1963), 46–49; Samuel F. Hunt, *Charles McMicken, the Founder of the University of Cincinnati* (Cincinnati, 1892); Greve, *Centennial History,* 1:890–93.

2. McCrane, *University of Cincinnati,* 49–87; Greve, *Centennial History,* 1:891–93; *Church's Musical Visitor* 1(July 1872):7; *New York Tribune,* November 24, 1895, clipping in Scrapbook, RG 5, series 9, vol. 1, Cincinnati Art Museum.

3. Mary Noble Welleck Garretson, "Thomas S. Noble and His Paintings," *The New-York Historical Society Quarterly* 24(October 1940):113–23.

4. Garretson, "Thomas S. Noble," 113–23; Burke, *Elizabeth Nourse,* 20–21; "This Week in Art Circles," *Cincinnati Enquirer,* October 8, 1916, section 4, p. 8.

5. Garretson, "Thomas S. Noble," 114; Greve, *Centennial History,* 1:295; "Cincinnati Music Hall," *New York Tribune,* clipping in Scrapbook of Newspaper Clippings, Old Letters, Etc., 5, PLCH; Kenneth R. Trapp, " 'To Beautify the Useful': Benn Pitman and the Cincinnati Woodcarving Movement, 1873–1893," typed manuscript, CHS.

6. Trapp, " 'To Beautify the Useful'," 4–17; Benn Pitman, *A Plea for American Decorative Art* (Cincinnati: C. J. Krehbiel & Co., 1895), 12; Julia Ross Alden, "Famous Fireplaces," unidentified newspaper clipping in Scrapbook: Miscellaneous Clippings (1880–86), 241, PLCH; *Cincinnati Enquirer,* May 13, 1875, 4.

7. Elizabeth F. Perry, "Decorative Pottery of Cincinnati," *Harper's Magazine* 62(May 1881):834; Herbert Peck, *The Book of Rookwood Pottery* (New York: Bonanza Books, 1968), 4.

8. Peck, *Rookwood Pottery,* 4; Kenneth R. Trapp, "Toward a Correct Taste: Women and the Rise of the Design Movement in Cincinnati, 1874–1880" in Cincinnati Art Museum, *Celebrate Cincinnati Art,* 51–53.

9. Dee Brown, *The Year of the Century* (New York: Charles Scribner's Sons, 1966), 112–30, 138–43, 290.

10. Howells quoted in Lally Weymouth and Milton Glaser, *America in 1876: The Way We Were* (New York: Random House, 1976), 36; Trapp, "Toward a Correct Taste," 51–53.

11. Peck, *Rookwood Pottery,* 4.

12. Trapp, "Toward a Correct Taste," 54; M. Louise McLaughlin to Clara C. Newton, April 6, 1893, Newton Papers, box 1, item 92, CHS; *Cincinnati Enquirer,* February 20, 1878, 8.

13. *The Scientific, Literary . . . Institutions,* 22; Carol Macht, "Introduction," in Cincinnati Art Museum, *The Ladies, God Bless 'Em: The Women's Art Movement in Cincinnati in the Nineteenth Century* (Cincinnati: Cincinnati Art Museum, 1976), 10.

14. Trapp, "Toward a Correct Taste," 59–60; Peck, *Rookwood Pottery,* 5–6; Maria Longworth Storer, *The History of the Cincinnati Musical Festivals and of the Rookwood Pottery* (Paris: Herbert Clarke, 1919); Macht, "Introduction," 10–11.

15. Kenneth R. Trapp, "Rookwood and the Japanese Mania in Cincinnati," *Bulletin* of the Cincinnati Historical Society, 39(Spring 1981), 59–60; *Cincinnati Times-Star* [June 1880], clipping in John Rettig Scrapbook, vol. 1, CHS; *Washington Post,* November 25, 1878, clipping in Mary Louise McLaughlin Scrapbook, compiled by Ross Purdy, CHS; also see *Cincinnati Daily Gazette,* October 14, 1878, 5, for additional evidence of the city's growing reputation.

16. Trapp, "Toward a Correct Taste," 61–66; Lucile Henzke, *American Art Pottery* (New York: Thomas Nelson, Inc., 1970), 173–82.

17. Peck, *Rookwood Pottery,* 6–7; "Midget," "Cincinnati as an Art Center—John Rettig," *Criterion* 1(October 1887):114–19.

18. Peck, *Rookwood Pottery,* 7. This exhibit became an annual event, with the site of the show changing; in 1881 the Pottery Club displayed its work at the Literary Club, the first time, according to one newspaper, "its secret precincts" had been "invaded by womanhood," *Cincinnati Daily Gazette,* April 30, 1881, 4.

19. Trapp, "Toward a Correct Taste," 67.

20. *Cincinnati Daily Gazette,* November 27, 1879, 6; Peck, *Rookwood Pottery,* 8–9; *Cincinnati Daily Gazette* (c.1880), clipping in Margaret King Scrapbook, CHS; Storer, *Cincinnati Musical Festivals.*

21. Clara Chipman Newton, "Early Days at Rookwood Pottery," handwritten manuscript, Newton Papers, box 2, folder 7, CHS; Peck, *Rookwood Pottery,* 8–12.

22. Peck, *Rookwood Pottery,* 9; Newton, "Early Days," 6–10.

23. Newton, "Early Days," 12–18.

24. Ibid., 1–3; Elizabeth R. Kellogg, "The Chicago World's Fair" in *Clara Chipman Newton: A Memorial Tribute* (Cincinnati: privately printed, 1938), 7–13; Laura Fry to Florence Murdoch, May 1, 1937, Laura Fry Papers, CHS; "Clara Chipman Newton," in Cincinnati Art Museum, *The Ladies,* 64–65.

25. Peck, *Rookwood Pottery,* 12–15; Newton, "Early Days," 10–12; Laura Fry to Ross Purdy, April 15, 1940, Purdy Collection, CHS; Kenneth E. Smith, "Laura Anne Fry: Originator of Atomizing Process for Application of Underglaze Color," *Bulletin* of the American Ceramic Society, 17(September 1938):368–72.

26. Peck, *Rookwood Pottery,* 10–11; "War Among the Potters," *Cincinnati Daily Gazette,* October 7, 1880, 8.

27. Peck, *Rookwood Pottery,* 19–21; Joseph Bailey, Sr., to Clara Chipman Newton, July 9, 1882, Newton Papers, box 1, item 3.

28. Peck, *Rookwood Pottery,* 24–25; *Cincinnati Daily Gazette,* March 20, 1883, 4.

29. Peck, *Rookwood Pottery,* 25–30; Newton, "Early Days," 1–3.

30. Peck, *Rookwood Pottery,* 31–32.

31. Ibid., 32–37; Trapp, "Rookwood and the Japanese Mania," 64–68.

32. Peck, *Rookwood Pottery,* 39–45; Rose G. Kingsley, "Rookwood Pottery," *The Art Journal* (London), 59(November 1897):341. Rookwood enjoyed financial success until sales slipped during the 1930s; the pottery never recovered and it moved to Starkville, Mississippi in 1960. Operations ceased in 1967.

33. Pitman, *American Decorative Art,* 10–13; "Cincinnati Music Hall," *New York Tribune,* clipping in Scrapbook of Newspaper Clippings, Old Letters, Etc., PLCH.

34. Pitman, *American Decorative Art,* 5–17. For a thorough understanding of John Ruskin's influence on American thought, see Roger B. Stein, *John Ruskin and Aesthetic Thought in America, 1840–1900* (Cambridge: Harvard University Press, 1967); a somewhat different perspective may be found in T. J. Jackson Lears, *No Place of Grace: Antimodernism and the Transformation of American Culture, 1880–1920* (New York: Pantheon Books, 1983), 60–96.

35. "Ceramics in Art," *Cincinnati Commercial,* September 29, 1879, 2; George Ward Nichols, Art Education Applied to Industry (New York: Harper & Brothers, 1877), 17–42.

36. *Cincinnati Daily Gazette,* May 21, 1878, 4.

Notes to Interlude: Alfred Traber Goshorn

1. The best account of the evening is in *Cincinnati Daily Gazette,* April 5, 1877, 2. The 1876 Centennial Exhibition is usually considered the nation's first World's Fair. New York attempted one in 1853, but the European community did not support the enterprise.

2. Ibid., 2; Greve, *Centennial History,* 1:882.

3. "Alfred Traber Goshorn" in Marietta College, *The Alumni Memorial* 9(1903):

34–35; Harry Ellard, *Baseball in Cincinnati* (Cincinnati: [Johnson and Hardin], 1907), 39–76; Greve, *Centennial History,* 1:851, 874, 962.

4. The most thorough account of the history and organization of the Cincinnati Industrial Expositions is Spiess, "Cincinnati Industrial Expositions."

5. Greve, *Centennial History,* 1:851; "Alfred Traber Goshorn," 36.

6. Faith K. Pizor, "Preparations for the Centennial Exhibition of 1876," *The Pennsylvania Magazine of History and Biography* 94(April 1970):213–32.

7. A very perceptive account of the Centennial Exhibition is John Maas, *The Glorious Enterprise: The Centennial Exhibition of 1876 and H. J. Schwarzmann, Architect-in-Chief* (Watkins-Glen, N.Y.: American Life Foundation, 1973). See also *Catalogue of a Collection of Books Presented to Alfred Traber Goshorn* (Cincinnati: Robert Clarke & Co., 1878).

8. Greve, *Centennial History,* 2:721–25.

9. "Alfred Traber Goshorn," 36–38.

Chapter 9

1. Quoted in Kenneth R. Trapp, "Art Palace of the West: Its Beginnings," in Cincinnati Art Museum, *Art Palace of the West* (Cincinnati: Cincinnati Art Museum, 1981), 17. Unless otherwise noted, the information on the Woman's Art Museum Association is from this excellent essay, and from Carol Macht's fine "Introduction" in Cincinnati Art Museum, *The Ladies.*

2. Cincinnati Academy of Fine Arts, *First Annual Report.* Stockholders of the ill-fated academy included Joseph, Nicholas, and Landon Longworth, George Ward Nichols, Maria Longworth Nichols, Pitts Burt, Julius Dexter, Learner B. Harrison, William S. Groesbeck, George K. Schoenberger, Rufus King, Larz Anderson, John Shillito, Manning Force, William Wiswell, Charles T. Webber, and Israel Quick, a collection of names that turns up repeatedly in the city's cultural history.

3. "Reports of the Early Attempts to Raise Money for the Museum, 1879–1881," a copy of a report, probably written by Elizabeth F. Perry, in History of the Museum file, Record Group 3, series 3, box 1, CAM.

4. Barbara Howe, "Uniting the Useful and Beautiful: The Arts in Cincinnati," *The Old Northwest* 4(September 1978):319–36.

5. Ibid.

6. *Cincinnati Daily Gazette,* May 15, 1880, 7.

7. Charles West's contribution came in part as a result of Melville Ingalls's prodding; see the letter from Ingalls to West, September 6, 1880, reproduced in Cincinnati Museum Association, *First Annual Report, 1881–1882,* 11. For Ingalls's very persuasive dinners, see Betty L. Zimmerman, "Art Palace of the West: Its Leaders" in Cincinnati Museum Association, *Art Palace,* 60.

8. Henry Probasco to Miss Neave, November 7, 1879; Probasco to Mr. Wendle, January 15, 1880, RG 2, series 1, box 1, folder 1, CAM. See also *The Week: Illustrated* 1(January 12, 1884):306.

9. Besides samples of Cincinnati pottery, WAMA acquired examples of German, English, French, and other American pottery, as well as representative pieces of Etruscan, Greek, and North American Indian pottery.

10. See typed copy of the museum's charter in RG 3, series 3, box 1, folder 22, CAM; Joseph Longworth to board of directors, University of Cincinnati, [1883], Art Academy Rec-

ords, RG 2, series 1, box 1, folder 3, CAM; *Cincinnati Commercial-Gazette,* November 27, 1889, clipping in Cincinnati Art Museum Scrapbook, 62, CAM.

11. Cincinnati Museum Association, *First Annual Report,* 46–47; Zimmerman, "Art Palace," 67–68; *Cincinnati Commercial,* December 3, 1882, 8.

12. L. P. di Cesnola to Cincinnati Museum Association, November 11, 1881; Charles G. Loring to Alfred Traber Goshorn, March 29, 1883, RG 2, series 1, box 1, folders 3 and 5, CAM; Goshorn to Loring, April 2, 1883, RG 2, series 2, vol. 1, CAM.

13. Goshorn to Sir Philip Cunliffe-Owen, November 26, and December 12, 1882, February 3, 1883, July 19, 1884, RG 2, series 2, vol. 1, CAM.

14. *Cincinnati Commercial,* December 3, 1882, 8; Margaret Rives King to Florence Carlisle, November 29, 1879, in History of Museum file, CAM; Macht, "Introduction," 9; Goshorn to William Henry Elder, April 3, 1886, RG 2, series 1, vol. 1, CAM; Zimmerman, "Art Palace of the West," 68; *Cincinnati Enquirer,* April 21, 1885, clipping in Cincinnati Art Museum Scrapbook, 32. During a two-year period (December 1883 to December 1885), the museum lost through death four of its most important supporters: Joseph Longworth, Charles West, Reuben Springer, and George Ward Nichols.

15. See the extensive correspondence to various museum officials (1881–85) in RG 2, series 1, boxes 1–22, CAM.

16. Ripley Hitchcock, "The Western Art Movement," *The Century Magazine* 32(August 1886):579; unidentified newspaper clipping in Cincinnati Art Museum Scrapbook, 50, CAM.

17. See folder entitled "Replies to the Opening of the Museum," RG 2, series 1, box 2, CAM.

18. *Cincinnati Enquirer,* May 18, 1886, 4.

19. Howe, "Uniting the Useful," 330–31; John Sartain to Goshorn, January 26, 1886, William P. Pepper to Goshorn, January 21, 1886, and L. P. di Cesnola to Goshorn, January 21, 1886, all in RG 2, series 1, box 3, CAM.

20. *Western Christian Advocate* is quoted in *Cincinnati Enquirer,* July 17, 1886, 4; Sartain to Goshorn, January 26, 1886, and Pepper to Goshorn, January 21, 1886, RG 2, series 1, box 3, CAM. See also Cincinnati Museum Association, *Annual Report, 1890* (Cincinnati: Robert Clarke & Co., 1890), 18.

21. *Cincinnati Commercial,* December 17, 1877, 8; Trapp, " 'To Beautify the Useful,' " CHS; Kenyon Cox to "Dear Father," September 21, 1879, in Cox, *An American Art Student in Paris,* 175–76. The elder Cox was being considered for the presidency of the University of Cincinnati, a position which his son hoped would allow him to carry out reforms in the art school. Although not selected at this time, Cox did serve as dean of the Cincinnati Law School and, from 1885 to 1889, as president of the university.

22. For the best description of the McMicken School's art show, see "The Last Day," *Cincinnati Commercial,* June 18, 1881, 7; the letter from Roger Wilson is in the same issue, same page.

23. *Cincinnati Commercial,* June 19, 1881, 2. Among the students supporting Louis Rebisso were Caroline Lord, Elizabeth Nourse, Laura Fry, and Clement J. Barnhorn.

24. *Cincinnati Commercial,* June 19, 1881, 2; June 21, 1881, 2; June 22, 1881, 2; June 24, 1881, 7.

25. Denny C. Young, "The Longworths: Three Generations of Art Patronage in Cincinnati," Cincinnati Art Museum, *Celebrate Cincinnati Art,* 31–32; Trapp, "Art Palace of the West," 31–32.

26. McGrane, *University of Cincinnati,* 88–90; Joseph Longworth to University of Cincinnati Board of Trustees, [1882], RG 2, series 1, box 1, CAM; *Cincinnati Commercial,* December 9, 1882, 8.

27. Cincinnati Museum Association, *Third Annual Report* (Cincinnati: Robert Clarke & Co., 1883), 14; J. Edwards Clarke to Goshorn, [1882], RG 2, series 1, box 1, CAM; *The Courier,* June, 1884, in Cincinnati Art Museum Scrapbook, 31.

28. W. W. Peabody to Melville Ingalls, June 13, 1885, Willis P. Tharp to Ingalls, November 13, 1884, and Tharp to David Sinton, September 21, 1885, all in RG 2, series 1, box 1, CAM; Cincinnati Art Museum, *Fourth Annual Report, 1885* (Cincinnati: Robert Clarke & Co., 1886), 9.

29. *Cincinnati Graphic* 3(January 3, 1885):4; William H. Humphreys to Museum Board, [1885], RG 2, series 1, box 1; Goshorn to Martha Keller, June 13, 1885, RG 2, series 2, vol. 1, p. 238; Goshorn to Keller, February 8, 1887, RG 2, series 2, vol. 2, p. 102; William W. Rothacker to Goshorn, November 15, 1885; December 31, 1885, RG 2, series 1, box 1; Goshorn to Rothacker, November 18, 1885, RG 2, series 2, vol. 1, p. 279, all in CAM.

30. Ripley Hitchcock to Goshorn, May 18, and June 5, 1886, RG 2, series 2, box 3, CAM; Hitchcock, "Western Art Movement," 576–93.

31. Thomas S. Noble to Goshorn, May 19, 1887, RG 2, series 1, box 4; Noble to Goshorn, May 20, 1887, RG 2, series 1, box 1, CAM. Three years before Noble made his trip to the East, the *Cincinnati Graphic* had criticized the academy's "unwarranted opposition" to the use of nude models, pointing out that it was "over-prudish" and a great handicap for developing artists. Goshorn undoubtedly read this and Noble's trip was his gentlemanly way of pushing the principal towards the future; see *Cincinnati Graphic* 1(October 25, 1884):2.

32. Goshorn to Joseph Henry Gest, March 13, 1889, RG 2, series 1, box 8; Goshorn to Ingalls, February 27, 1890, RG 2, series 1, box 9, CAM.

33. "The Art Museum," unidentified newspaper clipping, June 24, 1893, Cincinnati Art Museum Scrapbook, 132.

34. "Address of Melville E. Ingalls, President," Cincinnati Museum Association, *Seventh Annual Report* (Cincinnati: Robert Clarke & Co., 1887), 39–41; Ingalls to Julius Dexter, March 30, 1889, RG 2, series 1, box 7, CAM.

35. *Cincinnati Commercial-Gazette,* March 9, 1890, 4; March 7, 1890, 4. Director Goshorn seldom accepted his salary, a fact unknown to the general public.

36. See respective *Annual Reports* of the Cincinnati Museum Association, as well as the catalogues of the annual Spring Exhibitions.

37. Cincinnati Museum Association, *Nineteenth Annual Report,* 1899 (Cincinnati: Robert Clarke & Co., 1900); Lewis H. Meakin to Joseph H. Gest, July 28, 1893, and June 20, 1890, Gest Papers.

38. Ingalls to Goshorn, September 14, 1890, RG 2, series 1, box 9, CAM; *Cincinnati Commercial-Gazette,* October 10, 1890, 4.

39. See Cincinnati Museum Association, *Annual Reports.*

Chapter 10

1. R. F. Outcault, "Among the Artists," *The Criterion* 1(November 1887):135–36; Ernest Bruce Haswell, "The Cincinnati Art Club," *Bulletin* of the Historical and Philosophical Society of Ohio, 9(July 1951): 203–5.

2. *The Week: Illustrated* 1(January 5, 1884): 294. The Sketch Club active in the 1860s included James H. Beard, Charles T. Webber, Thomas D. Jones, Thomas S. Noble, Israel Quick, and possibly Henry Farny.

3. Unidentified newspaper clipping in Rettig Scrapbook, vol. 3, CHS. Considerable in-

formation may also be found in Theodore A. Langstroth, comp., "The Colorful World of John Rettig," PLCH.

4. Langstroth, "Colorful World," vol. 2, PLCH; John Rettig, "Account Book," PLCH; unidentified newspaper clipping, October 15, 1887, in Rettig Scrapbook, vol. 3, CHS; Alexandrina Ramsay, "The Art of a Scene Painter," *Monthly Illustrated* 4(June 1895): 329–35.

5. Cincinnati Art Club, "History of the Cincinnati Art Club, 1890–1968," typed manuscript, PLCH; Fenn, *Beat of the Drum*, 87–88. Original members included McLaughlin, Bartlett, Edward Butler, Matt Daly, Albert Elzner, Edward Johnston, Remington Lane, Lewis Lutz, William McCord, Percy Morris, Joseph Sharp, Van Loo, Rettig, and the dog.

6. Cincinnati Art Club, "History," 23–30; Fenn, *Beat of the Drum*, 79–82.

7. Woman's Art Club Constitution (1892), box 1; Mary Spencer, "A Sketch," box 14; and Woman's Art Club, "Minutes," January 14, 1893, box 2, all in Woman's Art Club Papers, CHS. Charter members included Laura Fry, Dixie Selden, Annie Sykes, Caroline Lord, Kate Wilson, Clara Newton, and Mary Spencer.

8. "Charles Meurer," in Cincinnati Art Museum, *Golden Age,* 85; Charles A. Meurer, Advertising Flyer, RG 2, series 1, box 18, CAM; Ernest Bruce Haswell, "Cincinnati as an Art Center," *Art and Archaeology* 8(September–October 1919), 257. For more on Meurer, especially concerning his painting *My Passport,* which attracted considerable attention at the Chicago World's Fair when government officials confiscated it because of its life-like display of money, see Elsie W. Flagle, "My Uncle: C. A. Meurer, A Celebrated Still-Life Artist," PLCH.

9. Joseph Henry Gest, "The Exhibition of the Society of Western Artists," *International Studio* 22(April 1904):ccxlv–cclvi; *Lewis Henry Meakin* (Cincinnati: Cincinnati Art Museum, 1918).

10. *Chicago Tribune* quoted in Reid Badger, *The Great American Fair: The World's Columbian Exposition and American Culture* (Chicago: Nelson Hall, 1979), 45.

11. The heated correspondence between M. Louise McLaughlin and Maria Storer is in the Clara Newton Papers, CHS.

12. Henry F. Farny to Joseph Henry Gest, February 17, 1896, box 21; and Leon Van Loo to Gest, May 28, 1893, box 16, RG 2, series 1, CAM.

13. Meakin to Gest, [1893], Gest Papers, box 2; Woman's Columbian Association of Cincinnati and Suburbs, "Minutes," April 18, 1892, 29. For a list of paintings by Cincinnati artists exhibited at the Chicago World's Fair, see RG 2, series 1, box 16, CAM; and for further information on the role of Cincinnati women, see Woman's Columbian Association of Cincinnati, *Catalogue of the Exhibit in the Cincinnati Room* (Cincinnati, 1892); and Jeanne Madeline Weimann, *The Fair Women* (Chicago: Academy Chicago, 1981), 221–32.

14. For the magazine articles on the Art Academy, see various clippings in Academy Records, RG 2, series 1, box 1, folder 26, CAM.

15. E. Gest to Clarissa Gest, May 2, 1875, Gest Papers, box 2; Arthur T. Hamlin, *Harvard and Cincinnati: A Century of Service* (New York: Archon Books, 1969), 1–22.

16. Peck, *Rookwood Pottery,* 100; Elizabeth R. Kellogg, *Memories of Joseph Henry Gest: Gentleman, Scholar, Administrator and Artist* (Cincinnati: Byway Press, 1937), 7–15.

17. *Cincinnati Tribune,* February 25, 1894, 14.

18. Lewis Lutz to Gest, June 26, August 22, and 28, 1893, Gest Papers, box 2.

19. *Cincinnati Times-Star,* November 6, 1893, clipping in Cincinnati Art Museum Scrapbook, 137; Meakin to Gest, November 28, 1893, Gest Papers, box 2.

20. *Cincinnati Commercial-Gazette,* March 4, 1890, 5; March 7, 1890, 4; May 18, 1890, 1, 4.

21. Mrs. Bellamy Storer to Goshorn, [1899], RG 2, series 1, box 8, CAM; *Cincinnati*

Times-Star, May 29, and October 22, 1890, clippings in Cincinnati Art Museum Scrapbook, 92. The first scholarships were awarded to Bruce Horsfall, Mrs. W. B. Newman, Mary Hall, F. Marcia Hunt, Artus Van Briggle, and Mary Sheerer. Horsfall received the first foreign scholarship.

22. Maria Storer to Gest, April 2, and April [?], 1891, RG 3, series 4, box 1, CAM.

23. Storer to Ingalls, [1892], RG 2, series 1, box 14, CAM; Lutz to Gest, June 14, and August 14, 1892, Gest Papers, box 2. The Chamber Scholarships, established by John W. Chamber in 1891, offered European study to students from Boston, New York, Philadelphia, and Cincinnati; apparently the major art institutions nominated students and in part funded the program.

24. Storer to Ingalls, [1892], RG 2, series 1, box 14, CAM.

25. Storer to Ingalls, September 4, 1894, and January 29, 1896, RG 2, series 1, boxes 18 and 22, CAM.

26. "Proposal for Foreign Scholarship" (draft), September 10, 1887, Academy Records, RG 2, series 2, box 1, folder 2, CAM; Clement Barnhorn to Gest, October 6, 1895, Gest Papers, box 2; "Scholarship Proposal" (draft), [1892], Academy Records, RG 2, series 3, box 1, folder 1, CAM; Cincinnati Museum Association, *Twelfth Annual Report, 1892* (Cincinnati: Robert Clarke & Co., 1893).

27. Robert Julian to Thomas S. Noble, June 21, 1894, Academy Records, RG 2, series 3, box 1, folder 14; Noble to Goshorn, June 23, 1894, RG 2, series 1, box 18, CAM; Cincinnati Museum Association, *Twenty-Fourth Annual Report, 1904* (Cincinnati, 1905).

28. Storer to Gest, November 23, 1892; Mrs. W. B. Newman to Gest, May 23, 1896, RG 2, series 1, boxes 14 and 22, CAM.

29. Edward Simmons, *From Seven to Seventy* (New York: Harper's, 1922), 17; George Biddle, *An American Artist's Story* (Boston: Little, Brown and Co., 1939), 125–26. Other Americans who studied at the Academie Julian about this time were Theodore Wendel, Childe Hassam, Willard Metcalfe, Robert Reid, Edmund Tarbell, Frank Benson, and Maurice Prendergast. For a description of the Academie, see Corwin K. Linson, "With the Paris Art Student," *Frank Leslie's Popular Monthly* 34 (September 1892):289–302.

30. Meakin to Gest, January 20, and June 20, 1890, Gest Papers, box 2. Meakin supported the Impressionist movement and was strongly influenced by it, although he never considered himself an Impressionist. He particularly admired Claude Monet, and in 1893 tried to arrange a Monet exhibit for the Cincinnati Art Museum.

31. Meakin to Gest, July 28, 1893, ibid.

32. Lutz to Gest, September 20, 1891, ibid.

33. *Cincinnati Enquirer,* January 14, 1938, section 5, p. 8; Clement Barnhorn to Gest, September 12, 1891, January 16, 1892; and Vincent Nowottny to Gest, October 3, 1892, Gest Papers, box 2.

34. Vincent Nowottny to Thomas Noble, December 1, 1892, Academy Records, RG 2, series 1, box 1, folder 14, CAM; Meakin to Gest, September 15, 1893, Gest Papers, box 2; Charles Winter to Gest, April 19, 1895, Academy Records, RG 2, series 1, box 20, CAM.

35. Ingalls to Gest, June 21, 1894, RG 2, series 1, box 17, CAM; Cincinnati Museum Association, *Fourteenth Annual Report*; Clement Barnhorn to Gest, October 6, 1894, Gest Papers, box 2.

36. *Cincinnati Tribune* quoted in Bruce Weber, "Frank Duveneck and the Art Life of Cincinnati, 1865–1900," in Cincinnati Art Museum, *Golden Age,* 25.

37. Thomas Noble to L. B. Harrison, [1890], RG 2, series 1, box 10, CAM; Noble to Gest, [1893], Academy Records, RG 2, series 1, box 1, folder 10, CAM.

38. Noble to Goshorn, March 14, 1890, Academy Records, RG 2, series 1, box 1, folder 7, CAM; Meakin to Gest, [1904], Gest Papers, box 2.

39. "Art Notes and News," January 19, 1895, unidentified newspaper clipping in Cincinnati Art Museum Scrapbook, 112; *Cincinnati Commercial-Tribune*, February 25, 1894, ibid., 150. See also the extensive correspondence from Clement Barnhorn to Joseph Gest, Gest Papers, box 10.

40. *Cincinnati Commercial-Gazette*, December 29, 1895, 16.

Chapter 11

1. *Cincinnati Business Proclamation* (Cincinnati: City of Cincinnati, 1904); *Illustrated Cincinnati: The Queen City of the West: Its Past, Present, and Future* (New York: Acme Publishing and Engraving Company, 1891). Other turn-of-the-century assessments can be found in: George Mortimer Roe, *Cincinnati, The Queen City of the West* (Cincinnati: Cincinnati Times-Star Company, 1895); A. O. Kraemer, *Picturesque Cincinnati* (Cincinnati: A. O. & G. A. Kraemer, 1898); George W. Englehardt, *Cincinnati, The Queen City* (Cincinnati: George Englehardt Co., 1901), and *Cincinnati, Its Industrial and Commercial Advantages* (Cincinnati: Cincinnati Industrial Bureau, ca. 1908).

2. Roe, *Cincinnati,* 396; Melville E. Ingalls, "Response," in *Complimentary Dinner to Melville E. Ingalls* (Cincinnati: Robert Clarke & Co., 1905), 31.

3. John Leonard, *The Centennial Review of Cincinnati* (Cincinnati: J. M. Elstner & Co., 1888). Leonard's optimistic approach to the city's second century was largely based on Cincinnati's geographic location, an argument popular earlier in the century but which lost much of its merit after Chicago rearranged its own geography by means of canals and railroads. See also Spiess, "The Cincinnati Industrial Expositions."

4. Henry James is quoted in H. Wayne Morgan, *New Muses: Art in American Culture* (Norman: University of Oklahoma Press, 1978), 73.

5. Charles Dudley Warner, *Studies in the South and West* (New York: Harper and Brothers, 1889), 263–79; for his comments regarding Chicago, see pp. 176–232.

6. At the Chicago World's Fair, Cincinnati advertised itself as "the world's carriage building center," and in 1900 the city hosted the national convention of carriage makers.

7. Cincinnati Chamber of Commerce, "Statistics of Cincinnati," looseleaf notebook in PLCH.

8. The quotation is from Robert L. Steiner, "The Business Cycle in a Conservative City: A Study of Urban Growth and Cyclical Stability in Competing Industrial Areas," (master's thesis, Columbia University, 1948), 51.

9. *Catalogue of Pictures at the Ladies Gallery, First Exhibition, 1854* (Cincinnati, 1854), Academy Records, RG 2, series 1, box 1, folder 2, CAM. See also W. M. Ramsay's remark that art "lifts up the whole social body—high and low, rich and poor alike. It ennobles and dignifies labor, and stimulates all classes to lead more useful and more graceful lives," *Banquet in Honor of Melville E. Ingalls* (Cincinnati: Robert Clarke & Co., 1890).

10. Englehardt, *Cincinnati,* 279.

Bibliography

Archival and Manuscript Material

Cincinnati Art Museum (CAM)

Annual Exhibition of Works by American Artists, 1894–1904
Annual Reports, 1881–1905
Art Academy Records
Art Museum Records
Cincinnati Art Museum Scrapbook, 1882–1902
Jane Porter Hart Dodd Scrapbook, 3 vols.
Frank Duveneck Scrapbook, 2 vols.
Vertical Files—Cincinnati Artists

Cincinnati Historical Society (CHS)

Laura Aldrich Scrapbook
Art Clubs—Western Art Union Scrapbook
Cincinnati Museum Association, Letterpress Volume of Correspondence Relating
 to Building, Subscriptions, etc.
Cincinnati Musical Festival Association, Minutes of the Association and of the
 Board of Directors
Cincinnati Musical Festival Association, Minutes of Executive Committee
Cincinnati Musical Festival Association Papers
Tyler Davidson Papers
Julius Dexter Miscellaneous Papers
Elizabeth Duveneck Papers
Laura Fry Papers
Gest Family Papers
Harmonic Society of Cincinnati, Minutes

Miner K. Kellogg, Private Journal and Other Papers, 1835–1848, microfilm copy. Originals in Indiana State Historical Society

Margaret Rives King Scrapbooks, 3 vols.

Ladies' Picture Gallery Scrapbook

Lawrence Maxwell Scrapbook

Clara Chipman Newton Papers

George Ward Nichols, Scrapbook on Musical Festival

Hiram Powers Papers

Lucie R. Rawson, Scrapbook of Programs, 1878–1913

Semi-Colon Club Papers

Isaac Strohm Papers

August Wilde Scrapbook

Woman's Columbian Exposition Association of Cincinnati & Suburbs, Minutes, 1891

Woman's Art Club Papers

Public Library of Cincinnati and Hamilton County (PLCH)

The Cincinnati Pottery Club and M. Louise McLaughlin, Scrapbook compiled by Theodore A. Langstroth

Cincinnati Theatre Album (1888–1902), Scrapbook compiled by Theodore A. Langstroth

The Colorful World of John Rettig, Scrapbook compiled by Theodore A. Langstroth

John Rettig Account Book

John Rettig Scrapbook

Scrapbook: Miscellaneous Clippings from Cincinnati Newspapers, 1880–1886

Scrapbook of Newspaper Clippings, Old Letters, Etc.

The Sketch Club Scrapbook, compiled by Theodore A. Langstroth

University of Cincinnati, Special Collections (UC)

College-Conservatory of Music Papers

Newspapers

Brainard's Musical World, 1873–1875

Boston Daily Globe, 1875

Boston Evening Journal, 1873–1875

Chicago Tribune, 1873–1878

Church's Musical Visitor, 1871–1897

Cincinnati Commercial, 1869–1882

Cincinnati Commercial-Gazette, 1883–1895

Cincinnati Commercial-Tribune, 1895–1915

Cincinnati Daily Gazette, 1845–1887

Cincinnati Enquirer, 1851–1938

Cincinnati Graphic, 1884–1885

Cincinnati Inquisitor-Advertiser, 1818–1820

Cincinnati Saturday Night, 1879
Cincinnati Times-Star, 1890–1893
The Criterion, 1887–1889
The Dial, 1860
Dwight's Journal of Music, 1852–1882
Folio, 1878–1880
Indianapolis Journal, 1878
Indianapolis News, 1878–1880
The Ladies Knapsack, 1863–1864
Liberty Hall, 1811–1816
Musical Record, 1879–1880
Musical Review, 1879–1880
New York Herald, 1875
New York Times, 1873–1880
New York Tribune, 1873–1880
The Score, 1879–1880
The Week: Illustrated, 1883–1884
Western Art Journal, 1855
Western Literary Journal, 1836
Western Messenger, 1835–1841
Western Monthly Magazine, 1833–1837
Western Monthly Review, 1827–1830
Western Spy, 1810–1813

Primary Sources

An Act of Incorporation of the Cincinnati Academy of Fine Arts, With an Address to the Members of the Institution by John P. Foote. Cincinnati: G. T. Williamson, 1828.

Austerlitz, E. H. *Cincinnati, From 1800 to 1875: A Condensed History of Cincinnati Combined with Exposition Guide for 1875.* Cincinnati: Bloch & Co., 1875.

Blum, Robert F. "An Artist in Japan." *Scribner's Magazine* 13(April 1893): 399–428.

Board of Trade of Cincinnati. *First Annual Report of the Manufactures, Trade & Commerce of Cincinnati. . . . January 1, 1870.* Cincinnati: Charles F. Wilstach & Co., 1870.

Bremer, Fredrika. *The Homes of the New World: Impressions of America.* New York, 1854.

Catalogue of a Collection of Books Presented to A. T. Goshorn. Cincinnati: Robert Clarke & Co., 1878.

Catalogue of Pictures at the Ladies' Gallery, First Exhibition, 1854. Cincinnati, 1854.

Catalogue of the First Annual Exhibition of the Associated Artists of Cincinnati. Cincinnati: W. T. Norman, 1867.

Cincinnati Academy of Fine Arts. *Catalogue of First Exhibition at Wiswell's Gallery, 1868.* Cincinnati: Robert Clarke & Co., 1868.

————. *First Annual Report* (October 26, 1868). N.p., n.d.

Cincinnati Business Proclamation. Cincinnati: City of Cincinnati, 1904.

Cincinnati Chamber of Commerce. *Annual Review for the Commercial Year Ending August 17, 1865.* Cincinnati: Gazette Steam Printing House, 1865.

————. "Statistics of Cincinnati." Looseleaf notebook, Public Library of Cincinnati and Hamilton County.

Cincinnati, Its Industrial and Commercial Advantages. Cincinnati: Cincinnati Industrial Bureau, 1908.

"The Cincinnati May Festival." *Rochester Musical Times* 5(May 15, 1873):1.

Cincinnati Museum Association. *Catalogue of the Spring Exhibition, 1895.* Cincinnati: Cincinnati Museum Association, 1895.

————. *Fourth Annual Exhibition of the Cincinnati Art Club.* Cincinnati, 1894.

Cincinnati Music Hall Association. *Annual Report, 1877.* Cincinnati, 1877.

Cincinnati Musical Festival Association. *Fifth Biennial Musical Festival at Cincinnati, 1882.* Cincinnati: Cincinnati Musical Festival Association, 1882.

Cist, Charles. *Cincinnati in 1841: Its Early Annals and Future Prospects.* Cincinnati: E. Morgan & Co., 1841.

————. *Sketches and Statistics of Cincinnati in 1851.* Cincinnati: William H. Moore & Co., 1851.

————. *Sketches and Statistics of Cincinnati in 1859.* Cincinnati, 1859.

Comegys, C. G. "Cincinnati: A Plea for an Institute." An address presented before the Historical and Philosophical Society of Ohio, March 29, 1889. Public Library of Cincinnati and Hamilton County.

Complimentary Dinner to Alfred T. Goshorn, April 4, 1877. Cincinnati: Robert Clarke & Co., 1877.

Complimentary Dinner to Melville E. Ingalls. Cincinnati: Robert Clarke & Co., 1905.

Conway, Moncure D. *Autobiography, Memories, and Experiences of Moncure Daniel Conway.* 2 vols. Boston: Houghton Mifflin & Co., 1904.

Cowell, Joe. *Thirty Years Passed Among the Players in England and America.* New York: Harper & Brothers, 1844.

Cox, Kenyon. *An American Art Student in Paris: the Letters of Kenyon Cox, 1877-1882.* Edited by H. Wayne Morgan. Kent, Ohio: Kent State University Press, 1987.

"Dear Julia: A Letter from Cincinnati, Written in 1870." *Bulletin* of the Cincinnati Historical Society, 18(April 1960):105-15.

The Decline and Fall of the Public Library of Cincinnati. Cincinnati, 1886.

Dickens, Charles. *American Notes and Pictures from Italy.* London: Macmillan & Co., 1893.

Drake, Daniel. "Remarks on the Importance of Providing Literary and Social Concert in the Valley of the Mississippi." *Cincinnati Mirror* 4(February 15, 1834):143.

Dramatic Festival Association. *Official Handbook of the Dramatic Festival.* Edited by Montgomery Phister. Cincinnati: H. C. Hall, 1883.

Englehardt, George. *Cincinnati, the Queen City.* Cincinnati: George Englehardt Co., 1901.

Foote, John P. *Memoirs of the Life of Samuel E. Foote.* Cincinnati: Robert Clarke & Co., 1860.

———. *The Schools of Cincinnati, and Its Vicinity.* Cincinnati: G. F. Bradley & Co., 1855.

Ford, Henry A., and Kate B. Ford. *History of Cincinnati, Ohio.* Cleveland: L. A. Williams & Co., 1881.

Frankenstein, John. *American Art: Its Awful Attitude.* Cincinnati, 1864.

Gest, J. H. "The Exhibition of the Society of Western Artists." *International Studio* 22(April 1904):ccxlv–cclvi.

Greve, Charles T. "Clubs and Club Life." *New England Magazine* 6(September 1888):479–83.

Hassard, John R. G. "Theodore Thomas." *Scribner's Monthly* 9(February 1875): 458–66.

Hayes, Rutherford B. *Diary and Letters of Rutherford B. Hayes.* Edited by Charles R. Williams. 2 vols. Columbus: Ohio State Archaeological and Historical Society, 1922.

Hitchcock, Ripley. "The Western Art Movement." *The Century Magazine* 32(August 1886):576–93.

Hooper, Henry. "Art and Music in Cincinnati." *New England Magazine* 6(September 1888):459–66.

Illustrated Cincinnati: The Queen City of the West: Its Past, Present, and Future. New York: Acme Publishing and Engraving Co., 1891.

Kingsley, Rose G. "Rookwood Pottery." *The Art Journal* (London), 59(November 1897):341–46.

Kraemer, A. O. *Picturesque Cincinnati.* Cincinnati: A. O. and G. A. Kraemer, 1898.

Krehbiel, Henry E. *An Account of the Fourth Musical Festival Held at Cincinnati, May 18, 19, 20, & 21, 1880.* Cincinnati: Aldine Printing Works, 1880.

Leading Manufacturers and Merchants of Cincinnati and Environs. Cincinnati: International Publishing Co., 1886.

Leonard, John W. *The Centennial Review of Cincinnati: One Hundred Years of Progress in Commerce, Manufactures, the Professions, and in Social and Municipal Life.* Cincinnati: J. M. Elstner & Co., 1888.

"Letters of a Poet to a Musician: Lafcadio Hearn to Henry E. Krehbiel." *The Critic* 48(April 1906):309–18.

"Letters of Thomas Buchanan Read." *Bulletin* of the Ohio State Historical and Archaeological Society, 46(January 1937):68–80.

Linson, Corwin K. "With the Paris Art Student." *Frank Leslie's Popular Monthly* 34(September 1892):289–302.

"Literary Cincinnati." *Literary World* 13(July 29, 1882):249–51.

Macready, William Charles. *The Diaries of William Charles Macready, 1833–1851.* Edited by William Toynbee. 2 vols. New York: G. P. Putnam's Sons, 1912.

Mansfield, E. D. *Personal Memories; Social, Political, and Literary, with Sketches of Many Noted People, 1803–1843.* Cincinnati: Robert Clarke & Co., 1879.

Mapleson, James Henry. *The Mapleson Memoirs: The Career of an Operatic*

Impresario, 1858–1888. Edited and annotated by Harold Rosenthal. New York: Appleton-Century, 1966.

Martineau, Harriet. *Restrospect of Western Travel.* London: Saunders and Otley, 1838.

Maxwell, Clara D. *Memories.* N.p., privately printed, 1916.

Mayer, Frank Blackwell. *With Pen and Pencil on the Frontier in 1851: The Diary and Sketches of Frank Blackwell Mayer.* Edited by Bertha L. Heilbron. St. Paul: Minnesota Historical Society, 1932.

"Midget." "Cincinnati as an Art Center—John Rettig." *The Criterion* 1(October 1887):114–19.

Mussey, Osgood. "The Fine Arts in Cincinnati and the West." *Western Lady's Book* 11(January 1855):47–8.

Nichols, George Ward. *Art Education Applied to Industry.* New York: Harper & Brothers, 1877.

————. *The Cincinnati Organ, with a Brief Description of the Cincinnati Music Hall.* Cincinnati: Robert Clarke & Co., 1878.

————. *Pottery: How It Is Made; Its Shape and Decoration.* New York: G. P. Putnam's Sons, 1878.

————. "Private Picture Collections in Cincinnati." *The Galaxy* 10(October 1870):511–20.

Nichols, Thomas L. *Forty Years of American Life.* London: John Maxwell and Company, 1864. Reprint. New York: Stackpole Sons, 1937.

Outcault, R. F. "Among the Artists." *The Criterion* 1(November 1887): 135–36.

Parton, James. "Cincinnati." *The Atlantic Monthly* 20(August 1867): 229–46.

Perry, Elizabeth F. "Decorative Pottery of Cincinnati." *Harper's Magazine* 62(May 1881):834–45.

Pitman, Benn. *A Plea for American Decorative Art.* Cincinnati: C. J. Krehbiel & Co., 1895.

Ramsay, Alexandrina. "The Art of a Scene Painter." *Monthly Illustrator* 4(June 1895):329–35.

Roe, George Mortimer. *Cincinnati: The Queen City of the West.* Cincinnati: Cincinnati Times-Star Co., 1895.

The Scientific, Literary, Social, Art and Public Educational Institutions and Collections of Cincinnati and Vicinity. Cincinnati: Robert Clarke & Co., 1881.

Sheldon, G. W. "The Cincinnati Dramatic Festival." *Harper's Weekly* 27(May 5, 1883):279.

Simmons, Edward. *From Seven to Seventy.* New York: Harper's, 1922.

Stevens, George E. *The City of Cincinnati.* Cincinnati: George S. Blanchard & Co., 1869.

Strahan, Edward. *The Art Treasures of America.* Philadelphia: George Barrie, 1880.

Taft, Alphonso. *A Lecture on Cincinnati and Her Railroads, Delivered Before the Young Men's Mercantile Library Association.* Cincinnati: D. Anderson, 1850.

Thomas, Theodore. *A Musical Autobiography.* Edited by George P. Upton. 2 vols. Chicago: A. C. McClurg & Co., 1905.

Transactions of the Western Art Union, for the Year 1847. Cincinnati: Ben Franklin Printing House, 1847.

Trollope, Frances. *Domestic Manners of the Americans.* 1832. Reprint. Edited by Donald Smalley. New York: Vintage Books, 1960.

United States Sanitary Commission. *History of the Great Western Sanitary Fair.* Cincinnati: C. F. Vent & Co., 1864.

Upton, George P. "The Cincinnati Musical Festival." *Lakeside Monthly* 9(June 1873):472–77.

Warner, Charles Dudley. *Studies in the South and West.* New York: Harper & Brothers, 1889.

Whittredge, T. Worthington. *The Autobiography of Worthington Whittredge.* Edited by John I. H. Baur. New York: Arno Press, 1969.

Women's Columbian Exposition Association of Cincinnati. *Catalogue of the Exhibit in Cincinnati Room.* Cincinnati: Robert Clarke & Co., 1892.

Secondary Sources

Abbott, Carl. *Boosters and Businessmen: Popular Economic Thought and Urban Growth in the Antebellum Middle West.* Westport, Conn.: Greenwood Press, 1981.

"Alfred Traber Goshorn." In Marietta College, *The Alumni Memorial* 9(1903): 34–40.

Allen, Gay Wilson. *Waldo Emerson.* New York: Penguin Books, 1982.

Andrews, William D. "William T. Coggeshall: 'Booster' of Western Literature." *Ohio History* 81(Summer 1972):210–20.

Appleton, Carolyn M., and Natasha S. Bartalini. "Henry Farny, 1847–1916." In *Henry Farny, 1847–1916.* Austin: University of Texas Press, 1983.

Badger, Reid. *The Great American Fair: The World's Columbian Exposition and American Culture.* Chicago: Nelson Hall, 1979.

Baer, Elizabeth. "Music: An Integral Part of Life in Ohio, 1800–1860." *Bulletin* of the Historical and Philosophical Society of Ohio 14(July 1956):197–210.

Baldwin, Hadley. "Thomas Buchanan Read." *Literary Club Papers.* Vol. 43, December 4, 1920. Cincinnati: The Literary Club.

Baughin, William A. "The Development of Nativism in Cincinnati." *Bulletin* of the Cincinnati Historical Society, 22(October 1964):240–55.

Baur, Bertha. "Foremost American Music Schools: The Cincinnati Conservatory of Music." *Musical Observer* 8(1913):66–68.

Bickerstaff, Laura M. *Pioneer Artists of Taos.* Denver: Sage Books, 1955.

Biddle, George. *An American Artist's Story.* Boston: Little, Brown and Co., 1939.

Biographical Encyclopaedia of Ohio in the Nineteenth Century. Cincinnati: Galaxy Publishing Co., 1876.

Biographical Sketches of American Artists. Lansing: Michigan State Library, n.d.

Birge, Edward Bailey. *History of Public School Music in the United States.* Boston: Oliver Ditson Co., 1928.

Board, Helen. *Berthe Baur: A Woman of Note.* Philadelphia: Dorrance and Co., 1971.

Bolton-Smith, Robin, and William H. Truettner. "Lily Martin Spencer (1822–1902): The Joys of Sentiment." In *Lily Martin Spencer, 1822–1902: The Joys of Sentiment*. Washington, D.C.: Smithsonian Institution Press, 1973.

Boothe, Billy R. "A Survey of Portraits and Figure Paintings by Frank Duveneck, 1848–1919." Ph.D. diss., University of Georgia, 1970.

Boyle, Richard J. *American Impressionism*. Boston: New York Graphic Society, 1974.

————. *John Twachtman*. New York: Watson-Guptill Publications, 1979.

————. "The Second Half of the Nineteenth Century." In *The Genius of American Painting*. Edited by John Wilmerding. New York: William Morrow & Co., 1973.

Brinker, Lea J. "Women's Role in the Development of Art Institutions in Nineteenth Century Cincinnati." Master's thesis, Marquette University, 1968.

Brown, Dee. *The Year of the Century*. New York: Charles Scribner's Sons, 1966.

Buley, R. Carlyle. *The Old Northwest: Pioneer Period, 1815–1840*. 2 vols. Bloomington: Indiana University Press, 1951.

Burke, Mary Alice Heekin. "Elizabeth Nourse: Cincinnati's Most Famous Woman Artist." *Queen City Heritage* 41(Winter 1983):65–72.

————. *Elizabeth Nourse, 1859–1938: A Salon Career*. Washington, D.C.: Smithsonian Institution Press, 1983.

Caffin, Charles H. "Robert Frederick Blum." *The International Studio* 25(December 1903):cxcii.

Carter, Denny. *Henry Farny*. New York: Watson-Guptill Publications, 1978.

————. "Henry Farny." *The American West* 15(November–December 1978): 36–48.

Cazden, Robert F. "The German Book Trade in Ohio Before 1848." *Ohio History* 84(Winter–Spring 1975):57–77.

Centenary of the Cincinnati Observatory. Cincinnati: Historical and Philosophical Society of Ohio, 1944.

Cincinnati Art Club. "History of the Cincinnati Art Club, 1890–1968." Typed manuscript, n.d., Public Library of Cincinnati and Hamilton County.

Cincinnati Art Museum. *Art Palace of the West*. Cincinnati: Cincinnati Art Museum, 1981.

————. *Celebrate Cincinnati Art*. Edited by Kenneth R. Trapp. Cincinnati: Cincinnati Art Museum, 1982.

————. *The Golden Age: Cincinnati Painters of the Nineteenth Century Represented in the Cincinnati Art Museum*. Cincinnati: Cincinnati Art Museum, 1979.

————. *The Ladies, God Bless 'Em: The Women's Art Movement in Cincinnati in the Nineteenth Century*. Cincinnati: Cincinnati Art Museum, 1976.

————. *Robert F. Blum, A Retrospective Exhibition, 1857–1903*. Cincinnati: Cincinnati Art Museum, 1966.

————. *Robert S. Duncanson, A Centennial Exhibition*. Cincinnati: Cincinnati Art Museum, 1972.

————. *The Work of Joseph R. DeCamp: Special Exhibition, October, 1924*. Cincinnati: Cincinnati Art Museum, 1924.

"Cincinnati Conservatory of Music." *American Musician* 7(June 1903):8–9.

Cincinnati Museum Association. *Lewis Henry Meakin, 1850–1917.* Cincinnati: Cincinnati Museum Association, 1918.

Cincinnati Music Hall Association. *Golden Jubilee, Cincinnati Music Hall, 1878–1928.* Cincinnati: n.p., 1928.

Clark, Edna Mae. *Ohio Art and Artists.* Richmond: Garrett and Massie, 1932.

Cockerill, John. "Lafcadio Hearn: The Author of Kokoru." *Current Literature* 19(June 1896):476.

Cole, John Y. "Spofford in Cincinnati, 1845–1861." In *Ainsworth Rand Spofford, Bookman and Librarian.* Edited by John Y. Cole. Littleton, Colo.: Libraries Unlimited, Inc., 1975.

Condit, Carl W. *The Railroad and the City: A Technological and Urbanistic History of Cincinnati.* Columbus: Ohio State University Press, 1977.

Corcoran Gallery of Art. *Edward Potthast, 1857–1927.* Washington, D.C., 1973.

Coyle, William. *The Frankenstein Family in Springfield.* Springfield, Ohio: Clark County Historical Society, 1967.

Crane, Sylvia E. *White Silence: Greenough, Powers, and Crawford, American Sculptors in Nineteenth Century Italy.* Coral Gables: University of Miami Press, 1972.

Dean, Roberta H. "The Western Art Union, 1847–1851." Master's thesis, George Washington University, 1978.

de Chambrun, Clara Longworth, *Cincinnati, The Story of the Queen City.* New York: Charles Scribner's Sons, 1939.

————. *The Making of Nicholas Longworth: Annals of an American Family.* New York: Ray Long and Richard R. Smith, Inc., 1933.

Dedmon, Emmett. *Fabulous Chicago.* New York: Random House, 1953.

Draegert, Eva. "Cultural History of Indianapolis: Music, 1875–1890." *Indiana Magazine of History* 53(September 1957):265–304.

Dunlap, James F. "Queen City Stages: Highlights of the Theatrical Season of 1843." *Bulletin* of the Historical and Philosophical Society of Ohio, 19(April 1961):128–43.

Dunlop, M. H. "Curiosities Too Numerous to Mention: Early Regionalism and Cincinnati's Western Museum." *American Quarterly* 36(Fall 1984): 524–48.

Duveneck, Josephine. *Frank Duveneck, Painter-Teacher.* San Francisco: John Howell—Books, 1970.

Dwight, Edward H. "A Cincinnati Artist: Aaron H. Corwine." *Bulletin* of the Historical and Philosophical Society of Ohio, 17(April 1959):103–8.

————. "Robert S. Duncanson." *Bulletin* of the Historical and Philosophical Society of Ohio, 13(July 1955):203–11.

Earhart, J. F. "Henry Farny, the Artist and the Man." *Cincinnati Commercial,* January 21, 1917.

Easton, Lloyd E. "German Philosophy in Nineteenth Century Cincinnati—Stallo, Conway, Nast, and Willich." *Bulletin* of the Historical and Philosophical Society of Ohio, 20(January 1962):15–28.

Eidelberg, Martin. "Art Pottery." In *The Arts and Crafts Movement in America,*

1876–1916. Edited by Robert Judson. Princeton: Princeton University Press, 1972.

Ellard, Harry. *Baseball in Cincinnati*. Cincinnati: [Johnson and Hardin], 1907.

Engel, Bernard. "Poetry of the Early Midwest." Typed manuscript, n.d., Cincinnati Historical Society.

Ewen, David. *Music Comes to America*. New York: Allen, Towne & Heath, 1947.

Faust, Albert Bernhardt. *The German Element in the United States*. 2 vols. Boston: Houghton Mifflin Co., 1909.

Fenn, Forrest. *The Beat of the Drum and the Whoop of the Dance: A Study of the Life and Work of Joseph Henry Sharp*. Santa Fe: Fenn Publishing Co., 1983.

Findsen, Owen. "Cincinnati's Famous Bird-Watcher." *Cincinnati Enquirer,* April 7, 1985.

Flagle, Elsie W. "My Uncle: C. A. Meurer, a Celebrated Still-Life Artist." Manuscript in Public Library of Cincinnati and Hamilton County.

Flanagan, John T. *James Hall, Literary Pioneer of the Ohio Valley*. Minneapolis: University of Minnesota Press, 1941.

Frost, O. W. *Young Hearn*. Tokyo: The Hokuseido Press, 1958.

Garretson, Mary Noble Welleck. "Thomas S. Noble and His Paintings." *The New-York Historical Society Quarterly* 24(October 1940):113–23.

Garrison, Dee. *Apostles of Culture: The Public Librarian and American Society, 1876–1920*. New York: The Free Press, 1979.

Gary, Charles L. "A History of Music Education in the Cincinnati Public Schools." Ed.D. diss., University of Cincinnati, 1951.

Gibson, Arrell Morgan. *The Santa Fe and Taos Colonies: Age of the Muses, 1900–1942*. Norman: University of Oklahoma Press, 1983.

Gibson Art Company. "Faith in America." Typed manuscript in Cincinnati Historical Society, n.d.

Gifford, Robert Thomas. "The Cincinnati Music Hall and Exposition Buildings." Master's thesis, Cornell University, 1973.

————. "Cincinnati's Music Hall: A Century of Continuity and Change." *Bulletin* of the Cincinnati Historical Society 36(Summer 1978):79–103.

Goldin, Milton. *The Music Merchants*. New York: Macmillan Co., 1969.

Goss, Charles Frederic. *Cincinnati, the Queen City, 1788–1912*. 2 vols. Chicago: S. J. Clarke & Co., 1912.

Grandstaff, James Russell. "A History of the Professional Theatre in Cincinnati, Ohio, 1861–1886." 2 vols. Ph.D. diss., University of Michigan, 1963.

Grayson, Frank. "Singing Cincinnati." *Cincinnati Times-Star,* January 21, 1937.

Greve, Charles T. *Centennial History of Cincinnati and Representative Citizens*. 2 vols. Chicago: Biographical Publishing Co., 1904.

Grover, Oliver Dennett. "Duveneck and His School." Paper read before Woodlawn (Ohio) Woman's Club, January 18, 1915, Duveneck file, Cincinnati Art Museum.

Hale, John Douglass. "The Life and Creative Development of John H. Twachtman." 2 vols. Ph.D. diss., Ohio State University, 1957.

Hall, Virginius C. "Historical and Philosophical Society of Ohio: A Short History."

Bulletin of the Historical and Philosophical Society of Ohio, 14(April 1956):87–104.

Hamlin, Arthur T. *Harvard and Cincinnati: A Century of Civic Service*. Hamden, Conn.: Archon Books, 1969.

Hamm, Charles. *Music in the New World*. New York: W. W. Norton, 1983.

Harris, Neil. *The Artist in American Society, the Formative Years, 1790–1860*. New York: Simon and Schuster, 1966.

Hart, Kenneth Wayne. "Cincinnati Organ Builders of the Nineteenth Century." *Bulletin* of the Cincinnati Historical Society, 31(Summer 1973):79–98.

Haswell, Ernest Bruce. "The Cincinnati Art Club." *Bulletin* of the Cincinnati Historical Society, 9(July 1951):203–11.

––––––. "Cincinnati as an Art Center." *Art and Archaeology* 8 (September–October 1919):245–77.

Heerman, Norbert. *Frank Duveneck*. Boston: Houghton Mifflin, 1918.

––––––. "Frank Duveneck." In *Paintings by Frank Duveneck, 1848–1919*. New York: Whitney Museum of Art, 1938.

Henzke, Lucile. *American Art Pottery*. New York: Thomas Nelson, 1970.

Hodges, Fletcher, Jr. "Stephen Foster—Cincinnatian and American." *Bulletin* of the Historical and Philosophical Society of Ohio, 8(April 1950):83–104.

Holliday, Joseph E. "Cincinnati Opera Festivals During the Gilded Age." *Bulletin* of the Cincinnati Historical Society, 24(April 1966):131–49.

––––––. "The Cincinnati Philharmonic and Hopkins Hall Orchestras, 1856–1868." *Bulletin* of the Cincinnati Historical Society, 26(April 1968):158–73.

––––––. "Collector's Choice of the Gilded Age." *Bulletin* of the Cincinnati Historical Society, 28(Winter 1970):295–315.

––––––. "The Musical Legacy of Theodore Thomas." *Bulletin* of the Cincinnati Historical Society, 27(Fall 1969):191–205.

––––––. "Notes on Samuel N. Pike and his Opera Houses." *Bulletin* of the Cincinnati Historical Society, 25(July 1967):165–83.

Horine, Emmet Field. *Daniel Drake (1785–1852), Pioneer Physician of the Midwest*. Philadelphia: University of Pennsylvania Press, 1961.

Horowitz, Helen Lefkowitz. *Culture and the City: Cultural Philanthropy in Chicago from the 1850s to 1917*. Lexington: University Press of Kentucky, 1976.

Howe, Barbara J. "Clubs, Culture and Charity: Anglo-American Upper Class Activities in the Late Nineteenth Century City." Ph.D. diss., Temple University, 1976.

––––––. "Uniting the Useful and Beautiful: The Arts in Cincinnati." *The Old Northwest* 4(September 1878):319–36.

Howe, Henry. *Historical Collections of Ohio*. 2 vols. Cincinnati: C. J. Krehbiel & Co., 1908.

Hughes, Jon C. *The Tanyard Murder: On the Case with Lafcadio Hearn*. Washington, D.C.: University Press of America, 1982.

––––––. "Ye Giglampz; Devoted to Art, Literature and Satire." Typed manuscript in Public Library of Cincinnati and Hamilton County, 1982.

Hunt, Samuel F. *Charles McMicken, Founder of the University of Cincinnati*. Cincinnati, 1892.

Jacobowitz, Arlene. "Edward Henry Potthast." In The Brooklyn Museum, *Annual Report, 1967–1968*. New York: Brooklyn Museum, 1969.

Kellogg, Elizabeth R. "The Chicago World's Fair." In *Clara Chipman Newton: A Memorial Tribute*. Cincinnati: n.p., 1938.

———. *Memories of Joseph Henry Gest: Gentleman, Scholar, Administrator, and Artist*. Cincinnati: The Byway Press, 1937.

King, Margaret Rives. *Memoirs of the Life of Mrs. Sarah Peter*. Cincinnati: Robert Clarke & Co., 1889.

Knight, Marian. "The Fountain: Rededication to a Second Century." *Bulletin* of the Cincinnati Historical Society, 29(Summer 1971): 100–115.

Knittle, Rhea M. *Early Ohio Taverns: Tavern Signs, Stage Coach, Barge, Banner, Chair and Settee Painters*. Portland, Maine: The Southwest-Anthoensen Press, 1937.

Kobbe, Gustav. "Portraits and Ideals by William J. Baer." *New York Herald,* June 26, 1910.

Leading Manufacturers and Merchants of Cincinnati and Environs. Cincinnati: International Publishing Co., 1886.

Lears, T. J. Jackson. *No Place of Grace: Antimodernism and the Transformation of American Culture, 1880–1920*. New York: Pantheon Books, 1983.

Lewis, John. "An Historical Study of the Origin and Development of the Cincinnati Conservatory of Music." Ph.D. diss., University of Cincinnati, 1943.

Literary Club, *The Literary Club of Cincinnati, 1849–1874*. Cincinnati, 1874.

Maas, John. *The Glorious Enterprise: The Centennial Exhibition of 1876 and H. J. Schwarzmann, Architect-in-Chief*. Watkins Glen, N.Y.: American Life Foundation, 1973.

McAllister, Anna S. *In Winter We Flourish: Life and Letters of Sarah Worthington King Peter, 1800–1877*. New York: Longmans, Green and Co., 1939.

McCabe, Lida Rose. "The Robert Frederick Blum Scholarship: A Productive Memorial." *Form,* November 1913, 16–17, 29.

McCarthy, Kathleen D. *Noblesse Oblige: Charity and Cultural Philanthrophy in Chicago, 1849–1929*. Chicago: University of Chicago Press, 1982.

McGrane, Reginald C. *The University of Cincinnati: A Success Story in Urban Higher Education*. New York: Harper & Row, 1963.

McGrath, Edward J. "Reuben Springer: Cincinnatian, Businessman, Philanthropist." *Bulletin* of the Historical and Philosophical Society of Ohio, 13(October 1955):271–85.

MacKenzie, Donald R. "Collections and Exhibits: The Itinerant Artist in Early Ohio." *Ohio History* 73(Winter 1964):41–46.

———. "Painters in Ohio, 1788–1860, with a Biographical Index." Ph.D. diss., Ohio State University, 1960.

Malone, Dumas, ed. *Dictionary of American Biography*. New York: Charles Scribner's Sons, 1935.

Mansfield, Edward D. *Memoirs of the Life and Services of Daniel Drake*. Cincinnati: Applegate and Co., 1855.

Marzio, Peter C. *The Democratic Art: Pictures for a Nineteenth Century America*. Boston: David R. Godine, 1979.

Mase, Carolyn C. "John H. Twachtman." *The International Studio* 72(January 1921):71–86.

Mead, David. *Yankee Eloquence in the Middle West: The Ohio Lyceum, 1850–1870.* East Lansing: Michigan State College Press, 1951.

Merten, John W. "Stone by Stone: Along a Hundred Years with the House of Strobridge." *Bulletin* of the Historical and Philosophical Society of Ohio, 8(January 1950):3–48.

Miller, Lillian B. *Patrons and Patriotism: The Encouragement of the Fine Arts in the United States, 1790–1860.* Chicago: University of Chicago Press, 1966.

Monroe, Alden N. "Bigtop to Bijou: The Golden Age of the Show Poster." *Queen City Heritage* 42(Summer 1984):3–14.

Moody, Richard. *America Takes the Stage: Romanticism in American Drama and Theatre, 1750–1900.* Bloomington: Indiana University Press, 1969.

Morgan, H. Wayne. *New Muses: Art in American Culture.* Norman: University of Oklahoma Press, 1978.

————. "The Search for a National Culture." In *Unity and Culture: The United States, 1877–1900.* Edited by H. Wayne Morgan. London: Allen Lane-The Penguin Press, 1971.

Mueller, John H. *The American Symphony Orchestra: A Social History of Musical Taste.* Bloomington: Indiana University Press, 1951.

Murrary, Richard. "Kenyon Cox and the Art of Drawing." *Drawing* 3(May–June 1981):1–6.

National Cyclopaedia of American Biography. New York: James T. White and Co., 1936.

Orlando, Vincent A. "An Historical Study of the Origin and Development of the College of Music of Cincinnati." Ed.D. diss., University of Cincinnati, 1946.

Peck, Herbert. "The Amateur Antecedents of Rookwood Pottery." *Bulletin* of the Cincinnati Historical Society, 26(October 1968):317–42.

————. *The Book of Rookwood Pottery.* New York: Bonanza Books, 1968.

Pennell, Joseph. *Pen Drawing and Pen Draftsmanship.* New York: The Macmillan Co., 1920.

Pentland, Heather. "Sarah Worthington King Peter and the Cincinnati Ladies' Academy of Fine Art." *Bulletin* of the Cincinnati Historical Society, 39(Spring 1981):7–16.

Pizor, Faith K. "Preparations for the Centennial Exhibition of 1876." *The Pennsylvania Magazine of History and Biography* 94(April 1970): 213–32.

Poole, William Frederick. *The Tyler Davidson Fountain.* Cincinnati: Robert Clarke & Co., 1872.

Randall, Randolph C. *James Hall, Spokesman for a New West.* Columbus: Ohio State University Press, 1964.

Rattermann, Henry A. "Early Music in Cincinnati." Reprint of a paper read before the Literary Club, November 9, 1879. Public Library of Cincinnati and Hamilton County.

Reiter, Edith R. "Lily Martin Spencer." *Museum Echoes* 27(May 1954):35–38.

Ritter, Frederic Louis. *Music in England and Music in America.* London: William Reeves, 1884.

Rodabaugh, James H. "Charles T. Webber." *Museum Echoes* 27(August 1954): 59–62.

Ross, Ishbel. *Child of Destiny: The Life Story of the First Woman Doctor*. New York: Harper and Brothers, 1949.

Rudolph Wurlitzer Company. *Wurlitzer World of Music, 1856-1956: One Hundred Years of Musical Achievement*. Chicago: Rudolph Wurlitzer Co., 1956.

Rufus King in the Development of Cincinnati During the Last Fifty Years. Cincinnati: Robert Clarke & Co., 1891.

Russell, Theodore C. "Theodore Thomas: His Role in the Development of Musical Culture in the United States, 1835–1905." Ph.D. diss., University of Minnesota, 1969.

Sagmaster, Joseph. "Cincinnati's Golden Age of Music." Literary Club paper, January 2, 1939. Copy in Public Library of Cincinnati and Hamilton County.

Schroeder, Vernon D. "Cincinnati's Musical Growth, 1870–1875." Master's thesis, University of Cincinnati, 1971.

Shapiro, Henry D. "Daniel Drake's *Sensorium Commune* and the Organization of the Second American Enlightenment." *Bulletin* of the Cincinnati Historical Society, 27(Spring 1969):43–52.

Shapiro, Henry D., and Zane L. Miller. *Physician to the West: Selected Writings of Daniel Drake on Science and Society*. Lexington: University Press of Kentucky, 1970.

Shepherd, Anne B. "Peyton Short Symmes of Cincinnati's First Family." *Bulletin* of the Cincinnati Historical Society, 27(Fall 1969):223–37.

Shivers, Frank R. "Robust Life and Freedom: A Western Chapter in the History of American Transcendentalism, 1830–1841." Typed manuscript, n.d. Cincinnati Historical Society.

Sklar, Katheryn Kish. *Catharine Beecher: A Study in American Domesticity*. New York: W. W. Norton & Co., 1976.

Smith, Kenneth E. "Laura Anne Fry: Originator of Atomizing Process for Application of Underglaze Color." *Bulletin* of the American Ceramic Society, 17(September 1938):368–72.

Smith, Ophia D. "The Early Theater of Cincinnati." *Bulletin* of the Historical and Philosophical Society of Ohio, 13(October 1955): 231–53.

———. "Frederick Eckstein, The Father of Cincinnati Art." *Bulletin* of the Historical and Philosophical Society of Ohio, 9(October 1951):266–82.

———. "Joseph Tosso, the Arkansas Traveller." *The Ohio State Archaeological and Historical Quarterly* 56(January 1947):16–35.

———. "A Survey of Artists in Cincinnati, 1789–1830." *Bulletin* of the Cincinnati Historical Society, 25(January 1967):3–20.

Sollors, Werner. "Emil Klauprecht's *Cincinnati, Oder Geheimnisse Des Westens* and the Beginnings of Urban Realism in America." *Queen City Heritage* 42(Fall 1984):39–48.

Spanheimer, Sister Mary Edmund. "Heinrich Armin Rattermann, German-American Author, Poet, and Historian, 1832–1923." Ph.D. diss., Catholic University of America, 1937.

Spiess, Philip D., Jr. "The Cincinnati Industrial Exhibitions (1870–1888): Propaganda or Progress?" Master's thesis, University of Delaware, 1970.

————. "Exhibitions and Expositions in Nineteenth Century Cincinnati." *Bulletin* of the Cincinnati Historical Society, 28(Fall 1970):171–92.

Spraul, Judith. "Cultural Boosterism: The Construction of Music Hall." *Bulletin* of the Cincinnati Historical Society, 34(Fall 1976):189–202.

Spraul-Schmidt, Judith. "The Late Nineteenth Century City and Its Cultural Institutions: The Cincinnati Zoological Garden, 1873–1898." Master's thesis, University of Cincinnati, 1977.

Steen, Ivan D. "Cincinnati in the 1850s: As Described by British Travelers." *Bulletin* of the Cincinnati Historical Society, 26(July 1968):255–75.

Stein, Roger B. *John Ruskin and Aesthetic Thought in America, 1840–1900.* Cambridge: Harvard University Press, 1967.

Steiner, Robert L. "The Business Cycle in a Conservative City: A Study of Urban Growth and Cyclical Stability in Competing Industrial Areas." Master's thesis, Columbia University, 1948.

Steinway, Theodore, *People and Pianos: A Century of Service to Music.* New York: Steinway and Sons, 1953.

Stern, Joseph S., Jr. "The Queen of the Queen City, Music Hall." *Bulletin* of the Cincinnati Historical Society, 31(Spring 1973):7–27.

Stevens, Harry R. "Adventure in Refinement: Early Concert Life in Cincinnati, 1810–1826." *Bulletin* of the Historical and Philosophical Society of Ohio, 5(September 1947), pt. 1, 8–22; 5(December, 1947), pt. 2, 22–32.

————. "The First Cincinnati Music Festival." *Bulletin* of the Historical and Philosophical Society of Ohio, 20(July 1962):186–96.

————. "The Haydn Society of Cincinnati, 1819–1824." *Ohio State Archaeological and Historical Society Quarterly* 52(April 1943):95–119.

————. "New Foundations: Cincinnati Concert Life, 1826–1830." *Bulletin* of the Historical and Philosophical Society of Ohio, 10(January 1952):26–38.

Stevenson, Elizabeth. *Lafcadio Hearn.* New York: Macmillan Co., 1961.

Storer, Maria Longworth. *The History of the Cincinnati Musical Festivals and of the Rookwood Pottery.* Paris: Herbert Clarke, 1919.

Sutton, Walter. *The Western Book Trade: Cincinnati as a Nineteenth Century Publishing and Book-Trade Center . . . 1796–1880.* Columbus: Ohio State University Press, 1961.

Taft, Lorado. *The History of American Sculpture.* New York: Macmillan Co., 1930.

Teal, William P. "Cincinnati's Preeminence in Painting and Sculpture." In *The Contribution of Cincinnati to Modern Art.* Cincinnati: Board of Education, 1923.

Thomas, Louis R. "A History of the Cincinnati Symphony Orchestra to 1931." Ph.D. diss., University of Cincinnati, 1972.

Thomas, Rose Fay. *Memoirs of Theodore Thomas.* New York: Moffat, Yard and Co., 1911.

Tilton, Eleanor M. *Amiable Autocrat, A Biography of Dr. Oliver Wendell Holmes.* New York: Henry Schuman, 1947.

Tolzmann, Don Henrich. "Muskenlange aus Cincinnati." *Bulletin* of the Cincinnati Historical Society, 35(Summer 1977):115–29.

Tomsich, John. *A Genteel Endeavor: American Culture and Politics in the Gilded Age.* Stanford: Stanford University Press, 1971.

Trapp, Kenneth R. "Art Palace of the West: Its Beginnings." In *Art Palace of the West.* Cincinnati: Cincinnati Art Museum, 1981.

————. "The Growth of Fine Arts Institutions in Cincinnati, 1838–1854." Paper read before the Ohio-Indiana American Studies Association, April 21, 1978, copy in author's possession.

————. "Rookwood and the Japanese Mania in Cincinnati." *Bulletin* of the Cincinnati Historical Society, 39(Spring 1981):51–75.

————. " 'To Beautify the Useful': Benn Pitman and the Cincinnati Woodcarving Movement, 1873–1893." Typed manuscript, n.d. Cincinnati Biography—Benn Pitman. Cincinnati Historical Society.

————. "Toward a Correct Taste: Women and the Rise of the Design Movement in Cincinnati, 1874–1880." In *Celebrate Cincinnati Art.* Edited by Kenneth R. Trapp. Cincinnati: Cincinnati Art Museum, 1981.

Tucker, Louis Leonard. "Hiram Powers and Cincinnati." *Bulletin* of the Cincinnati Historical Society, 25(January 1967):21–49.

————. " 'Old Nick' Longworth, the Paradoxical Maecenas of Cincinnati." *Bulletin* of the Cincinnati Historical Society, 25(October 1967):246–59.

————. "The Semi-Colon Club of Cincinnati." *Ohio History* 73(Winter 1964): 13–26.

Tunison, Frank E. *Presto! From the Singing School to the May Musical Festival.* Cincinnati: E. H. Beasley Co., 1888.

Venable, William H. *Beginnings of Literary Culture in the Ohio Valley.* 1891. Reprint. New York: Peter Smith, 1949.

————. "The Cincinnati Society of Natural History." *McMicken Review* 4(1890): 24–26.

Ventre, John E., and Edward J. Goodman. *A Brief History of the Cincinnati Astronomical Society.* Cincinnati: Cincinnati Astronomical Society, 1985.

Vitz, Carl. "Three Master Librarians." *Bulletin* of the Cincinnati Historical Society, 26(October 1968):343–60.

Vitz, Robert C. " 'Im Wunderschoenen Monat Mai': Organizing the Great Cincinnati Musical Festival of 1878." *American Music* 4(Fall 1986):309–27.

————. "Starting a Tradition: The First Cincinnati May Musical Festival." *Bulletin* of the Cincinnati Historical Society, 38(Spring 1980):33–50.

————. "Supporting the Arts: The Cincinnati Musical Prizes of 1880 and 1882." *The Old Northwest* 7(Summer 1981):95–110.

Wade, Richard C. *The Urban Frontier: Pioneer Life in Early Pittsburgh, Cincinnati, Lexington, Louisville, and St. Louis.* Chicago: Phoenix Books, 1964.

Walters, Raymond. *Stephen Foster, Youth's Golden Dream: A Sketch of His Life and Background in Cincinnati, 1846–1850.* Princeton: Princeton University Press, 1936.

Weber, Bruce. "Frank Duveneck and the Art Life of Cincinnati, 1865–1900." In *The*

Golden Age: Cincinnati Painters of the Nineteenth Century Represented in the Cincinnati Art Museum. Cincinnati: Cincinnati Art Museum, 1979.

Weimann, Jeanne Madeline. *The Fair Women.* Chicago: Academy Chicago, 1981.

Welling, William. *Photography in America: The Formative Years, 1839–1900.* New York: Thomas Y. Crowell, 1978.

Weymouth, Lally, and Milton Glaser. *America in 1876: The Way We Were.* New York: Random House, 1976.

Wilby, Joseph. *The Historical and Philosophical Society of Ohio: A Paper Read Before the Society of Colonial Dames of America, Resident in Ohio.* Cincinnati: Procter & Collier, 1902.

Williamson, William Landram. *William Frederick Poole and the Modern Library Movement.* New York: Columbia University Press, 1963.

Wittke, Carl. *Refugees of Revolution: The German Forty-Eighters in America.* Philadelphia: University of Pennsylvania Press, 1952.

Women's Art Museum Association. *Constitution and By-Laws of the Women's Art Museum Association of Cincinnati, Ohio.* Cincinnati: Gazette Co., 1879.

Works Projects Administration. *Cincinnati: A Guide to the Queen City and Its Neighbors.* Cincinnati: Wiesen-Hart Press, 1943.

Wulsin, Lucien. *Dwight Hamilton Baldwin (1821–1899) and the Baldwin Piano.* New York: The Newcomen Society, 1953.

Wurlitzer World of Music, 1856–1956: 100 Years of Musical Achievement. Chicago: The Rudolph Wurlitzer Co., 1956.

Young and Klein, Inc. *Lithographing in Cincinnati.* 2 Parts. Cincinnati: n.p., n.d.

Young Men's Mercantile Library Association. *History of the Young Men's Mercantile Library Association, 1835–1935.* Cincinnati: Ebbert & Richardson Co., 1935.

Index

315